CHANGING IMAGES OF PICTORIAL SPACE

CHANGING IMAGES OF PICTORIAL SPACE

A History of Spatial Illusion in Painting

William V. Dunning

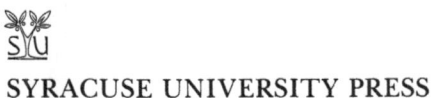
SYRACUSE UNIVERSITY PRESS

Copyright © 1991 by Syracuse University Press
Syracuse, New York 13244-5290

ALL RIGHTS RESERVED

First Edition 1991
12 13 14 15 16 11 10 9 8 7

This study was partially supported by the Share Fund and Faculty Research Funds of Central Washington University, Ellensburg, Washington 98926.

For a listing of books published and distributed by Syracuse University Press, visit our website at SyracuseUniversityPress.syr.edu.

ISBN: 978-0-8156-2508-7

Library of Congress Cataloging-in-Publication Data
Dunning, William, 1933-
 Changing images of pictorial space : a history of spatial illusion in painting / William Dunning.—1st ed.
 p. cm.
 Includes bibliographical references (p.) and index.
 ISBN 0-8156-2505-7 cloth —ISBN 0-8156-2508-1 pbk.
 1. Composition (Art) 2. Space (Art) 3. Painting—Technique. 4. Visual perception. I. Title.
ND1475.D86 1991
750'.1'8—dc20 90-10211

Contents

Figures vii
Preface ix
Acknowledgments xi
1. Background 1
2. The Middle Ages 10
 The Pre-Renaissance 13
 Cimabue: The Great Beginner 15
3. The Proto-Renaissance 21
 Giotto: Inventing a New Perspective 26
4. The Renaissance System of Perspective 35
 Linear Perspective 38
 Separation of Planes 41
 Atmospheric Perspective 43
 The Classic Color Theory 47
5. The Renaissance 55
 Masaccio: The Shadow Catcher 57
6. The High Renaissance 69
 Leonardo's Structure 71
7. Compositional Climax 83
8. The Baroque Age 89
 Caravaggio's Cartesian Space 96
9. The Rococo Age 101
 Tiepolo's New Priorities of Figure and Space 102
 Gainsborough Reverses Color Perspective 107
10. The Roots of Modernism 115
 Degas's New Viewpoint 124
11. Monet's Synthesis of Depth and Flatness 130

12. Cézanne's Elaborate Separation of Planes 142
13. The Modernists 152
 Picasso's Time and Space 156
14. Hans Hofmann's Spatial Chimera 160
15. Abstract Expressionism 170
 Zen 172
 The Dancer from the Dance 173
 Freud and the Automatic Hand 175
 Pollack Negates Compositional Climax 177
16. Kline's Structure by Absence 183
17. de Kooning's Illusion Denying Illusion 190
18. The Ascendancy of Pluralism 198
 Newman's Binocular Paintings 199
 Poons's Spatial Confetti 203
 Photo-Realism's Aporetic Content 205
 The Parting 210
19. Postmodernism and the Post-Cartesian Viewer 213
20. Postmodernism: A New Language 227
 Works Cited 237
 Index 245

Figures

1.1. Roman mural. *Odysseus in the Land of the Lestrygonians.* 7
1.2. Scene from the Story of Joshua. 8
2.1. Cimabue, Giovanni. *Madonna and Child.* 17
3.1. Giotto. *Enrico Scrovegni Presenting a Model of the Arena Chapel.* 29
3.2. Giotto. *The Vision of Joachim.* 32
4.1. Botticelli, Sandro. *The Miracle of St. Zenobuis.* 42
4.2. Ghiberti, Lorenzo. *The Story of Jacob and Esau.* 45
4.3. Church, Frederick. *The Andes of Ecuador.* 48
4.4. Raphael. *The Beautiful Gardener.* 50
5.1. Masaccio. *The Tribute Money.* 59
5.2. Masaccio. *Expulsion of Adam and Eve from Paradise.* 66
6.1. Leonardo da Vinci. *Virgin of the Rocks.* 73
6.2. Leonardo da Vinci. *Lady with an Ermine.* 76
6.3. Leonardo da Vinci. *Last Supper.* 79
7.1. Raphael. *Portrait of Angelo Doni.* 84
7.2. Lasansky, Mauricio. Drawing #21 from *The Nazi Series.* 85
8.1. Caravaggio. *David and Goliath.* 98
9.1. Tiepolo. *Apotheosis of the Pisani Family.* 105
9.2. Gainsborough, Thomas. *The Mall in St. James Park.* 108
9.3. Gainsborough, Thomas. *Blue Boy.* 111
9.4. Fra Angelico. *Madonna.* 113
10.1. Degas, Edgar. *Miss La La at the Cirque Fernando.* 126
10.2. Degas, Edgar. *The Tub.* 128
11.1. Monet, Claude. *La Grenouillière.* 132
11.2. Monet, Claude. *Poppy Field in a Hollow near Giverny.* 136
11.3. Monet, Claude. *Rouen Cathedral, West Façade.* 138
11.4. Monet, Claude. *Rouen Cathedral, West Façade, Sunlight.* 140

12.1. Cézanne, Paul. *Still Life with Apples and Oranges.* 144
12.2. Cézanne, Paul. *Mont Sainte Victoire.* 147
13.1. Picasso, Pablo. *Girl Before a Mirror.* 158
14.1. Hofmann, Hans. *Rising Moon.* 164
15.1. Pollock, Jackson. *White Light.* 181
16.1. Kline, Franz. *Mahoning.* 185
17.1. de Kooning, Willem. *Excavation.* 191
17.2. de Kooning, Willem. *Woman I.* 195
18.1. Newman, Barnett. *Vir Heroicus Sublimis.* 201
18.2. Poons, Larry. *Untitled.* 204
18.3. Johns, Jasper. *Flag.* 205
18.4. Eddy, Don. *Silverware for M.* 207
19.1. Rice, Dan. *Satan Sanitation.* 220
20.1. Salle, David. *Dual Aspect Picture.* 230

Preface

WHEN PAINTERS WRITE ABOUT ART, they write about pictorial space—the illusion of depth on the flat surface of a painting—and its relationship to this flat surface. Leonardo in his notebooks described the techniques and devices that are used to sustain this pictorial space. Malevich, Pevsner, and Gabo wrote of nothing if not space and its relationship to time. Hans Hofmann's *Search for the Real* focuses on the relationship between the physical surface of the canvas, the real space outside the canvas, and pictorial space. William Seitz, a respected painter and art historian, maintains that "through one pictorial device or another the greatest percentage of the world's painting has dealt with the representation of space" (Seitz 1983, 40). And in his recent book on painting, aptly titled *Working Space,* Frank Stella insists that "after all, the aim of art is to create space—space that is not compromised by decoration or illustration, space in which the subjects of painting can live. This is what painting has always been about" (Stella 1986, 5).

No knowledgeable artist, critic, or art historian disputes the importance of recording how and why our conceptions of pictorial space have changed from the Greco-Roman to the postmodern period, and how the methods and techniques needed to depict this space have changed as well. But surprisingly, no one has yet written a comprehensive history centered around these changing images of pictorial space. This book traces one plausible path in the evolution of the conception and the depiction of space in European (primarily Italian and French) and American painting, and the ways in which that evolution signified ideological changes in society over a period of twenty centuries.

Space, in European painting, has been depicted by means of several methods of perspective. The most persistent of these methods was Renaissance perspective. But when most art historical writers—even such excellent writers as Erwin Panofsky and Samuel Edgerton in his book *The Rediscovery of Renaissance Perspective*—refer to "Re-

naissance perspective," they mean linear perspective only. It was, however, no such obvious and singular device as linear perspective that captured the imagination and guided the direction of painters from Masaccio to David Salle.

This book will demonstrate that those new styles and images in painting that most convincingly reflected the concepts of their time were characteristically created by separating, reversing, and recombining the five structural elements of the Renaissance illusion, which is created by a combination of the shading of volume—unified by a single light source—with the Renaissance system of perspective: the separation of planes, linear perspective, atmospheric perspective, and color perspective (the classic color theory).

I will also show that the evolution of concept and structure in painting is generated by successive new combinations and permutations of the five major elements of pictorial illusion, and that before the last half of the twentieth century, changes in pictorial space, the picture plane, lateral and spatial composition, compositional climax, and the representation of the external world, as well as the image of man himself, were initiated by permutations of these five major elements of the Renaissance illusion. Recently the emphasis has begun to change, and many postmodern painters are beginning to experiment with recombining linguistic rather than illusionistic aspects in painting.

Like many art history books, this book progresses chronologically. It begins with the destructuring of the Greco-Roman illusion and proceeds through the Middle Ages, the Italian Renaissance, impressionism, the death of modern art, and the beginnings of postmodern art. It traces the history of illusion and its attendant devices, structures, and concepts, rather than the history of periods or styles. Because it focuses on that point at which strategy and practice intersect, it should be of value to students of painting as well as to students of art history.

I hope to offer to readers a plausible understanding of the historical development of visual structure as well as painterly concept and image. Such a structural grasp of different spatial concepts and illusions, and the role played by each, will, I believe, contribute to an understanding of art that transcends inconstant style.

Ellensburg, Washington William V. Dunning
June, 1990

Acknowledgments

I TENDER MY SINCERE appreciation to those colleagues who respected me enough to offer me the courtesy of candor: John Herum helped me start this project, encouraged me throughout the process, and taught me how to create, from inchoate thoughts, a book; Patricia Garrison helped me to organize and edit; Phil Garrison gave me invaluable guidance concerning criticism, literature, and linguistics; Phil Tolin helped with my comments on perception; and Quentin Fitzgerald's perceptive prodding prevented what I had read from getting in the way of what I saw.

WILLIAM V. DUNNING is Professor of Fine Arts at Central Washington University. He has contributed articles to such journals as *Northwest Review, The Journal of Art,* and *Scholarship in Review* and to *Great Lives from History: Twentieth Century.*

CHANGING IMAGES OF PICTORIAL SPACE

1
Background

OUR WESTERN EUROPEAN WORLD VIEW began to take shape in ancient Greece, kindled by Pythagoras and the Ionians, six centuries before Christ. To the followers of Pythagoras and the Ionians, the essence of the world was manifested in numbers, the purest of ideas, disembodied and ethereal; and these numbers were sacred. That mathematics was the path to both wisdom and power seems not to have occurred to anyone before them. The last of the Pythagorean astronomers, Aristarchus of Samos (supposedly born in 310 B.C.), discovered through this mathematical approach that the sun was the center of the solar system; but because he had no disciples, his idea was ignored until Copernicus rediscovered it in the sixteenth century.

Mathematics was understood as the key to divine wisdom.[1] This quantified mathematical path to truth, knowledge, and the understanding of reality lasted for three hundred years, then waned during the late Greco-Roman period. This perception of quantity was temporarily awakened during the early Middle Ages, only to drift away again until it was fully revived during the sixteenth and seventeenth centuries through the investigations of Copernicus, Kepler, and Galileo, since which time it has dominated our society—at least through the 1950s.

The post-Pythagorean world view that has evolved to the present day is associated primarily with Plato and Aristotle, but the man who infused Greek philosophy with a rigorous methodical logic and clarity was the mathematician Euclid, who lived in Alexandria around 300 B.C. Euclid's geometry began with laws and axioms so simple, obvious, and self-evident that they needed no proof. His statement

1. The Pythagoreans believed that the definitive elements of the cosmos were limited to spatial fragments. Because the sciences of optics and mechanics were perceived as divisions of mathematics, they thought of these sciences in terms of spatial images and represented them geometrically (Burtt 1954, 122).

that "the shortest distance between two points is a straight line," required little reflection to verify that there was no shorter alternative route. Like the later Renaissance system of perspective, Euclid's method built upon a foundation composed of units of self-evident truth and proceeded to erect a more complex edifice of conclusion; the conclusion seemed indisputable.

Only two societies in the history of world art have invented a system which depicts the world and its space in a Euclidean manner similar to that of European perspective: the Greco-Roman society, and the Renaissance in Italy. Popular opinion once held that the Greeks first discovered perspective, that this perspective was developed by the Romans and lost during the Middle Ages, and that this same perspective was rediscovered during the Renaissance. But it was not the "same perspective." There is another equally valid perception of the genesis of Renaissance illusion.

Greco-Roman and Renaissance perspectives, in spite of their apparent resemblance, were not the same in either practice or concept. Suzi Gablik tells us that Greek painters did not establish the same shared viewpoint (that specific location of the implied viewer which can be geometrically determined by the position of the vanishing points within the painting) for every object in a painting. Each object was granted its own separate perspective and set of vanishing points (Gablik 1984, 14). Miriam Bunim, in her seminal investigation of space in medieval painting, observes that the space represented in Roman painting was generalized and unmeasurable because the parallel lines used to depict separate objects did not share a common vanishing point (Bunim 1940, 176). And, in his application of geometry to art, William Ivins tells us that the Greeks thought of each object as existing in its own space. They apparently had no concept that objects might share a related existence in a unified space: each monument, statue, theater, and temple was "placed wherever room [could] be found for it, like pots on an untidy shelf, with no thought of vistas or approaches, and no thought that any one erection could get in the way of or make any difference in another" (Ivins 1946, 16).

Though they may have been related in content, the painted objects and figures were not structurally or spatially related to each other or to the background because they were not drawn as if they were all seen from the same location. Consequently, their size and shape did not depend upon their position in relation to the viewer. The resulting image was fragmented, unlike the unified image that

Renaissance perspective would yield. It was only toward the end of the Roman empire that a more naturalistic style began to develop and Roman artists started depicting specific characteristics of things as they saw them and "a vague intuitive feeling or groping for unified spaces" could be detected (Ivins 1946, 56).

Erwin Panofsky, who initiated the iconological method in art history, explains that Roman painting followed the principles of mathematical optics as outlined by Euclid: orthogonals (parallel lines that lead toward depth) converge; objects in the distance are depicted as smaller than those in the foreground; and individual objects are foreshortened, so that wheels and shields are depicted as ellipses. But in this system of perspective, the converging orthogonals seldom converge to one unified point, and these orthogonal lines often form a herringbone pattern (thence, the system is sometimes referred to as "herringbone perspective"). Roman paintings thus depict a world unstable and incoherent within itself: "Rocks, trees, ships, and tiny figures are freely distributed over vast areas of land and sea; but space and things do not coalesce into a unified whole nor does the space seem to extend beyond our range of vision" (Panofsky 1965, 121).[2]

Greek and Roman painters established each viewpoint from a location that was directly related to the individual object depicted. The painter then moved the viewpoint to the next object, and so on, so each object and figure was seen from its own separate viewpoint. Consequently, each object and figure resided in its own private space, spatially unrelated to other objects in the painting. Roman painters used the vanishing point, but inconsistently and only on architecture when it was depicted on a large scale. Smaller buildings were sometimes depicted by simply inclining the roof line downward and the foundation line upward (Bunim 1940, 26).

Renaissance painters, on the other hand, drew each object and figure from the same location, or viewpoint; the result was that the vanishing points of all the depicted objects coincided so as to unify and relate one object to another within the "same space." This space, suddenly unified, possessed the two main qualities that were to char-

2. Not only was the Greco-Roman method of perspective limited by its conception of space as discontinuous and finite, but also expressly by the classical system of optics that had created it. The Eighth Theorem in Euclid's *Optica* relates the diminishing size of objects to visual angles and expressly denies any proportional relationship between distance and the size of an object (Panofsky 1965, 128).

acterize pictorial space until the advent of Picasso:[3] a unified viewpoint, and a cohesive spatial relationship between all the figures and objects in a painting (Panofsky 1965, 122).

This basic difference between the Greco-Roman and the Renaissance systems of perspective suggests that the unified Renaissance system of perspective might never have developed from the fragmented Greco-Roman one. It may have been both propitious and necessary for medieval artists to destructure the first system—to take the elements of that illusion apart. Then, after medieval mathematicians had further advanced the understanding of optics as well as the concept of infinity, artists of the Renaissance inverted the Greco-Roman priority of mimesis over unity and restructured those previously separated perspectival elements so as to create yet another apparently similar—though more structurally and conceptually unified—illusion.[4]

This new, more complex, Renaissance system of perspective was created by unifying the shading of volume with four separate perspectives: the separation of planes, aided by linear, atmospheric, and color perspective. Once such a perception of this evolution is accepted, the Middle Ages can be understood as a lively, vital, and necessary transition between Classical Antiquity and the Renaissance, rather than as a drought of a thousand years between periods of green.

The Greco-Roman culture had based their aesthetic conclusions, says Edgar De Bruyne, "on direct observation and immediate considerations" (De Bruyne 1969, 45). Medieval thinkers, on the other hand, arrived at their aesthetic opinions after consolidating a synthesis from a series of texts, a method reflected in the scholastic,

3. I shall later argue that Cézanne is a better choice than Picasso because it is Cézanne who again draws separate objects in frontal view, so each again suggests a separate viewpoint.

4. The first contribution of the Middle Ages "was to transform the picture plane into a material and substantial pictorial surface which has an independent existence apart from the figures and objects and then to divide this positive and active pictorial agent into the essential planes of tridimensional space upon which the Renaissance could elaborate with the aid of a systematic method of perspective that preserves the substantial quality of this space. . . . this was done first by solidifying the elements of Roman painting, that is, reducing the figures and objects as well as the picture plane as a whole to a two-dimensional form and then reintroducing tridimensionality into the figures and objects, and into the picture plane with stage space" (Bunim 1940, 179–80).

theoretical character of their aesthetics (De Bruyne 1969, 46). Medievals had granted priority to theory over empirical observation—exactly the opposite of the Greco-Roman.

Aesthetic definitions during the Middle Ages were derived from four different written sources: "the Bible, the works of the philosophers, technical handbooks, and the literature of the Greek and Latin Fathers" (De Bruyne 1969, 1). Greco-Roman pictorial space, constructed from direct observation, had disappeared by the Romanesque period of the Middle Ages. Samuel Edgerton's *The Rediscovery of Renaissance Perspective* shows that Byzantine artists retained strong ties to classical painting. Byzantine art even retained some vestigial perspective, signifying space but without visually enclosing it. Classical space ceased to exist in the Romanesque era. Figure and space were compressed into a spatially ambiguous surface pattern, and "surface reigned absolute" (Edgerton 1975, 158).

The classical method of depicting space did not disappear abruptly. Sidney J. Blatt points out that an interest in content and surface quality had begun to replace illusion as early as the late Pompeian period, the first century of the Christian era (Blatt 1984, 164). Thus, these reversals—from the Greco-Roman priority of illusion over surface and of perspective over content to the opposite medieval priority—developed gradually. When society changes its assumptions regarding the importance of one idea or concept over its opposite, this change is reflected and echoed throughout every system affected by such an assumption.

The pagan-generated, Greco-Roman, natural appearance of figures in action gradually gave way during the early Christian era to simplified figures and rigid gestures. The continuing use of classical cast shadows and shading retained some illusion of volume for a while, but the figures gradually became stylized, and landscapes and architectural backdrops became symbolic rather than descriptive and volumetric (Blatt 1984, 165). The tendency toward flatness began in late Roman art and continued into the early Christian era (Bunim 1940, 180).

This change in direction from illusionist space and volume to stylized symbol was hastened by yet another inversion of priorities. The Church's desire to stress the Christian and the spiritual rather than the real or the material aspects of the previous pagan era encouraged representations of the figure in an ephemeral, dematerialized manner (Blatt 1984, 165).

Medieval painters separated the elements of illusion in Roman painting to generate two basic treatments of the picture plane. These two treatments are often referred to as *stage space* and the *stratified style*. The first style, stage space, divided the background into two parts: a ground plane, and the vertical background proper (Bunim 1940, 180). At first a horizontal ground plane accentuated the vestigial three-dimensional aspects because it actually supported figures and objects, but soon figures began to stand on the upper edge of the ground plane and this plane was transformed into a flat vertical baseline; no matter how two-dimensional this style of medieval painting became, this distinction between ground plane and background can always be identified (Bunim 1940, 181). This "stage" form, best exemplified in Byzantine paintings, had evolved from the "prospect scene" in Roman painting, a style that concentrated on architecture and linear perspective.

The second treatment of the medieval picture plane was called the stratified style: the background was divided into horizontal bands of color as often seen in Carolingian paintings. This style evolved in response to the bird's-eye view in Roman Odyssey landscapes in which depth was depicted as the separated horizontal zones of atmospheric and color perspective that can be seen in *Odysseus in the Land of the Lestrygonians* (fig. 1.1). In medieval works, each successively higher band of color had in the beginning symbolized a deeper position in space; this stratification is clearly evident in the mosaic scene from the Story of Joshua (fig. 1.2). Though painters during the Middle Ages gradually rejected the spatial aspects of atmospheric and color perspective, they nevertheless retained the stylized pattern of horizontal bands that had once depicted zones of receding depth on the ground plane.

The semiotician Umberto Eco, who began his career as a specialist in medieval philosophy, explains that the period known roughly as the Middle Ages defines at least two distinct periods in history: that period of crisis and clashes of cultures that extended from the fall of the Roman empire to the year 1000, and from then to the period of "what in our schooldays was called Humanism." Some historians, he says, consider this "a period of full bloom" (Eco 1986a, 73). Medieval aesthetics, as a reaction to the disorder of those centuries following the fall of Rome, began with an aesthetics governed by numbers in the tradition of Pythagoras, then moved toward more humanistic concerns and the aesthetics of the Carolingian period: "Then with the emergence of a stable political order, there emerged

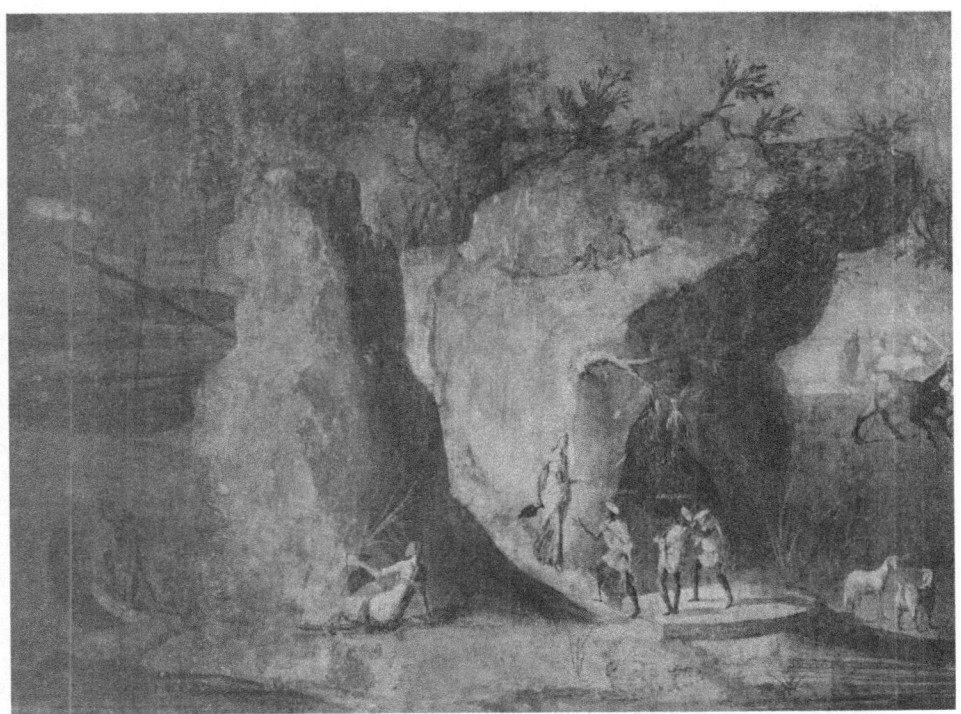

1.1. Roman mural. *Odysseus in the Land of the Lestrygonians* (detail from Odyssey frieze). 40 B.C. Fresco (height, about 55″). From a house on the Esquiline Hill, Rome. Vatican Library, Vatican City. Photo: Alinari/Art Resource, New York.

also a systematic theological ordering of the universe; and once the crisis of the year 1000 was past, aesthetics became a philosophy of cosmic order" (Eco 1986b, 116).

Medieval painters had unraveled the fibers of Greco-Roman perspective to yield two distinct styles: the stratified and the stage styles. I shall show that toward the end of the Middle Ages painters gradually began to reweave these fibers that had been so laboriously separated, and a new fabric—Renaissance perspective—gradually began to take shape.

The Renaissance system of perspective was created by restructuring the elements of Greco-Roman perspective, impressionism was created by restructuring the elements of Renaissance perspective,

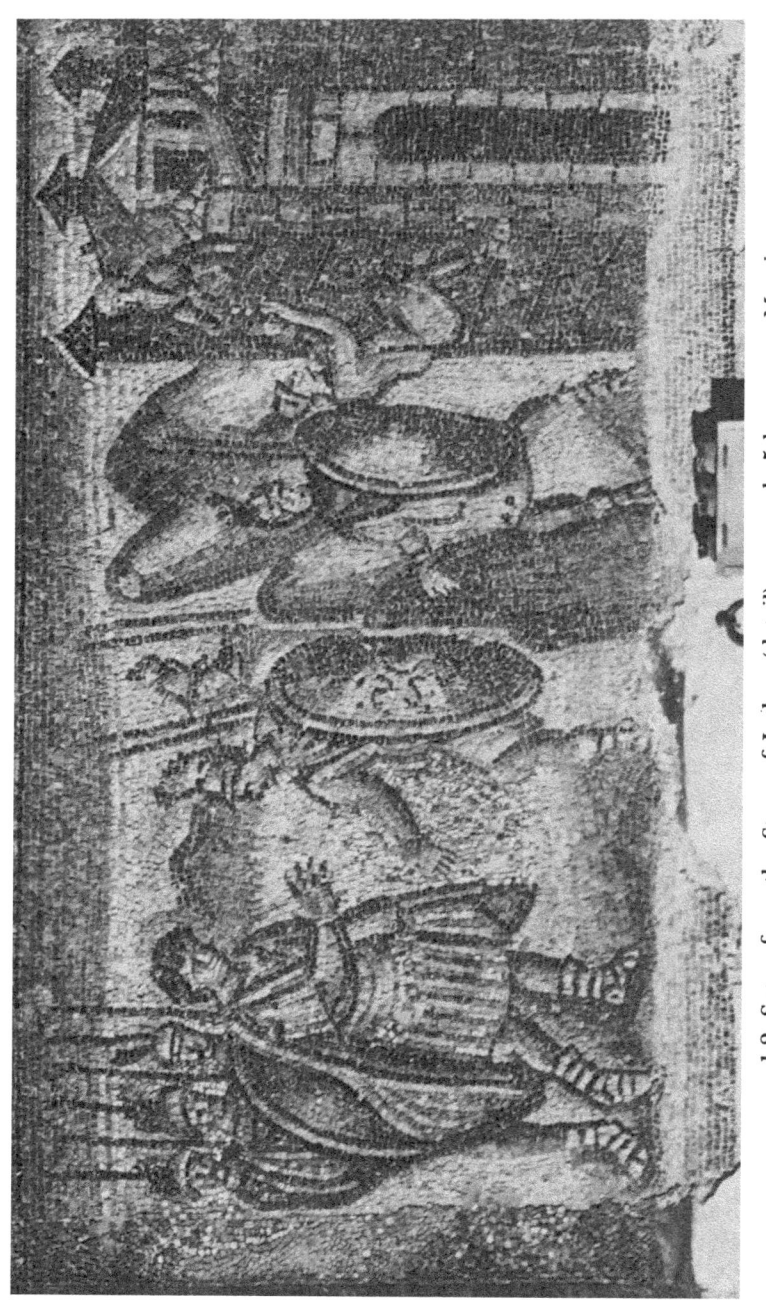

1.2. Scene from the Story of Joshua (detail). A.D. early 5th century. Mosaic of the nave; Santa Maria Maggiore, Rome. Photo: Alinari/Art Resource, New York.

and modern art was created by restructuring the elements of impressionism. European perspective has thus been through at least two complete cycles of separating and recombining these elements in the quest for new images. In short, the various techniques involved in mimesis—creating an illusion—have furnished fertile ground for two millennia of creative strategy in painting.

2
The Middle Ages

DURING THE MIDDLE AGES "man was in every sense the centre of the universe" (Burtt 1954, 18). The whole of nature was believed to have been created by God, for man, and thus subordinate to man and his eternal destiny.

Partly because of the dominance of Ptolemy's Aristotelian paradigm of the universe as an enclosed globe encircling a fixed earth, people in the Middle Ages took it for granted that the whole world existed for their benefit alone, and the universe was, therefore, intelligible to their mind. Nothing existed outside this Aristotelian sphere of the universe. All else was simply void. Medieval thinkers believed everything should maintain its proper place in relation to the center of the universe (Edgerton 1975, 159). They could not imagine an all-pervasive and uniform space as we do. Therefore, medieval artists, who like the Greek and Roman artists before them were heavily influenced by Aristotle, did not conceive of objects as existing in the "same space" (Edgerton 1975, 159).

Because the concept of infinity was outside the conceptual range of most Greek and medieval thinkers, the artists during these periods were precluded from understanding the geometrical postulate that all parallel lines in an entire painting must eventually meet at infinity, thereby unifying the relationship between the objects depicted (Gablik 1977, 35).[1]

In his influential essay, "Die Perspektive als 'Symbolische Form',"[2] Erwin Panofsky contends that because Aristotle lacked any con-

1. Space in antiquity "was understood by artists as a discontinuous residue between objects rather than as something which transcends and unites them" (Edgerton 1975, 158).
2. An excellent but anonymous English translation, "Perspective as Symbolic Form," is available from the Warburg Institute at the University of London. I have listed the page numbers from the English translation. Copies of the German original are no longer available from Warburg because of the "fragile condition of the paper" in the original magazine.

sciousness of a "continuous quantity" relating one individual thing to another, there could be no infinity that extended beyond the existence of these things (Panofsky 1924–25, 7). This lack of a concept of infinity clearly demonstrates how the theories and the aesthetics of space dominate the manner in which the people of an era perceive real space (Panofsky 1924–25, 7).[3]

The two great movements that united to form this medieval cosmology were Greek philosophy and Judeo-Christian theology; as Edwin Arthur Burtt points out, this synthesis formed the foundation for medieval art as well as for physics.[4] Medievals referred only to their religion and those facts and relationships that they could experience with their unaided, unamplified senses (Burtt 1954, 18).

Artists during the Middle Ages cared more for their faith and the theological significance of the image than for individual or mimetic qualities. Because the role of painting was to *remind* the viewer of the thing depicted, a strong likeness was not necessary; recognition was enough. "One tree suffices to evoke the earthly Paradise," says De Bruyne, "a few walls surmounted by bell towers or cupolas 'inform' us that we are in Jerusalem" (De Bruyne 1969, 176). In short, an individual represented the species.

Today we are accustomed to think in terms of immense units of time and space; thus it is difficult for us to realize how *unimportant* those dimensions were to the medieval scholar or scientist. Relationships between time and space "were accidental, not essential characteristics" (Burtt 1954, 27). Medieval men did not interpret their world in terms of substance, essence, matter, form, and quality (Burtt 1954, 18).

True to the medieval intentions of merely "reminding" the

3. Here is Edgerton's explanation: "In other words, the space one perceives is conditioned by both the way one enjoys seeing it—perhaps as traditionally shown in pictures—and the way it is explained in contemporaneous thought, that is according to its accepted explanation by the science of the day. Pictorial representations of space in any given age are thus symbolic forms of this combined perceiving process" (Edgerton 1975, 159).

4. This synthesis of Christian theology and Greek philosophy took a decidedly Neoplatonic bent in the early Middle Ages. And Burtt maintains that "the Pythagorean element in Neo-Platonism was very strong. All the important thinkers of the school liked to express their favourite doctrines of emanation and evolution in terms of the number theory, following Plato's suggestion in the Parmenides that plurality unfolded itself from unity by a necessary mathematical process" (Burtt 1954, 53). This connection between Platonism—in one form or another—and mathematics seems to be a general tendency throughout history.

viewer of the subject depicted, no illusion of volume or space was attempted in medieval paintings; yet the practiced modern viewer does not perceive these paintings as visually flat. Because late medieval thinking had centered on the Aristotelian notion of quality and essence rather than the more Platonic notion of quantity and measurable increments of time and space, such a thing as maintaining a consistent illusion of depth, or flatness, on a two-dimensional surface neither existed nor was possible in the consciousness of the medieval painter. Heinrich Wolfflin insists that it was thought to be impossible to reproduce spatial depth, or volume, on a flat surface. He maintains that "it is wrong to believe that a Medieval picture was ever looked at with our concepts of illusionistic effects" (Wolfflin 1954, 4).

As figure and ground came to be compressed into patterns, one could often not be distinguished from the other (Edgerton 1975, 158). When figure is difficult to distinguish from ground, when neither is accorded priority over the other, shapes tend to alternate in spatial dominance: first one appears salient, then the other. Consequently, when looking at medieval paintings, a twentieth-century painter (with an eye conditioned to detect the subtle adjustments which create depth on a two-dimensional surface) perceives a heaving, scrambling visual surface. This spatially unresolved surface, with its sharp-edged value contrasts, appears to be alive with shapes competing for spatial dominance. The shapes read as first salient, then recessive. They move back and forth as if hung on invisible strings and tuned to respond to the viewer's shifting glance as wind chimes respond to the movement of air.

Medieval painters had unraveled the optical, or illusionistic, threads that created the Greco-Roman fabric of depth. They seldom made any attempt to achieve an illusion of volume, relief, or roundness. Many paintings during the Middle Ages treated not only figures, faces, and limbs as flat, outlined pattern, but even the folds on the robes were indicated by symmetrical, geometric, patterns that appear as decorative surface folds rather than creating what the illusionist would call "structural folds."

Because illusion held little interest for artists of the Middle Ages, they did not use spatial relationships to unify their compositions in the manner of the later Renaissance artists. Medieval artists, more subjective in the way they viewed their world and seeing each element and image separately, paid little attention to the spatial rela-

tionship between one object and another. Medieval painters felt as if they existed in, and were a part of, their pictorial world, while during the Renaissance, painters of perspective stood outside the world they represented and observed—as if through a window—from a single, unifying viewpoint.

The Pre-Renaissance

Many ideas had to change in order to set the stage for an interest in, and a search for, pictorial illusion and the depiction of volume and space. The Crusades, the growth of communes, and a secular culture with a vernacular literature giving voice to pagan and humanistic tendencies contributed to a new point of view, and the growth of new intellectual centers encouraged secular elements in the arts (Bunim 1940, 105). A new interest in the psychology of vision and the analysis of visual perception in the thirteenth century also affected the practice of painting (De Bruyne 1969, 176).

There were three well-developed categories of aesthetics in the late Middle Ages: (1) proportion, (2) light, (3) symbol and allegory (Eco 1986b, 24). The Greco-Roman period had also considered these three categories important to the structure of art, but the medieval versions were different in emphasis and concept as well as in their relationship to one another. Once again the medieval variant was a rearrangement of the same three categories from the earlier period.

While medieval theory attempted to incorporate the aesthetics of proportion with the aesthetics of light, the most typically medieval aspect of the period, Eco feels, is the "tendency to understand the world in terms of symbol and allegory" (Eco 1986b, 52). The uneducated could easily visualize their beliefs in images and symbols, so teachers as well as theologians used allegory to convey ideas that were too complex for ordinary people to grasp in the form of scholastic theory. In this way, paintings were used to teach: Honorius of Autun insisted that "pictures were the literature of the laity" (Eco 1986b, 54).

Medieval art had been concerned more with subtle allegory than clear narrative—the visible as a manifestation of the invisible. Medieval scholars interpreted the sentence "The Ark was built of well-squared timbers" to mean the Church was composed of perfect saints: they reasoned that the Ark, outside of which there can be no

salvation, stands for the Church; the well-squared beam is a symbol of the perfect man, and a perfect man can only be a saint (De Bruyne 1969, 75). Thus, medieval scholastics typically found a subtle (invisible) meaning hidden in the obvious (visible). But this popularity of allegory in nature and in painting—though not in poetry—began to show some evidence of decline in the thirteenth century in favor of a closer observation of nature (Eco 1986b, 64).

Medieval theories of proportion were highly theoretical and only gradually used in practice (Eco 1986b, 44). The Book of Wisdom taught that God created the world according to number, weight, and measure and these cosmological concepts came to be regarded as aesthetic (Eco 1986b, 17). But proportion was never defined in terms of a single standard because the scholastics reasoned that there were an infinite number of "ways of being," so there must also be an infinite number of ways to make "things in accordance with proportion" (Eco 1986b, 44).

An aesthetic concern with proportion preceded any concern with light or color in the Middle Ages, just as it had in classical antiquity (De Bruyne 1969, 16). Nevertheless, "the most obvious symptom of qualitative aesthetic experience was the medieval love of light and colour" (Eco 1986b, 43). In contrast to the theoretical quality of medieval proportion, light and color, appreciated in a way that was highly sensuous and immediately perceptible, came to be expressed scientifically only after the fact (Eco 1986b, 44).

The coloring of painted figures during the twelfth and thirteenth centuries was limited to simple, basic colors. The value of any hue was seldom modified by light or shade, and the shape of each color tended to be strictly enclosed within sharp, linear boundaries (Eco 1986b, 44). Bright color was enjoyed in everyday life in clothing, ornaments, and even weaponry, as well as in art. Pure, brilliant color was equated with the brilliance of light (Eco 1986b, 45). Both philosophers and mystics were fascinated by luminosity as well as the light of the sun (Eco 1986b, 46). Insofar as objects were luminous, they were not only noble, but also divine (Eco 1986b, 60). In the thirteenth century, when Arabic treatises on optics and perspective influenced them to consider light as a cosmic system, medievals began to identify light with truth, the sun with the eternal Intellect, the day with Christ, and an ocean of light with celestial happiness (De Bruyne 1969, 16–17).

Before the twelfth century, painters placed one object or figure in front of another only by overlapping, or positioning one figure

above another.[5] When one flat object overlapped or was positioned above another, the overlapping shape or the lower shape was considered to be in front, but there did not appear to be any space between them. One flat figure, or part of a figure, looked as if it were cut out of a magazine and pasted flat on another flat figure. At this point it can be seen that the elements of Greco-Roman perspective had been thoroughly unraveled.

Toward the end of the thirteenth century, however, an impetus toward three-dimensional representation could be seen. The ground plane began to support figures on its surface once again, and these figures were no longer depicted in isolated three-quarter or frontal positions but were allowed to form active communicating groups (Bunim 1940, 182). Buildings had been represented as little more than façades up to that time, but now a series of diminishing planes created some recession and depth (Bunim 1940, 182). This early attempt to create the impression of depth by diminishing the size of objects as they recede is an important aspect of linear perspective and the beginning of a separation of planes in space. Both devices became an indispensible part of the Renaissance system of perspective.

Cimabue: The Great Beginner

Thirteenth-century viewers of art—unlike people of the twentieth century, who have been raised on photographs, movies, and television—were not dependent on the convention of the two-dimensional illusion. Cimabue's paintings could not be described as illusionistic, nor were they intended to be so. At that time, the paintings in churches were the only two-dimensional images available to most people, and the paintings of Cimabue's peers, though they manifest little concern for illusion, were quite convincing as visual icons and ideas to his contemporaries.

In his exhaustive study *The Birth and Rebirth of Pictorial Space*, John White has observed that Cimabue's contemporaries represented buildings in a manner that allowed the foreshortened sides to recede randomly to the left or the right: so that any side was presented to the viewer, as the painter happened to choose arbitrarily,

5. The medieval artist "brings space to our perception in part merely by putting one thing *above* another, in part by putting one thing *behind* another but without being able to control the distance" (Panofsky 1924–25, 6).

regardless of its context or position in the picture. The perspective of each building was unrelated to the perspective of the next (White 1967, 30).

Together with this new spatial unity, Cimabue began to use dark and light to create an illusion of volume in details. Most painters during the thirteenth century still applied their paint in "abstract strokes, which signify, quite as much as depict, light and shadow, on the areas of flesh" (De Bruyne 1969, 175). There was no rigorous direct unified use of light—with corresponding darks—as an instrument of illusion. Both Cimabue and Cavallini, however, made a rudimentary use of a dark side and a light side to create volume in details. In *Madonna and Child* (fig. 2.1), the folds on the robe of Jesus and the Madonna all have a dark and a light side. This is the basic method for developing an illusion of volume; it suggests that light hits one side of a round object and not the other.[6] But it is obvious that Cimabue used this formula only in the wrinkles, fingers, and noses. He did not subordinate the detail to the mass in the Renaissance manner. He created some volume in the details but not in the major masses. The robed figure of the Madonna remains flat from one edge to the other, as does the figure of Jesus. The wrinkles seem merely bumps on a flat surface.

As one of the structural qualities of color, "value" refers to the darkness or lightness of an area regardless of its hue. A black-and-white photograph of a painting shows only the value of each area, not its color. John Shearman labels the color method that was used by Cimabue and his contemporaries "absolute color." In this method, each pigment in its undiluted saturate state has a specific value; blues are inherently darker than yellows. The most familiar pigments on the pallette at this time form a value scale from light to dark: "from yellow, the lightest, down through cinnobar (or vermillion), apple-green, turquoise, rose-red, to the darkest, lapis lazuli" (Shearman 1962, 14).

In the absolute color method, the dark part of the composition always coincides with the composition that has been established by the dark colors, such as blue (lapis lazuli). The light areas in the

6. Miriam Bunim finds "a striking development in the representation of the drapery in the thirteenth century as compared with the Romanesque. The movement toward naturalism, which is evident in the position and proportions of the figures, is present in the drapery due to an effort to have the fall of the folds motivated directly by the contours of the body and an attempt to grade the transitions from light to dark more carefully" (Bunim 1940, 113).

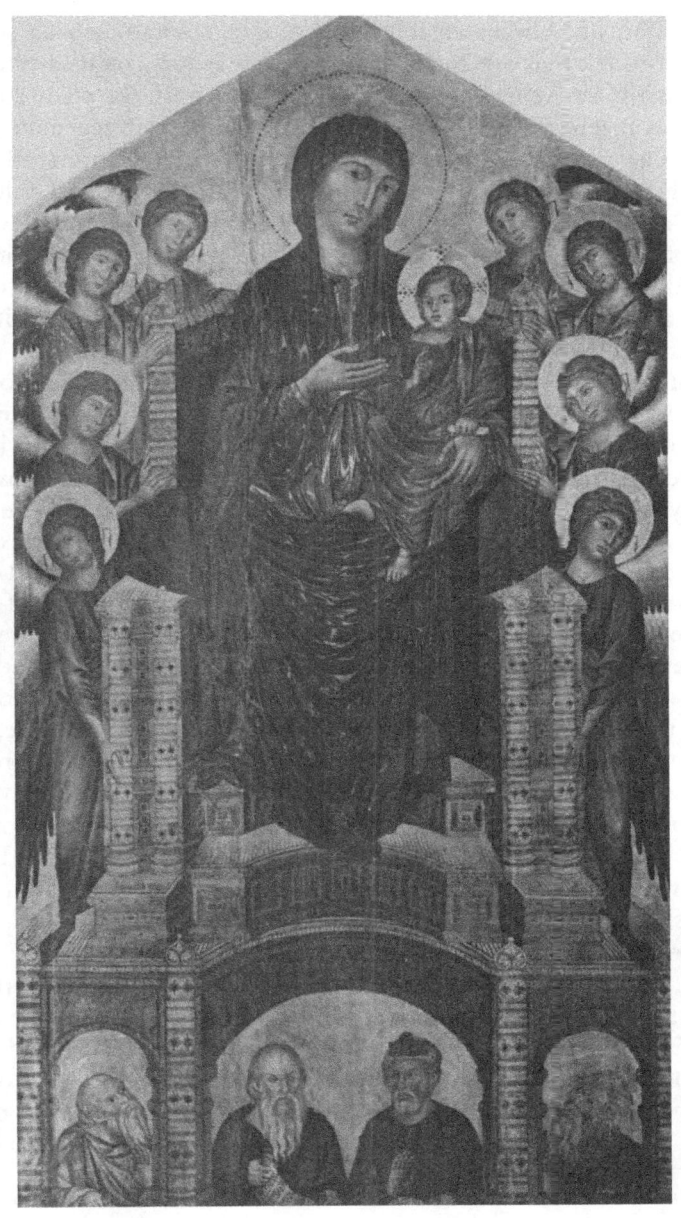

2.1. Giovanni Cimabue. *Madonna and Child*. c. 1288. Panel, tempera with gold leaf (385 cm. × 223 cm.). Uffizi Gallery, Florence. Photo: Alinari/Art Resource, New York.

composition are always established by light colors, such as yellow. The half-tone areas are established by those colors, such as red, that are normally in the half-tone value range. In short, the color composition was inseparable from the value composition (Shearman 1962, 38). It was not until the fifteenth century, when painters adopted what Shearman calls "saturation modeling," that they had full control of color value. And it was only with Leonardo's later development of what Shearman calls "tonal unity" in the use of color that major dark compositional areas could range in large uninterrupted shapes across the painting to create a new dark-light compositional structure that was independent of color (Shearman 1962, 38).

Painters since the Renaissance have found it imperative to control and adjust the value of each color. They not only know how but are also aware of the necessity to make dark yellows and light blues. However, painters during the thirteenth century, using the absolute color system, were guided more by symbolic concerns and the pursuit of simple pure luminous color. They showed little interest in value control. Pure blues were necessarily a dark value, and pure yellows were light. They felt no need to adjust the value of each color to its context in order to unify and control illusion. Cimabue used few dark yellows or light blues. His choice of color predetermined its value because the purity of the color was more important to him than the value.[7] If Cimabue chose to paint an area blue, that area would automatically be a dark value, and yellow areas were automatically light. He had no choice, therefore no control, of value. Cimabue had not started to use value to simplify the shapes or the composition. Consequently, when judged by Renaissance standards, his paintings appear to be composed of small, complex, unorganized, spotty darks and lights, which are all of similar size.

The only areas in *Madonna and Child* that begin to show value control, or a shading of volume in the mass, are the small figures on the bottom sides of the painting. The leg of the angel on the right side of the painting was shaded with a strong dark side and light side, and the whole leg looks round. This volume in the mass of the leg allowed the artist to leave out most of the wrinkles and still main-

7. In *The Name of the Rose,* Umberto Eco accurately depicts medieval attitudes toward color by prompting his narrator, Adso, to explain: "For three things concur in creating beauty: first of all integrity or perfection, and for this reason we consider ugly all incomplete things; then proper proportion or consonance; and finally clarity and light, and in fact we call beautiful those things of definite color" (Eco 1983, 79).

tain interest and richness in that area. In this same figure, the skirt and blouse are of different colors but the value of the two colors is the same. This was the beginning of value control and what Shearman calls "saturation modeling."

Lowering the eyelids, or squinting the eyes, diminishes the amount of light admitted to the eyes and effectively darkens a painting. This device is used by modern painters to force value to assume more importance than color, and it identifies areas that are lacking in spatial cohesiveness caused by abrupt value changes. Even though the arm in the bottom figure of Cimabue's painting is a light value and the sleeve is a darker value, this "squint test" does not result in the shape of the arm floating, or popping out spatially in front of the sleeve, as will happen with the arm and sleeve of the Madonna. This "spatial popping" is also clearly evident where the neck of the Madonna meets the blue robe, because of the contrast in value between the light flesh and the dark blue of the robe.

In the heads of the angels around the periphery, each color is a different value and a separate shape; therefore, each separate color appears to hang at a separate visual place in space. The halo, the hair, the face, and the robe on each individual angel appear to a modern painter to float at a different visual distance. If all the parts of one object fail to maintain visually the same spatial distance, then certainly a multiplicity of objects cannot be coaxed to occupy a visually stable spatial placement within this shifting depth.

The arm on the small figure on the lower right maintains its spatial integrity because the dark fabric of the sleeve is highlighted and becomes considerably lighter where the sleeve meets the light arm. Cimabue (or one of his assistants) painted the sleeve lighter in order to match the value of the arm. This painting begins to evidence some illusion of volume in the mass, but this illusion is achieved only on the peripheral figures, where there was less restriction because of convention and formula. As in many forms of religious art that do not use central perspective, abstraction, rigidity, and simplification were a symbol for the divine (Blatt 1984, 167). Angels, less divine than the Virgin and Child, were accordingly less formalized and abstract. Mere humans were often depicted even more realistically.

Because Cimabue was the first painter in a thousand years to partially unify his paintings spatially and achieve some illusion of volume, historians have often considered him the link between the Middle Ages and the Renaissance. He took the first necessary steps

toward reweaving the elements of the illusion. Vasari, from his vantage point in the sixteenth century, looked back and saw Cimabue as the great beginner—that painter who began the journey toward the Renaissance style in painting.

During the Middle Ages, man had thought of himself as part of a larger whole—a unit in a family, a city, or a corporation—unlike Renaissance man, who considered himself an individual. The laws of art were thought to be found inscribed in nature as early as the eighth and tenth centuries (De Bruyne 1969, 149). But the twelfth and thirteenth centuries saw a revitalized interest in nature as a whole; in such a context systematic attempts to describe nature were seen as an expression of God's glory (Blatt 1984, 183).

The elements of perspective from the classical period, separated during the Middle Ages, were now beginning to be recombined in order to create a new and different image. The fourteenth century would give birth to a new illusion—an illusion so real, so unlike anything ever seen before, that it would startle viewers.

3
The Proto-Renaissance

THE PRIMARY FOCUS OF PAINTERS at the beginning of the Renaissance was the imitation of nature and the creation of a three-dimensional illusion on the flat surface of a painting. Italian artists made definite, though rudimentary, progress toward a systematic method of spatial representation, Bunim points out. Roof lines at the sides of buildings were drawn at a descending angle, while the lines at the base of buildings ascended, causing parallel lines to converge. Parts of individual foreshortened planes were constructed by means of a vanishing point, and objects often grew smaller as their distance from the bottom edge of the ground plane increased (Bunim 1940, 187).

The fourteenth-century attempts did not yet employ a single vanishing point located on the horizon for all the horizontal lines of receding parallel planes (Bunim 1940, 187). However, the "vanishing axis," wherein all the planes converged to a single horizontal line but not to a single vanishing point, was "used to coordinate a number of planes, and in several instances it was applied with such zeal that it creates the impression of a unified and systematic construction" (Bunim 1940, 151). These painters learned to diminish the size of objects and figures progressively as they receded into depth, but they still had not understood that the single viewpoint of the spectator was the connection between diminution and the system of convergence (Bunim 1940, 151).

The genesis of new spatial concepts at the end of the thirteenth and the beginning of the fourteenth century in Italian painting can be attributed directly to the synthesis of Byzantine and Gothic elements (Panofsky 1965, 135; Bunim 1940, 134). The depiction of a three-dimensional stage structure sprinkled with representative objects in Byzantine illuminations combined with a more illusionistic figure and a unification of the figure and the background in Gothic art to create a new sense of volume and space (Bunim 1940, 135). Those two medieval categories of Byzantine stage space and Car-

olingian atmospheric stratified space that Bunim tells us had been unraveled from the Roman prospect scenes and Odyssey paintings were now being combined to form a new spatial image. A new system of perspective was being woven from the previously separated fibers of Greco-Roman perspective.

At this point the medieval priority of quality over quantity was once again inverted. Though it would not be apparent until the fourteenth or fifteenth century, the Aristotelian concentration on quality and essence was slowly being replaced by a more Platonic interest in quantities—measurable increments of time and space— and Europe began to concentrate once again on mathematics as the key to knowledge (Burtt 1954, 53–55). This reborn Pythagorean interest in quantity began to steer Renaissance painters away from the spiritual, toward a more materialistic depiction of reality. They began to avoid the gilded surface and concentrate on an illusion of volume and solidity. It was thus, Bruce Cole feels, that Giotto "fell heir to an art that was slowly changing from abstraction to illusionism" (Cole 1976, 39).

Three integrated inversions of priorities are evident at this point. First, the Pythagorean interest in the quantification of elements began to assume more importance than the qualities of elements. Second, this interest in quantities caused the representation of material goods to be valued more highly than that of spiritual qualities. (This second reversal is the undoing of the earlier medieval granting of primacy to the spiritual over the Greco-Roman materialistic representation.) The combination of these first two inversions created a third: the valuing of illusion over abstraction.

The first indications of a developing new humanistic consciousness can be easily detected during the fourteenth century. The revival of the Franciscan and Dominican religious orders combined with the growth of secular patronage, made possible by political and commercial progress, to influence both the concept and the depiction of space. We learn from Cole that the principles of poverty, humanity, humility, and simplicity, as espoused by St. Francis of Assisi (c. 1181–1226), were extremely popular in Florence and exerted a considerable influence on the inauguration of "a more accessible, humane representation of the sacred stories and images" in place of the "iconic, hierarchical, isolated treatment of religious drama" that had gone before (Cole 1976, 16–17). The new popularizing and humanizing influences displaced the older Byzantine idea that the pri-

mary function of painting was to teach with a more optical and representational approach to painting (Bunim 1940, 134).

From our twentieth-century perspective, the tendency that began in the fourteenth century to give the material a higher priority than the spiritual indicates a relationship between the emerging illusion in Renaissance art and an embryonic capitalism. In his essay, "Renaissance Economic Historiography," Walter Ferguson explains that Renaissance culture was different at its roots from that of the Middle Ages because it had been formed by the expansion of commerce and industry, which had created a wealthy urban society and given rise to a new and powerful middle class. Peasants too were better off than they had previously been, because a decrease in population, brought about by war and the Black Death, had made wages rise and rents fall. The nobility was impoverished, feudalism was declining, and centralized state governments were growing stronger (Ferguson 1969, 117–22).

Frederick Antal, in examining the social background of Florentine painting, finds that works of art in the fourteenth century were no longer produced by and for the monastic structure. They were produced, not only *for* the newly influential middle-class laity, but almost entirely *by* this laity, and these works increasingly reflected the middle-class, materialistic point of view strongest in Central Italy—particularly Florence and Siena. Siena was a petty-bourgeois democracy, while Florence "had a uniquely powerful oligarchic upper bourgeoisie" and led the world in the art style of the upper middle class (Antal 1969, 183).

The shrinking markets, smaller profits, and stiffer competition demanded more rational, efficient techniques for business and resulted, according to Ferguson, in a more rapid advance for developing capitalism than that which would take place during the sixteenth century. The concentration of wealth that resulted from the new taxation was responsible for the high level of the patronage of the arts (Ferguson 1969, 121).

Merchants and financiers, with their new financial resources, had overcome the nobility and were guided by a "kind of rationalism, a desire and a capacity for giving full weight to material relations" (Antal 1969, 183). Along with their belief in God, these early capitalists also held a firm conviction that they could control their own destiny through rational thought (Antal 1969, 184). At least one Florentine businessman, Francesco Datini, headed each of his ledgers

with the inscription "in the name of God and of profit" (from Ferguson 1969, 123). This rational materialism was more pronounced in Florence than anywhere else in the world because it "followed naturally from the essence of capitalism, of monetary economy, a manner of thinking by which the world could be expressed in figures and controlled by intelligence" (Antal 1969, 183–84).

The growth of capitalism was an important element in stimulating the development of lay culture in two ways: first, it encouraged literacy in everyone engaged in business; and second, inherited wealth made it possible for the upper classes to take advantage of higher education and so to form an appreciative audience for the arts (Ferguson 1969, 122).

Though capitalism would not fully dominate the economy until the sixteenth century, there was a substantial relationship between the Renaissance interest in depicting apparently "real" objects and an emergent capitalistic focus on objects as an important aspect of the economy. These "movables, valuable by money, the common measure" were called "commodities" by John Locke as early as the seventeenth century. Florence had become one of the great industrial cities during the fourteen century, and this sudden economic focus upon commodities might be interpreted as motivation for the artist as well as for the newly established patrons, both merchant and banker, to indicate an interest in the depiction of these commodities.[1]

The concept of class can be expanded to include aspects of life other than economic. Class affects, for instance, entertainment and sexuality: "In capitalist society," Timothy J. Clark points out, "economic representations are the matrix around which all others are organized" (Clark 1985, 7). Economic life, he says, "is itself a realm of representations. How else are we to characterize money, for instance, or the commodity form or the wage contract?" The representations of an era are "continually subject to the test of a reality more

1. In *The Name of the Rose*, Eco induces William—the older Franciscan monk who serves as mentor to Adso, the narrator of this fourteenth-century story—to describe the new power residing in money: "And the [new] kings are the merchants. And their weapon is money. Money, in Italy has a different function from what it has [in other countries]. Money circulates everywhere, but much of life elsewhere is still dominated and regulated by the bartering of goods, chickens or sheaves of wheat, or a scythe, or a wagon, and money serves only to procure these goods. In the Italian city, on the contrary, you must have noticed that goods serve to procure money. And even priests, bishops, even religious orders have to take money into account. This is why, naturally, rebellion against power takes the form of a call to poverty" (Eco 1983, 144).

basic than themselves—the test of social practice." It is social practice which shapes any discourse or representation; it tests our categories and concepts, and it "blurs the edge of a particular language game" (Clark 1985, 6).

There may have been some cognitive synthesis of the two elements of the sign—the signifier and the signified. In other words, fourteenth-century painters and viewers perhaps "reified" depictions of the newly important commodities. Jacques Derrida, who gave us deconstruction, the word and the strategy, insists that we substitute signs for the things themselves, and that the sign is the next thing to "an original and lost presence, a presence from which the sign would be derived" (Derrida 1973, 138). He maintains that "when we cannot take hold of or show the thing . . . then we signify, we go through the detour of signs" (Derrida 1973, 138). The sign is a deferred presence. "Whether it is a question of verbal or written [or, I might add, painted] signs, monetary signs, electoral delegates, or political representatives, the movement of signs defers the moment of encountering the thing itself, the moment at which we could lay hold of it, consume or expend it, touch it, see it, have a present intuition of it" (Derrida 1973, 138). Thus, the depiction of objects within the context of the painting may have served some need relative to the fetish qualities of such objects. Furthermore, the works of art themselves began to be commodities to be bought and sold.

It was probably no accident that both capitalism and this new illusionistic art of the Renaissance developed at about the same time in the same city: fourteenth-century Florence.

At the beginning of the fourteenth century, society was coming to the end of an essentially ecclesiastical culture and moving toward materialism. In hindsight, it is easy to see a gradual reversal of priorities, over a long period of time, concerning the opposition of the spiritual and the material. Antal contends that the Italian middle class wanted their objects of worship represented as devout, but not so devout as to be emotionally disturbing; they preferred a rational, tranquil image. This sober-minded middle class, with their close ties to reality, would be satisfied only with a religious art that "showed a considerable degree of fidelity to nature" (Antal 1969, 187–88). And achieving an illusion of volume was the first necessary step toward fidelity to nature and the depiction of materiality in painting.

The depiction of volume led to an illusion of depth and space. From this point in history, man's thinking in philosophy, science, and art gradually began to drift toward an interest in such space—to

which was finally added time—as a central concern. This concern with first space, then time, continued to grow through the Renaissance, impressionism, then modern art until it became both the method and the content in painting.

Giotto: Inventing a New Perspective

Renaissance man had just begun to concern himself with the scientific observation and recording of nature. In making such observations, Renaissance man might have thought himself fulfilling his duty to discover God's abiding laws as they govern man's relationship to nature and the things in it. In *Theories of Art from Plato to Winckelmann*, Moshe Barasch states that this observation and recording inevitably led to mimesis: "Not a single Renaissance treatise fails to make the point that the imitation of nature is the very aim of painting and sculpture and the more closely a work of art approaches this aim the better it is. In fact the belief that art imitates nature can be regarded as a hallmark and distinctive sign of the Renaissance." (Barasch 1985, 114). I pointed out earlier that the medievals had reversed the Greco-Roman priority of empirical observation in favor of written theory: the Renaissance once again held empirical observation more important. The burgeoning interest in depicting volume and depth and the propensity to imitate nature in painting got off to a strong start with Giotto di Bondone (1266?–1337).

Giotto did not continue the medieval concept of space; he anticipated what we now call "two-point perspective" by slanting his buildings in space: oblique views of objects take up more space in depth than do frontal objects (Panofsky 1965, 119). During the first years of the fourteenth century, Giotto, at the height of his maturity, began his greatest work, the frescoes in the Arena Chapel in Padua. And, in a manner unheard of during the Middle Ages, he used three new spatial devices in these frescoes in order to reinforce the unity of his work: unified shading, unified viewpoints, and the maintenance of a nearly flat visual surface in his paintings.

The first device is the unified shading on the figures and architecture in the frescoes throughout the chapel. The dark and light sides on all the objects, in all the frescoes, are arranged as though the single light source emanated from the window on the entrance wall (White 1967, 58). This device tends to unify all the frescoes in the chapel and create the appearance that the frescoes, and all the objects depicted in them, exist within the same atmosphere.

The second device is Giotto's unifying of all the viewpoints in

the scenes from the frescoes of the "Life of Christ." The viewpoint of each painting is oriented to a spectator standing at the center of the building (White 1967, 58).

The third device is Giotto's ability to maintain a painting surface that remained visually almost flat. Painters in the Middle Ages had not maintained a visually flat surface; the medieval picture plane, though "planar" (that is, organized in flat, shallow layers of space), appeared to be constantly shifting. Each figure, or separate part of a figure, that covers the surface of a medieval painting seems to alternately advance and recede as the focus and attention of a trained modern viewer shifts and changes.

But Giotto knew that painting should complement that surface of the wall, not destroy it: "He understood that fresco painting could achieve its highest level only when it respected the flatness of the walls it covered" (Cole 1976, 74). Giotto applied each brush-stroke so it would function to visually preserve the solidarity of the wall and keep any pictorial space to a minimum (Cole 1976, 73).

Giotto no longer needed to cover the whole surface of the painting with objects and figures. He left much of the surface uncovered and still maintained a surface that often appeared almost flat because of his newfound control of color value. Panofsky says that while Giotto's surface no longer appeared opaque and impervious, it nevertheless retained a "planar firmness" (Panofsky 1965, 138). The picture started to become a window again, but a window covered with a translucent pane rather than the open, Greco-Roman window. This imaginary sheet of glass that combined the "qualities of firmness and planeness with that of transparency" was able to function as a genuine projection plane for the first time in history (Panofsky 1965, 138).

Objects and figures of different colors were carefully adjusted so as to be similar in value. Hence, in those areas where there are no overt attempts at perspective or mass to imply shallow space, the figures maintain a stable presence on a flat plane which extends throughout the surface of the painting. This often flat plane tends to stabilize the objects and the painting visually. Panofsky writes that entering the pictorial world of Giotto feels "as if we were stepping off a boat and setting foot on firm land," and he insists that this is the birth of modern space (Panofsky 1965, 136). Giotto introduces us to a space that had, for the first time, the potential to evolve into a depiction of continuous and infinite depth (Panofsky 1965, 137).

Giotto purposely emphasized the flatness of the frescoed wall by surrounding the painted architectural framework on each wall with

a plain red band that separated the marbled decoration of the walls at all four corners. This border draws "attention to the fact that the architecture is painted on a flat wall, and not solid marble" (White 1967, 106). Giotto's intent was not only to exploit the new visual world of representation that he was creating but also to maintain a compatible relationship between the rudimentary new illusion and the flat surface of the wall. Certainly these frescoes of the "Life of Christ" do not maintain so flat a surface as the paintings of Jasper Johns or Willem de Kooning would six hundred years later, but they do appear to be simplified, shallow, consistent, and controlled, and they assert a single, unified image, rather than the medieval multiplicity of broken and fragmented shapes of varying color and value.

Giotto moved painting in the direction of illusion, but he was not yet interested in creating a complete illusion of depth. Giotto often went to "considerable effort to make the spectator aware of the fact that he is looking at a painted picture of events that took place in the distant past" (Cole 1980, 171). This dualistic conflict of the illusionistic window versus the flat solidity of the picture plane is one of the most fundamental oppositions faced by any painter. Giotto's resolution of this dualism is a clearly executed example of a balance between the two elements.

Giotto attempted to suggest the figure's placement in space by simply overlapping one object or figure in front of another. But because he lacked knowledge of atmospheric, linear, and color perspective, he could suggest only a space composed of overlapping planes. He did not separate these planes to create an illusion of space between the overlapping figures. Although Giotto has a clear idea of which objects were meant to be in front of the others, "the viewer does not receive cues as to *how far apart* the pictorial objects are, or how 'deep' the foreshortened planes and objects go" (Edgerton 1975, 96–97). His images, when compared to Masacio's, often seem paper-thin, as if pasted one on top of the other. The figures visually maintain their spatial placement on the solid, flat surface of the wall at approximately the same distance because Giotto held the value of each major shape similar to the value of the surrounding shapes. The uniformity of values also appears to strengthen the flatness and the solidity of the wall.

Giotto, like Duccio, made several rudimentary and inconsistent attempts at linear perspective. The top group of three figures that hold the model of the temple in *Enrico Scrovegni Presenting a Model of the Arena Chapel* (fig. 3.1) illustrates Giotto's lack of consistency in the

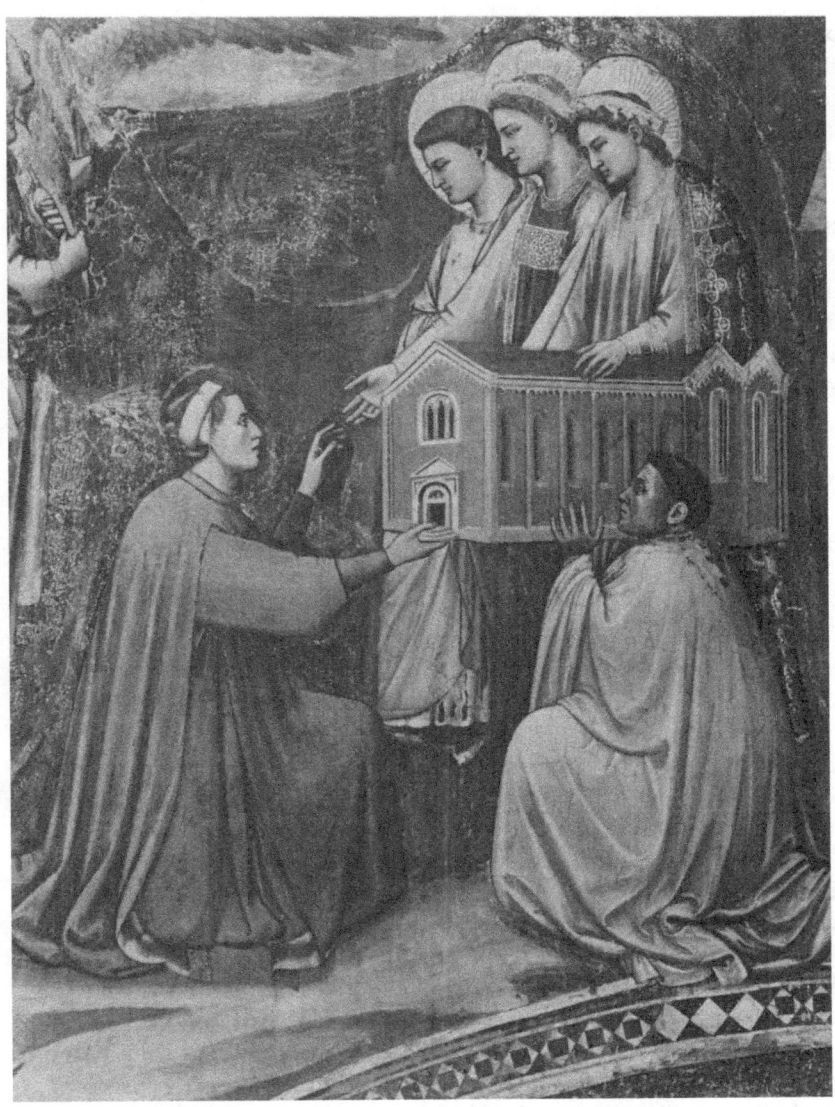

3.1. Giotto. *Enrico Scrovegni Presenting a Model of the Arena Chapel,* detail from bottom left center of *The Last Judgement* (1305–1306). Fresco (1000 cm. × 840 cm.). Scrovegni Chapel, Padua. Photo: Alinari/Art Resource, New York.

use of linear perspective. He drew the rear head in the group of three figures as large as the front head. And because atmospheric perspective had not been invented, Giotto painted the face of the last figure as detailed and as strong in darks and lights as he painted the face on the figure in front. During the fifteenth century, Masaccio would make much more consistent use of both linear and atmospheric perspective.

Cimabue had achieved volume in the details but not in the whole figure. Giotto, though sometimes achieving the illusion of volume in the mass of a single figure, did not generate an illusion of volume in a group. He had learned to make some figures look round but not a group, as Masaccio would do in the next century.

The fresco of *Enrico Scrovegni Presenting a Model of the Arena Chapel* demonstrates several structural differences between Giotto's paintings and those of his predecessors. Because Giotto began to value mimesis and unity over the medieval love of unadulterated pure color, he tended to hold his color consistently in the light value range, particularly in those areas that contained several colors. This technique allowed him to keep several different colors, such as red, yellow, and blue, at the same value by lightening the value of the reds and blues. These light values allowed him to evade the handicap imposed by the lack of an ability to create dark yellows. Giotto had initiated, but not yet mastered, what Shearman calls the technique of "saturation modeling," with its more comprehensive value control. But he had escaped the confines of the earlier "absolute color" system and mastered simple value control.

It was this value control that unified his paintings compositionally. Although its background has faded somewhat, this painting will first appear as a dark ground interrupted by two simplified light shapes. The light shape on the right consists of five objects: the three women, a man, and the small model of a building that they hold between them. Giotto painted each of the five objects the same value—save for the small dark shapes of the hair—so they visually unite to form one large shape. The shape on the left consists of a single figure. Simplifying the visual organization of the painting was accomplished by value control, and this simplification became the first important step toward Renaissance composition.

One of the principal precepts in later High Renaissance art is the subordination of detail to the mass. When Cimabue and his contemporaries, who valued detail over mass, did not create an illusion of volume in the mass, they felt compelled to cover the figure with detail and wrinkles. Cimabue relied on the volume and activity of

the wrinkles to make the surface richer and the mass appear more solid. But when Giotto learned to achieve an illusion of volume in the mass, he no longer felt it necessary to cover his figures with so many drapery folds and details. Giotto's "new art aims, before all else, to construct a figure that will have substance, dimensionality, and bulk—that, like a figure in sculpture, will project into the light and throw a shadow or give the illusion that it does" (de la Croix and Tansey 1986, 539).

Giotto achieved a strong illusion of volume at the hips of the man kneeling in the lower corner. The strong dark on the back of the pelvic area causes this figure to come to a "corner," like a cube, and the hips to appear in volume. The upper part of the figure, however, has no dark side; it remains visually flat.

The Vision of Joachim (fig. 3.2) demonstrates the same pursuit of volume and unity. The stone above the shed is well developed in volume; it has a strong dark side and light side. The shed itself, however, is minimally developed, with only a weak contrast between the dark and light sides. The figure has some dark penetrations down the middle so there is some attempt at volume, but the attempt is not very successful.

Giotto's figures cast no shadows on the ground beneath them. Cast shadows were extremely rare until Masaccio's paintings in the fifteenth century (Cole 1980, 138). The absence of cast shadows makes objects appear to float unless the figures are standing on or near the bottom of the painting. In this painting, the animals appear to be floating almost as much as the angel; the goat looks as if he has just leapt into the air. Still, the value control in this painting is excellent. Giotto has visually unified this painting by making almost everything in the painting approximately the same value. Close value control covers a multitude of compositional sins and maintains a much flatter space.

Vasari tells us that Giotto painted from life; he actually looked at a model when he painted, and he seemed to transform a two-dimensional surface into people and objects.[2] Other religious paintings in the fourteenth century, however, were more medieval didactic images filled with Christian symbolism: "They were not seen simply as stimulating compositions of color and line," Cole emphasizes, "but as

2. "There in a little time, by the aid of nature and the teaching of Cimabue, the boy not only equalled his master but freed himself from the rude manner of the Greeks [Greeks contemporary to Giotto], and brought back to life the true art of painting, introducing the drawing from nature of living persons, which had not been practiced for two hundred years" (Vasari 1958, 7).

32 Changing Images of Pictorial Space

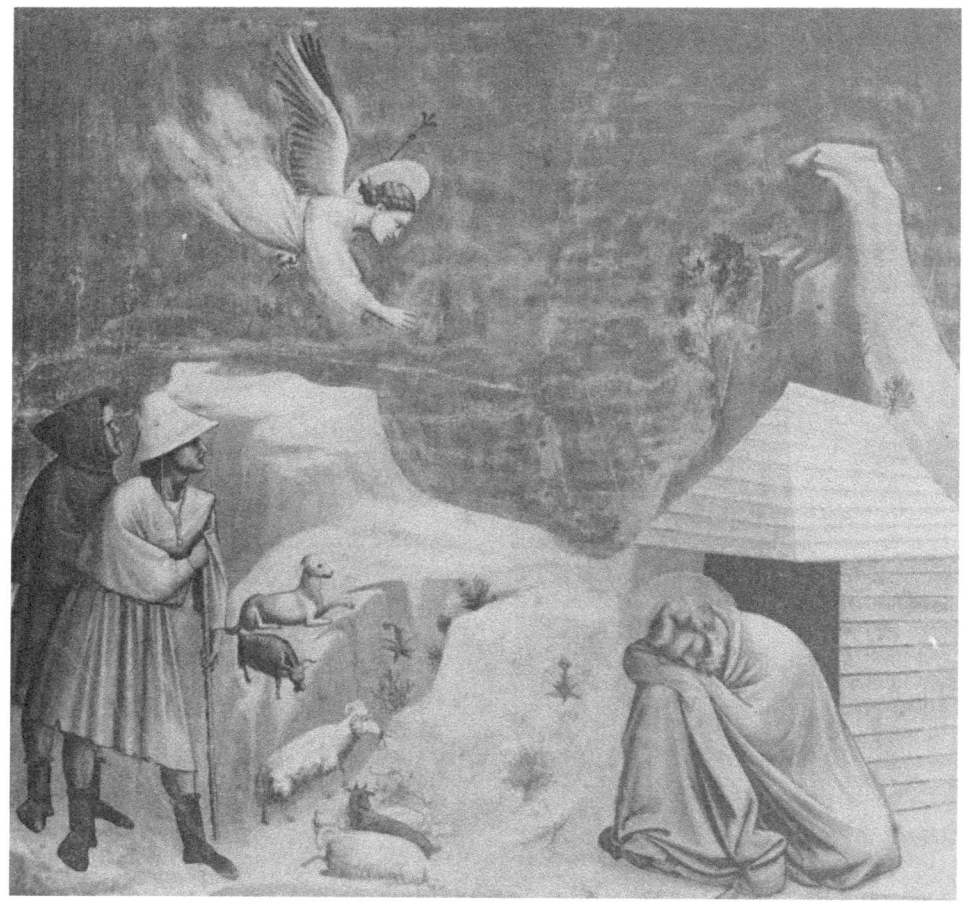

3.2. Giotto. *The Vision of Joachim*. 1304–1306. Fresco (200 cm. × 185 cm.). Scrovegni Chapel, Padua. Photo: Alinari/Art Resource, New York.

mysterious, profoundly moving icons thought to embody some of the awesome power held by the holy figures they portrayed." Indeed, there were many reports of these man-made images performing miracles, and men had been executed for profaning a likeness of the Madonna, even the one on a Florentine coin (Cole 1980, xxi).

The supernatural essence of a painting was so overwhelming, says Cole, that pictures were not written about as works of art. The archetypal idea that the image of a person could transmit a supernatural portion of its subject was still a vital part of fourteenth-cen-

tury art: "This idea is so alien to us that we must constantly remind ourselves that earlier onlookers really saw the frescoes and panels as the sacred, visual embodiments of active supernatural forces" (Cole 1980, xxi).

With our extended experience in viewing two-dimensional photographic and painted illusions in the twentieth century, we have difficulty realizing just how shockingly real Giotto's paintings appeared to fourteenth-century viewers. These viewers had never before encountered anything on a two-dimensional surface that seemed so convincingly real. Giotto's synthesis of the immediate presence of illusion with the supernatural power of the icon dazzled fourteenth-century viewers beyond our ability to understand. He had invented a new form in painting, a form that disoriented viewers from the real world and involved them in the supernatural in a way that had never before been possible.

The political journalist Gary Wills, after seeing just one of Giotto's panels in Boston, said that Giotto's new image must have hit the late thirteenth century with all the impact of our first moving pictures. We have perhaps forgotten how strongly people react to the first experience of a powerful new illusion, but we do know how audiences reacted to an early movie of only thirty seconds duration by Auguste Lumière: *L'Arrivée d'un Train en Gare de La Ciotat*. The illusion of a train appeared in the distance, heading toward the camera, and as it loomed into the foreground, panic seized the audience. People jumped up and ran out of the theatre (Tarkovsky 1987, 57). Valentino's face spread across the silver screen caused suicides, and Garbo's face plunged audiences into the deepest transcendental ecstacy (Barthes 1982, 82).

Realism is not by any means a timeless or universal standard. The degree of realism to which an object is said to be represented depends primarily on how expertly the painter captures or improves upon the image in terms of current conventions. When we say that a picture looks like nature, we mean that it matches the manner in which we have usually seen nature depicted.[3] Giotto's paintings may have looked startlingly real to the fourteenth-century viewer, but when new techniques and illusionistic devices were invented in the fifteenth century, Giotto's paintings no longer startled.

3. "Again, what will deceive me into supposing that an object of a given kind is before me depends upon what I have noticed about such objects, and this in turn is affected by the way I am used to seeing them depicted. Resemblance and deceptiveness, far from being constant and independent sources and criteria of representational practice are in some degree products of it" (Goodman 1976, 39).

The optical physiologist M. H. Pirenne, who has spent a lifetime studying perspective, concludes that all newly invented visual elements of realism in painting may for a time conflict with the realism of elements already in use and thus strike contemporaries of the artist as strange, yet at the same time as markedly true. The exotic combination may be startingly realistic and completely captivating while it is still new, but viewers from a later era will not be dazzled in the same manner: "on the contrary, what may strike them may be the lack of other elements, more recently introduced by other artists. It is because we have seen the works of Giotto's successors, that those of Giotto himself no longer appear as realistic to us as to his contemporaries" (Pirenne 1970, 174).

Giotto imitated the objects and people in his God's nature. He achieved a better illusion of volume than had previous painters, but he did not achieve a strong or a unified representation of depth. He tried to depict space by manipulating objects: he used solids to generate space rather than placing these objects in a preexisting space (Panofsky 1965, 119). When fifteenth- and sixteenth-century painters spoke of imitating nature, they put at least as much importance on the spatial relationships between objects as on creating a facsimile of the object itself.

After Giotto's first works, almost every Florentine painter adopted his style, and few works after the advent of Giotto were done in the style of the thirteenth century (Cole 1976, 122). During that period between Giotto and Masaccio, several painters, particularly Taddeo Gaddi, Ambrogio Lorenzetti and Pietro Lorenzetti, "made the most spectacular progress not only in the struggle for an exact perspective construction but also in the representation of space" (Panofsky 1965, 139). Sienese painters, however, abandoned the pursuit of one-point perspective after 1350 (Cole 1980, 139), and Florentine painters turned away from Giotto's optimistic image (Cole 1976, 131).

But around 1375 the next generation of young Florentine artists turned once again to both the form and the content of Giotto's painting (Cole 1976, 140). Such painters as Agnolo Gaddi and Sinello Aretino revived Giotto's direction and prepared the way for Masaccio and the early Renaissance of the fifteenth century. It was then that the invention and unification of the four major devices necessary to generate the Renaissance illusion would be accomplished.

4

The Renaissance System of Perspective

WHEN MOST WRITERS refer to "Renaissance perspective" they mean, primarily if not exclusively, linear perspective. Sometimes such writers do briefly acknowledge "aerial perspective," a term that combines just the rudiments of two separate and more elaborate perspectives: atmospheric and color. Yet the Renaissance system of perspective was actually composed of four major perspectives that, together with a unified light source, generated Renaissance pictorial space: the Renaissance illusion. These four major perspectives were linear perspective (which incorporates both converging lines and diminishing size), the separation of planes, atmospheric perspective, and what I shall call the classic color theory—that color perspective specific to the Renaissance system.[1] Renaissance perspective, then, is a complex and interrelated system for depicting what appears to be a unified, mathematically correct illusion—of volume, depth, and the accurate placement of figures and objects in space—on a two-dimensional surface.

Nothing so simple and obvious as linear perspective could have managed by itself to dominate the imagination of painters for six hundred years. In fact, linear perspective, as well as the shading of volume, aroused little interest among advanced painters from about 1870 through the twentieth century, but other devices of Renaissance perspective did retain their attention. Only a rich variety of combinations and permutations such as are possible with the four major perspectives could have depicted a sufficient variety of realities to command the lasting interest of such a host of painters. Artists were so ensnared by this convention that they were not able to free themselves from it for six hundred years.

1. I consider "classic color theory" to be an appropriate name for this device of perspective because the Renaissance version is similar to, and derivative of, the method used in Roman Odyssey paintings and it tends to be consistently practiced in those methods of painting that are most clearly influenced by classical art.

Though Renaissance perspective may appear to mimic what can be seen with one eye from a permanently fixed viewing point (for instance, looking at a scene through a peep-hole), it cannot reproduce actual vision on a flat surface. Although the Renaissance system of perspective in its time may have appeared to be an objective method of depicting the world, it has always remained subjective in execution. Painters cannot depict everything they can objectively see because each inevitable change of focus changes what is seen. They must always interpret and discriminate between what they will stress and what they will ignore. If ten Renaissance painters were assigned the same scene to paint and told to paint this scene exactly as seen, the ten paintings would each be unique.

Given the limitations of planar representation, even "the most realistic paintings can only contain a restricted number of visual elements taken from reality" (Pirenne 1970, 175). Painters throughout history have focused on an immense variety of these "visual elements taken from reality," and these elements have been combined in innumerable ways. Those aspects of the external world that can be depicted on a two-dimensional surface are structured in a manifold of dichotomous choices, such as the choice between a transparent or an opaque picture plane. The painter is constantly forced to choose one aspect over the other. Thus, far less than half those aspects to which we have access in the external world may be indicated on any flat surface. No single painting can depict a whole "truth." Each painting is only a supplementary view of any external "truth."

Although central perspective may insure a rational, even a mathematical, system for depicting space, the system depends upon two important assumptions: that we see with a single motionless eye and that the plane section through the cone of sight is an adequate reproduction of our retinal image (Panofsky 1924–25, 1). I might add that even within those two basic limitations, Renaissance perspective appears to mimic only foveal vision, and foveal vision is a minute percentage of retinal vision. To equate the image in Renaissance perspective with sight is an extremely bold abstraction from reality, "for the structure of an infinite, unchanging, and homogeneous—in short, purely mathematical—space is directly opposed to that of psychophysiological space" (Panofsky 1924–25, 1).[2]

2. Panofsky never defines "psychophysiological space," but Edgerton explains it as "the kind of space we see empirically, without theological preconceptions or mathematical structure, it is neither homogeneous, infinite nor does it extend uniformly in all directions" (Edgerton 1975, 161).

Vision functions in a manner different from the painted image in Renaissance perspective. In the real world, we use two major, and several minor, visual faculties to create depth perception as well as a fluid image of space. Binocular vision—we see two separate views of the world because we have two eyes—and movement parallax—an apparent change in the position or shape of objects, or the relationships between objects, owing to a change in the direction from which they are viewed (Haber and Hershenson 1973, 316)—are the two most important faculties in our interaction with depth and space. These two faculties, however, are unavailable to those who imitate, with colored smudges on a two-dimensional surface, the patterns of light and shade that enable us to capture frozen portraits of a three-dimensional world on a flat surface.

The unified Renaissance system of perspective elicited strong approval from painters, the public, and the Church for three principal reasons: it appeared to be rational, scientific, and objective; it functioned as a manifestation of their belief in the existence of a rational universe; and it gave painters a new tool which they could use to create a new kind of spiritual and religious response in the viewer.

During the Renaissance the pursuit of reason, rationality, and order were of highest priority; the search for objectivity governed people of this time, and they equated objectivity with divine truth. With the invention of perspective, art seemed to have become science. But any perspective, no matter how objective the method may seem, must be interpreted subjectively. Consequently, what this perspective achieved was "a translation of Psychophysiological space into mathematical space: in other words, an objectification of the subjective" (Panofsky 1924–25, 16).

Renaissance perspective, particularly linear perspective, seemed to facilitate the quest for a mathematical and consistent objectivity that made the new system conceptually attractive to the rational mind of Renaissance man. The inventors of perspective nurtured the Platonic belief that nature was essentially mathematical and therefore mathematical perspective encompassed the true principles of nature (Gablik 1977, 69). In response to the Renaissance pursuit of reason, artists played their part in the search for "objective truth" and contributed to the progress of science "by finding a relatively nonsubjective way to make pictorial images which everyone, regardless of cultural background, could learn to become oriented to or respond to" (Edgerton 1975, 164).

But, to the best of the Renaissance painters, perspective became even more than just a aegis of their faith: this system empowered the painter to use painting as a vehicle to create a religious experience in a new manner. Perspective robbed religious paintings of that magical region within which the work of art itself is the wonder, but the style opened a new region of visions within which, says Panofsky, "the wonderful becomes an immediate experience of the spectator in that the super-natural occurrences break into his own apparently natural visual space, thereby making him really aware of their supernatural aspect." Perspective also enabled the artist to render visible the psychological aspects that lodged in the souls of those religious figures represented in the paintings. The central perspective treatment of space transformed reality into vision and seemed to "reduce the divine to a mere content of human consciousness," but if human consciousness contained the divine, such a demonstration must expand "human consciousness into a vessel for the divine" (Panofsky 1924–25, 18).

In his study of the psychology of Renaissance perspective, Michael Kubovy seconds Panofsky's contention that perspective is not a rigid system designed only to create an illusion, but he also points out that it made possible the Renaissance artist's ability to depict deeply religious content in a form that could "produce in the viewer spiritual effects that could not have been achieved by any other formal means. In that sense, perspective should be viewed as 'symbolic form'" (Kubovy 1986, 173). In other words, Renaissance perspective was not a truth waiting to be discovered, but a convention, an invented style, instigated by society's priorities and assumptions, and therefore matching the beliefs and ideologies of the culture so well that its limitations and boundaries were all but invisible to the Renaissance viewer.

Linear Perspective

An architect named Brunelleschi invented Renaissance linear perspective in the fifteenth century, and Alberti explained it in his *Della Pittura* in 1436. Alberti's treatise, dedicated to Brunelleschi, formulated the aesthetic and scientific attitudes of Renaissance painting (Barasch 1985, 112). Alberti demonstrated his perspective with drawings of a cube and limited his construct of linear perspective to a one-eyed view at the eye level of the normal person; there was no departure from this low monocular viewpoint in any organized or meaningful way until the nineteenth century. It was Alberti

who lay the groundwork for the whole Renaissance period with his observation that "the picture is a plane section of the visual cone" (Panofsky 1924–25, 14).³ Alberti demonstrated that in two important aspects—the relationship between the shape of an object and its position—one aspect was simultaneously a cause and a result of the other, so they were thus relative, not absolute: "Simple as his construction was, it was full of implicit mathematical and philosophical ideas of the greatest importance" (Ivins 1946, 76).

Linear perspective had grown from the study of optics, and optics had always been considered pure science. Optics was rational, objective, observable, and orderly.⁴ Optics, however, was not only a science but also a branch of the Faith: "The initial impetus to study optics in medieval Europe was that its geometric concept of light-filled space provided some kind of rationalization of how God's grace pervaded the universe" (Edgerton 1975, 60). The predictable and orderly system of linear perspective likewise came to be integrated with the Christian faith as well as with capitalism.

Alberti's concept that a painting was analogous to a flat section across the visual cone made possible a mathematical rationalization of a pictorial space that had already been unified aesthetically (Panofsky 1924–25, 15).⁵ Alberti's perspective can be set forth in four

3. Alberti writes that painters "should understand that, when they draw lines around a surface, and fill the parts they have drawn with colours, their sole object is the representation on this one surface of many different forms of surfaces, just as though this surface which they colour were so transparent and like glass, that the visual pyramid passed right through it" (Alberti 1972, 49).

In the sixteenth century, Leonardo explained in his notebooks this method of tracing a scene onto a flat surface, and this explanation serves as an excellent analogy of the "plane section of the visual cone." "Take a piece of glass of the size of a half sheet of royal folio paper," he wrote, "and fix it well in front of your eyes, that is between your eye and the object you wish to portray. Then move away until your eye is two-thirds of a braccio away from the piece of glass, and fasten your head by means of an instrument in such a way as to prevent any movement of it whatsoever. Then close or cover up one eye, and with a brush or a piece of red chalk finely ground mark out on the glass what is visible beyond it; afterwards copy it by tracing on paper from the glass" (MacCurdy 1939, 877–78).

4. Brunelleschi's and Alberti's central perspective, what we simply call perspective today, was then called "artificial" perspective, as opposed to the mathematical principles of optics, which were referred to as "natural" perspective (Panofsky 1965, 139).

5. "This projection—by definition a central one and perfectly analogous to that produced in a photographic camera—can be constructed by elementary geometrical methods" (Panofsky 1965, 126). And the first sentence in Alberti's dissertation gives notice of his mathematical intentions: "In writing about painting in these short books, we will, to make our discourse clearer, first take from mathematicians those things which seem relevant to the subject" (Alberti 1972, 37).

principal axioms (White 1967, 123–24): (1) Straight lines are not distorted; (2) objects or distances parallel to the picture plane are not distorted;[6] (3) diagonals (orthogonals) converge to a single vanishing point which corresponds to the position of the viewer's eye;[7] and (4) objects diminish in measured increments in proportion to their distance from the viewer.

Alberti suggested that the rate of diminishing size in a foreshortened plane is determined by the distance of the *viewer* from the picture plane, and the point corresponding to this distance should be on the same level as the point to which the parallel lines converge (Bunim 1940, 189).[8] Not only did Alberti formulate the aesthetic and illusionistic attitudes of the Renaissance, but when he substituted a theoretical dissertation for a practical demonstration such as Brunelleschi's (White 1967, 121), he facilitated the seventeenth-century separation of theory and practice that grew to become the foundation of modern theory and criticism.[9]

In the twentieth century, artists tend to think of linear perspective as simple, obvious, even heavy-handed. Yet this converging of parallel lines as they recede into depth—which creates a geometrically consistent diminishing in the size of receding objects—excited artist and viewer alike during the fifteenth century.

I have discussed linear perspective first because it was the first perspective to be invented and it may well have led to the invention of the other three perspectives. But it is not the most efficient method for creating an illusion of depth in all kinds of painting. For

6. The first two axioms are shared by the fourteenth-century systems that rely on the depiction of objects in foreshortened frontality (White 1967, 123).

7. Alberti calls orthogonals "colinear" planes and lines (Alberti 1966, 52). John Spencer explains that "colinear planes and lines are those parallel to the line of sight but perpendicular to the picture plane. Such lines are called orthogonal today, that is, at right angles to the picture plane. Though parallel, they seem to meet as do the classic railroad tracks in elementary drawing books" (from Alberti 1966, 107).

8. Evidence of the early Renaissance method of constructing perspective, as explained in the writings of the period, can be traced in the paintings of a number of Italian artists, but there are some paintings in which there does not appear to have been any organized system of perspective and others where the system has not been used as accurately as might be expected (Bunim 1940, 189).

9. The fifteenth-century methods of perspective were not complete and definitive, Bunim notes, for "they did not achieve complete mastery of the subject as a science. The mathematical implications of this subject and the concepts from which our mathematical terminology today is derived were contributed by geometers of a later period" (Bunim 1940, 188).

instance, it is more limited than atmospheric perspective in regard to the subject it is capable of representing. Linear perspective is primarily dependent upon straight lines—parallels, verticals and horizontals—and it is an excellent device for depicting architecture and man-made environments because man so loves the straight and the parallel line. Atmospheric perspective, in contrast, is more useful in landscape and those situations where there are no straight or parallel lines.

Separation of Planes

The separation of planes is the second of the four perspectives that constitute the complete Renaissance system. Separation of planes is a refinement of an earlier device, overlapping planes. It mandates the visual separation of the overlapping planes, one behind the other in graduated increments of distance, from foreground into deep background; this separation is accomplished by the use of the other three perspectives. The French art historian Pierre Francastel, a synchronist who incorporates ideas from other fields into his theories, maintains that the window created by Alberti's method of linear perspective depicted a miniature view of the universe, and the laws of physics and optics functioned to create an optical illusion of perspective by the visual separation of frontal planes (Francastel 1977, 37).

In fifteenth- and sixteenth-century paintings, the low eye level and one-point perspective created the effect of a stage. The "picture plane" might be understood as a large pane of glass across the very front of this stage. All the objects, action, and spatial illusion took place behind this picture plane until the late sixteenth century, when the Mannerists began to allow small portions of objects and anatomy to penetrate this plane visually and extend slightly in front of it.

Rudolf Arnheim, who has earned a reputation as an expert in the application of the psychology of visual perception to art, notes that in the fifteenth century "the rule prevails that no feature of the visual image will be deformed unless the task of representing depth requires it. In the earliest and simplest applications of one-point perspective, objects are placed frontally whenever possible" (Arnheim 1974, 286).

In the *Miracle of St. Zenobuis* (fig. 4.1), Botticelli used the separation of frontal planes, simply and obviously. Each group of human figures creates a frontal plane in the foreground, and the frontal

4.1. Sandro Botticelli. *The Miracle of St. Zenobuis.* 1495–1500. Tempera on wood (26½" × 59¼"). John Stewart Kennedy Fund, 1911. Metropolitan Museum of Art, New York.

planes of the architecture establish the second plane. The one-point linear perspective of the planes that recede between the two buildings strengthens the illusion of depth, and the distant end of those planes creates the third spatial step into the background. Virtual depth ends at the horizon. Also evident is the use of frontal planes to diminish any unnecessary distortion, as Arnheim mentioned. There are at least four separate planes (and perhaps as many as seven) placed distinctly at four separate distances from the viewer.

The concept of overlapping planes may have derived directly from the design of stage sets.[10] But the illusion of distance and atmosphere that caused these planes to appear separated, rather than merely overlapped, was created by linear, color, and atmospheric perspective.

10. The development of perspective has traditionally been allied with the painting of stage scenery, but this idea depends upon the interpretation of a paragraph written sometime after 27 B.C. by the architect Vitruvius: "For to begin with: Agatharchus at Athens, when Aeschylus was presenting a tragedy, was in control of the stage, and wrote a commentary about it. Following his suggestions, Democritus and Anaxagoras wrote upon the same topic, in order to show how, if a fixed centre is taken for the outward glance of the eyes and the projection of the radii, we must follow these

Atmospheric Perspective

Atmospheric perspective, rather than the more obvious and popular linear perspective, deserves credit as the foundation of the sixteenth-century illusion, as well as the foundation of most of the Renaissance-based spatial illusions that came after. Atmospheric perspective is the most effective method of creating an illusion of distance between separated planes in order to clarify the organization of the ground plan. It also adapts more readily than the other components to almost all the other illusions and spatial concepts throughout the history of European and American art (Cézanne's "little sensation," which will be explained later, is the most notable exception).

Atmospheric perspective has been the most effective method of creating an illusion of depth for at least the last five hundred years. It has been important in various historical styles of painting—Roman,[11] Oriental, Renaissance, impressionism, and modern—because it does not have the severe limitations that linear perspective does, and it is not so obvious. For instance, atmospheric perspective does not violate the visual surface of the flat picture plane so violently as linear perspective (White 1967, 145). Yet it has seldom been mentioned, even briefly, and no detailed explanation exists. That seems a puzzling oversight.

Masaccio, in the first quarter of the fifteenth century, used atmospheric perspective well (as will be demonstrated in chapter 5). Atmospheric perspective had not been used before the fifteenth century, but in that century it was used extensively, even in relief sculpture.[12] Ghiberti, for example, reserves the strong darks and lights for the figures in the foreground of his relief sculpture, *The Story of*

lines in accordance with a natural law, such that from an uncertain object, uncertain images may give the appearance of buildings in the scenery of the stage, and how what is figured upon vertical and plane surfaces can seem to recede in one part and project in another" (Vitruvius 1934, 71).

But, Ivins insists, "The knowledge of perspective attributed to Agatharcus, Anaxagoras, and Democritus is a modern myth based on the utterly unwarranted reading into a casual remark by Vitruvius, who lived at least four hundred years later, of ideas that neither Vitruvius nor any Greek of the fifth century B.C. could possibly have had" (Ivins 1946, 31).

11. Roman panoramic landscape painting depends on "a gradation in the tonalities which creates a more naturalistic atmospheric environment and suggests greater depth" (Bunim 1940, 31).

12. The first atmospheric perspective in relief sculpture was used by Donatello in the St. George predella at Or San Michele in Florence (c. 1415).

Jacob an Esau (fig. 4.2). The actual depth of the lines that delineate the architecture becomes proportionately shallower as the buildings appear to recede into the distance. The diminished assertiveness of the lines creates a weaker dark-light definition as each successive plane recedes into the virtual distance.[13]

The term *aerial perspective* is often encountered in the literature of art history. Most writers use this term to refer to the combined effects of atmospheric and color perspective.[14] Aerial perspective is a vague term; it serves neither clarity nor poetry. I recommend that it be discontinued, because it simultaneously clouds the clarity of idea in two separate perspectives: one relies on value, the other on color.

Separating aerial perspective into its two components of atmospheric and color perspective facilitates clarity and understanding. It allows atmospheric perspective to cover those illusionistic devices that depend on value, and it concedes to color perspective those illusionistic effects that depend on hue. The reasons for this separation will be even more evident when the discussion focuses on Cézanne in chapter 12, where I shall demonstrate that Cézanne separated atmospheric perspective from color perspective. But Leonardo's notebooks give evidence that as early as the sixteenth century he had clearly separated these two perspectives in his understanding, if not in his painting:

> Perspectives are of three kinds. The first has to do with the causes of the diminution or as it is called the diminishing perspective of objects as they recede from the eye. The second the manner in which colours are changed as they recede from the eye. The third and last consists in defining in what way objects ought to be less carefully finished as they are farther away. And they are these:

13. De la Croix and Tansey observe that Ghiberti's "relief becomes flatter and flatter until the architecture in the background is represented by barely raised lines, creating a sort of 'sculptor's aerial perspective' in which forms are less distinct the deeper they are in space" (de la Croix and Tansey 1986, 557). These authors use the term *aerial perspective* here, but, because aerial perspective is defined as blurring and moving toward blue and less saturate color in the virtual distance, and since color is not utilized in relief sculpture, their meaning in this instance must surely be limited to atmospheric perspective.

14. Everyone from Wolfflin to the perceptionists is prone to this; even Haber and Hershenson, two of the most authoritative authors in the field, of visual perception fail to separate atmospheric from color perspective. "Aerial perspective refers to the fact that the retinal projections of distant objects are less sharp and less saturated in color than near objects. In general, the more the color [or value] of an object approximates the background, the more it tends to recede into it and to appear far away" (Haber and Hershenson 1973, 307).

4.2. Lorenzo Ghiberti. *The Story of Jacob and Esau.* c. 1435. Relief panel (31" × 31"). East doors, Baptistery. Florence. Photo: Alinari/Art Resource, New York.

> Linear Perspective
> Perspective of Colour
> Vanishing [atmospheric] Perspective
> (MacCurdy 1939, 864).

While linear perspective and the separation of planes cannot be exaggerated without distorting or losing the illusion, atmospheric perspective can withstand immense exaggeration—often without attracting the viewer's notice. More than two hundred miles of atmospheric perspective can be compressed into two feet of depth in a

still-life, and most viewers will not notice the perspective: they will perceive the depth but not the method.

The governing principle is dependent upon the control of the relationship of focus and value between objects and their surrounding ground. If an object or figure is sharply focused and contrasts with the value of a blurred ground, it appears to advance. If the figure is blurred and remains similar in value to the ground, it tends to recede. The idea is to dissolve distant objects into the background while sharply separating the nearest objects from the background by the use of focus and value contrast.

Texture can be another part of atmospheric perspective. The painter can blur and lose texture and detail on surfaces as they recede or can actually create perspective by diminishing the size relationships of the units of texture as the surface recedes. This effect is related to both focus and an elaboration of linear perspective. Texture consists of a series of units repeated over the entire surface. On frontal planes, all the units remain equal distances from the viewer, and geometry dictates that they will all be the same size. A diagonal surface—at a slant to our line of sight—will have textural units that diminish in size as they recede, according to the rules of linear perspective (Haber and Hershenson 1973, 296).

The following more detailed explanation of atmospheric perspective covers all contexts and lighting situations:

Atmospheric Perspective

Salient	Recessive
Objects that contrast in value with the ground	Objects similar in value to the ground[15]
Focus	Blur
Sharp edges and detail (rough texture reads as sharp detail)	Blurred edges and detail[16] (smooth texture reads as blurred detail)
Volume is created by the use of strong dark and light sides, and so it seems to advance[17]	Flatness

15. Leonardo had observed, "That dimness (il mezzo confuso) which occurs by reason of distance, or at night, or when mist comes between the eye and the object, causes the boundaries of this object to become almost indistinguishable from the atmosphere" (MacCurdy 1939, 897).

16. Leonardo is insistent about this point: "I say that when objects appear of minute size, it is due to the said objects being at a distance from the eye; and when

In order to create a less analytical, more holistic and intuitive, mental image of atmospheric perspective, some painters visualize a foggy day and objects emerging out of the fog. Fog increases the illusion of depth because it exaggerates all the principles listed above.

In *The Andes of Ecuador* (fig. 4.3), Frederick Church exploited atmospheric perspective in order to strengthen the effect of the separation of planes. The mountains in the distance fade, plane by plane, into the misty atmosphere until they disappear. The principles of atmospheric perspective, as first used in the fifteenth century and further perfected in the sixteenth century, amplify the illusion of depth and help to separate planes in space and control the visual placement of objects on the ground plane. Atmospheric perspective was one of the most important prerequisites to the achievement of the mature Renaissance illusion.

The Classic Color Theory

The classic color theory is the fourth of those perspectives that make up the Renaissance system of illusion.[18] Like atmospheric perspective, color perspective emphasizes the illusion of separation between planes and can be exaggerated so as to strengthen the illusion that one plane, or point, is behind and separated in space from the other. Exaggerating depth cues by means of atmospheric and color perspective helps to compensate the painter for the loss of binocular vision and movement parallax. Leonardo put these principles into writing and coined the terms "aerial perspective" and "perspective of color" (Barasch 1985, 157).[19]

this is the case, there must of necessity be a considerable quantity of atmosphere between the eye and the object, and this atmosphere interferes with the distinctness of the form of the objects, and consequently the minute details of these bodies will become indistinguishable and unrecognizable" (MacCurdy 1939, 807).

17. Leonardo wrote that "things near to the eye will seem of greater bulk [volume] than those remote" (MacCurdy 1939, 250).

18. The "classical system of color perspective" was reborn at the same time as linear perspective (Lapicque 1959, 82).

19. One of the foremost experts on the fifteenth and sixteenth-century Italian Renaissance, Anthony Blunt, has investigated Leonardo's notes in depth, and he insists that Leonardo's expertise is unique and unsurpassed in the field of atmospheric and color perspective. "Leonardo appears as a complete innovator. Earlier writers, such as Alberti, were apparently quite unaware that the edges of objects became less clearly defined and the details on them less distinct as they get farther away. They seem not to have noticed or not to have been interested in the fact that hills are blue

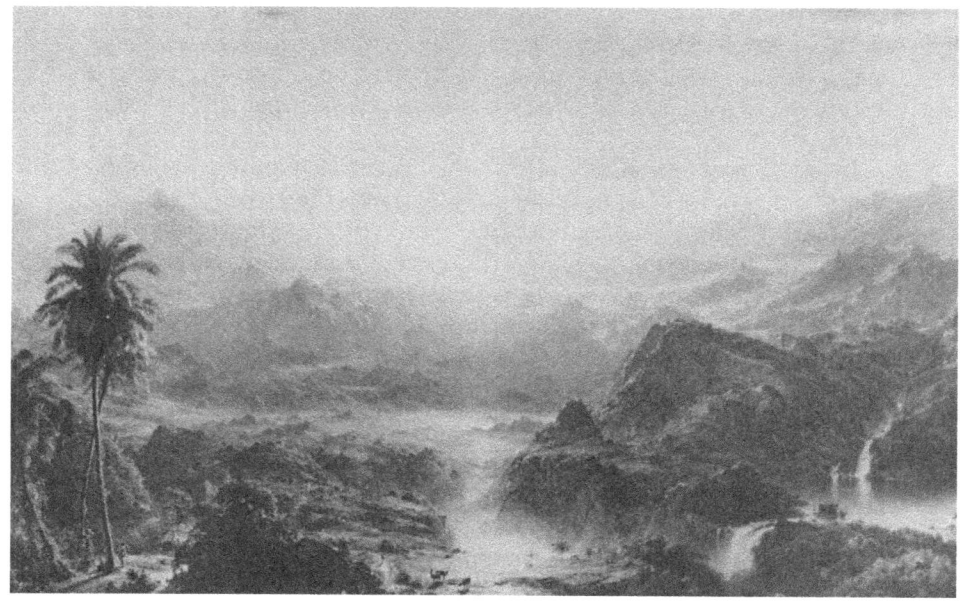

4.3. Frederick Church. *The Andes of Ecuador*. 1855. Oil on canvas (48" × 75"). Courtesy, Reynolda House, Museum of American Art, Winston-Salem, N.C.

The classic color theory is founded on the observation that warm colors appear to advance and cool colors to recede. This observation is supported by principles that can be demonstrated in the fields of psychology, physics, and physiology. It can be easily observed that objects do shift towards blue as they recede into the distance. Physicists have demonstrated that the shorter blue rays bend far more than the longer wave lengths as they travel through the atmosphere. This tendency for the shorter blue light waves to bend causes most of the blue light to scatter into the atmosphere; accordingly, the sky is blue during the day when the sun is high.

As the distance between the viewer and viewed object increases, the quantity of blue atmosphere that acts as a filter between them is

in the distance. . . . Leonardo was the first to carry out a really systematic study of the subject, the effects of which appear in his paintings and no less in his theoretical writings" (Blunt 1962, 29–30).

increased proportionately: objects appear progressively bluer as distance increases. At the same time, the greying effect of moisture or dust particles in the air, combined with the blue atmosphere, tends to grey distant colors; thus, color in the distance tends to shift toward a greyed blue.

While the atmosphere scatters and dissipates the blue light of the sun's rays, the warmer rays penetrate straight through the atmosphere to cast their reddish light on the earth and its objects. Colors in the foreground will therefore be warmer, more saturate, and more intense.

The classic color theory is well illustrated in Raphael's *Beautiful Gardener* (fig. 4.4). The principles can be outlined in a form similar to that used for atmospheric perspective:

Construct for the Classic Color Theory

Salient	Recessive
Warm colors	Cool colors
Saturate, intense or bright color	Greyed-down color, tone, tint, and shade
	Light colors in the distance tend to shift toward red
	Dark colors in the distance tend to shift toward blue

A subtle refinement of the classic color theory, the "tail" of the theory, holds that light objects in the background will stray toward red, or maintain a warmer temperature, while dark areas will drift toward blue.[20]

In France, Charles Lapicque is distinguished as a physicist and a painter and he has investigated Leonardo's notes on color perspective in detail. He drew upon all three areas of expertise to write "Color Into Space," an essay that explains the principles of what he calls the "classical system of color perspective" or the "classical theory

20. In Leonardo's words: "But in the far distance that object will show itself most blue which is darkest in color" (MacCurdy 1939, 921).

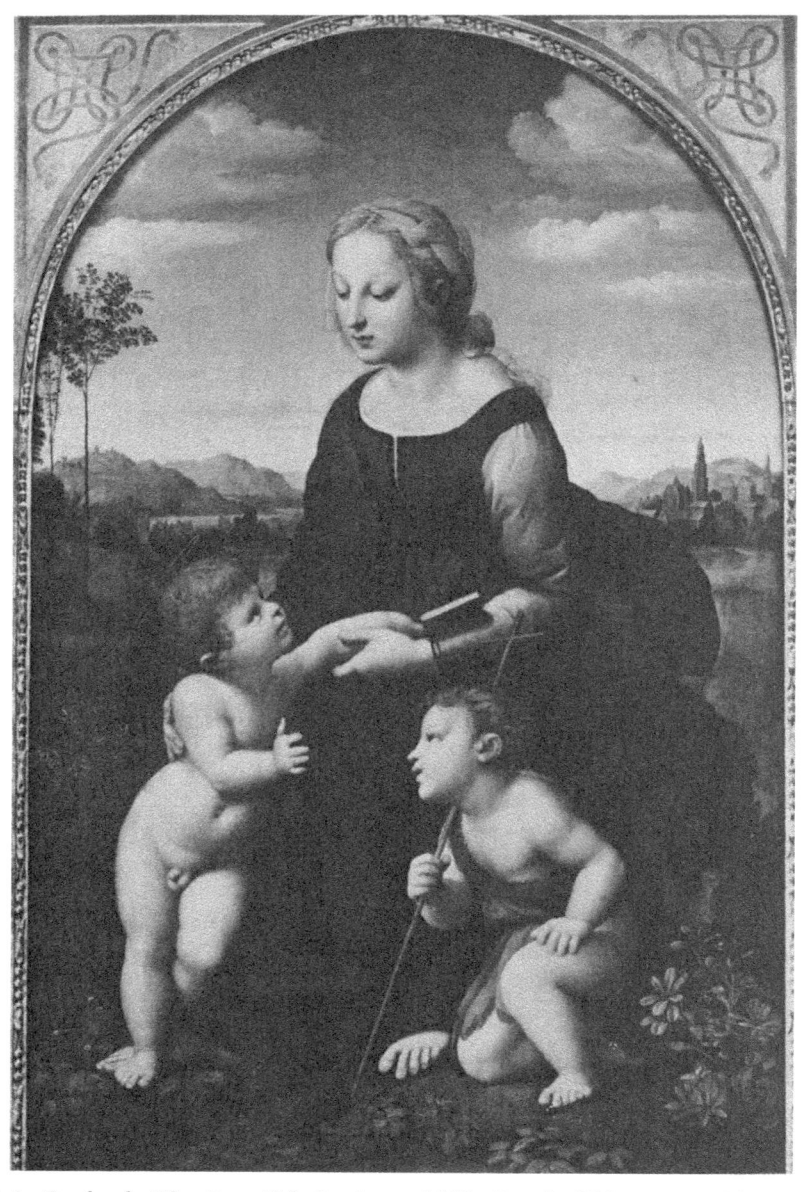

4.4. Raphael. *The Beautiful Gardener*. 1508. Panel (122 cm. × 80 cm.). Louvre, Paris. Photo: Alinari/Art Resource, New York.

of colors in space" (Lapicque 1959, 82). Lapicque has demonstrated that because blue light scatters out of the sun's rays on the way through the atmosphere, a light object in the distance will appear warmer; and as these rays reflect off the object and start their journey toward the viewer's eye, the blue light continues to scatter out into the atmosphere, causing the light object to appear warmer still.

A dark object in the distance will shift toward blue because it does not reflect as much light.[21] This means that the only light between the object and the eye is in the form of scattered blue rays that are roaming loose in the atmosphere. This refinement of the classic color theory was also recorded by Leonardo.[22]

The classic color theory is demonstrated clearly and simply in many of the paintings of Leonardo, Raphael, and other sixteenth-century painters. Warm, saturate colors are reserved for the foreground, and a cool, icy, greyed blue for the background.[23]

An illumination engineer, M. Luckiesh, published the influential book *Visual Illusions* in 1922. He described an experiment that demonstrates a pronounced tendency for red to appear more salient than blue. A mechanical fabrication containing two, large, illuminated letters—one a saturate red E and one a saturate blue H—was designed in a manner that allowed observers to move one letter until it appeared to be the same distance from the observer as the other: "Nearly all the observers (without being acquainted with the actual positions) were obliged to set the red H further behind the blue E in

21. Lapicque notes, "returning to the observations in Leonardo's *Treatise*, we can retain the following of his conclusions: because of the effect of the atmosphere, dark areas in the distance will look intensely blue; local colors which will undergo the greatest change are the darker ones, like red or green. But since green is a color already close to blue, it will be less altered by the effect of distance than red, which will suffer a radical transformation. Bright colors [Lapicque is referring to light values; the word *brightness* usually refers to light value rather than hue saturation] will not be greatly changed" (Lapicque 1959, 75).

22. Leonardo wrote in his notebooks, "We may see also in the dark shadows of mountains far from the eye that the atmosphere which is between the eye and these shadows will appear very blue, and in the portion of these mountains which is in light, it will not vary much from its first color" (MacCurdy 1939, 401).

23. De la Croix and Tansey comment on Titian's use of color for spatial placement in his painting Venus of Urbino. "One must study the picture carefully to realize what subtlety of color planning is responsible, for example, for the placing of the two deep reds (in the foreground cushions and in the background skirt) that function so importantly in the composition as a gauge of distance. . . . Here color is used not simply for the tinting of preexisting forms but as a means of organization that determines the placement of forms" (de la Croix and Tansey 1986, 648).

order to make both appear to reside at the same distance. This added distance for the red H was approximately 2.4 feet when the blue E was at a distance of 24 feet. In other words the difference in the positions of the two averaged 10 percent of the total distance in this case" (Luckiesh 1965, 136–38).

In addition to physical explanations for this phenomenon, there are also physiological explanations as to why warm colors appear to advance. This effect is thought to be caused by "chromatic aberration," which is the tendency for the lens to focus yellow light waves directly upon the retina, red and yellow-red focus behind it—as in farsightedness—and blue and blue-purple in front of it—as in nearsightedness (Libby 1974, 67).[24] The result is that "when the lens does bring red and yellow-red lightwaves to an effective focus on the retina, it is acting upon them as though they had been reflected from surfaces which are nearer than is actually the case" (Libby 1974, 67).[25]

Because the eye is forced to refocus for shorter wavelengths, the long wavelengths of the warm colors cannot be focused at the same time; viewers, must refocus each time they move their attention from short to long wave color, or vice versa. The fact that the eye cannot focus on long and short wave colors simultaneously may also explain why a warm figure stands out more against a cool ground than against a neutral one. Because of chromatic aberration the uncertain eye cannot focus on both colors at once, so it tends to focus on the figure (in this case a warm color), and the ground blurs. This focusing of the figure and blurring of the background intensifies the figure-ground separation, which causes the warm figure to assert itself visually in front of the ground.

Chromatic aberration may also explain why the classic color theory can be efficiently reversed. Blue—particularly a light cerulean

24. Luckiesh also attributes the aggressive spatial tendencies of yellow and red to chromatic aberration (Luckiesh 1965, 135).

25. Lapicque agrees with Libby, that "there is little or no change produced in the longest or medium wave lengths: red, orange and yellow are thus registered correctly by the eye. However, the color which has the shortest wave length, blue, is considerably bent in the course of its passage through the lens, so that its point of focus lies in front of the retina. The blue rays thus overlap the contours of the image upon the retina and form a sort of bluish blur or halo around it" (Lapicque 1959, 94). Logically it also follows, according to the laws of atmospheric perspective, that the blurred edges of the blue shapes will cause them to appear to be farther away than the more sharply focused red and yellow areas.

blue, which is closer to cyan and thus a near complement to red—has been used intermittently throughout the history of art as a successful advancing color. When a blue figure resides on a red background, the eye again tends to focus on the figure, causing the red background to blur and appear recessive, thus visually separating figure from ground.

Since the beginning of the Renaissance, the most usual color practice followed the tenets of the classic color theory.[26] But many artists before the sixteenth century practiced alternative color perspectives.[27] The most common of these alternatives employed color relationships that were in exact opposition to the classic color theory: blues in the foreground functioned to create salience, while reds were reserved for recession and backgrounds. A reversal of the classic color theory was accepted in the early fifteenth century and in other periods not dominated by classicism.[28] This method is particularly evident in medieval manuscripts (Lapicque 1959, 74–95). Gainsborough used such a reversal of the classic color theory in *Blue Boy* (I shall examine this subject in chapter 9).

The precepts of the classic color theory have been followed literally by many of the major artists since the fifteenth century, including Leonardo, Raphael, and Cézanne. Except for Gainsborough, few seem "to have deviated in any important or original way from the classical manner of using color in space" until the nineteenth century, when the impressionists began to make additional observations and started to use more warm color in the middle ground (Lapicque 1959, 86). Then Gauguin and the Fauves made radical departures from this dominant theory.

The unified system of Renaissance perspective staked a powerful claim on the viewer's attention, and those devices that function to augment the force of the illusion also contributed to compositional

26. Roman painters used a form of color perspective in their panoramic landscape paintings, Bunim notes: "A sense of depth is created by the vista and by the impressionistic technique—a gradual fading of the colors as they approach the horizon" (Bunim 1940, 34).

27. One of these alternative color perspectives created a space that is "flattened and yet infinite, perceptible though contradicting all our physical sensations. Space of this kind is suggested by the champlevé enamels of the twelfth to the fourteenth centuries, chiefly produced in Limoges" (Lapicque 1959, 83).

28. Artists such as "the sixteenth century tapestry weavers allowed themselves to use red in the distance only when they ignored the Renaissance system of perspective with its single vanishing point; whenever they adhered to that system, they renounced red in their backgrounds" (Lapicque 1959, 86–87).

unity (White 1967, 198). Subordinating all the objects, figures, and architecture to the same set of rules functioned as far more than a device for an effective imitation of nature (White 1967, 198). The geometrically logical relationship among the variety of objects in the pictured world increased both illusion and unity. Furthermore, the diminishing size of receding objects, in harmony with diminished contrast in value and hue as objects gradually vanished into depth, locked the elements of line, proportion, light, space, value, and color together into one image that seemed inseparable, objective, and unified. Such a unified pictorial space differed radically from that in Greco-Roman art, in which each separate image was understood to exist in its own private space without emotional or psychological relationships. In Greco-Roman art, space was what happened between solids, and it separated rather than unified objects.

However, painters would begin to unravel the thread and fibers that created the fabric of this new integrated, apparently inseparable, Renaissance image as early as the sixteenth century, for it was the sixteenth-century painters who first began to separate form from content (Barasch 1985, 164). This separation of form from content facilitated experiments with various permutations and combinations of perspective devices (Barasch 1985, 164).

5
The Renaissance

ALTHOUGH OBSERVATION and imitation of nature remained the primary concern of fifteenth-century art, formal elements were gradually beginning to assume more importance. Medieval painters had produced their work for the broadest possible public, but fifteenth-century painters aimed at a small, educated audience. Artists hoped these literate viewers would understand both the complex subject matter and the subtle ideas—disguised rather than paraded—and thus appreciate the formal elements in painting (Barasch 1985, 109–10).

Philosophy, as well as art, was changing in the new century. Through the efforts of Marsilio Ficino, a new approach to Neoplatonism evolved during the fifteenth century: Ficino and his friends strove to reconcile Platonism and Christianity. Panofsky notes that by the time of Ficino's death this new approach to Platonism had inundated all Europe and, with changes in content to fit the time and place, "remained a major force in Western culture for many centuries" (Panofsky 1965, 182). The new Platonic movement blurred or destroyed those boundaries—particularly between love and beauty—which had ordered and compartmentalized thought during the Middle Ages (Panofsky 1965, 182, 184). This destruction in the fifteenth century of the previous order of thought would permit its reconstruction by scientists during the seventeenth century.

Abolishing the dualistic borderlines between such concepts as the sacred and the profane gave secular art a sudden access to emotional vistas previously accessible only through religion (Panofsky 1965, 188). Thus, the creation of art could be equated with religious inspiration, and genius became linked with divine inspiration.

The Neoplatonist movement was instrumental in society's return to mathematics as its source of truth, and this new approach to mathematics began to change from geometric to algebraic (Burtt 1954, 43, 54). Consequently, painters became interested in a geometrically consistent and mathematically accurate placement of objects

and figures within a visual depth that seemed to be filled with visible atmosphere. This atmospheric quality was achieved by atmospheric perspective, which was capable of depicting consistent graduated increments of change. There emerged a "mathematically ordered 'systematic space,' infinite, homogeneous, and isotropic, making possible the advent of linear perspective" (Edgerton 1975, 161). As a result, the fifteenth-century artist could depict objects that seemed to be placed accurately in space at apparently measurable distances from each other.

There had been much debate during the thirteenth and fourteenth centuries about many of Aristotle's theories, particularly as to what constituted the ultimate boundary of the universe. The medieval assumption that the universe was finite was examined and questioned, but it would not be reversed until the seventeenth century, when mathematics merged with natural philosophy, and the ideas of Copernicus, Kepler, Descartes, and Newton were synthesized (Blatt 1984, 195).

As the new mathematics triggered the discovery of new secrets and realities in the fifteenth century, a new concept of space began to coalesce, Blatt points out—a concept of space that was itself not localized, rather than a space that defines an entity's location. Some philosophers and scientists even began to anticipate the notion that an infinite space might be the residence of the heavenly bodies, in contrast to the medieval concept of the universe as a finite object (Blatt 1984, 195). This new consciousness of space—infinite, but mathematically measurable and unified—began to be evident in Renaissance thinking about art, philosophy, and science.

Narrative innovations (such as the rendering of full-sized architecture and trees in proportion to the scale of man), combined with the expanded ability to depict facial expression, increased dramatic content and allowed the fifteenth-century "artist to render visible the psychological aspects that lodged quietly in the souls of those religious figures represented in the paintings" (Panofsky 1924–25, 18).[1] Such innovations were a direct result of the four new devices of perspective. In addition to facilitating the imitation of nature, the new spatial and compositional unity created by perspective bolstered religious, scientific, and philosophical ideologies.

1. Ivins comments that "This drama was full of action. Action implied relationships between human figures located in the same visual spaces and not in different ones" (Ivins 1946, 62).

During this period when the Renaissance system of perspective was developing, Gutenberg also invented a moveable type: the printing press. Edgerton maintins that "together these two ideas, the one visual, the other literary, provided perhaps the most outstanding scientific achievement of the fifteenth century: the revolution in mass communication." As a consequence, perspective drawings and paintings, through the influence of the printing press, came to depict a wider range of subject matter and to reach a larger audience than any other medium in the history of art. Because this combination of perspective and printing in the Renaissance made the development of modern science and technology possible, Edgerton reasons that linear perspective may have contributed even more to science than to the history of art (Edgerton 1975, 164).

Masaccio: The Shadow Catcher

Giotto's style swept through Florence during the last quarter of the fourteenth century, and Tommaso di Giovanni di Simone Guidi Masaccio (1401–1428) continued that general direction (Cole 1980, 109). Masaccio captured a three-dimensional illusion of reality more convincingly than had any earlier artist. Not only was he able to achieve a consistent illusion of volume, but he could also separate objects and figures with an atmospherically charged space in an unprecedented manner. Masaccio's figures stand in an almost visible atmosphere, and real light seems to fall on their tunics, as if actual daylight had permeated the painting.

Among the frescoes in the Brancacci Chapel are some of the earliest examples of architecture that is rendered proportionally accurate in its relationship to the figures; it depicts the streets and buildings of fifteenth-century Florence (Cole 1980, 167). Masaccio kept the heads of his figures at the height of the horizon line; as Alberti would note in his dissertation published about seven years later, this device makes the painted figures appear to be on the same level and standing on the same plane as the spectator.[2] Even the

2. Alberti states: "This [centric] point is properly placed when it is no higher from the base line of the quandrangle than the height of the man that I have to paint there. Thus the beholder and the painted things he sees will appear to be on the same plane" (Alberti 1966, 56). Spencer says, "This concept of observer and observed seeming to be on the same plane is most important for Alberti's aesthetic. By this means actual and represented space are seemingly one, and the observer's identification of himself with the painting is heightened" (from Alberti 1966, fn., 109–10).

robes that clothe Masaccio's figures are similar to those worn in the city at that time: the painted figures might have seemed to duplicate the fifteenth-century viewer's own image (Cole 1980, 167).

The viewer's sensation of close proximity to the apparent mass of the painted figures destroyed what was left of "the old iconic barrier between the viewer's world and the realm of the image" in the same manner that Donatello's earlier sculpture had (Cole 1980, 116). The bridge between painted image and real world was strengthened by Masaccio's choosing, like Donatello, to depict his figures in specific recognizable environments so the action appeared to take place in a world that was familiar to the viewer (Cole 1980, 142).[3] Masaccio thus glorified his city of Florence as a place of great religious miracles; the sacred dramas no longer occurred in some undefined locale but were now depicted in the same streets that the viewer might pass through on the way to the chapel (Cole 1980, 167).

Masaccio used the five elements of the illusion not only to strengthen the illusion but also to unify each painting compositionally and to relate one painting to another, as in the Brancacci Chapel. But more importantly, he exploited the illusion in order to fuse two worlds—the world depicted in paintings and the real world of the viewer—in such a way as to make the Bible stories, the saints, and the religious miracles become a living part of the viewer's world and life. Masaccio was able to use Renaissance perspective to unite the world of the painting with that of the spectator because the Renaissance system of creating an illusion was unusually consistent and persuasive, and it added credibility to whatever scene was depicted.

Taking a cue from Francastel, Norman Bryson in *Word and Image* contends that Renaissance perspective adds an *illusion* of truth to painted narrative because it synthesizes the *discursive* and the *figural*. In Bryson's view, the "discursive" facility in the mind, which "thinks in words," interacts with and influences the "figurative" facility, which participates in the "visual experience of painting" that is independent of words, "its 'being-as-image'" (Bryson 1981, 5–6).

Masaccio's *Tribute Money* (fig. 5.1) is mostly figural, rather than discursive, because it supplies the viewer with more visual information than is needed to understand its "narrative content": it offers more information than is verbally relevant. A large part of this irrelevant information, Bryson insists, is present because of the demands

3. It has also been assumed, but with no real proof, that the content of *Tribute Money* may have referred to the contemporary Florentine tax (Catasto) that was first imposed in 1427; but references to contemporary events are rare in the frescoes of Masaccio's contemporaries in Florence (Cole 1980, 136).

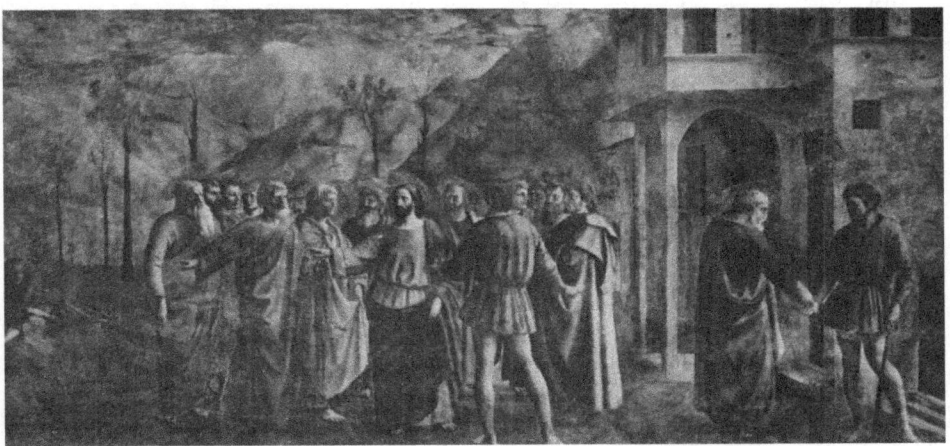

5.1. Masaccio. *The Tribute Money.* 1427. Fresco (width, 266 cm.). Brancacci Chapel, Florence. Photo: Alinari/Art Resource, New York.

of Renaissance perspective (Bryson 1981, 10–11). Renaissance perspective does not necessarily "reflect the real" with more accuracy than works without perspective. There are excellent realist painters, such as Van Eyck, who knew nothing about perspective.

But perspective strengthens realism because it greatly expands the neutral figural information beyond what is needed to support the discursive or the narrative. The artist is required to include in such paintings excess and irrelevant information, such as the "exact knowledge of where the apostles, Christ, and the soldier are located in space" (Bryson 1981, 12). Such knowledge is not necessary to the narrative and is required only because of the technique of Renaissance perspective. Thus, perspective insures that the painting will always include information that is not demanded by narrative (Bryson 1981, 12–13).

Perspective can also permit the painter to "hide" discursive meanings within the figural elements of the painting, "so that instead of a dangerous interval between the two, filled at once with suspicion, there is a smooth transition from the one into the other" (Bryson 1981, 14). In *Tribute Money*, the message conveyed by the difference between the kind of robe worn by the apostles and that of the soldier is more convincing discursively because these differences seem to have a spatial rationale irrelevant to the narrative aspect.

They appear to be discursively unmotivated and innocent, as opposed to the halo, which "lacks convincing spatial existence" and so appears to be there solely to create discursive fact (Bryson 1981, 14).

The subtle perception of *profane* and *sacred* oppositions that is created by the posture of the figures is even more narratively convincing because the viewer has to make an effort to find these subtle discursive nuances in the nondiscursive territory of the figural. The contrast between the insolence of the slouching, slant-shouldered soldier who is depicted in the "debased act" of taking money and the dignified vertical emphasis of the apostles' posture tends to highlight the difference between profane soldier and sacred apostle (Bryson 1981, 14). These meanings are not easily apparent, and when we work to discover them we tend to accept them as "fact" more easily than those obviously discursive elements like the halo that seems so obviously propagandistic. "Because the information concerning the spatial disposition of the bodies of the soldier and the apostles seemed so irrelevant and so innocent, when we discover that meanings are lurking even in this innocent territory, we are all the more inclined to believe those meanings—and to lose interest in the meanings that were so garishly articulated by the halo and the clothing" (Bryson 1981, 15).

These meanings seem so "immaculate" because they have been discovered in neutral territory within the "innocent, perspective-based spatial information": we find that "truth cannot reside in the obvious, the central, the stressed, but only in the hidden, the peripheral, the unemphasised" (Bryson 1981, 15, 19). Perspective persuades so efficiently because it fabricates a specific format for signification; it is persuasive, rather than true, and Bryson reminds us that none of the details that are furnished by a realist image need correspond to any actual event (Bryson 1981, 20). This credibility, or persuasive quality, that inheres in Renaissance perspective may be one more reason that the Church, as well as the young capitalist society in formation, found itself partial to such a technique.

Masaccio was more efficient and consistent in his ability to create an illusion of volume than Giotto had been. In *The Tribute Money* the figures and their extremities are unified by a crisp, well-defined, dark and light side. This unity is the result of using a single light source—the light always flows in the same direction. This single light source also generates cast shadows that amplify the illusion of volume, mass, and weight and help to unify the composition. The composition is further unified by the restricted color of the robes (Cole 1980, 163). Masaccio used restricted color as a structural aid in

depicting unified form and mass, rather than employing the more colorful "shot" pastels favored by so many of his contemporaries (Cole 1980, 143).[4]

John Shearman calls the early fifteenth-century practice of modeling the illusion of volume by variations in the saturation of the color of the object "saturation modeling." Even though this practice created a more realistic image than the earlier method of "absolute color," it was nevertheless responsible for delaying the higher realism that would be achieved during the High Renaissance after Leonardo introduced his method of modeling in what Shearman calls "Tonal Unity."

Most late fifteenth-century painting achieves an illusion of volume through the method of saturation modeling: an object of a specific color was shaded from light to dark by varying the intensity of the color, adding black to create shadow or white to create highlight (Shearman 1962, 14). This change from the medieval absolute color method to saturation modeling reflected an inversion of the medieval tendency to grant higher priority to purity of color than to illusionistic aspects.

In the center of the painting, Masaccio rendered the tax collector with strong dark and light sides to his tunic and his stockinged legs: the entire figure was executed in consistent volume. Masaccio was one of the first fresco painters since Giotto to shape "form exclusively through the use of light and dark" (Cole 1980, 157). He seemed to sculpt with light. Where his predecessors had used line to separate one form from another, Masaccio allowed his form to emerge out of shadow into the light (Cole 1980, 166).[5]

4. The term "shot" pastels refers to the practice of depicting highlights or shadows in a color other than the base color, instead of using lighter or darker values (tints or shades) of the same color by adding white or black. For instance, yellow, green, or even pink highlights might be used on a blue robe (Cole 1980, 11). What Cole calls "shot" color, Shearman refers to as "colour-change," noting that this method was used by painters such as Agnolo Gadi and Lorenzo Monaco as an alternative to the simple "saturation modeling" employed by Massaccio and other fifteenth-century painters. Shearman explains color-change as a variation of the local color between highlight and shadow. "Frequently colour-changes are no more than decorative, and there is no other logic in the selection of these pairs, but the tonal difference inherently present in the coupling of, say, yellow and blue, may be made to model form. Masolino, in the frescoes at Castiglione Olona, is typical of several Quattrocento artists who consistently select their colour-couples in this way, so that the tonal contrast of pigments alone provides an alternative to variations of saturation" (Shearman 1962, 14).

5. Many of Masaccio's frescoes have been disfigured in the repainting, when line was used to reinforce the silhouette of the figures (Cole 1980, 157).

Masaccio's single light source generates cast shadows on the ground plane beneath the figures, and these cast shadows help to define the ground plane as horizontal and receding (perpendicular to the figures), Bunim notes. These shadows also add to the illusion of mass and weight already suggested by the shaded illusion of volume in the figures (Bunim 1940, 27–28). Cast shadows are seldom seen in the work of other early fifteenth-century painters (Cole 1980, 138).

Masaccio was not only able to make each figure look round, he also made the entire group appear round. When thirteenth- and fourteenth-century painters learned to shade the appearance of volume, they succeeded in enclosing only the space that was displaced by the apparent volume of the painted object. But the space between Masaccio's figures seems to assert its own atmosphere. The large group in the middle of the painting appears to be circular and decidedly in front of the background. The illusion of recession is remarkable in spite of the fact that Masaccio purposely used the mountain in the background to limit the visual depth in order to preserve the visual solidity of the wall upon which it is painted (Cole 1980, 162).

The multiple parts and figures of Masaccio's circular crowd are unified by a consistent treatment of light, volume, and spatial placement. The unoccupied space between the figures is active, atmospheric, and palpable. Figures no longer look like flat cutouts pasted on the background in the manner of Cimabue or Giotto. Masaccio's paintings, when contrasted with those of his contemporaries, must have made the fifteenth-century viewer feel that the world had "grown a mightier race of men, who walk in their majestic certainty upon a freer, wider, and a firmer earth" (White 1967, 135).

This illusion of mass, spatial placement, depth, and atmosphere could now be depicted more convincingly than ever before, largely because of the use of atmospheric perspective.[6] On the right side of the main group in Masaccio's painting are three heads placed one in front of the other in much the same relationship as the three figures in Giotto's *Enrico Scrovegni Presenting a Model of the Arena Chapel* (fig. 3.1), discussed earlier. In Masaccio's painting, however, the three

6. De la Croix and Tansey state: "The foreground is united with the distance by aerial perspective, which employs the diminution in light and the blurring of outlines that come with distance. This device, used by Roman painters, was forgotten during the Middle Ages and rediscovered by Masaccio, apparently independently. Masaccio realized that light and air interposed between ourselves and what we see are part of the visual experience we call 'distance'" (de la Croix and Tansey 1986, 566).

heads appear to be separated by space. They seem to enclose a visible atmosphere between them. Masaccio was able to achieve this illusion primarily through the use of atmospheric perspective. Three important rules of atmospheric perspective are evident in the relationship of the three heads.

1. Volume appears salient and flat areas appear recessive; the forward head is volumetric, while the most distant head appears flatter and seems to recede into the distance.

2. Strong darks and lights appear salient, while values similar to the background are recessive. The salient head was painted with strong darks and lights in order to create volume, while the receding head was given less contrast of dark and light. The value of this receding head is similar to the value of the background.

3. Sharp edges and details appear salient, and blurred edges appear recessive. The near head is sharply focused in edge and detail, while the far head is relatively blurred and simplified in detail.

In this one small area of the painting, Masaccio has demonstrated the main tenets of the atmospheric perspective that strengthens the strong spiritual quality in his paintings. In contrast to the sharp focus on almost hard-edged material details in paintings executed by many of his contemporaries, Masaccio creates volume and space largely through atmospheric effects so that his paintings seem more of the spiritual than of the material world. This same quality is obvious in the atmospheric Roman *Odysseus in the Land of the Lestrygonians* (fig. 1.1), where "the pictorial space is all mist and dream, with solid bodies depicted as if dissolved in atmosphere. Here space seems to symbolize the world of the spirit rather than of matter" (Edgerton 1975, 158).

Masaccio demonstrates his mastery of linear perspective not only in the architectural rendering but also by the methodical diminishing in the size of objects as they recede. This too is demonstrated in the arrangement of the three heads in *The Tribute Money*: the second and third heads are progressively smaller than the first. One of the primary functions of the unified vanishing point in linear perspective is to guarantee geometric and mathematical consistency in the diminishing size of objects as they appear to recede into the distance.[7]

Masaccio was the first to use elaborate linear perspective in a fresco painting (Kubovy 1986, 17); he employed linear perspective

7. The vanishing point in linear perspective "alters all the measurements in breadth, depth, and height in a constant ratio and therefore for each object univocally determines its apparent size" (Panofsky 1924–25, 5).

in *The Holy Trinity* in Santa Maria Novella in Florence as early as 1427, ten years before Alberti's dissertation. Masaccio's one-point perspective and unified light source indicate his interest in the "scientific" aspects of his time as applied to painting (Cole 1980, 139). "This quest for scientific procedures for accurately representing nature from the perspective of an observer," Blatt comments, "was an integral part of the fifteenth-century philosophical emphasis upon the dignity of man and his capacities to understand nature" (Blatt 1984, 190).

Masaccio also observed the two most important principles of Renaissance color perspective: he placed cool, greyed color in the background and reserved the warmer, more saturate colors for the foreground. Masaccio exploited all five of the major devices of Renaissance perspective: unified light source, separation of planes, linear perspective, atmospheric perspective, and color perspective.

Masaccio synthesized these illusionistic innovations to function as a method of visual organization. Like Giotto, Masaccio arranged the dark and light sides of the figures and objects in all the paintings in the Brancacci Chapel so the light appears to originate from the same source. This unifying light appears to pour from the real window that admits daylight into the chapel (Cole 1980, 166). Not only does this device unify the illusion from one panel to the next, but it is also responsible for the sense of actual light that permeates the surface of Masaccio's frescoes and thereby facilitates the integration of his painted world with the world of the viewer.

Cole notes that these painted figures seem to be lighted—like Giotto's figures in the Arena Chapel—by the very daylight that allows the painting to be seen, and the very daylight that lights the viewer. Masaccio was not the first to use this device, but he achieved the effect more convincingly than had any artist before him. The figures and architecture "are rendered with realistic consistency, to the point that the solemn figures seem to breathe the same air as the spectator" (Cole 1980, 166).

In addition to unifying the lighting, Masaccio also unified the composition with linear perspective. The single viewpoint not only created a new spatial unity, weaving all the objects, figures, architecture, and scenery into one cohesive image, but it was also a powerful compositional device (White 1967, 137). Masaccio keyed all the vanishing points in every fresco in the chapel to the same viewing point in the middle of the chapel, thus firmly establishing a correct permanent position for the viewer (White 1967, 135).

The overall unification, especially the combination of unified vanishing points with a unified system of lighting, related each fresco in the chapel to every other fresco so the entire chapel functioned as a single cohesive body of work perceived as one unified image. When Masaccio splashed the light from the window in the real world across the architecture and the figures in his painted world, when he related the vanishing point to the viewer's position, and when he depicted contemporary local architecture and clothing, he allowed, for the first time, the viewer psychologically to enter this painted illusion and to abide in a world of religious miracles.

The most important function of perspective was to create a unified rational space: it was finally possible to organize elaborate group scenes in a spatially complex fashion (Kubovy 1986, 1). Masaccio consistently placed single human figures, or groups of human figures, so they occupied a major portion of the front of the stage within a shallow space. He then created an abrupt drop to the background, or "rear of the stage." This approach to spatial composition was an ideal anthropocentric solution for a society that still fancied itself the center of the universe.

In Masaccio's painting of the *Expulsion of Adam and Eve from Paradise* (fig. 5.2), the illusion of volume is consistent and believable. Masaccio rendered a dark and a light side to all four legs and both torsos. This shading is well executed in some places and rather clumsy in others. Adam's near leg is clumsily painted, if judged by later sixteenth-century standards (but it should be remembered that this painting was done in the difficult medium of fresco). The line between the dark and the light side is straight and rather abrupt, with little half-tone transition from dark to light.

Eve's forward leg is more convincingly painted. The transition from light to dark is more gradual, and the edge between the dark and the light side is mottled so it breaks up the rigid straightness of the dark edge in a painterly manner, more suggestive of the softness of flesh. To the painter's eye, however, the best technique in the painting is the area that includes Adam's stomach, rib cage, and back.

This area illustrates another important reversal of priorities: the importance of unity over detail, the subordination of detail to the mass.[8] On Adam's left side is a large dark section that extends from

8. Certainly this subordination of detail to the mass is one of the primary differences between Italian painting and the painting of the north. Northern painters caressed the detail at the expense of mass and unity.

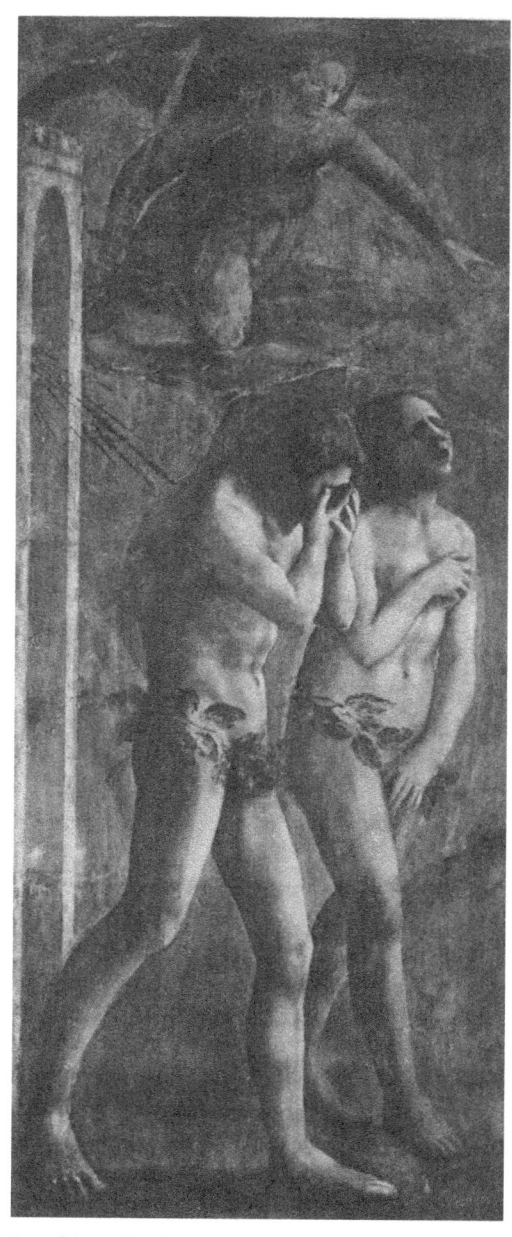

5.2. Masaccio. *Expulsion of Adam and Eve from Paradise*. 1427. Fresco (width, 89 cm.). Brancacci Chapel, Florence. Photo: Alinari/Art Resource, New York.

shoulder to heel. This major dark area creates an appearance of volume (or mass) in the figure, and it creates a "corner" so the right side of the figure appears to recede to the right. This section is larger and darker than the smaller, half-tone details on the rib cage.

In direct opposition to the manner in which we tend to see detail, Masaccio did not paint the small dark areas that delineate details as strong (dark) as the major dark areas that create the structural mass of the overall figure. In order to paint a convincing figure, one that seems unified in mass and volume, Masaccio simplified the shading and refrained from putting small dark spots of detail all over the figure. Small dark details tend to make paintings look spotty and unorganized—as if they had been arranged arbitrarily. During the Italian Renaissance, darks came to be tied together in major areas that covered an entire side of the body, as Masaccio has done in this painting. This new translation of the way we tend to see dark and light created an organization in which the structural dark masses were the largest and darkest part of the shading, while the details were smaller and lighter. Details were subordinated in both size and value to the structural masses.

Since the fifteenth century, every style of Western painting has been dependent, to one degree or another, on the ideas that came to sharp resolution in Masaccio's painting during the fifteenth century. These ideas bred other ideas and concepts. Michel Foucault speaks of a similar concept when he examines how we construct the idea of an author. He notes that an author (and, I would add, a painter) can create much more than a series of books or paintings; the author can generate a "theory, tradition, or discipline" that will spawn other books, authors, paintings, and painters (Foucault 1934, 113).[9] Masac-

9. Foucault's label for such authors (or painters), "transdiscursive," applies to a body of work that "contains characteristic signs, figures, relationships, and structures which could be reused by others" (Foucault 1984, 114). Thus, Giotto and Masaccio can be said to have begun a transdiscursive tradition of interest in illusion that dominated, in one construct or another, painterly discussion until the last half of the twentieth century.

But there is a second category of even more uncommon, subtle, and far-reaching influence than the "transdiscursive." Foucault refers to those who qualify for this second category, which first appears during the nineteenth century, as "founders of discursivity." They found a paradigm, a system of rules, a set of possibilities for the formation of other texts. "Freud is not just the author of *The Interpretation of Dreams or Jokes and Their Relation to the Unconscious;* Marx is not just the author of the *Communist manifesto* or *Das Kapital:* they both have established an endless possibility of discourse" (Foucault 1984, 114). Among nineteenth-century painters, such a category would

cio's paintings were a focus of breeder ideas from which other ideas and concepts radiated. Masaccio's discoveries "led to further experiments by his contemporaries and successors, who tended to specialize in one of the branches of pictorial science that Masaccio founded" (de la Croix and Tansey 1986, 567).

This new unity of perspectives, however, marked the death of other conventions and freedoms. Viewers quickly became accustomed to Masaccio's new sacred reality. But, though the Renaissance system of perspective created an illusion of volume and space and appeared to furnish an objective description of the real world, it was, nevertheless, not the way we actually see. The execution of this apparently "objective and mathematical" style of perspective was still dependent upon subjective priorities and interpretations. Perspective itself created yet another illusion: the illusion of objectivity.

seem to describe only Cézanne. His paradigm of the plane, rather than line and shade, as a schema for the representation of the world outside the painting was influential in the formation of images as diverse as those of Picasso, Hofmann, and de Kooning.

6

The High Renaissance

ART THEORY in the sixteenth century focused on "the intrinsic problems of art itself": the relationship between art and nature became a topic of only secondary significance (Barasch 1985, 164). Though art in the fifteenth century had been occupied with concerns outside itself—primarily its ability to imitate nature—this tendency was reversed in the early sixteenth century. When Renaissance artists had developed their perspective system to the point that they were able to represent a unified deep space, they were forced to recognize the proportion of man relative to the scale of architecture (Gablik 1977, 53). Space was then defined in terms of consistent proportions, which are the relationships among formal elements. The sixteenth century, with its concern for formal elements, accordingly "constitutes a bridge to the Modern period which is characterized by formal-operational thought" (Gablik 1977, 53).

The first use of the terms *formalist* and *formalism* in criticism grew out of Russian literary studies in 1916 (Williams 1976, 114). But painters began to demonstrate an occupation with formalist concerns at least as early as the sixteenth century: practice often precedes the birth of the word that describes it. When sixteenth-century painters separated and subordinated content to form, they initiated a process of separating and recombining, unraveling and reweaving, the elements of structure and form in order to create new structures and images.

Following a direction established during the High Renaissance, modern art would come to emphasize form as content to the exclusion of representation or mimesis. The relationship of painting to the piece of nature portrayed became no longer a topic of even secondary significance. This so-called "meta-art," which flourished in the twentieth century, had its origins in the sixteenth, and the story of how that happened begins here.

The Renaissance peaked early in the sixteenth century and the first two decades are called the High Renaissance. The careful scien-

tific observation and recording of nature was still important during this period in the fields of science, astronomy, mathematics, mechanics, and art, among others. Art began to be even more strongly influenced by science as artists delved into physics, optics, anatomy, botany, and mathematics (Blatt 1984, 225).

The important centers of society—religious, geographical, and theoretical—had started to shift dramatically in the sixteenth century. Religious upheavals had created a number of distinct religious centers in competition with Rome, which had previously been the unquestioned center of religion for more than a thousand years (Burtt 1954, 40). Vernacular languages in literature and nationalist tendencies in art further weakened Rome's dominance as the center of civilization (Burtt 1954, 40).

Once the globe had been circumnavigated and the Commercial Revolution had begun, man's previously known world seemed suddenly diminutive and puny. When the burghers of Nuremberg commissioned the first globe of the Earth in 1490, capitalism was fast becoming the dominant economic system as merchants became bankers and money itself became a "commodity to be bought and sold" (Calder 1979, 24, 14). The Florentines (from whom we get the word *florin*) were the financial giants of Europe (Calder 1970, 16).

We consistently underestimate the influence of bankers and the new industrial development on the course of the Renaissance: we tend to think only of the "flowering of scholarship and art" (Calder 1970, 14). A combination of capitalism and ecclesiastical worldliness had begun to undermine "blind faith," and it is hard to say whether the structure of the Church was changed more by the spiritual princes' sins of the flesh or the capitalistic princes' claims to religiosity (Calder, 1970, 18). The Church had "passed through a crisis that shook it to its foundations," a crisis caused by "the intrusion of too much money into the fabric of church government" (Ferguson 1969, 120).

The fifteenth century began with a stable world view. The prevailing Ptolemaic method of astronomy, dominated and supported by Aristotelian logic, could account for all the known celestial phenomena with as great an accuracy as the method that Nicolaus Copernicus (1473–1543) would invent (Burtt 1954, 36). In addition, the orthodox Aristotelian school held that nature "was fundamentally qualitative as well as quantitative; they believed the key to the highest knowledge must, therefore, be logic rather than mathematics" (Burtt 1954, 55). Furthermore, sensible thinkers are not prone to

abandon a time-tested theory of the universe in favor of another unless there are some demonstrable advantages (Burtt 1954, 36).

Given these three conditions, the fact that Nicolaus Copernicus and others were able to replace this Aristotelian geocentric conception of the universe with a new heliocentric model suggests there must have existed an alternative mode of thinking that was more sympathetic to mathematics. The synthesis of Christian theology with Greek philosophy in the early Middle Ages had taken a decidedly Platonic cast, then given ground to Aristotelianism. In the fifteenth and sixteenth centuries, however, as restless men probed for the secrets of nature—but before they made a definitive break with ancient traditions—Ficino and his followers accomplished "a revival of Platonism in Southern Europe" (Burtt 1954, 54).

The Pythagorean element was strong in Neoplatonism, and important thinkers in this school, holding that the universe was mathematical, liked to express their doctrines of emanation and evolution in terms of number theory (Burtt 1954, 53–54). Copernicus was a Neoplatonist, and the Neoplatonists of the fifteenth and sixteenth centuries were changing their geometric concept of mathematics to an algebraic one (Burtt 1954, 43). When these Neoplatonists began to investigate and find new "objective" solutions rather than accept the calcified assertions of scholastics, the new empirical spirit of observation and recording fostered the belief that "what can be traced to natural causes ought not to be ascribed to miracles" (Calder 1970, 19–20). Science emerged when the supernatural as a major causal factor was replaced by an active search for natural causes.

Copernicus's theory would have to wait for sixty years before it could be confirmed in a more empirical fashion by mathematicians such as Kepler, Galileo, Descartes, and Newton (Burtt 1954, 51). This direction would continue through the seventeenth century, culminating in a renewed search for the secrets of the universe that was both empirical and based in mathematics. True to the prevailing empirical method, Renaissance artists, relying heavily on mathematical proportions and formulae, observed the effects of perspective in the rendering of illusion and on aesthetic relationships.

Leonardo's Structure

Leonardo's work was more "painterly," in Wolfflin's meaning of the word, than any before him. His painterly technique strengthened the illusion of volume (relief) by intensifying contrast in focus

and blur. Because the soft, blurred edges disappear into the hazy background, the solid, rounded middle appears even more salient by contrast. "Linear," considered in contrast to "painterly," suggests the retention of a crisp silhouette. Linear figures are sharper edged and often contrast with the value of the ground. They often, but not always, appear flatter than painterly shapes (Wolfflin 1950, 18–54).

Wolfflin's purpose in establishing a relationship between the painterly and the linear is to point out that a lucid outline creates more clarity in the spatial separation and relation of objects. The crisp silhouette also demands that figures or forms be drawn in a position that renders them readily intelligible. But the usual objective in painterliness is an elusive quality of mystery as objects emerge out of shadow, in oppositon to the tangibility and clarity of linear art (Podro 1982, 118).

In the detail of Leonardo's *Virgin of the Rocks* (fig. 6.1), the right side is an excellent example of the painterly style. The large dark shape between the child and the red cloak is a shadowed area that covers part of at least three objects: the child, the angel, and the red cloak. Because the edges of these three objects are difficult to locate within the shadow, the silhouette is lost in these areas. This same painterly approach was used throughout the painting. While reading Leonardo's notebooks, Kenneth Clark was intrigued with the artist's observation of the visual effects of a figure in a dark doorway. "Very great charm of shadow and light is to be found in the faces of those who sit in the doors of dark houses. The eye of the spectator sees that part of the face which is in shadow lost in the darkness of the house and that part of the face which is lit draws its brilliancy from the splendour of the sky. From this intensification of light and shade the face gains greatly in relief . . . and in beauty" (Leonardo, from Clark 1963, 77). It is easy to see what influence this vision might have had on the development of a painterly image as well as the development of *sfumato*.

In addition to strengthening both composition and illusion, painterliness tends to emphasize structure over mimesis. Blatt maintains that when line and edge no longer coincided with the contour of objects, art began to break free of mimesis: "A shift occurred from the perceptual to the conceptual, from outer to inner form, from surface to underlying structure, and from concrete detail to abstract form" (Blatt 1984, 345). When Leonardo conceded a higher priority to painterliness than to linearity, he consequently reversed the priorities of other oppositional elements: structure was then

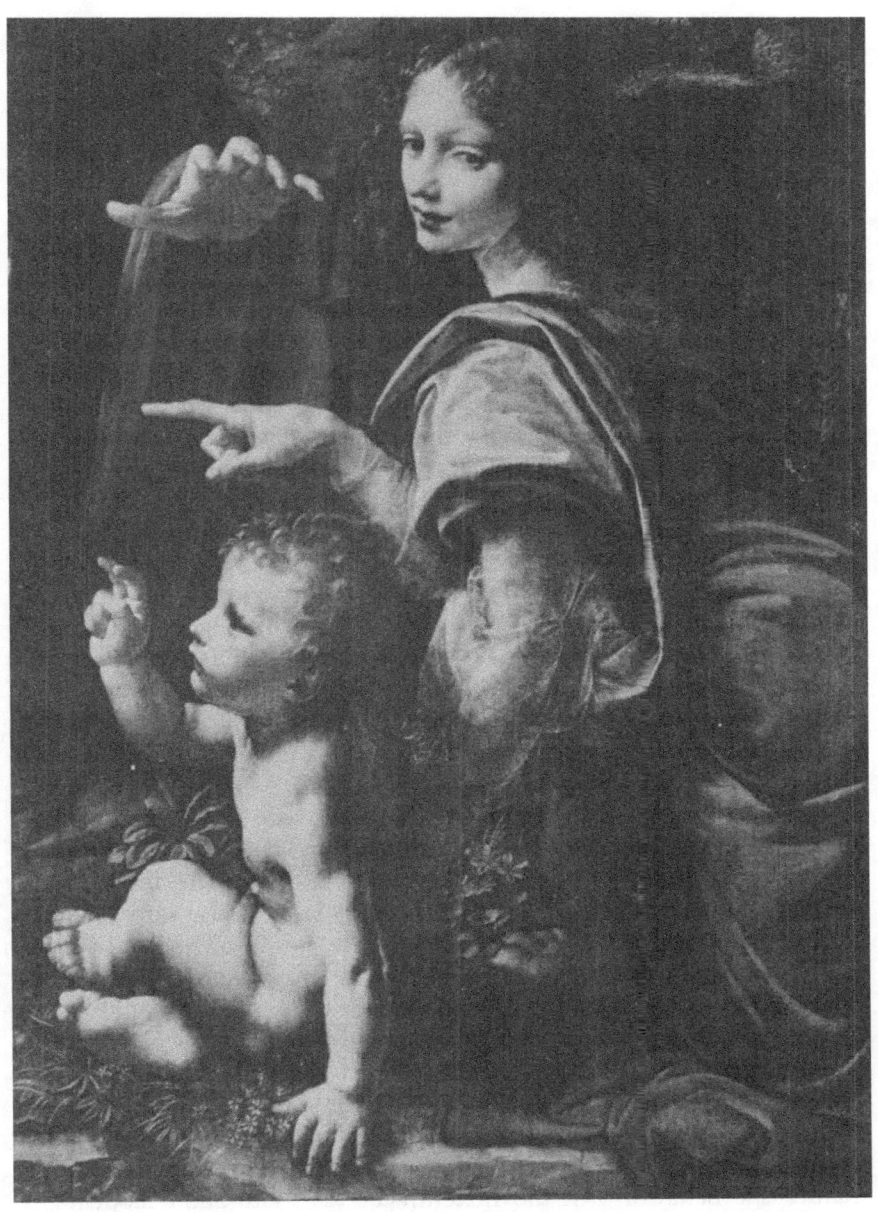

6.1. Leonardo da Vinci. *Virgin of the Rocks* (detail). 1483–1490. Oil on canvas, transferred from panel (198 cm. × 123 cm.). Louvre, Paris. Photo: Alinari/Art Resource, New York.

granted priority over mimesis, concept over perception, mystery over clarity, and abstract form over concrete detail. Leonardo's painterly approach guaranteed that such previously important aspects of "truth" as mimesis, clarity, and detail would suffer, at the same time that the newly privileged aspects of structure, concept, mystery, and abstract form were fortified.

Leonardo began to model form independently of color, and the color on objects maintained a common range of value: Shearman calls this method "tonal unity" (Shearman 1962, 18). Leonardo modeled the illusion of volume by adding black to the base color; he abandoned change in color as a method of creating the value adjustments necessary to create relief (Shearman 1962, 17). Leonardo's colors all appear to be modified by light in the same way, so that the continuity of unified volume is maintained "over each multi-coloured figure: every colour-plane achieves or can achieve, a uniform depth of shadow" (Shearman 1962, 17).

There is one important way that color, as Leonardo uses it, differs in its reaction to light from, for instance, the "saturation modeling" method as used by Masaccio. With Leonardo, colors of light value, like yellow, achieve full saturation in the highlights, while colors of inherently darker value, like blue, are lightened by white to form less saturate tints in the highlights and achieve full saturation only in the half-tones and full shadow (Shearman 1962, 17). Leonardo's tonal unity depends on the assumptions that "white and black are not real colours, but are the modifications of colours which indicate their lighting" and that "black/white structure is independent of the local colour on which it is superimposed; it is immaterial whether an object be blue or white if the lighting conditions are the same," because the highlight and the shadow will maintain the same values (Shearman 1962, 22). That is, the highlight in the blue area will be the same value as the highlight in the white area, and the shadow in white area will be as dark as the shadow in the blue.

Shearman points out that there are two major consequences to tonal unity: first, and more important, this method provides a more cohesive and unified control of plastic elements in spite of the disruptive effects of polychromy; second, this method relates light, color, and form in a manner that approximates "their scientific and naturalistic behavior." In the fifteenth-century "saturation modeling" method used by Masaccio, *light* was a function of *color*; relief was created by changes or variations in the intensity of color. For this

reason, Masaccio often maintained similar colors throughout his paintings, as in *Tribute Money*, in order to maintain unity. But Leonardo's *color* was a function of *light*: his color appeared and disappeared according to the lighting conditions, and it is governed by the fall of light upon it, not by the properties of the pigment. In other words, "the colour of the form is now, in the Albertian sense, one of its permanent qualities, rather than temporary or accidental ones" (Shearman 1962, 18). As a result, Leonardo could change from one color to another at will and still maintain visual and spatial unity.

Generally, Leonardo followed the conclusions of Albertian optical theory: because light reveals form and shade obscures it, true color is most saturate in light (Shearman 1962, 22–23). Color was summoned to visibility out of shadow by the action of light (Shearman 1962, 33). If color was most saturate in highlight, then it would follow that light-colored objects would have a greater range of value and therefore seem more volumetric than dark objects; accordingly, most dark objects were painted to appear flat (Shearman 1962, 23). This depicting of more detail and volume in the lights is sometimes called "crowding the lights."

Leonardo achieved strong new illusions of volume by means of a unified dark and light side modified by the principles of atmospheric perspective. The darks grow darker as they come forward, in keeping with the precepts of atmospheric perspective. In this method of shading objects to appear round, there is a visiable "core" shadow—that part of the shadow that is darkest—toward the most salient point of the figure or object depicted, just before the dark side meets the light side (Kaminsky 1949, 13–16).

In *Lady with an Ermine* (fig. 6.2), the influence of atmospheric perspective on the shading of volume is easy to see. The darks are obviously darker in the woman's hand and wrist and the head of the ermine, both of which are the most salient areas in the painting. Even the dark side of the woman's head becomes darker in the core shadow as it advances toward the checkbone.

Leonardo's paintings are sometimes so illusionistic that they fool the eye into believing there is actually a physical projection in relief from the surface of the painting. Ironically, Leonardo, the artist who invented composition in dark and light, believed relief was the most important goal of the artist: Wolfflin cites Leonardo's written statement that "relief is the principal aim and soul of painting" (Wolfflin 1952, 23). The most efficient method for achieving this appearance

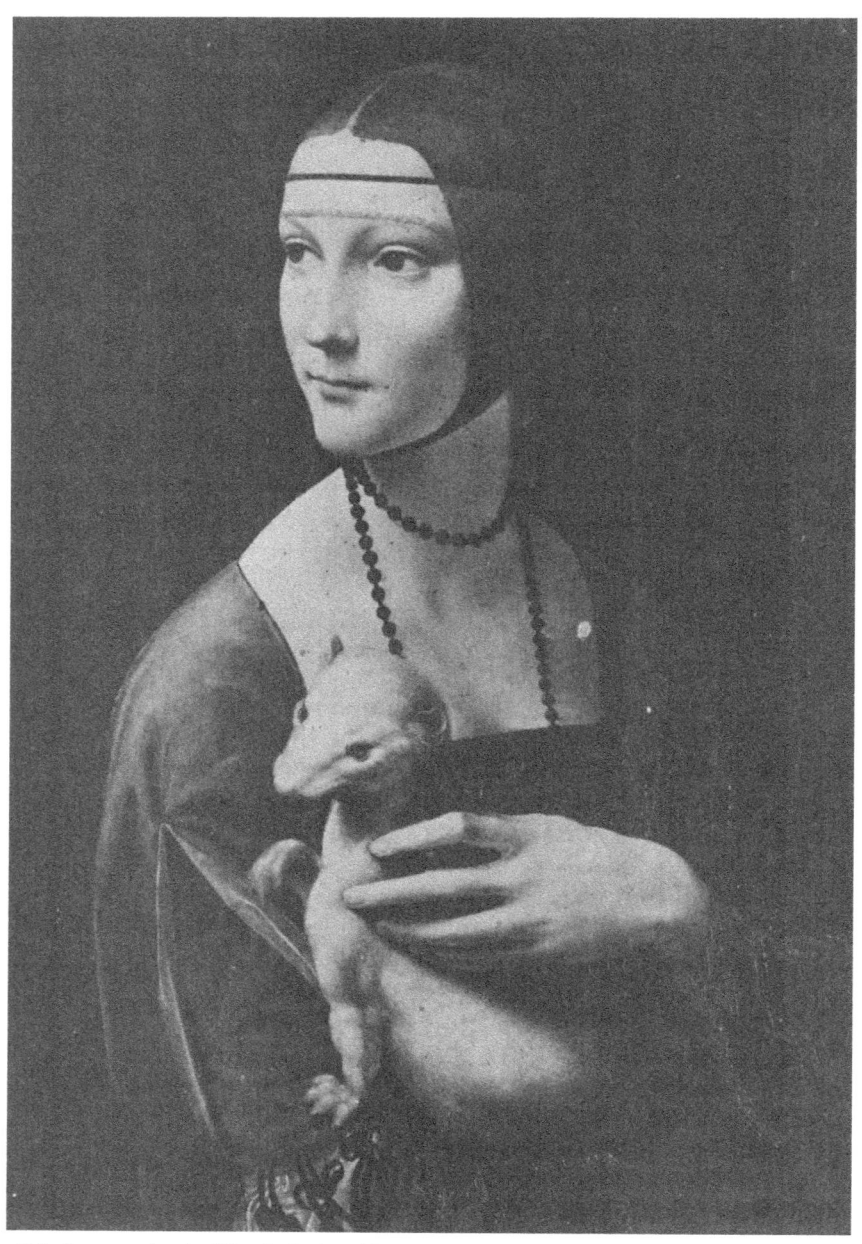

6.2. Leonardo da Vinci. *Lady with an Ermine.* c. 1483. Panel (55 cm. × 40.4 cm.). Museum Czartoyski, Cracow. Photo: Alinari/Art Resource, New York.

of mass and relief utilizes a unified light source and the principles of atmospheric perspective. But a major weakness automatically inheres in this method of shading: it tends to make human flesh look as if it were carved of colored stone; figures look like colored sculpture, not flesh.

Like all artists, Leonardo faced one of the eternal problems plaguing the painter—or the philosopher: he was constantly forced to choose between one of two desirable, but dichotomous, oppositions such as volume or softness, mass or luminosity, painterliness or linearity, and strong color or shading.[1] Thus, when Leonardo chose a method of shading that involved a unified light source modified by atmospheric perspective, he insured that some aspects of the reality of the figure he wished to present would be contradicted: the figure would appear to be hard, like colored sculpture. Had he chosen a more diffused light source, however, the figure might have appeared softer and more fleshy, but it would have lacked the strong volumetric relief that Leonardo sought.

Painters during the High Renaissance continued to use ostensibly the same anthropocentric formula for spatial composition as their fifteenth-century predecessors. In paintings from both centuries, large figures occupy most of the foreground and enclose shallow sculptural space. This sculptural space is often contrasted to a rapid and direct visual recession into deep background. Leonardo's concept of the dark doorway created a variation on this formula for spatial composition: a dark background with no apparent finite depth allows light figures to emerge from receding shadows.

But Leonardo wanted to do more with darks and lights than just create volume, so he began to restructure the darks and lights in his painting. He began to think about using darks and lights to create volume and, simultaneously, to structure the composition. As he had to use these darks and lights in every painting in order to create an illusion of volume, perhaps he thought it would be useful if these darks could serve double duty. Leonardo's painterly approach, inspired by his dark doorway, opened the way for him to begin re-

1. Ernst Gombrich, who nurtured the use of perceptionist theory in art criticism, corroborated the idea that the painter must choose between such elements as color and light. "Why should not the painter be able to imitate the colors of any object if the maker of wax images manages this trick so remarkably well? He certainly can, if he is willing to sacrifice that aspect of the visible world that is likely to interest him most, the aspect of light?" (Gombrich 1961, 37–38).

weaving the volume-producing darks and lights into a new compositional image.[2]

Composition is the technique of making a painting appear to be visually organized. If a handful of toothpicks is thrown on the floor, they will not appear organized; the arrangement will look haphazard and accidental. If, however, these toothpicks are arranged in any simple pattern, they begin to look organized. The toothpicks may be arranged in squares, radials, circles, or triangles—any simple or geometric shape or repeated series of shapes.

The dark-light composition in the detail of *Virgin of the Rocks* makes use of a series of light oval shapes on a dark ground. Leonardo echoed the oval shapes by further arranging them in simple overlapping and interlocking ovals: Mary's elbow is an oval; the cowl forms an oval around her arm; and the wrinkles in the red cape are arranged in a series of ovals. The child's arm, and Mary's cape, and her elbow, each form an oval. Another large oval is formed by the arrangement of Mary's cape, head, and hand, and the feet and two hands of the child. In short, it is easy to find oval shapes and arrangements throughout the painting. Arranging the light shapes in simple geometric shapes on a dark background was the first and simplest method used to compose in dark and light.[3]

Leonardo had been trained in perspective by his master, Verrocchio, who in turn had been trained by Uccello (Calder 1970, 57). Thus, it is not surprising to find linear perspective executed to near perfection in Leonardo's *Last Supper* (fig. 6.3). This painting, "one of the earliest examples of a fully integrated perspective with a common vanishing point for both the figures and the background" (Blatt 1984, 225), also illustrates another method of composition in dark and light. Leonardo organized this painting so the top left half is dark and the bottom right half is light. The light windows break into

2. Wolfflin explains that the painterly style, organized in terms of dark-light composition, "works with broad, vague masses, the contours barely indicated; the lines are tentative and repetitive strokes, or do not exist at all. In this style, not only individual figures but the entire composition are made up of areas of light and dark; a single tone serves to hold together whole groups of objects and contrast them with other groups" (Panofsky 1965, 30–31).

3. De la Croix and Tansey explain that what we see in Leonardo's paintings "is the result of the moving together and interpenetration of lights and darks. 'Drawn' representations, consisting of contours and edges, can be beautiful, but they are really not true to the optical facts. Moreover, a painting must embody not only physical chiaroscuro but the lights and darks of human psychology as well" (de la Croix and Tansey 1986, 601).

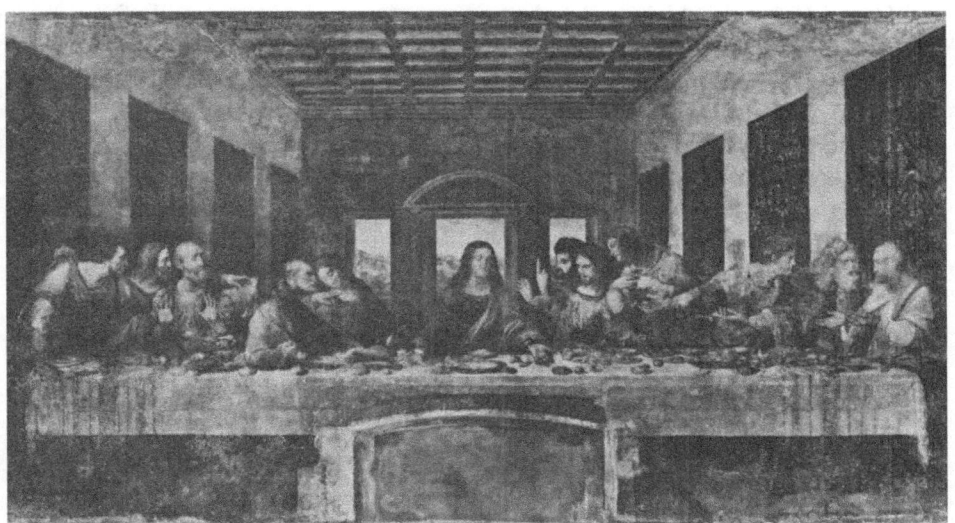

6.3. Leonardo da Vinci. *Last Supper.* c. 1495–1497/8. Oil, tempera wall painting (420 cm. × 910 cm.). Refectory, Santa Maria della Grazie, Milan. Photo: Alinari/Art Resource, New York.

the dark area, and the dark openings in the wall on the right break into the light side. The figures, which read as alternating dark and light stripes and spots, allow darks to extend down into the light area and interlock with those light areas that extend up into the dark. Organizing a painting in two halves, one dark and one light, and then letting the darks break into the lights, and vice versa, is one of the better methods of composing in dark and light. This construct weaves the composition into a cohesive whole in which all the parts, space, volume, and composition, interrelate.

Leonardo's use of the painterly technique, coupled with his invention of sfumato and "tonal unity," led him to initiate a powerful new structural composition achieved by organizing areas of dark and light, rather than patterns of color. This innovation may have been the most important structural idea in the history of Western Art.[4]

4. Leonardo's compositional innovation was such a powerful influence in the art world of the sixteenth century, even in sculpture, that it, along with the aesthetic concept of purism in the use of materials, was most likely the impetus for the death of polychromed sculpture. Michelangelo's awareness of the older Leonardo's method of composing in dark and light may have led him to achromatic sculpture quite

Composition in dark and light came to be synonymous with form and structure. Color, which was no longer considered necessary to composition, came to be considered decorative by the seventeenth century. Ingres, in the nineteenth century, expressed the sentiment of the Classicist concisely with his often quoted remark that "a thing well enough drawn is well enough painted." I shall later demonstrate that the dichotomy between value-structure and color-structure is one of the most influential oppositions in the changing image of painting.

Painters who experiment with composition must choose among many options. They can organize their paintings with dark and light, or they may choose any of several other dualistic elements, such as warm and cool color, thick and thin paint, or transparent and opaque surfaces. They may even try to combine two or more of these methods. But the increasing use of oil paint, along with Leonardo's dark-light composition, made it easy to combine, into a cohesive, interlocking whole, four oppositional fibers or elements: dark and light, warm and cool, thick and thin, and opaque and transparent. These four oppositional elements fused in four congruent, interlocking axes of composition.

This structure, which I will refer to as *compositional congruency* or *congruent composition*, was used extensively, though not exclusively, from the sixteenth to the nineteenth century. Then Monet and Cézanne, among others, once again separated these same four pairs of elements to create yet another organizational system.[5] But this linked

early. Michelangelo began to carve his sculture in a more painterly manner, creating large areas of light penetrated by dark compositional areas, and his powerful influence established dark-light composition as the reigning structure in sculpture as well as in painting. Wolfflin insists that "Michelangelo broke away from colour effects from the very beginning, and as a result everyone else forthwith began working in monochrome. . . . I cannot endorse the judgement, often repeated, that modern lack of colour in sculpture is due to the ambition to imitate antique statues. The rejection of colour was determined upon before any archaeological purist could have thought of this idea. . . . The Renaissance saw the antique as coloured as long as it used colour itself and in all cases where antique monuments were introduced into pictures they were treated as polychromatic; from the moment when the desire for colour ceased, the antique was seen as white, but it is wrong to say that it gave the initial impulse" (Wolfflin 1952, 242).

5. Faber Birren refers to this interlocking of compositions as "chiaroscuro modeling" (Birren 1965). But I don't feel comfortable with that term used that way because he is the only writer who so uses it and it tends to be confused with tenebrism or the use of a dark and light side to create the illusion of volume.

pairing of opposites is still used by many artists in the twentieth century; it is so natural to the medium of oil painting that it often comes automatically to advanced painters, who may well practice it without being aware of it.

In Leonardo's paintings, the areas of light value are not just warm; examining the original paintings makes it obvious that they are also thicker and more opaque. The dark areas are cooler, thinner, and more transparent. That is the definition of *compositional congruency*: the light areas are warmer, thicker, and more opaque, while the dark areas are cool, thin, and often more transparent.[6]

This congruent structure has two distinct advantages: it simplifies the compositional task, and it strengthens the illusion. First, it unites four major methods of lateral composition so the possible combinations remain simple—four interacting variables are difficult for the conscious mind to track. This structure consolidates the four variables and keeps the light-dark composition congruent to the warm-cool, the thick-thin, and the opaque-transparent composition. If a diagram of the four separate compositions were traced on four separate sheets of tracing paper, the four separate diagrams would prove to be identical.

Second, such a structure strengthens the illusion of depth and volume. All four major structural elements work in concert to reinforce the illusion of depth and volume. Atmospheric and color perspective dictate that if the background is dark, light areas will appear to be salient; if the background is cool, warm areas will appear to be salient. It is also evident that many painters know that opaque areas appear solid and near, while transparent areas appear atmospheric, spatial, and distant; and thus areas of thick paint appear to advance while thinly painted areas appear to recede. If—because all four pairs of elements were widely used to accentuate depth, space, and solidity—we consider each of these four structures to be part of the Renaissance system of perspective, then it might also be legitimate to

6. According to John Shearman, "In the earlier quasi-Absolute colour-system a colour-composition automatically created a tone-composition [in dark and light], and the two were indivisible: the tonal [or dark-light] composition was the product of colour and line. After the Leonardesque evolution tonal position was the product of light, form, and space, so that colour, now independent, was free to surge dynamically over the picture surface, as in the *Last Supper*" (Shearman 1962, 38). Though such a possibility became possible, according to Shearman, with Leonardo's method of tonal unity, it is obvious that few painters separated warm-cool composition from dark-light composition with any regularity or purpose until the late nineteenth century.

think of this structure as yet another permutation of the elements of one organized system (Renaissance perspective) in order to generate another related organized system (congruent composition).

Another innovation of Leonardo's, the technique of *sfumato*, the smoky contour, assisted the invention of painterliness, facilitated the invention of dark-light composition, and was responsible for the soft focus and graceful look of his paintings. This technique of glazing, scumbling, and burnishing of the paint surface, in order to create the soft, blurred, sensuous surface quality that Leonardo was known for, may be one of the most underrated creative acts in history.

Sfumato causes a depicted scene to appear to be seen through a thin smoke screen that diminishes glare and obscures edges. Barasch observes that "the small sizes and forms are no longer strictly definable and calculable. The invention of sfumato suggests the beginning of a new period in aesthetic appreciation and art theory" (Barasch 1985, 159). By using sfumato, Leonardo was able to de-emphasize line and edge in an even more efficient and painterly manner than Masaccio. Leonardo painted the backgrounds and the cast shadows in the same value range to invest the figure in a painterly, three-dimensional, atmospheric medium of a "new spatial system" (Shearman 1962, 19–20).

Sfumato increased the illusion of volume at the same time as it allowed figures to emerge into light out of Leonardo's dark doorway, because it softened the receding edges and facilitated value transitions. The softness and gradual transitions of sfumato also facilitated the painterly loss of silhouette. Frank Stella contends that the atmospheric softening of Leonardo's sfumato created a magical sculptural impression: "The result is a pictorial 'rounding' of space that paves the way for Caravaggio and becomes, at the same time, part of our basic spatial vocabulary for judging great painting" (Stella 1986, 6). Sfumato facilitated painterliness, composition in dark and light, and what Leonardo called the atmospheric "perspective of disappearance."

Leonardo concentrated his full attention and innovative power on form and structure in painting. More than anyone else, Leonardo was responsible for making form the major content of painting. This concept that form and structure were more important than mimesis—the imitation of nature—would gradually grow in importance, to influence Caravaggio in the seventeenth century, then to dominate art theory and practice for more than four hundred years.

7
Compositional Climax

PAINTERS DURING THE FIFTEENTH AND SIXTEENTH CENTURIES unraveled and rewove elements of the Renaissance illusion to create yet another structure, "compositional climax." These painters arranged their works so as to create a transition from less visual incident, or activity, towards the edges, to a climax of incident somewhere near the middle of the painting. Sometimes these painters created a major and a minor area of increased activity—primary and secondary climax. The climax tends to relate each separate part of a painting to all the other parts and thus to subordinate the importance of individual shapes and detail to the overall image as a whole. Sacrificing the images *in* the painting to the image *of* the painting will assume more importance in the eighteenth century.

Many painters since the Renaissance have structured their paintings with these six different methods of climax. Dark-light composition in tandem with various combinations of these six methods of climax was the primary method of organizing paintings from the Renaissance to the middle of the twentieth century, until Jackson Pollock invented the "all-over" style to offer an alternative to compositional climax. Nonetheless, it is difficult to understand fully the impact of Pollock's image without a knowledge of compositional climax.

These six methods of climax as used by a sixteenth-century artist, Raphael, can be understood by comparing them with the technique of a twentieth-century artist, Mauricio Lasansky. Raphael (Raffaello Santi, or Sanzio, 1483–1520) was born thirty-one years after Leonardo, though they died within a year of each other. I have chosen a portrait by Raphael, the *Portrait of Angelo Doni* (fig. 7.1), in order to demonstrate that the figure tends to assume automatically such an arrangement. Mauricio Lasansky, in the *Nazi Drawings* series, of which I have chosen #21 (fig. 7.2), not only demonstrates the mastery of five of the six methods of compositional climax but uses

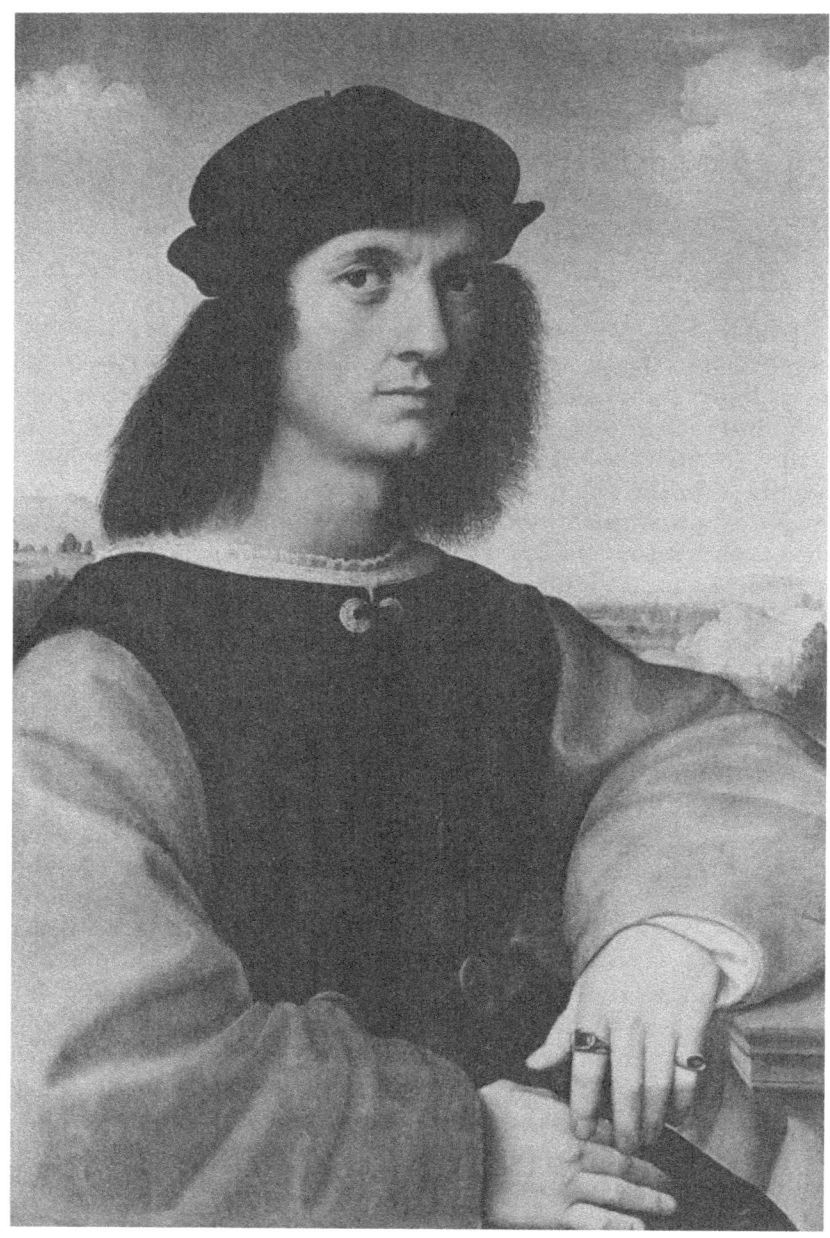

7.1. Raphael. *Portrait of Angelo Doni.* c. 1506. Oil on panel (24³/₄″ × 17³/₄″). Pitti Gallery, Florence. Photo: Alinari/Art Resource, New York.

7.2. Mauricio Lasansky. Drawing #21 from *The Nazi Series*. Series executed 1961–1966. Drawing, lead pencil, red earth color is water base, brown is turpentine base (76" × 35"). Collection of Mark A. Levitt. Philadelphia Museum of Art.

86 *Changing Images of Pictorial Space*

them consistently, and in combination, to generate a powerful image. (In chapter 16 I shall demonstrate that Franz Kline uses this same structure in nonrepresentational painting.)

Climax by transition from *large to small shape* is a device that has been used often since the Renaissance. The painting is composed with larger shapes toward the outside of the canvas; these shapes gradually diminish in size until there is a climax of detail. Often, particularly in portraits, this climax is realized in the details of the face—nose, lips, and eyes—with the small shapes of the hands and fingers as secondary climax.

Raphael has used just such a typical formula in *Portrait of Angelo Doni*. Starting at the top perimeter, with the large shape of the sky as a background, he created a transition in one direction from the sky to the large, dark shape of the hat and hair, and then to the head, which is divided into the smaller shapes of the eyes, nose, and mouth. Raphael established a secondary climax through a transition from the sky, to the landscape, to the arms, the hand, then the fingers. In landscapes or exteriors where diminishing size is used to define space, these smaller shapes are often depicted in the distance because they coincide with the diminishing size that is created by linear perspective.

In Lasansky's drawing of the stretched human hide, the shapes start as large ones in the middle and at the edges and move to the smaller ones of the arms, then the fingers, then the teeth. This transition from larger shapes to detail is a common method of climax in drawing and painting.

Climax by transition from *flat to volume* requires that the flat shapes at the perimeter of the painting change to semi-flat as they move into the painting, then partial volume, and finally full volume at the climax. Again, there may be a primary and secondary climax, and transitions of volume usually coincide with transitions from large to small shapes. The large shapes are flat and smaller shapes are progressively more volumetric, but the better artists know when to vary from any standard formula.

In Raphael's portrait, the sky is painted as mostly flat, the hair and hat are semi-flat, the head is shaded in semi-volume, while the details of the eyes, nose and mouth—by virtue of the use of stronger darks and lights—are in strong volume. The semi-flat landscape is a transition between the flat sky and the semi-volume of the sleeves and upper part of the hand, then the volume of the fingers.

In the Lasansky drawing the shapes in the middle and at the perimeters are flat. The arms are drawn in semi-volume as a transi-

tion between flat areas and the volumetric detail of the fingers and teeth.

Climax in *dark and light* suggests that smaller shapes and details in the climax, which are drawn in more volume, should use stronger darks and lights in order to create this volume. The larger, flatter shapes tend to use less contrast in value. How the contrast is used varies, as the smaller shapes may be either lighter or darker than their background. The method differs with the context of the atmospheric perspective used.

Raphael used little contrast in value in the flatter sky and clouds because they are in the distance; slightly more in the hair and hat; then strong contrast in the salient volumetric details of the face. The value contrast also increases in each step from the distant sky to the tips of the fingers.

In the Lasansky drawing, stronger darks and lights are grouped in the details of fingers and teeth, with another strong dark in the secondary climax of the dark patch at the crotch.

Climax in *focus and blur* is accomplished when the larger shapes towards the perimeter, which appear to recede, are blurred while smaller details in the climax are sharper and more focused. Because dark-light climax combines with focus and blur to create a climax in atmospheric perspective, climax is often reserved for foregrounds.

Raphael's distant sky and clouds are soft and blurred, the hair and hat are slightly focused, and the facial details are sharply focused. A similar transition is obvious from the sky to the sharp focus of the fingers and rings.

In Lasansky's drawing, large receding shapes in the background are blurred and the salient shapes are more focused as they get smaller. The most focused areas are in the fingers and teeth, which are the smallest and most salient details.

Warm and Cool climax is often related to the classic color theory but may be reversed. In the classic color theory, the large, flat, background shapes tend to be cool. Smaller volumetric details, usually salient, are warm. This technique will work just as effectively if it is reversed.

The sky in Raphael's painting is cool blue. The hat and hair are warmer and dark, and the face is warmer still. The one minor change in standard climax that Raphael grants in this painting is that the sleeves are a warmer, more intense color than the secondary climax of the hands and fingers.

Because the Lasansky drawing has no color, the contrast of warm and cool is not demonstrated here.

Climax in *depth*, or climax of salient and recessive areas, would suggest that paintings should be arranged so the larger, flatter, background shapes remain in the distance, leaving the climax for the foreground. However, this arrangement can be reversed, particularly in landscapes and exterior scenes.

Raphael's nearly flat sky and clouds, which join the landscape, lead us rapidly—in the Renaissance manner—to the salient figure.

In Lasansky's drawing there is also a climax in depth: the hands and teeth are more salient than the larger, greyer, more blurred shapes. Here too, we can see how natural it is to weave major compositional elements into one piece; thus synchronized, they create a strong consistent climax of image and method. Lasansky uses these compositional devices as a structural formula so he can be free to concentrate on image.

The reason these types of climax work so naturally together is that they are all derived from the basic elements of the Renaissance illusion—shading, linear perspective, atmospheric perspective, or color perspective—and these elements work in concert to create their own image and balance. Each of these elements has, at times, been ignored or reversed in order to change the structure and the image of compositional climax. Nonetheless, the structure is a cause and a part of the powerful image, just as it also imposes limitations upon the image.

Later I shall demonstrate that, when twentieth-century artists came to value abstraction over mimesis, they rejected volume, shading, and linear perspective. This reversal of priorities led Jackson Pollock to find an alternative to compositional climax, because these specific, rejected, elements of volume and perspective were part of the main structure of compositional climax. In short, there is no single, correct, manner in which such elements should be interlocked. The elements in such structures may be recombined and restructured in many different combinations to create entirely new images.

8
The Baroque Age

THE SEVENTEENTH CENTURY, it can be argued, marked the true end of the Middle Ages. Certainly the medieval workshop tradition had continued through the sixteenth century, and Renaissance perspective can easily be interpreted as an extension of the medieval interest in optics as a unifying article of the Faith. As Edgerton suggests, "the paradigm of the Middle Ages did not really end until the acceptance of the heliocentric universe discovered by Copernicus and Galileo. The paradigm of the Renaissance, in turn, ended finally with Einstein's special theory of relativity" (Edgerton 1975, 152).

Copernicus published his *De Revolutionibus Orbium Coelestium* in 1543 and demonstrated that our solar system revolved around the sun, not the earth. For sixty years after Copernicus, no one was bold enough to champion his theory save a few eminent mathematicians (Burtt 1954, 56). But his theory, though it met with initial opposition, had been widely accepted by the seventeenth century and was instrumental in launching a new concept of the universe in which man was no longer viewed as its center, or in the center. The mathematician Johannes Kepler (1571–1630) served as the transition between Copernicus, the first great modern astronomer, and Galileo, the second (Burtt 1954, 56). Though earlier philosophers had held that knowledge was ultimately mathematical, Kepler insisted on applying theory to observed facts: his method "was genuinely empirical in the modern sense of the term" (Burtt 1954, 61).

Kepler, a Neoplatonist, held that quantity is the fundamental feature of things (Burtt 1954, 68). Aristotelianism had dominated thinking from the late Middle Ages until the sixteenth century because it made intelligible the world of commonsense experience. But Kepler realized that Copernicus's cosmology was radically different and would be better supported by Ficino's recently revived Neoplatonism than by the prevailing Aristotelianism (Burtt 1954, 70). Kepler was also influential on the development of attitudes about illusion. Alpers tells us that in the statement that sight is like a pic-

ture ("ut pictura, ita visio") Kepler was "the first person ever to employ the term *pictura* in discussing the inverted retinal image." Furthermore, this is the first time that the eye was spoken of as an instrument that focuses an image—a real picture—on the surface of the retina. When he defined the eye "as a mechanical maker of pictures" in such a way that "to see" was "to picture," he provided a model of nature and art that worked a profound influence on painters, particularly northern ones (Alpers 1983, 36).

Kepler's contemporary, Galileo (1564–1642), also believed that mathematics was the key to divine knowledge. He held that the only difference between God's knowledge and our discovered mathematical truth was that "his is complete, ours partial; his immediate, ours discursive" (Burtt 1954, 82). Because Galileo believed the book of the universe was written in the language of mathematics, he used mathematical demonstrations rather than scholastic logic to unlock the secrets of the world (Burtt 1954, 75). Galileo's mathematical demonstrations and proofs concerning such things as the uniform acceleration of falling bodies, the phases of Venus, and the spots on the sun's face convinced his Aristotelian contemporaries that some of Aristotle's statements were false (Burtt 1984, 78).

While those who practiced the scholastic and Aristotelian qualitative method in physics had exhibited little interest in the dimensions of space and time, Galileo not only discovered that space and time could be formulated mathematically (Burtt 1984, 93, 96)[1] but, indeed, made them his fundamental categories. Galileo portrayed the universe as a mathematical machine consisting of the movement of matter in time and space, and a metaphysical theatre in which man was now considered just "an unimportant spectator and semi-real effect of the great mathematical drama outside" (Burtt 1954, 104).

René Descartes (1596–1650) was important to this new mathematical movement in three ways: he posited a logical new theory of existence and "self"; he worked out a detailed hypothesis of the mathematical structure of the material universe; and, with his invention of analytical geometry, he established the first direct relationship between numbers (arithmetic and algebra) and geometry (space) (Burtt 1954, 105–6).

1. Perhaps two centuries of seeing and accepting the world, and its space, represented in painting by means of the mathematical precision of the Renaissance system of perspective had some bearing on the seventeenth century's readiness to accept mathematics as an important key to reality.

Descartes's "self" has an inalienable nature involving *consciousness* (awareness, feeling, and volition), *extension* (the displacement of, or potential mobility in, space), or both. Descartes argued convincingly that extension was the sole physical attribute of being; following his argument, the baroque period developed an obsession with space and it became the new philosophical frontier of the universe (de la Croix and Tansey 1986, 710).

Descartes established a mechanical model of the universe that was fundamentally different from that of the Platonic or Aristotelian Christian view. His model allowed the hand of God only at the beginning: that is, God was viewed as the prime mover (Burtt 1954, 113). Descartes had set the stage for Boyle, Locke, and Leibniz to liken the universe to a giant clock, wound by God and kept in motion by nothing more than his "general concourse" (Burtt 1954, 113).

Paul De Man, Derrida's foremost American supporter, contends that the relationship between philosophy and mathematics was particularly close in the seventeenth century; epistemology came to be expressed in the language of geometry (integrating space, time, and number), considered the only method of elegance and rigor. Reasoning was held to be the only infallible mode of logic because it adhered to the true [Euclidean] method; other methods were lost in a degree of confusion that could only be perceived by minds of more geometrical bent. Such an epistomology is clearly a connection "between a science of the phenomenal world and a science of language" (De Man 1986, 13).

There was a time says J. Hillis Miller in *The Disappearance of God*, when men felt that God lived and walked and spoke to man, and His Word was on the lips of all. Scholars find evidence that society, in the beginning, experienced God's immediate presence "in nature, in society, and in each man's heart" (Miller 1975, 2). I would add that in Genesis, the first book of the Bible, Adam and Eve walked and talked with God as with another man. But, as early as the second book, Exodus, He appeared to Moses not as a man but as a burning bush, and when Moses asked what he should tell the children of Israel when they asked who had sent him, a more philosophical and abstract God began to distance Himself when He answered, "I AM THAT I AM" and continued, "Thus shalt thou say unto the children of Israel, I AM hath sent me unto you" (Exodus 3:14). Later, in an act of further distancing, He told Moses, "Thou canst not see my face: for there shall no man see me, and live" (Exodus 33: 20).

A new incarnation of God on earth—the birth of Jesus—brought God back to earth to walk with us once more and so to unite "a fallen world and a distant God" (Miller 1975, 3). Christendom's daily participation in the sacrament of the Eucharist functioned as a communion with God, and nature came to be seen as a storehouse of symbols and signs of the divine truth: "Each page of the book of nature was written by God and was another revelation of God by God" (Miller 1975, 3). During the Renaissance, many writers had intuitively conceived of a nature inhabited by God, as evidenced in the pantheism of writers such as Giordano Bruno, but baroque poetry gives testimony to that "crucial moment of the change from a poetry of presence to a poetry of allusion and absence" (Miller 1975, 7). By the eighteenth century, Boyle's, Locke's, and Leibniz's idea of the giant clock wound by the creator would banish God to the sole function and distant status of an uninvolved prime mover.

Medieval scientists had seen the world as friendly, finite, serving their needs, fully intelligible, and composed of those qualities that they could experience directly—color, sound, beauty, joy, heat, cold, and fragrance. Descartes's world, in contrast, was a monotonous, though infinite, mathematical machine wherein not only humanity's importance but God's immediate influence was lost. In this world, furthermore, all those qualities that had made the medieval world beautiful were suddenly to be credited only to the human nervous system—perception (Burtt 1954, 123–24).

The contributions of Copernicus, Kepler, and Galileo led the baroque period to expand its metaphysical interests well beyond the earth. Man's optical range now included the macroscopic spaces of the celestial world in one direction and the microscopic spaces of the cellular in the other (de la Croix and Tansey 1986, 710).

The Renaissance priority of practice over theory was inverted, and seventeenth-century painters granted new status to theory, partly as a revolt against the rigidity of the medieval workshop tradition that had persisted through the Renaissance (Barasch 1985, 313). Training in art theory began to be required as a structural framework in the Academy of St. Luke, which had been founded in Rome in 1577:[2] later, this new framework would become as restricting as the workshop tradition of the Middle Ages had been (Barasch 1985, 311–14). The first school of painting in the modern world was established after 1577. This school established academic standards

2. St. Luke was the patron saint of painters.

in which success depended upon official recognition (Waterhouse 1976, 4).

Religious concerns began to be increasingly replaced by scientific investigations and an emphasis on the dignity and the importance of the individual (Blatt 1984, 257). The first of the two great changes in the nature of man's knowledge and understanding in the history of Western culture took place in the middle of the seventeenth century, and with it the Classical age had its beginning (Foucault 1970, xxii). In this age of reason, understanding and knowledge came to be considered the way to freedom and happiness.

As more complex personal theory and practice became the hallmark of the baroque, the mathematical relationships in painting which had come to serve as the deus ex machina—the device, or rather the formula, as savior—of Renaissance art were now "persecuted almost with hatred" (Panofsky 1968, 75). The sixteenth-century Italian philosopher Giordano Bruno seems to have foreseen the eighteenth-century philosophy of Kant and the baroque period's departure from the classical formula toward more reliance on the personal genius and intuition of the individual when he stated that the only valid rules in art are those created by the artist, and there are as many true rules as there are true artists (Panofsky 1968, 67).

Scientists during the seventeenth century began to "concentrate less on macroscopic mechanics and focused instead on micromechanical models" (Blatt 1984, 358). This microcosmic investigation tended to stress the *concept* of reality over the visual aspects of reality—the structure of nature over the appearance of nature. Because of these new ideas and directions, "the seventeenth and early eighteenth centuries, though continuing in the shadow of the Italian Renaissance, was one of the great creative periods in the history of aesthetic thought" (Barasch 1985, 311). This is not to say that a full-fledged aesthetic, in the modern sense of the word, had developed: aesthetics as we know it had its genesis in the eighteenth century (Barasch 1985, 56).

Each new inversion of priorities, each new interpretation or permutation of perspective created its own distinct image. The Renaissance understood and practiced perspective quite differently from the baroque era, and Italian painters interpreted it quite differently from northern ones; the Renaissance gave priority to the "objective significance" of perspective, while the baroque and the North granted more status to "subjective significance" (Panofsky 1924–25, 17). Baroque painters, involved in the emotional content of their

subjects, invited the participation of the viewer by twisting movement (extreme contraposto) and dramatic gesture (Clark 1978, 94).

After the Sack of Rome in 1527, the mediocre remnants of the followers of Raphael were disbursed throughout Italy, and Michaelangelo's anticlassical direction was powerfully demonstrated in the *Last Judgment*, which was the first important commission for art work after the Sack of Rome (Waterhouse 1976, 1). Thus after Michelangelo's *Last Judgment* mannerism came to be the dominant style in Rome from 1535 to 1590 (Waterhouse 1976, 1). Though the mannerists had held to the letter of the precepts of Renaissance perspective, they had twisted the spirit of the classic style until there was little left of classic balance or clarity. Figures were often more than ten heads tall, as opposed to the normal eight, and they seemed to "writhe and bend" like boneless rubber dolls "in order to achieve a more intense expressivity" (Panofsky 1968, 73).

The mannerists had rejected the classic clarity of rational perspective based on Alberti's cube in favor of composition within a shallow space that often pressed all the figures into one "unbearably crowded" plane (Panofsky 1968, 73–74). Figures were still volumetric like those in the Renaissance, but mannerism had reacted against the precise organization of space in Renaissance compositions and the sense of depth behind the picture plane was markedly diminished (Blatt 1984, 245).

One of the characteristics of the baroque period in painting was the tendency, inherited from the mannerists, to crowd and stack objects and human figures, one on top of the other, flat against the picture plane. This stacking strengthened the power of the image because it afforded the advantage of being able to stay within the bounds of classic perspective without having to diminish the size or impact of images as they receded.

Though the baroque painters, like the mannerists before them, technically stayed within the rules and confines of Renaissance perspective, they completely restructured the unified view from the low eye level and the formulaic space-defining box of the stage as prescribed by Alberti. It was the Renaissance Albertian "tradition that painters felt they had to equal (or to dispute) well into the nineteenth century" (Alpers 1983, xx).

It is evident at this point that baroque painters were searching for an alternative to the status quo; in their search were the beginnings of a gradual metamorphosis of what had so long appeared to

be the sole and self-evident truth in painting—the Renaissance illusion. The centered, pyramidal compositions of Renaissance painting began to evolve into the asymmetrical baroque compositions with diagonals used to create lateral tensions between shapes as they rocked across the surface of the painting. While Renaissance painting had created space by linking linear perspective to the size and placement of objects, baroque painting achieved an even greater illusion of depth by integrating foreshortening and diagonals with linear and atmospheric perspective.[3]

The Council of Trent in 1545 was an important influence on both mannerism and the baroque. The Council had urged a strong control of the subject matter in religious paintings and a purge of the pagan tendencies of Renaissance Humanism; opposition from the rebellious Calvin and his followers incited the Church to exploit art as anti-Protestant propaganda (Waterhouse 1976, 16). The Jesuits, in particular, appreciated the full propaganda potential of art: it nourished communion between viewers, and the divine and kept them constantly aware of the power and splendor of the Papacy, thus boosting their feeling of self-importance and their capacity for service to the Church (Waterhouse 1976, 17).

The use of propaganda after the Council of Trent differed from that of the Middle Ages, as the baroque and mannerist message was aimed toward the highly educated rather than the illiterate masses. Many of the schemes were not intelligible to "the simple mind unaided"; mythological and symbolic allusions were often so esoteric as to need an interpreter (Waterhouse 1976, 1–2).

3. In a last fling for linear perspective, Claude Gellée, also known as Claude Lorrain, used a complex combination of viewpoints located on the same horizon line to create a "bifocal construction." Taking a cue from Marcel Rothlisberger, Hubert Damisch points out, in "Claude: A Problem in Perspective," that Claude first established a single vanishing point (as in one-point perspective) near the center of the horizon line, which was located two-fifths of the height of the painting from the bottom edge. Then he circumscribed a circle, using this first point as center, large enough to contain the entire painting easily and so that no part of the circle touched the painting. The two points where this circle crossed the horizon line outside the painting became the vanishing points for another integrated construction of two-point perspective. Often, as in his drawing. *Classical Landscape* (1666), Claude would then set up another two-point perspective with two new vanishing points set on the same horizon line, but this time both points were located well within the confines of the painting. These three separate constructions were well synthesized and created an excellent effect of monumentality (Damisch 1984, 29–35).

Caravaggio's Cartesian Space

Michelangelo Caravaggio (1575–1610) painted in a manner more realistic than the style in vogue at the time in Rome; his influence is evident in the work of countless seventeenth- and eighteenth-century painters who feature realistic or naturalistic aspects (Friedlaender 1969, vii). Caravaggio's style, which can be called "realistic" for its time, differed in four important ways from the work of his contemporaries. (1) The people he depicted are plebian rather than the idealized types of the Carracci or the mannerists. (2) Caravaggio's colors are varied and individualized to the fabric depicted; even the texture of these fabrics is specific and recognizable so it would be easy for an expert to assign a trade name to any fabric or color, unlike the draperies depicted by the mannerists and others, which were "of vague color and always of uncertain weave." (3) Caravaggio's lighting was carefully arranged in the studio, and it always issued from a specific source, rather than being nebulously diffused. (4) His subjects seem earthy and real, "in contrast to the uncertain race and temper, the vague setting in time and place, with which previous painters had invested their sacred figures" (Waterhouse 1976, 10).

Caravaggio was a strongly eclectic painter who had studied the formal elements and themes of several different painters. Like Galileo, though, he based his own investigations on the observation of nature rather than on the preconceptions of others (Friedlaender 1969, viii, xii). Caravaggio alone among the painters of his period looked to the new men of science for direction; he rejected tradition and based his work on empiricism (Salerno 1985, 19). He focused on the object to be depicted and put little effort into technical experimentation because he was convinced that "truth lay in the rendering of the tangible world" (Salerno 1985, 19).[4] This naturalism, this convincing mimesis, was the cause of the most severe criticism of Caravaggio's paintings during the seventeenth century.

The dark backgrounds in Caravaggio's paintings function to limit the depth of the space behind the picture plane and so "to bring the miraculous event directly and persuasively before the eyes and into the heart of the worshipper" (Friedlaender 1969, x). Caravaggio insisted almost religiously that his paintings speak directly to the viewer, "using the easily understandable terms of the visible

4. Salerno asserts, however that Caravaggio "would have included the subjective emotions in his definition of the tangible" (Salerno 1985, 19).

world" (Friedlaender 1969, ix). His critics, however, who conceived of art as more transcendental and metaphysical, accused him of a lack of technical ability and of creating "art without understanding what art is" (Friedlaender 1969, ix–x). But the difference between their conception of the relationship between the painting and the viewer and Caravaggio's conception of it was the actual reason for their attacks. Caravaggio had dragged the ideology of Roman art "down to earth from its higher spheres" (Friedlaender 1969, 120).

In some of his paintings, he stacked one human part on another until he filled the "screen" with flesh. As figures were stacked one on top of the other, there was a propensity for parts of the figures to penetrate the picture plane—a hand here, an elbow there.[5] These figures seemed to extend from pictorial space into the real space of the spectator, enjoining reality and illusion.

In *David and Goliath* (fig. 8.1), Caravaggio gives us no indication that David is not standing against the frame of the painting. If we read this as David's position, then his outstretched arm seems to thrust Goliath's head through the picture plane to invade the viewer's space. Thus, the existence of David and the head of Goliath are defined,—in an almost Cartesian sense—by their extension into the viewer's space. Moreover, the space in front of the picture plane is defined and made palpable by the extension into that space of the objects that occupy it. Masaccio, in the fifteenth century, had invited the spectator to enter the illusionistic space of his painted world, but Caravaggio's David seems to reach through the "pane" of the picture plane to invade the world of the spectator.

The apparent invasion of the viewer's world space by David's arm and Goliath's severed head seems to be directly in accord with the seventeenth century's expanding interest in space. The projection through the picture plane seems an application of Descartes's conclusion that space, and the objects that occupy it, define our existence. Caravaggio endowed his figures with the living illusion of Cartesian presence when he made David's arm holding the severed head appear to extend into the viewer's space in front of the painting. In this way, Caravaggio's realistic mysticism was a symbol of the

5. The penetration of the picture plane had been tried earlier. In the fifteenth century, Andrea del Castagno, in a portrait of a general called *Pippo Spano*, creates an illusion of a "heavy, armored, foreshortened foot that seems to protrude over a sill of the opening. . . . And by having parts of his figure appear to project into the space of the viewer, Andrea takes a step beyond Masaccio's *Holy Trinity* in the direction of Baroque illusionism" (de la Croix and Tansey 1986, 569).

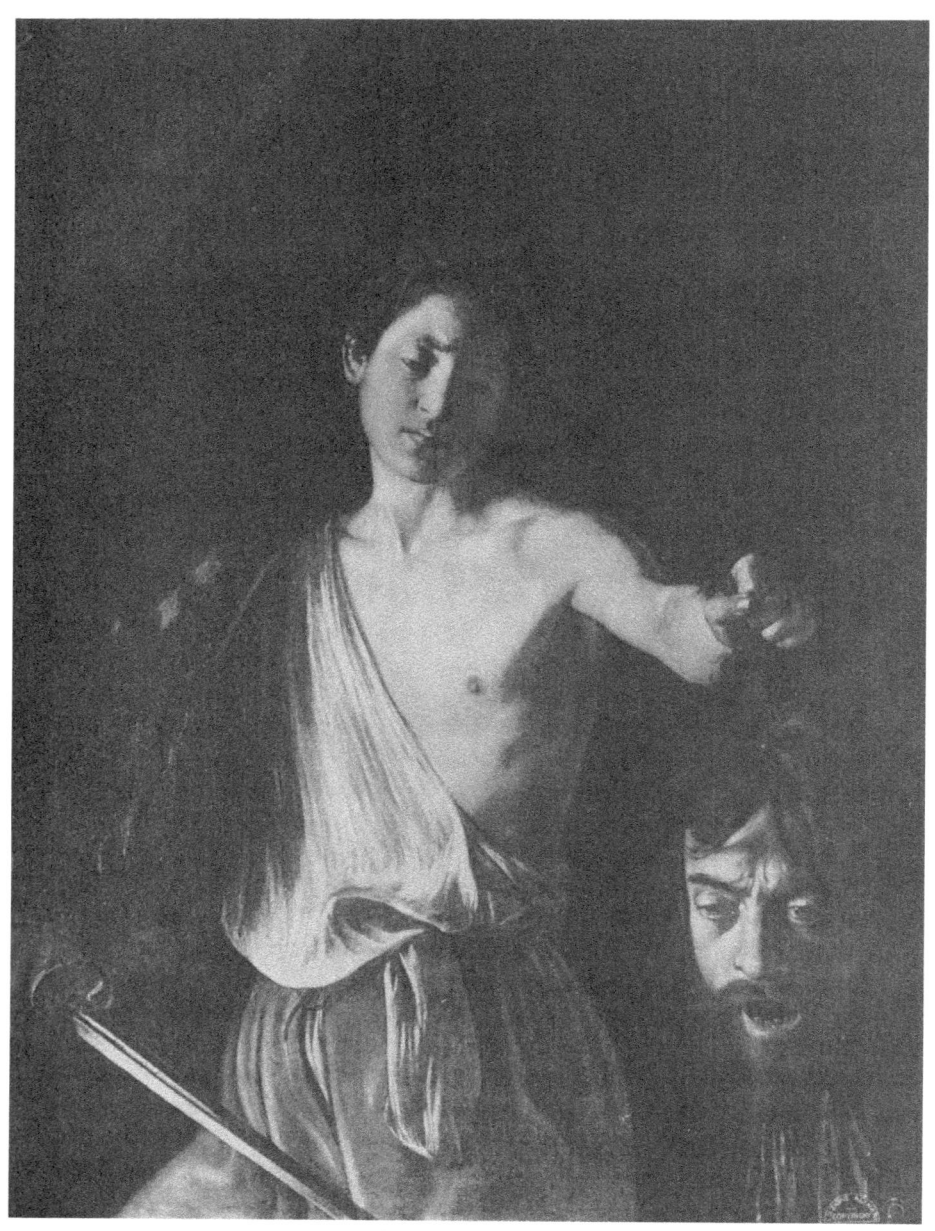

8.1. Caravaggio. *David and Goliath.* 1609–1610. Oil on canvas (49″ × 39″). Borghese Gallery, Rome. Photo: Alinari/Art Resource, New York.

seventeenth-century concept of "being" and the universe, as well as a powerful and persuasive embodiment of contemporary religious passion.

Frank Stella interprets Caravaggio's penetration of the picture plane, his ability to develop the space in front of the painting in addition to the "stage" of the painting, as an important step in developing the potential of twentieth-century abstract painting. "Painting before Caravaggio could move backward, it could step sideways, it could climb walls, but it could not march forward; it could not create its own destiny. Without a deliberate sense of projective space, painting could not become real. The road to pictorial reality must pass through the dissolution of perimeter and surface. This is the road paved by Caravaggio to lead great art toward what we now call great painting" (Stella 1986, 19).

The images packed toward the front edge of the stage in one single, often "unbearably crowded," plane may appear to be similar to the overlapping images in medieval painting, but there is one important difference. The figures in a painting of the Middle Ages were flat in a way that was consistent with the overall planarity (not flatness) of the painting. The figures of the baroque, however, were volumetric and often foreshortened, "a contrast foreign to the art of the Middle Ages" (Panofsky 1968, 74).

Many of Caravaggio's paintings contain an area of elaborate stilllife. Perhaps Caravaggio was demonstrating that although he could depict figures if that was the wish, he could also perform his tricks with any subject: people, fruit, or carpenter's tools. It made no difference; the result and the spatial image were the same. Caravaggio, like Leonardo, was interested in form. He depicted a naturalistic reality, but this had ceased to be his primary concern. In an extension of Leonardo's interest in form over content, Caravaggio used objects only as a support for the light shed upon them.

Caravaggio delineated objects and figures with a concentration on the painterly use of darks and lights, rather than the hard, linear, sculptural volumes and silhouettes of the sixteenth century; he emphasized shading instead of outline or silhouette. Caravaggio's tenebrism sometimes obscures a form's solidarity, but the silhouette is never completely lost. Many of his followers, however, allowed the shadows first to invade the edges, then to destroy the solidarity of forms (Friedlaender 1969, 15).

Caravaggio's concentration on shade and his painterly use of shadows are easy to recognize as a logical extension and embellish-

ment of Leonardo's dark doorway. Leonardo had invented even the means of the extension: sfumato, painterliness, and dark-light composition. Caravaggio used these ideas to create paintings with a new power, paintings that expressed a living Cartesian presence by their invasion of the viewer's own space.

2

The Rococo Age

THE ROCOCO PERIOD has been criticized for being decorative, superficial, full of empty grace, merely pretty. But rococo painters in the eighteenth century were among the most consummate craftsmen in the history of art. Their structure was beyond question and the groundwork was being laid for the unprecedented amount of change that was to take place later in the nineteenth century.

Johan Huizinga's classic study, *Homo Ludens*, has been called the most important work on the philosophy of history in the twentieth century. Huizinga contends that, though the rococo has often been misunderstood as feeble and unnatural, the "ornamentation never attacked the severe and sober lines" of the underlying structure and "few periods of art have managed to balance play and seriousness as gracefully as the rococo" (Huizinga 1944, 187). Artists during the rococo period, though they disguised it well, balanced the seriousness of solid structure against its antonym, pure play, perhaps better than artists of any other period in the history of art. Perhaps we have failed to appreciate the rococo period as fully as we might because their concerns were different than ours have been until recently, and we had a tendency to see them—as Jonathan Culler so aptly put it when referring to a little-appreciated romantic poem—as "the aberration of an age and sensibility out of tune with our own" (Culler 1981, 155).

Modern aesthetics—the examination and evaluation of works of art—was born in the last half of the eighteenth century, "when European intellectuals began to wonder how such diverse artistic objects as an Egyptian mummy case, a Ming vase, and a Renaissance altarpiece could have anything in common" (Edgerton 1975, 56). This examination and evaluation led to the invention of art criticism as we know it (Fried 1980, 2).

What Tompkins tells us about the aesthetics of poetry and literature holds equally true for painting. She points out that the arts in the late eighteenth century, at the dawn of mass communication,

began to separate from political life as the patronage system began to break down. Art at this time was intended to create in the audience an emotional experience rather than to mold character or guide behavior; the art experience was "aimed at the psychic life of individuals rather than at collective standards of judgment on public issues" (Tompkins 1980, 215).

Tompkins also points out that at the same time criticism was distancing itself from social and moral concerns; it was also beginning to emphasize the psychology of perception. Critics, speculating about the responses of the audience, held that psychological elements in the perception of art should transport the audience to intense emotional experiences. Writers such as Edmund Burke and Sir Joshua Reynolds based their speculations regarding the universal aspects of perception on these emotional responses to art; for them, art came to be regarded as a discipline of scholarly and scientific study rather than as a social event for artist and audience. Emotional experiences were of interest in and of themselves rather than because of their tendency to create better citizens. The art work became "more like an icon than a cudgel, and less likely than before to do anyone any harm. Or, one might add, any good" (Tompkins 1980, 216).

Tiepolo's New Priorities of Figure and Space

Before Giovanni Battista Tiepolo (1696–1770), one of the most fundamental schisms in the history of art was the seventeenth-century debate between the Poussinists (Charles Le Brun and his advocates of line and form as the single most important element in art), and the Rubenists (Roger de Piles and his advocates of color supremacy) (Barasch 1985, 365–72). This schism was well known as "*le débat sur le coloris*" (Barasch 1985, 355). Under Le Brun's influence, the French Academy was dominated by the anti-color dogma that structure in painting lies primarily in the drawing—sometimes described as "line" or "composition." Color, considered devoid of significance, was relegated to a position subordinate to drawing.

Giving a higher priority to the structure of dark and light than to the effects of color was, Barasch finds, a consequence of Cartesian metaphysics. Le Brun reasoned that drawing demands reason, but color appeals only to the senses; therefore, drawing seemed to be as superior to color as human reason is to the animal senses (Barasch 1985, 355). As Bryson notes, Le Brun's reasoning included Des-

cartes's argument that design was superior to color because there can be design without color but there cannot be color without design. Furthermore, Le Brun held that the materiality of color degraded the spirituality of the image and that the challenge of the Rubenists threatened what Bryson calls the "Cartesian concept of the painterly sign," for Descartes himself had proclaimed: "Reason tells us that the figure is in the objects; only a vague sentiment tells us that it is coloured." It is rare to find so evident and so close a connection between painting and philosophy as Le Brun's obvious dependence upon the reasoning of Descartes (Bryson 1981, 60).

Le Brun's rationale that drawing was superior because it was more logical and intelligent still echoed the Renaissance primary concern with objectivity and dismissed color as the product of base emotion and low intellect—the antonym of reason. De Piles argued that painting was dependent upon other disciplines for most of its knowledge and expertise: specifically, anatomy for drawing the figure and optics for perspective (Barasch 1985, 356). He maintained that only the "modulation and tuning of color" were unique to the painter (Barasch 1985, 356). Thus, de Piles theorized, the only discipline unique to art was the use of color (Barasch 1985, 356). Furthermore, de Piles held the Newtonian position that color and light are inseparable in nature (Bryson 1985, 60).[1]

Although Tiepolo's palette is usually mentioned as merely of high key, "light and airy," he often relied heavily on contrast between warm and cool color and between saturate color and a duller greyed-down tone of similar value for the sensation of volume. Antonio Morassi, in his excellent biography of Tiepolo, tells us that Tiepolo's shadows are unusually luminous because of his practice of allowing the color in shadows to retain its fundamental value and full intensity (Morassi 1955, 28). In other words, Tiepolo often changed

1. In *Optica* Newton wrote: "In fact light is compounded of rays of all colors not only as it leaves the prism and is not yet separated into these colors, but also when it has not yet reached the prism and before any refraction has taken place. Consequently, it is not surprising that when light is separated into colors by the power of a prism to refract rays unequally, and the colors are again mixed by the aid of lens or by any other way previously shown, that, I say, they again compound white" (Newton [1670–72] 1984, 491).

The argument that color was superficial and inferior to the effects of light and shade could certainly not endure in the full weight of this new knowledge that white light was composed of all the colors and that therefore light and color were inseparable.

the temperature, rather than value or saturation, on the shaded side of his figures. When painters define volume by means of a dark side and a light side, they tend to place more intense color on the light side and more greyed-down color on the dark side. Tiepolo, however, created a sensation of mass by the use of a warm side in opposition to a cool side of equal color saturation. That is, he sometimes kept the two sides of a figure similar in value: neither was darker (or lighter) than the other, but one side was painted in warm flesh tones and the other side was painted in cooler tones.

Though this warm-cool method does not create the strong illusion of volume and relief that is possible with dark and light modeling, it is nevertheless an efficient method of implying volume because we tend to associate warm color with light, and cool with shadow. In the sixteenth century, Leonardo had written of his observation that shadows were cooler and bluer than the lighter areas, but Tiepolo was the first that I am aware of to experiment with contrast in temperature, rather than contrast in value, to suggest volume, and this method makes objects look more ephemeral and transparent.[2] Tiepolo can thus be seen as the prototype colorist who made the first move toward increasing the priority of color in relation to its opposing structure: dark and light.

This substitution of color temperature for dark and light played an important role in the nineteenth century as an influence on both Delacroix and Monet. Tiepolo took the first step in restructuring the depiction of volume in order to allow it to merge more easily into the flat picture plane which would be developed during the nineteenth century.

There are two widespread and erroneous beliefs about space in European painting: that "perspectival space is objectively superior to other systems of spatial representations and marks an irreversible advance" and that "'Quattrocento' space reigns unchallenged from Giotto until Cezanne" (Bryson 1981, 89). The belief that Renaissance methods of depicting pictorial space were conceded higher status than other methods of perspective creates the false impression that it was not until the second half of the nineteenth century that painting began to abandon Renaissance perspective. But, because rococo space was "radically unlike the space of Le Brun or Watteau," it was

2. "This transparency, which takes away all feeling of heaviness from the figures, is accentuated in the vast sky, where, in a blaze of light, through a veil of atmosphere, which shades into the distance through all the colours of the rainbow, the bodies became more ethereal and merge into the infinite" (Morassi 1955, 28).

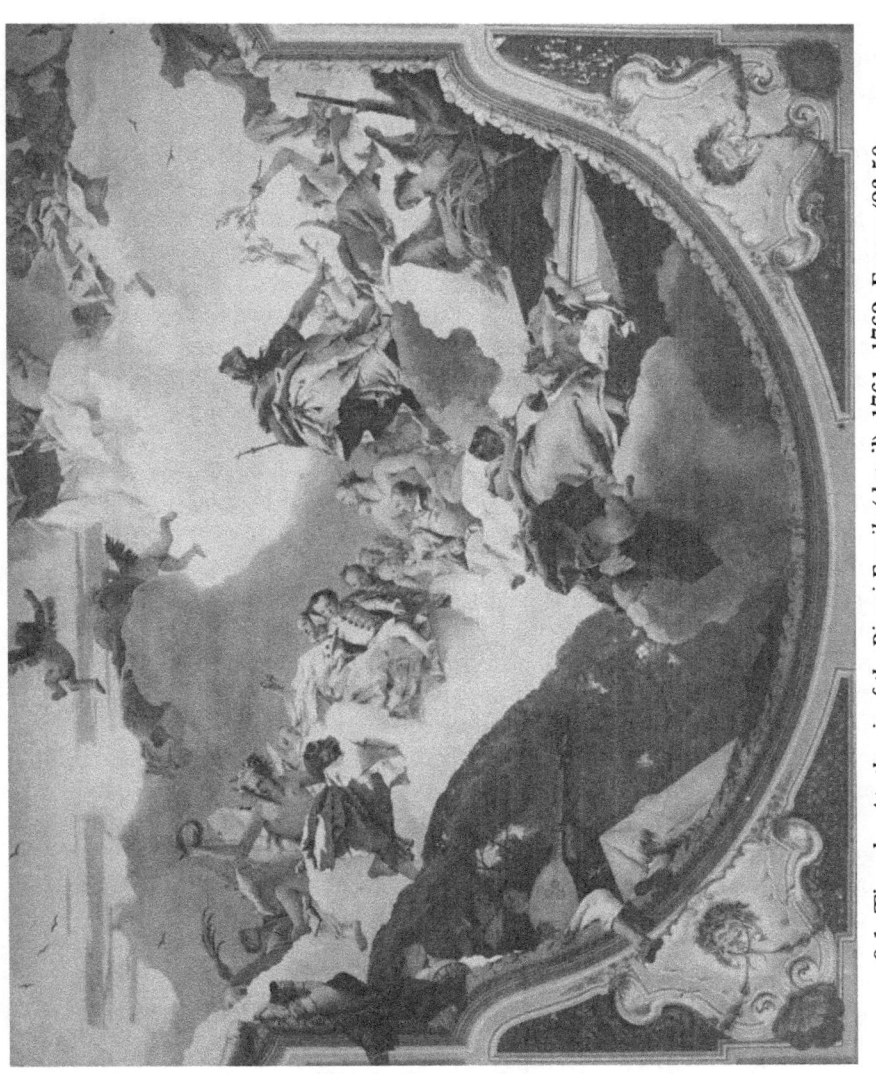

9.1. Tiepolo. *Apotheosis of the Pisani Family* (detail). 1761–1762. Fresco (23.50 m. × 13.50 m.). Villa Pisani. Strá, Veneto. Photo: Alinari/Art Resource, New York.

a distinct break with Albertian conventions (Bryson 1981, 91). Rococo painters no longer used linear perspective to place objects behind an implied pane of glass so as to distance them from the viewer (Bryson 1981, 89–93).

Tiepolo and the rococo painters offered little or no architectural reference within the image to challenge the viewer with its own assertion of scale. Thus, there were few straight perspective lines to hold the image in its space behind the wall. Instead, this space was filled with unworldly substances that look like cloud and "impersonate a spatial setting, without risking the creation of a space that would threaten to exclude the spectator" (Bryson 1981, 95). When rococo painters selected an external location, any evidence of spatial change was carefully erased: "there must be no horizon, and no vanishing point" (Bryson 1981, 96). This new space might be said to appeal more to the newly liberated senses than to reason.

Tiepolo often depicted many more figures in his paintings than had been popular in Southern Europe in the past. Because these figures were smaller, however, more space was left for other things such as clouds and landscape. He was vitally interested in an illusion of space that did not deny the picture plane. Consequently, the arrangement of the multitude of figures in paintings, such as *Apotheosis of the Pisani Family* (fig. 9.1), was important as a spatial device to create an illusion of depth that was yet compatible with this plane. The figures were carefully arranged in space from foreground to background: as they diminished in size, they functioned as a visual scale of distance and depth.

The human figures are often the only objects in Tiepolo's paintings that have a known specific size. His clouds have no size association—they can be read as small or as very large—but the figure is a known size with specific details. The diminishing size and the atmospheric loss and blurring of known detail as figures recede into the distance became an effective construct for creating a visual depth that was nevertheless not in conflict with the actual flatness of the picture plane.

Isaac Newton (1642–1727) has been of two-fold importance to the societies that followed him. Not only did he identity gravity with the movements of celestial bodies, but his discovery of the laws of motion resulted in connecting vague terms like force and mass with precise meanings as quantitative measurement, rendering the major phenomena in physics subject to mathematical treatment (Burtt 1954, 30–32). Newton's publication of *Philosophiae Naturalis Principia*

Mathematica in the seventeenth century further promoted the painters' interest in pictorial space.

Newton had given new meaning to the terms *space, time,* and *motion,* which were to become "the fundamental categories of men's thinking" (Burtt 1954, 33). These terms would become both the foundation of twentieth-century cosmology and the content of art. This concept of space as the content of painting begins to be evident during the eighteenth century; the use of figures as a spatial device gave painters a new reason for putting human figures in paintings other than as the center of attention. Space was man's new interest, and these figures were used to create a new spatial structure in painting.

Beginning in the seventeenth century, and gathering influence in the eighteenth, a new concept was developing in all the arts: the idea that the important priority in art was not the figure, but the image of the work itself. What was important was the image *of* the painting, not the image *in* the painting. A literary critic and the editor of *Critical Inquiry*, W. J. Thomas Mitchell, notes that the overall image assumed more importance than the notion of "figure," which came to be regarded as an attribute of old-fashioned "ornamented" language (Mitchell 1986, 24).

In this sense, Tiepolo used figures as a device to create a unified spatial image. Thus his paintings became one cohesive image: an image of space. The figures in a painting were no longer important as single images, only as structure to fabricate a unified spatial image. The subordination of individual images, even in poetry and prose, is fulfilled when the entire undivided poem or text is considered as one image or "'verbal icon,' and this image is defined not as a pictorial likeness or impression but as a synchronic structure in some metaphorical space—'that which' (in Pound's words) 'presents an intellectual and emotional complex in an instant of time'" (Mitchell 1986, 25).

Once again, important priorities had been reversed. Once space had been created to showcase man: man was the primary focus. Now man was used to create space: space assumed primacy.

Gainsborough Reverses Color Perspective

Thomas Gainsborough (1727–1788) also created landscape compositions that exploit the figure in pursuit of space. These paintings coax the viewer's attention farther and farther back toward an ever

108 *Changing Images of Pictorial Space*

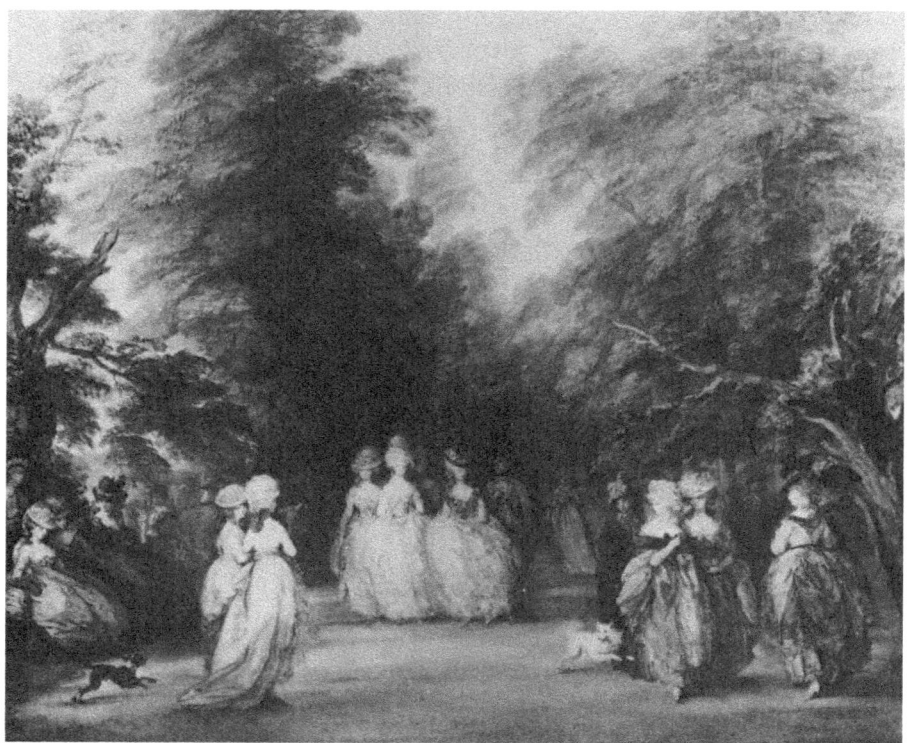

9.2. Thomas Gainsborough. *The Mall in St. James Park.* 1783. Oil on canvas (47½" × 57⅞"). Copyright the Frick Collection, New York.

deeper illusion of space. *The Mall on St. James Park* (fig. 9.2) marks an intermediate step between two kinds of spatial composition. Gainsborough's portraits show his earliest method of spatial composition: as in fifteenth- and sixteenth-century paintings, the figure fills most of the painting. The figure defines a shallow sculptural space in the foreground. Behind the figure is a sudden spatial leap to the background, with little if any transition.

But Gainsborough's landscapes demonstrate the newer approach to spatial composition. The attention of the viewer is often led as slowly and interestingly as possible from the foreground into an illusion of deep space in the background. Many of these landscapes entirely dispense with man. Some show only animals, and some have no figures at all, neither human nor animal.

The Mall painting is a transitional example of the use of the human figure to define medium deep space. As mentioned in the section on Tiepolo, the use of the human figure to create illusions of depth is the first step in replacing man with the image of form and space as the center of attention in painting.[3] In the Mall painting, Gainsborough used figures to define space. The figures are placed on the ground plane in carefully graduated increments of depth leading into the distance in such a fashion as to create a spatial maze. The painted figures fashion a visual path that leads the viewer's attention, in calculated steps and patterns, into the middle space of the background.

Painters have used this device for several hundred years in Western Art, and psychological corroboration for the logic of this structure has been found in the research of the perceptionist James Gibson. His psychophysical theory of perception is a partial explanation as to why the control of the ground plane has served as such a useful structural device in painting. He suggests that man understands physical space as objects residing on surfaces that slant away from the viewer, particularly the surface of the ground plane as it recedes (Gibson 1950, 6).

This ground surface furnishes support for movement and aids the equilibrium of the body, posture, and locomotion. Previous psychological theories of spatial perception operated on the assumption that space was perceived as an object or an array of objects arranged in nothing but air. Gibson, in contrast, insists that space is actually perceived as "a continuous surface or an array of adjoining surfaces." There may be no reliable perception of space separated from the perception of a continuous background surface (Gibson 1950, 6). "A pilot who cannot see the ground or sea is apt to lose touch with reality in his flying, a visual field of blue sky, or fog, or total darkness yields an indeterminate space which is the nearest thing to no space at all" (Gibson 1950, 60).

When we are walking in the outdoor world, the lower portion of our visual field is filled with a projection of the terrain: "This is the

3. Michael Podro notes this reversal of the attitude toward man as content in art. "The human subject-matter was initially held up as the paradigm of what was suitable material for art: it possessed an ideal or norm, something intersubjective and available to human rationality, and the external form had an inward emotional or even moral connotation. But it then turns out that the ideal or norm is itself valued for facilitating a certain use of mind. The ideal subject-matter is valued for its suitability for bringing perception and sensibility into play in a certain way" (Podro 1972, 45).

kind of world in which our primitive ancestors lived. It was also the environment in which took place the evolution of visual perception in *their* ancestors" (Gibson 1950, 60–61).

This lower bounding of the visual field corresponds to the ground plane that many artists, particularly since the seventeenth century, have used to structure pictorial space. Sometimes they depict a literal path, creek, river, or road that meanders across the ground laterally from one side of the canvas to the other in increasingly deeper spatial positions until it disappears into the blurred distance. Most eighteenth-century painters concentrated on value to control pictorial space; many of them even used a device called a Claude glass to do for them what a black-and-white photograph does for us: it reduced the landscape to gradations of value (which they considered to be structural) so the painter could ignore distractions of color, which they considered to be decorative (Gombrich 1961, 46–48).

Gainsborough was as interested in color as in value. Ruskin, in fact, regarded Gainsborough "the greatest colourist since Rubens" (Ruskin 1851, 91). *Blue Boy* (fig. 9.3), with all the cold icy blues in the foreground and all the warm reds, browns, and earth colors in the background, may be the first intentional reversal of the classic color theory. The illusion of depth, nevertheless, is strong and convincing.

Gainsborough accomplished this illusion by exaggerating atmospheric perspective to the point that it compensated for any loss of depth that may have been caused by the reversal of the classic color theory. The sharp detail at the front of the painting contrasts with the blurring of the background and strengthens the illusion. Also, the contrast in temperature between figure and ground separates figure from ground. Because of chromatic aberration—the inability of the eye to focus on both red and blue at the same time—color perspective works well, whether used as a warm figure on a cool ground or as a cool figure on a warm ground.

Gainsborough's accomplishment in *Blue Boy* further supports my contention that atmospheric perspective should be separated from color perspective rather than being lumped with it in a simplistic concept of aerial perspective. The need to separate these two concepts will become even more obvious as this discussion nears the nineteenth century because painters during the nineteenth century accelerated their experiments involving the relationships, reversals, and separations of atmospheric and color perspective.

I mentioned in chapter 4 that, through the history of Western

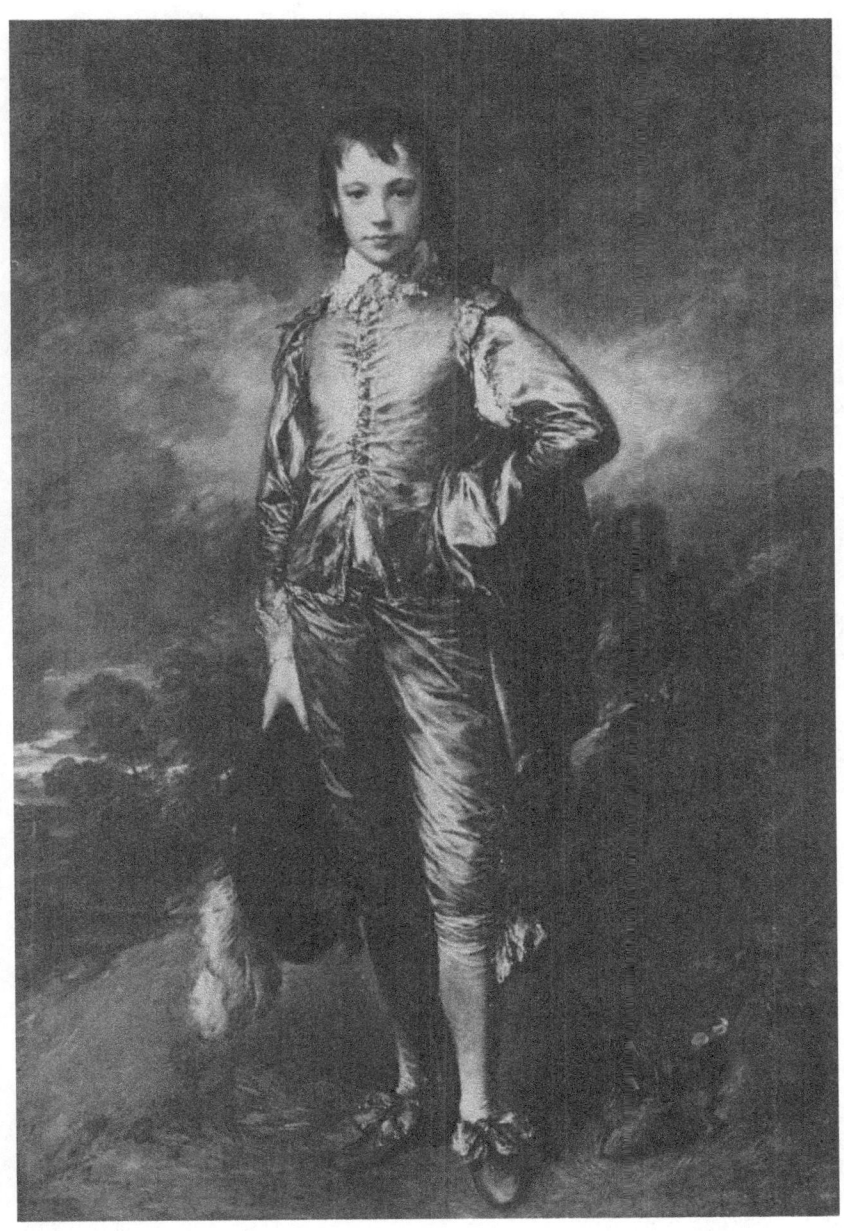

9.3. Thomas Gainsborough. *Blue Boy.* 1779. Oil on canvas (70" × 48"). Huntington Library and Art Gallery, San Marino, Calif.

European Art, the second most commonly followed color practice used principles exactly opposite to those of the classic color theory. This practice can also create a strong illusion of depth. In application of this approach, blue—usually opaque and similar to cerulean blue with a little white in it—appears to advance; it appears solid and tangible.

Chromatic aberration would seem to indicate that either the classic color theory or its reverse is viable (Libby 1974, 67; Luckiesh 1965, 135).[4] When a red field or background is interrupted by a blue figure, the temperature contrast tends to strengthen and exaggerate the figure-ground separation. The blue figure on a red background may visually advance as effectively as a red figure on a blue background. In either case, focusing on the figure prevents the eye from focusing on the background; the background blurs and appears to recede, leaving the figure salient.[5] We should remember, however, that the most important quality in determining a color's spatial placement is its saturation. An intense, saturate color tends to appear more salient than a dull greyed tone of the same color.

Fra Angelico's *Madonna* (fig. 9.4) is an excellent example of the fifteenth-century use of blue in the foreground with warm, reddish tones in the background. This blue is quite effective in its appearance of saliency and solidity.

The reds that were used for the background in reversals of the classic color theory were often cool and atmospheric, somewhat transparent—similar to alizarin crimson—in contrast to the solidity of the opaque blue.[6] This opacity strengthens the tendency for blue to advance because opaque areas tend to appear solid and salient while transparent areas appear more atmospheric and visually pene-

4. Lapicque insists that according to "this other theory, blue is endowed with the . . . qualities of nearness, solidity and tangibility; and red, with qualities of lightness, airiness and distance" (Lapicque 1959, 82).

5. "The illuminators of medieval manuscripts, for instance, frequently used a convention for rendering color in space which is entirely opposed to the classical norm. In these miniatures, distant *red* skies are sharply cut off from the blacks, blues and whites of the foreground; figures in blue, grey or black might be placed in front of a gold-flecked orange wall from which they are separated by a slight blue perceptible interval. The objects themselves may appear more or less tangible, and the space more or less clearly measurable, but the relative position of the planes is rarely ambiguous" (Lapicque 1959, 82).

6. "Dufy, whose distances are transparent, atmospheric and charged with movement, delights in using warm tones in the background, for instance in some versions of the *Regatta at Cowes* where a red the shade of wine dregs appears on the middle and far distance" (Lapicque 1959, 87).

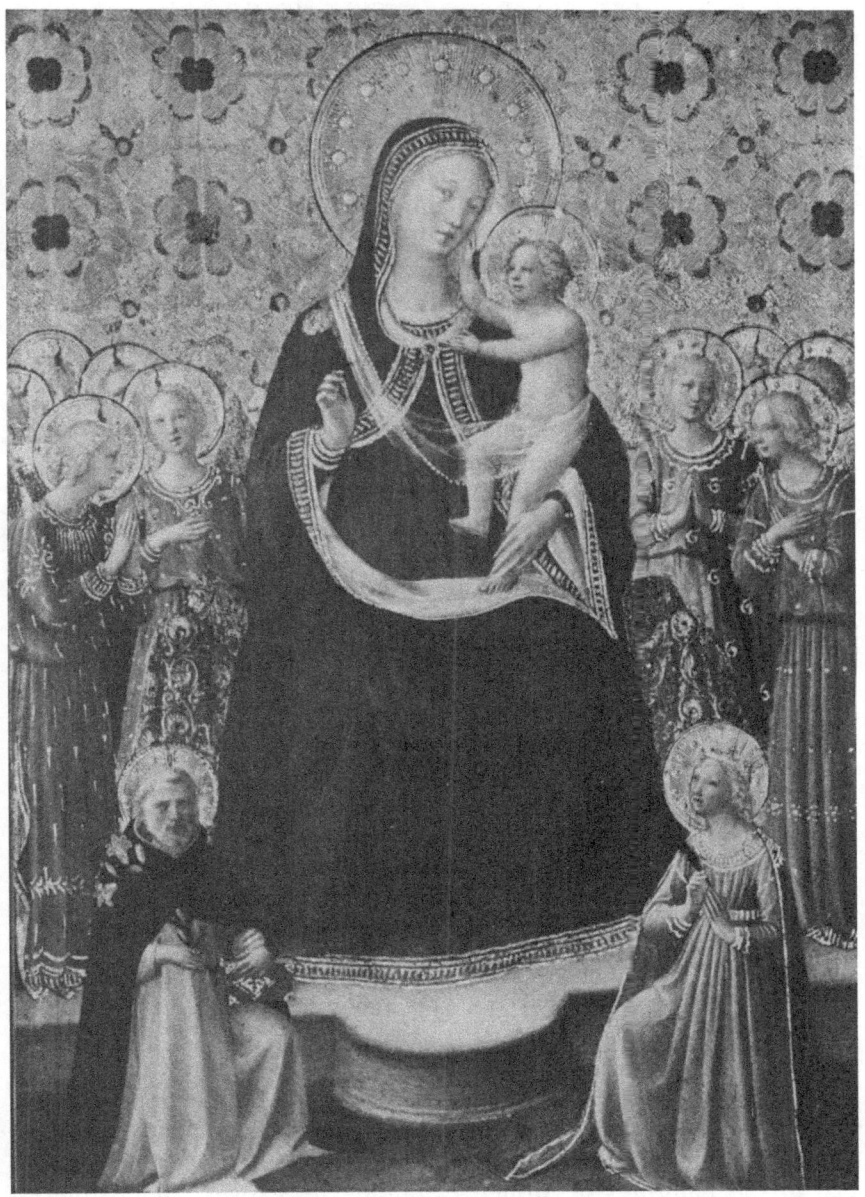

9.4. Fra Angelico. *Madonna*. 1425. Panel (23 cm. × 18 cm.). Bisenzio Collection, Rome. Pinacoteca Vaticana, Vatican City. Photo: Alinari/Art Resource, New York.

trable. Though I have found no support for this theory in art historical literature, the effect, obvious and easily observed, has been used frequently and consistently by many artists.

Colors that are finely ground tend to be more transparent (like watercolor) than the more coarsely ground colors, which tend to be opaque (like tempera). Opaque colors, stopping vision at the surface of the canvas, tend to appear salient; transparent colors, seeming to entice the viewer to look through the surface into space, appear recessive. Most finely ground transparent color cannot be applied thickly enough to create opacity without disastrous results to the surface quality of the painting. Similarly, transparent watercolor cannot be used opaquely without losing the richness of the color unless a touch of white pigment is added to create opacity. This contrast between transparent and opaque promotes the illusion of volume and depth. The thinner, more finely ground, transparent dark areas tend to recede, while the thicker, more coarsely ground, light areas are opaque and tend to be salient.

I suggest a construct that not only will work with both color perspectives but will also facilitate the understanding or use of either theory. This construct even makes it easy to alternate the two theories in the same painting as the Fauves were to do in the nineteenth century.

An Alternate Color Perspective

Salient	Recessive
Color that contrasts in temperature with the background	Color that is similar in temperature to the background
Saturate, intense color	Greyed color; shades and tones
Opaque color and objects that appear solid and tangible	Transparent color and areas that are atmospheric

Understanding the principles of color perspective will help to clarify the nineteenth- and twentieth-century relationship between value and color. Such an understanding of color perspective is crucial to the paintings of Monet, Cézanne, the Fauves, and painters like Barnett Newman and Larry Poons during the 1960s. I will demonstrate that each of these painters manipulates the principles of color perspective in order to achieve the particular image of pictorial space for which they are known.

10

The Roots of Modernism

ALTHOUGH THE FIFTEENTH CENTURY made major contributions and the twentieth century has seemed a time of constant change, it was the nineteenth century that fomented more changes in the basic structures of art than any other period. During this century art and science were transformed by new concepts that had been kindled by non-Euclidean geometry, the fourth dimension, Darwin, Kant, and others.

Science, which had already begun to permeate literature and philosophy in eighteenth-century France, during the first half of the nineteenth century exerted even more influence on them. The dispassionate methods of enquiry employed by science, its combined use of observation, logical reasoning, and experiment were put to good use in other disciplines (Dampier 1966, 307). Whole new realities suddenly became available to the artist through new discoveries, such as non-Euclidean geometry.

According to Foucault, there are two great discontinuities in the nature of knowledge and understanding in Western culture: "the first inaugurates the Classical age (roughly half-way through the seventeenth century) and the second, at the beginning of the nineteenth century, marks the beginning of the modern age." The basis and the order of our thinking today is not at all the same as that of the Classical thinkers (Foucault 1970, xxii).

Art theory after the French Revolution was still careful to demonstrate the artist's potential for contributing to the good of society, but it meticulously dissociated itself from any claims that it affected specific changes in social behavior, in favor of proclaiming its effect at "the most profound level of human experience" (Tompkins 1980, 216). Art had been separated from ordinary life to become a vehicle for the transmission of timeless, universal values. The audience for art in the nineteenth century was no longer a patron who was known to, and consulted by, the artist. The new audience was a faceless middle class; hence artists no longer had any direct method of mea-

suring the impact of their work on the audience (Tompkins 1980, 218).

The priority of content over form had been inverted during the sixteenth century, and form was now privileged over content—or, rather, form had become the content. Thus, formalism and the avant-garde attitude were born around 1859, the year that Darwin published *On the Origin of Species*. This formalism came to dominate both critic and artist in avant-garde art from Manet through minimalism (Twitchell 1987, 20). Manet, Degas, Monet, and Cézanne, in their first overt attempts to make space and composition the subject matter of art, struck what was to become the central theme of modern art. Conceptual, infinite space was a consequence of the spatial illusion first realized by the artist; a new "possibility then existed: to make space creation the sole criterion of art" (Read 1955, 100).

As if in answer to this new interest in space, a new and powerful mathematical idea of space was born. Euclid's fifth postulate stated that through a point not on a given line, one and only one line can be drawn parallel to the given line. In her recent book, *The Fourth Dimension and Non-Euclidean Geometry in Modern Art*, Linda Dairymple Henderson has documented the impact of these ideas on the arts. Even very early commentators on Euclid's geometry sensed that his fifth postulate was not fully self-evident and could possibly be deduced from other postulates (Henderson 1983, 3). Mathematicians realized that if other conditions were substituted for the fifth postulate (i.e., that no lines could be drawn through the point, or that more than one line could be drawn through the point) the nature of "straight lines" would be altered and that space would somehow be curved. Thus were born several varieties of non-Euclidean geometry.[1]

Non-Euclidean geometry led to other modifications of the concept of space. Might not its curved space add other dimensions to the three known to Renaissance spatial geometry: height, width, and depth? Whether additional dimensions also provided other levels or

1. "Lobatschewsky and Gauss were the first to destroy the Euclidean concept of fixed space, and to demonstrate that it is only *one* instance in an unending succession of spaces. (Gauss considered the three-dimensionality of space, not as an inherent quality of space, but as a specific peculiarity of the human soul.) With the creation of non-Elucidean geometries, it became clear that mathematicians were not recording nature so much as interpreting it, and that there were no *a priori* means of deciding from the logical and mathematical side which type of geometry does in fact represent the spatial relations among physical bodies" (Gablik 1977, 70).

forms of reality, non-Euclidean geometry, which dominated the nineteenth-century painter's new interest in space, excited artists and writers alike.[2]

Many prominent artists were influenced by the idea of the fourth dimension. However, the artists were not experts in the practice of non-Euclidean geometry, and the fourth dimension remained only a subject for speculation. Though Kant, in the eighteenth century, had connected space and time as *a priori* intuitions, developed through reason and conditioning everything experienced through the senses, the fourth dimension was not defined as the relationship between space and time until Einstein did so at the beginning of the twentieth century. Yet time, which had been of interest to artists as early as the seventeenth century, became an important center of focus in the late nineteenth century. Art, music, and science felt an increasing sense of the importance of time as a dimension of experience and reality.

Late baroque art had shifted away from images of the timeless and the eternal and toward depictions of particular events in time. This direction was pursued further as impressionists attempted to depict the very moment of an experience (Blatt 1984, 302). Such a precise moment in time was partly implied by those paintings in which one precise area was focused sharply while details were progressively more blurred the farther they were from the center of focus. This technique was an attempt to mimic what may be seen in peripheral vision. Use of a central area of focus suggests the fraction of a second the vision may come to rest on a particular area before resuming its constant and active search for new areas of interest upon which to focus. This method is in direct contrast to what Svetlana Alpers calls a "displacement of time" as it was practiced by seventeenth-century Dutch painters when they subjected a still world to careful scrutiny and compiled detailed descriptions of a multitude of objects seemingly without end. Such obsessive attention to the de-

2. Henderson contends that "the complex spatial possibilities suggested by a fourth dimension, as well as by the curved space of non-Euclidean geometry, were the outgrowth of developments in early nineteenth-century geometry. Popularized during the later years of the century, these notions had begun to capture the public's imagination by the turn of the century in much the same way Black Holes have done in recent years." Dostoevsky referred to higher dimensions and non-Elucidean geometry in his *Brothers Karamazov*, and several other writers—including P. G. Wodehouse, H. G. Wells, Oscar Wilde, Joseph Conrad, Ford Madox Ford, Marcel Proust, and Gertrude Stein—did so in their work as well (Henderson 1983, xix).

tail of all the objects in the painting seems to ignore or displace the element of time, for each detailed observation must take place during a separate and prolonged section of time (Alpers 1983, 109).

In order to hold dominion over a culture, an idea need not be "true." We are often beguiled by the mere appearance of truth, and Renaissance perspective appeared to be so obvious, so objective, and so self-evidently true that no painter could construct a credible alternative for several centuries. Perspective distributes "information in a pattern which at once arouses our willingness to believe" (Bryson 1981, 12). Perspective is mere convention that standardizes the practice of depicting and repeating objects and figures. The use of such convention does not imply that these depictions are in any way objective: every method of depicting the world is based on the subjective selection of pertinent facts (Francastel 1967, 16).

Derrida, after considering Emile Benveniste's article, "Categories of Thought and Language," assures us that we think in terms of language. Language extends our capacity to think, and "We *think only in signs*" (Derrida 1976, 50).

Benveniste insists that the manifold ways in which men use language have two characteristics in common. First, the reality of our language is unconscious; we are barely aware of the complex operations we execute in order to speak. Second, all our thoughts are expressed in language: "We can say everything and we can say it as we wish." Our thoughts are given form through our language and cannot be separated from it nor transcend it (Benveniste 1971, 55).

The content of our thoughts must pass through language and conform to its framework. Thought is given form through language and cannot transcend it nor be separated from it. Without the structure of language, thought is something so vague and undifferentiated that we cannot comprehend it as content (Benveniste 1971, 56).

When we analyze another language, we recognize its limitations relative to our own, but the limitations of our own language tend to elude our notice (Derrida 1982, 198). It would be easier to examine the limitations of Indo-European languages, for example, from the vantage point of another language, such as Ewe.

In order to render some of the limitations of our language visible, let me suggest the lucidity of another kind of language of which most of us know at least a little, a language able to probe concepts and ideas that are not accessible to us in other written or spoken languages. As Derrida notes, this second language is not phonetic; although it can be written clearly, it cannot be spoken. Galileo reasoned that the book of nature was written in this very language (Der-

rida 1976, 16). This language that can probe otherwise inaccessible regions is Algebra (Derrida 1976, 303): "We ascertain through mathematics that language—vengeance upon linguists—is absolutely incapable of accommodating certain forms of modern thought" (Derrida 1976, 83).

If Algebra can function as an additional language to expand our concepts and our thinking, then we may have access to other such languages, one of which is painting. The painted image became the first writing, "a closed and mute system within which speech had as yet no right of entry" (Derrida 1976, 283). Then painting developed in two separate directions. The first direction remained painting, eventually evolving in Europe toward illusion, while the second direction began to simplify itself into "proto-writing": first pictographs, then hieroglyphics, then the phonetic alphabet (Derrida 1976, 293).

Certainly there are other visual languages, but the one most familiar and most easily understandable to our society is the illusion that developed during the Renaissance. We have used this illusionistic language in many forms—painting, photography, movies, and sculpture—for six centuries, and it has become so familiar that it appears to be native, natural, and self-evidently true; its boundaries and limitations have become as invisible to us as those of our native tongue.

Renaissance illusion and perspective have come to seem so self-evidently true that we tend to be blind to its departures from a true representation of reality. The Renaissance system of illusion, Mitchell notes, convinced an entire civilization "that it possessed an infallible method of representation, a system for the automatic and mechanical production of truths about both the material and the mental worlds." This "artificial perspective" denied its own artificiality and claimed to be a "natural" representation of the way we see the world and the way things are (Mitchell 1986, 37).

In order to recognize the limitations that our visual and spatial thinking has inherited because of being shaped and organized by six centuries of this visual language, we must study it as we would study a verbal language. It was those painters toward the end of the nineteenth century that began in earnest to probe the boundaries of this visual language and thus make manifest its capabilities and limitations, as well as its potential to mutate into other related languages. These mutations, in turn, gave us access to new areas of thought and concept.

An obvious priority in the language of Renaissance and baroque

painting was the granting of a higher status to value (dark-light structure) than to color. I shall demonstrate that this is one of several priorities that was methodically reversed during the course of the nineteenth century in order to probe the boundaries of the traditional Renaissance language in painting. Such changes gradually transmuted this traditional language into a new but related language that came to be known as modern art.

Though Renaissance perspective still seemed to be true, the new logical and mathematical evidence of other realities gradually began to breech its invisible boundaries and limitations. For the first time in four centuries, painters found scientific and rational grounds—in the concepts of non-Euclidean geometry—for believing there existed other powerful and equally valid ways to experience the world. They could now assume that there were other equally "objective" ways to represent these other realities, and they created powerful and convincing images that endowed these new assumptions with credibility.

These new geometries changed art, not only because they placed more importance on personal concept, but also because they created new demands for a consistency of structure, a new and logical rigor: it seems that even while engaged in the act of denying Euclid we are forced to use the method he gave us (Shapiro 1978, 216).[3] Thus, the pre-Kantian statement by Giordano Bruno in the sixteenth century, that there are as many true rules in art as there are true artists, became even more significant. Each painter might now have a personal construct that could be used to depict only a limited and unique niche of reality.

Social realities that had masked themselves as "truth" to an entire civilization were now replaced by myriad individual realities. Traditional devices that had been used to create the Renaissance illusion became subjects of experimentation and keys to new illusions. Thirsting for individual alternatives to well-worn imitations of nature, artists twisted, probed, and investigated all the conventions and devices of illusion—particularly linear perspective, the classic color

3. Shapiro says this change might be compared with the realization by mathematicians that they could profitably depart from Euclid's "real world" geometry and invent new and imaginary geometries that were just as useful. These new geometries were still submitted to the rules of logic; the rational relationships between theorems, axioms, and postulates were just as rigorous. Consequently "in painting as in mathematics, the role of structure or coherence became more evident and the range of its applications was extended to new elements" (Shapiro 1978, 216).

theory, and atmospheric perspective—during the nineteenth century. This was the age of an intense, methodical unraveling and reweaving of the elements of the Renaissance illusion.

From Aristotle to Locke, empiricists had held that reason was dependent upon the input of the senses for data. William Drummond, the seventeenth-century Scottish poet, had written, "What sweet contentments doth the soul enjoy by the senses! They are the *gates* and windows of its knowledge." Immanuel Kant in the *Critique of Pure Reason* once again focused attention on this important idea. But Kant differed from his predecessors: he maintained that experience was a more complex affair than they had supposed, and though all knowledge begins with sensate experience,[4] this knowledge depends upon the formal contribution of the mind itself. He held that "givens" (empirical intuitions such as color and sound) were interpreted through the formal organization imposed upon them by the experiencing person—the perception of the phenomena of sense through a combination of both sense and thought (Kant 1943, 21–22).[5]

Kant argued that the thinking mind shapes manifold sensate experiences and judgments with the help of *a priori* intuitions, particularly those of space and time (Kant 1943, 33).[6] Experience grew and evolved as the mind reacted to its environment, Kaminsky comments: "Thus, by analyzing what the mind does in giving rational form to external data, we should begin to see how the categories develop in experience. Like an art work that gradually attains form as the artist molds and remolds his clay, experience attains form as man reacts to a constantly changing environment" (Kaminsky 1962, 11).

The idea that the "animal senses"—as Le Brun had spoken of them in his advocacy of drawing over color—were not just a confused form of response, but another source of rational knowledge

4. *The Critique of Pure Reason* begins with this sentence: "That all our knowledge begins with experience there can be no doubt" (Kant 1943, 1).

5. "But, though all our knowledge begins with experience, it by no means follows that all arises out of experience. For, on the contrary, it is quite possible that our empirical knowledge is a compound of that which we receive through impressions, and that which the faculty of cognition supplies from itself (sensuous impressions giving merely the *occasión*), and addition which we cannot distinguish from the original element given by sense, till long practice has made us attentive to, and skilful in separating it" (Kant 1943, 1).

6. "Time and space are, therefore, two sources of knowledge, from which, *a priori*, various synthetical cognitions can be drawn" (Kant 1943, 33).

and learning, granted the respectability of reason to that knowledge that we acquire through the senses. This new attention to the role of the senses as rational knowledge opened new alternatives to artists, and it became an important reinforcement for those painters who wished to indulge the color sense. For the first time, they found rational justification for the gratification of the senses. This new reasoning supplemented the arguments of de Piles and liberated color from the low-priority and almost expendable role to which it had been relegated. Color was no longer considered merely a decorative element, unrelated to structure; it became a tool for creating direct impact on the senses and the emotions. The impressionists were further motivated to seek the sensuous pleasures of color because of their contempt for the superficiality and hypocrisy of the Victorian era, the polite veneer of European society, and the pomp and decadence of the French Academy (Blatt 1984, 295).

Late nineteenth-century painters instigated at least two major changes that would continue to guide artists during the coming twentieth century: they discovered the first logical alternatives to— or new models of—the conventional structures of Renaissance space; and each painter cultivated an individual and personal construct that ignored or excluded many of the obvious aspects of reality because these aspects fell outside the scope of their interests and investigations. Those ignored aspects of reality, though important, were nevertheless considered irrelevant to the artist's chosen direction. In other words, important truths in the real world could be ignored in order that the artist might better pursue other specific truths in more depth.

An individual's perception of the world is limited, but reality presents an infinite variety of perceptions, and an artist may depict fresh elements or new aspects of reality not previously represented: in this case the artist will have made an "artistic discovery" (Pirenne 1970, 173).

This proliferation of individual realities resulted in the beginning of a new strategy that would develop into "reductionism" in the twentieth century. The emphasis on individual strategies led to specialization, and the twentieth-century artist was encouraged to adopt a field of interest that was narrowed or reduced to one tightly focused, microcosmic investigation.

Because of this tight, new focus, painting became art about art rather than art about nature. Lévi-Strauss tells us that man is unique in his ability to create systems that multiply themselves within them-

selves. Man makes tools in order to make other tools; he uses language to talk about language; and he makes art that talks about other art. If one says, "man has two legs," then those four words are used to describe man himself and the words are used as language. But if one says, "*man* has three letters," the words are used to describe a particular aspect of language itself; thus, it is metalanguage —language about language.

Painting at the end of the nineteenth century began to exhibit many of the characteristics of a meta-art. If the painted shape of a man is used to describe man, it is art as language. But if the shape of a man is used to establish spatial parameters, then the visual signifier *man* is used to talk about the structure of art, not man, and it is therefore meta-art. If a painter used form and structure to "talk about" nature, then art is being used as language. If using the elements of nature as signifiers, with the intention of talking about the form and structure of painting, then the painter is making meta-art. When Ingres realized that painting was no longer "a window on the world, but a separate and autonomous entity, with its own particular, and strange, history," he discovered the aporia[7] that if it was not to be "a copy of the world, then it forms a field without origin except in other paintings" (Bryson 1981, 121)—painting inspired by painting and painting about painting.

A study of the literature and painting produced during the last one hundred and fifty years generates a perception that God has gradually distanced himself, and in the nineteenth and twentieth centuries, what Miller terms "God-in-hiding" can be experienced only as a "terrifying absence." Man feels his connections broken. He is disconnected from nature, from other men, and even from himself. If only "God would return or if we could somehow reach Him might our broken world be unified again" (Miller 1975, 2).

During this period of God's withdrawal, the world saw many changes in science and technology: industrialization, the rise of the middle class, the breakdown of class structure, and a coming together in great cities (Miller 1975, 4). This industrialization and crowding into man-made cities has transformed the world and erased the evidence of God's creation from man's immediate experi-

7. The word *aporia* or *aporetic* implies doubt, particularly doubt concerning boundaries or beginnings; thus it suggests a sense of reversal in the primacy of cause and effect or origins. Derrida even used *aporia* as an analogy for deconstruction when he spoke of "that singular aporia called 'deconstruction'" (Derrida 1986, 137).

ence and replaced it with the creations of man. Man's world reflects only the image of man: he cannot revitalize himself with that which is not human, and there is no room for God in man-made cities (Miller 1975, 5).

Has man excluded God by building cities, or have such cities been built because God has disappeared? Either way, the two are related: because men live in cities, they have experienced what it means to live without God, and modern literature and art betray by their very form this absence of God (Miller 1975, 6). But the arts thrived in these cities where God could not abide. Modern thinking, dominated by the presumption that each man is imprisoned by his own consciousness (Miller 1975, 8), is mirrored in the arts.

One of the important themes of art in modern times has been a sense of isolation and alienation: we are alienated from God, from nature, from other men, and from ourselves (Miller 1975, 8). Many nineteenth-century art works sought answers to this question: how can modern man find meaning outside himself—meaning that will indicate who he is and what his place is in society and in the universe? (Miller 1975, 9). The title of Gauguin's 1897 painting *Where Do We Come From? What Are We? Where Are We Going?* asks just such a question.

This age of doubt generated a kind of skepticism about the role and the nature of representation in art, Timothy J. Clark comments. "Certain doubts had previously been expressed in regard to this subject, but they had been peripheral rather than central to the task of constructing a likeness" (Clark 1985, 10). Doubts about representation were translated into doubts about vision, and "doubts about vision became doubts about almost everything involved in the act of painting." This aporia, these doubts concerning the boundaries of art, vision, representation, and everything important to the act of painting became a value and an aesthetic in its own right (Clark 1985, 12).

Degas's New Viewpoint

The work of Edgar Degas (1834–1917) illustrates a strong beginning to the new experiments with the abstract elements and structures of nineteenth-century art. He experimented with color as a structural device, he restructured the convention of Albertian perspective, and he used structure itself as subject matter in another step toward meta-art. One of Degas's most important biographers,

Ian Dunlop, maintains that "the studio for Degas was the equivalent of the laboratory for the alchemist—a place for experiment" (Dunlop 1971, 169).

Degas unraveled and rewove the precepts of the classic color theory in every new pattern that he could think of. He experimented with reversing the theory as Gainsborough had done: many of his paintings of dancers have vibrant blue costumes against a warm background.[8] He tried keeping the background hot as Hell in paintings like *Miss La La at the Cirque Fernando* (fig. 10.1). Sometimes he used all cool color. He tried theatrical bottom lighting. He often granted more importance to color contrast than to the traditional value contrast. In short, he experimented as much with the structural possibilities of color as any painter.

But in spite of his use of color, Degas is most remembered for his attack on classical composition. His strategy was simple: he merely raised or lowered his viewpoint in relation to the scenes he painted. He investigated the potential of worm's-eye and bird's-eye views in place of the mid-level, Albertian view of the subject, which is the result of a horizon line or vanishing point located at mid-height in the painting. This horizon line, located near the middle of the painting, is an innate part of Renaissance linear perspective; Degas, however, raised the horizon line in some of his interior views, such as *The Tub* (fig. 10.2), until it was above the top of the canvas and in others lowered it until it fell out the bottom.

Lowering or raising the horizon until it can no longer be located within the framework of the painting tends to flatten space because the viewer peers directly at a flat, though perhaps slightly slanted, plane—the floor or the ceiling behind the figure—and effectively eliminates most of the linear perspective that is unavoidable in an Albertian view of a room. Both the high and the low viewpoint tend to soften the relationship between space and the picture plane (White 1967, 68). Although Tiepolo and others had painted worm's-eye views of heavenly scenes displaying angels and devils and deities, Degas was the first to make extensive use of both the worm's-eye and bird's-eye views to depict normal people, everyday objects, and interiors.

In his attacks on the Albertian viewpoint, Degas began to try

8. Dunlop comments that Degas "often ignored traditional theory of colour perspective, which placed bright hues in the foreground and cool colors in the background, and in fact did the reverse" (Dunlop 1971, 193).

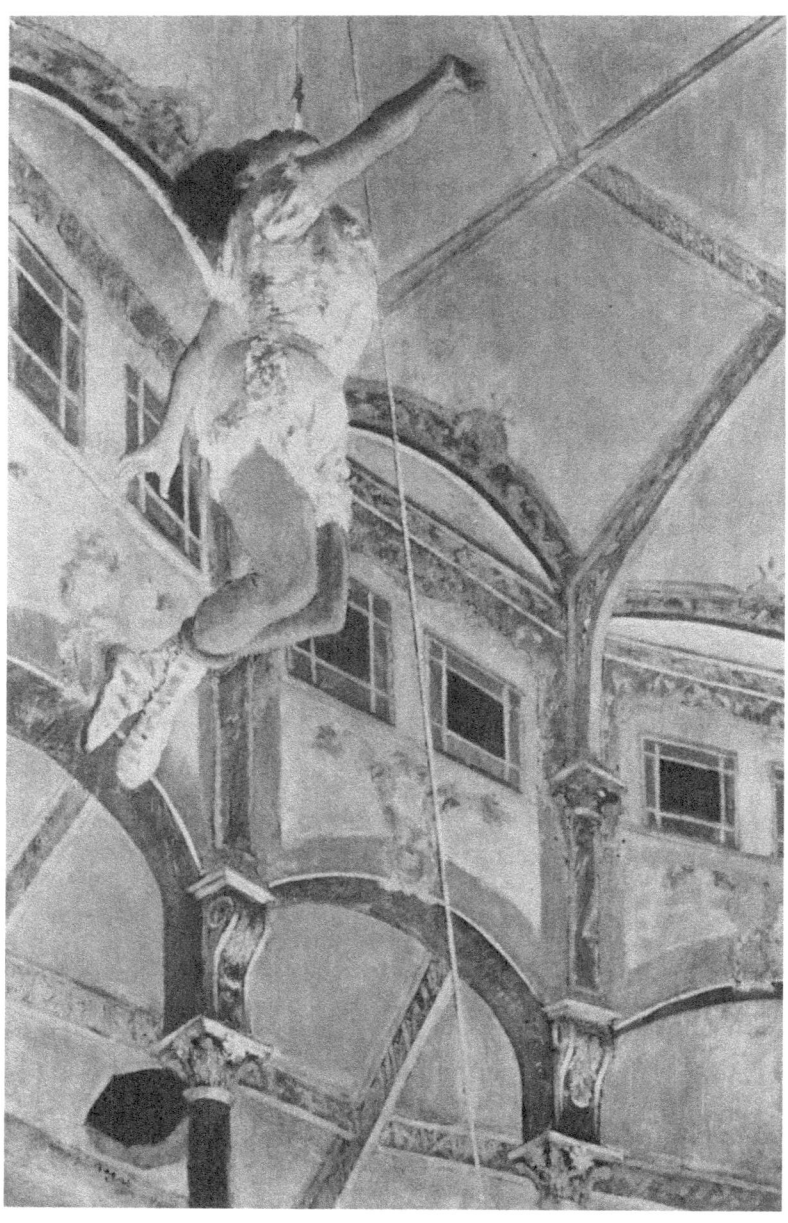

10.1. Edgar Degas. *Miss La La at the Cirque Fernando*. 1879. Oil on canvas (46″ × 30½″). Reproduced by courtesy of the Trustees, National Gallery, London.

every imaginable angle and vantage point from which to observe and draw his subjects, and he posed these subjects in every position the human body could credibly assume—hence his interest in ballet dancers. With all their stretching and limbering discipline, these dancers are the next best thing to contortionists, but they are more familiar and believable.

Degas's experimentation with radical vantage point and eye level, as demonstrated in *The Tub* (fig. 10.2), lay in direct contrast to the fifteenth-century practice of using frontal planes whenever possible in order to keep all distortion to a minimum. Degas's low viewpoints created situations that demanded foreshortening and distortion. His experiments and distortions resulted in a new approach to composition that structured the painting in terms of more diagonals and fewer Albertian horizontals and verticals. These new diagonals created a more dynamic composition: they were more electric with tension and suggestions of movement and temporality than the stable clarity of the classical approach, in which horizontals and verticals froze motion to timeless monumentality. Degas experimented with moving the position of the implied viewer but still did not succeed in departing from the most important principle of Renaissance linear perspective. The structure of his perspective, which still oriented each object and figure to a single specific viewing location thus maintained the unifying Renaissance construct of a single unmoving viewer. Degas's experiment may be seen as the beginnings of constructing a new kind of post-Cartesian viewer, a topic I shall discuss further in chapter 19.

Though Degas was closely associated with the impressionists, he had little in common with them. While they painted landscapes, he painted interiors and figures. While they used the landscape to avoid linear perspective, he used low and high vantage points to the same end. While they relied more on direct observation on the site, he relied on his imagination (Dunlop 1979, 125).

It is plausible to interpret Degas's approach to the figure as another step in substituting space, in place of man, as the center of interest in painting. As form became his content, he began to use models, like still lifes, as nothing but a subject to be exploited in his search for new form and structure. Perhaps this is why he seldom painted faces. His use of the figure was more a habit, a respectful nod to tradition, than any genuine interest in the person, or personal events. The figure was there only as the other part of the figure-ground equation. Even though Degas worked from the model,

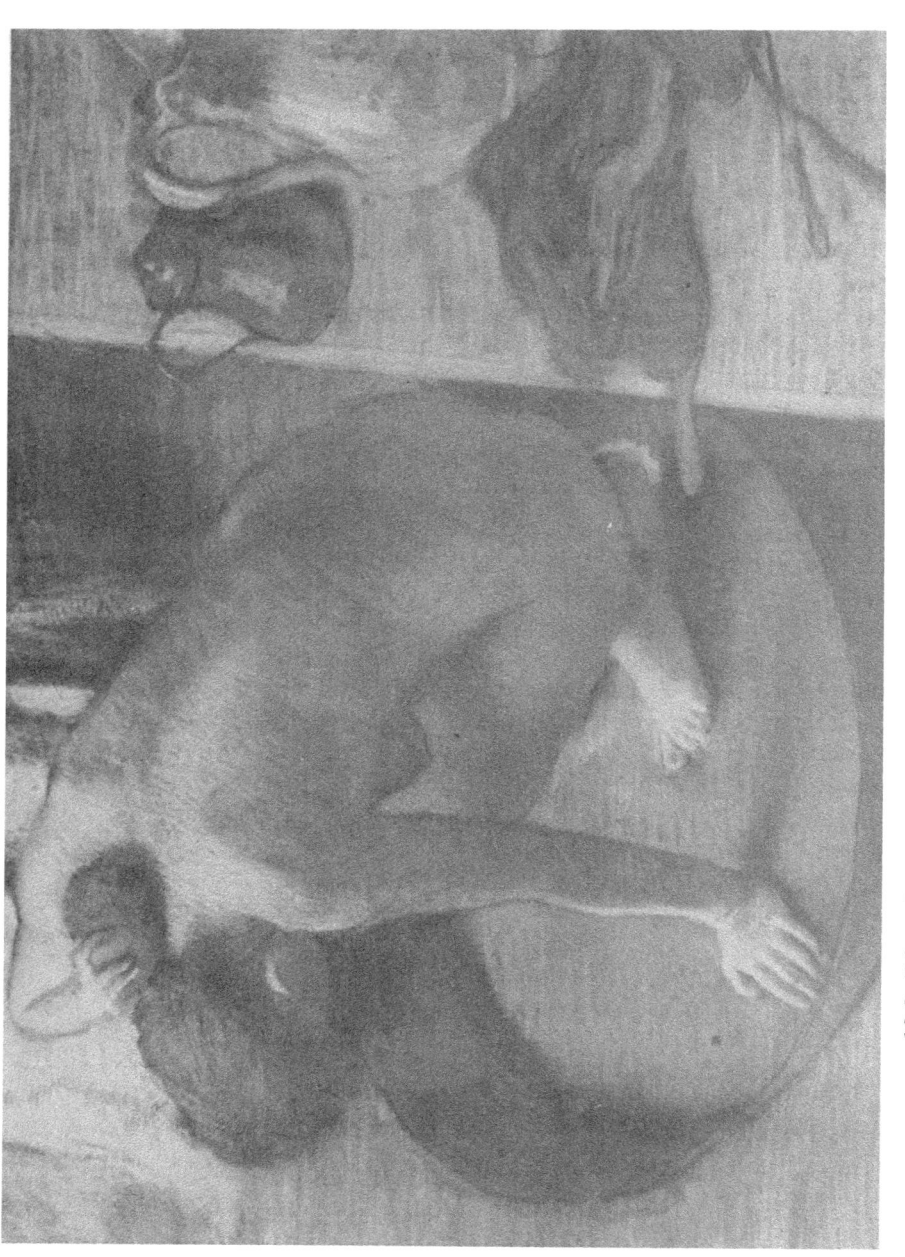

10.2. Edgar Degas. *The Tub*. 1885–1886. Pastel on paper ($23^{7}/_{8}'' \times 32^{5}/_{8}''$). Louvre, Paris. Photo: Giraudon/Art Resource, New York.

he had become so emotionally detached that the figure in his paintings functioned only to make the picture possible (Hunter and Jacobus 1976, 12).

Degas's pursuit of his own individual reality at the expense of the conventional social reality of the past emphasized individual vision. It was this emphasis that led to specialization and a pursuit of reductionism through the last half of the nineteenth and the first half of the twentieth century.

11
Monet's Synthesis of Depth and Flatness

FROM THE LAST HALF of the nineteenth century through the 1950s the thrust of ideas in painting will concentrate on the flattening, or reflattening, of pictorial space. (Willem de Kooning and Jasper Johns were to execute the final step in this direction.) Creative insights in the history of art E. H. Gombrich finds analogous to "the forging of master keys for opening the mysterious locks of our senses to which nature herself originally held the key." Once the key is shaped and the door is opened, "it is easy to repeat the performance. The next person needs no special insight—no more, that is, than is needed to copy his predecessors' master key" (Gombrich 1961, 359–60).

The Renaissance perception of man as the center of the universe stands in opposition to modern man's sense of being just another rather trivial element in the giant tapestry of an ever-expanding universe—a slight distortion, an insignificant point, in the fabric of infinity. Evidence of this new attitude began to appear in the work of Monet and his integration of the human form into the overall fabric of the painting in a way that facilitated the flattening of pictorial space. When the problem of spatial separation between figure and ground had been solved, one of the major obstacles to pictorial flatness had been overcome. Instead of painting objects the way we see them, the impressionists painted the act of seeing itself, and the resulting paintings captured a multitude of sensations (Ortega y Gasset 1972, 30).

Thus impressionists departed the single light source and rational space of Renaissance painting and began to "see" the world, in a manner influenced by Rembrandt, as flickering lights ricocheting off the surface of a variety of objects. All images—water, trees, people, and landscape—were painted in the same objective manner, using

the same technique. The image *in* the painting was subordinated to the image *of* the painting as a cohesive entity.

This unified treatment is apparent in *La Grenouillère* (fig. 11.1). Monet defined everything in the painting with dark and light areas of the same approximate size and shape. The dark and light horizontal shapes that capture the essence of water are similar to the vertical darks and lights that read as human figures. The dark and light shapes of the boats maintain the consistency of this visual construct. The arrangement of these darks and lights, so similar in size and shape, within each figure or depicted surface functions to develop the volume and space of the individual objects. But these same areas of dark and light simultaneously destroy volume and space by their relentless flickering across the surface of the painting. When seen as a cohesive image across the surface of the entire canvas, these flickering lights constantly summon the viewer's attention back to the flat canvas. The use of flickering light to develop recursively, then destroy, the illusion of volume, then flatness, creates two separate images, each negating the other.

Monet was still making concessions to classical space: a minimal use of diminishing size, the low Albertian viewpoint, the separation of planes, a modified use of the classic color theory, atmospheric perspective, and the low Albertian viewpoint that still implied a single Cartesian viewer. Monet retained strong darks and lights in the foreground and dissolved distant objects into the value of the background in what Leonardo called "the perspective of disappearance," or "vanishing perspective."

As mentioned earlier, the new privileging of atmospheric perspective over the traditional linear perspective wreaks less vengeance on the sensation of flatness in the picture plane. *La Grenouillère*, like many of Monet's early paintings, is realized in terms of dark-light contrast with little color contrast. The following reproductions of Monet's paintings will indicate his gradual reversal of the dark-light over color priority.

Photography was fairly common by the late nineteenth century, and the impressionists may have been influenced by the "believability" of a photograph. A photograph seemed to be quite credible as an illusion of the outside world in spite of the flat manner in which it depicted figures.[1] There was often no dark and light side to

1. Joel Snyder reminds us that "the construction of the camera did not flow out of the abrupt discovery of the 'image of nature' but rather that it was developed as an

132 *Changing Images of Pictorial Space*

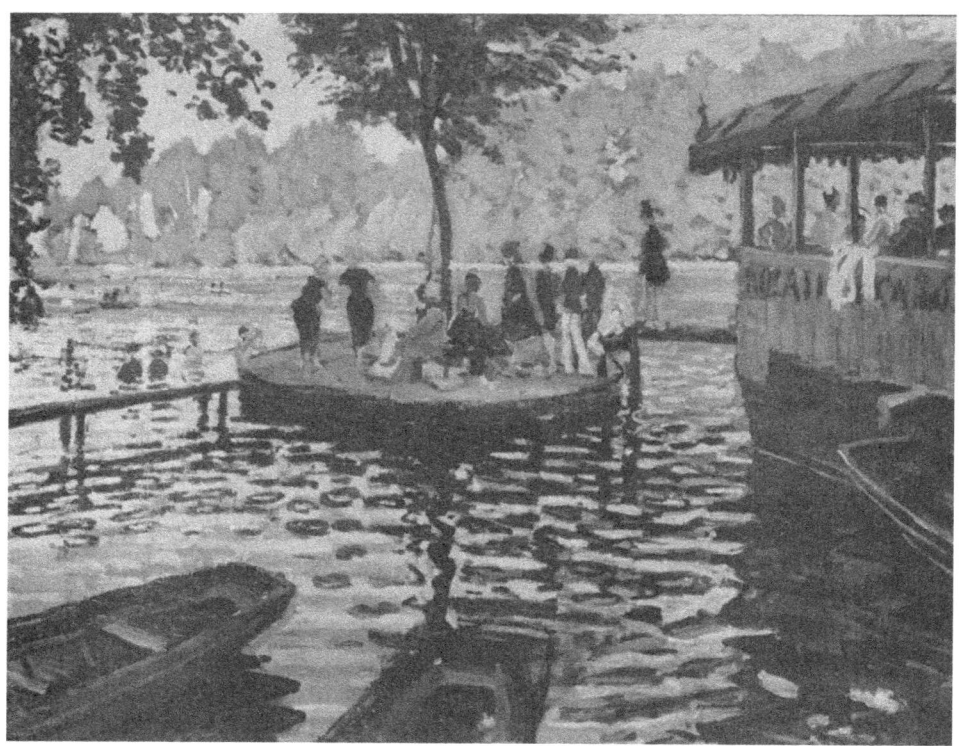

11.1. Claude Monet. *La Grenouillière*. 1869. Oil on canvas (29³/₈″ × 39¹/₄″). Collection, Metropolitan Museum of Art, New York. Bequest of Mrs. H. O. Havemeyer, 1929. The H. O. Havemeyer Collection.

photographed objects because early photographers had a tendency to stand with their back to the sun, so that pictures had even front light from one side to the other. Front-lighted figures in a photograph look quite flat compared to the traditional painter's volumetric rendition. The influence of such photographs may have been partly responsible for the impressionists' tendency to paint their figures flatter, less volumetrically.

aid for the production of realistic paintings and that such paintings provided the standard for the kind of image the camera was designed to produce" (Snyder 1980, 231). He adds that "camera makers had to be told what the specific need of the artist was before they could work out a design for a camera that would satisfy that need. The mechanism of the camera was thoroughly standardized to meet specific pictorial requirements" (Snyder 1980, 233).

Photography had another important influence on the direction of painting. Painters, realizing that the camera could do particular things far better and more easily than they could, made an effort to concentrate on areas in which the camera could not compete. There "seems to be little doubt that many artists in fact have reacted to this 'unfair competition', preferring to use modes of depiction as different as possible from photographic perspective" (Pirenne 1970, 182). Painters quickly gave up realism and facsimile portraiture. Photography confused the common viewer. Artists felt that this new invention had vulgarized the representational rendering of the external world, and they were concerned that the public had confused the aims of painting with those of photography (Rose 1976, 12). Consequently, painters began to redefine art in terms of those aspects which were proper to art: the two-dimensionality of the paint surface, the process by which the paint was applied, and the qualities of the personal marks created by this process (Rose 1976, 12).

In 1939, six decades after the beginning of impressionism, the painter Arshile Gorky was still pondering the camera's effect on painting: "the camera has rendered impotent any attempt to compete with it. . . . What reason, therefore, remains to sit in realism's stagnation? Art is more than mere chronicle. It must mirror the intellect and the emotion, for anyone, even a commercial artist or illustrator, can portray realism" (Gorky, from Ashton 1985, 207). In this reaction against realism, it was an outside element—photography— that motivated artists to restructure previous assumptions relating to the emphasis upon mimesis over form and abstraction. Certainly the boundaries between painting and photography would become more and more blurred during the twentieth century as people like Rauschenberg and David Salle used photography as a major part of their painting.

Impressionists painted landscapes partly because they were interested in the effects of sunlight and the attendant flattening and dissolution of linear form, and partly because it was a method of avoiding the obvious device of linear perspective, other than Degas's method. One reason these painters were seeking to avoid linear perspective was that they had discovered the expressive power inherent in maintaining the visual presence of the picture plane. Impressionists tried to avoid the deep spatial illusion of Renaissance perspective that carves illusionistic holes through the physical entity of the canvas and destroys its solidarity.

The impressionists wished just as fervently as the Renaissance

artists to depict the world the way it appeared, but they used no straight lines, and they used patches of color to represent a shimmering texture of light. Their technique created a dense, all-over image that treated both surface and event as items of equal importance, in place of the more traditional illusion of empty space that contained solid objects (Gablik 1977, 69). Thus, Hans Hofmann contends, the impressionists "rediscovered the full plastic significance of the picture plane as a two-dimensional entity. The reason for this rediscovery was a search for the entity of light, expressed through color, which resulted in re-establishing the two-dimensionality of the picture plane" (Hofmann 1967, 46).

This self-conscious awareness of the flat surface of the painting resulted from a reversal of priorities in the relationship between the illusionistic and the abstract or compositional elements. In the nineteenth century, we see the beginnings of a direction to culminate in the 1950s, when the flatness and abstraction of the original painting are accorded hegemony over the imitation of any object outside the painting.

This awareness of the solid entity of the picture plane both impedes and facilitates illusion in a recursive negation and affirmation of illusion. First, as Pirenne notes, it destroys illusion by calling to the viewer's attention the "so-called marginal distortions of exact perspective." Second, this awareness of the surface imparts stability to the perception of the scene represented even when the painting is viewed from a position other than in the center of the painting. This displacement of the viewer from the center should theoretically deform the perspective of the scene, "yet in practice these deformations are hardly noticeable." Finally, when maintaining an awareness of the surface qualities of the painting, the viewer sees the painting as a cohesive entity and must be affected more by composition and structural elements. That is, those specifically "artistic elements" that abstraction shares with representational painting assume more importance (Pirenne 1970, 12).

Baroque painters had compressed bulky masses against the flat picture plane in order to maintain a shallow pictorial space, and the impressionists pursued this direction to its logical conclusion: a flat picture plane. The impressionists, however, perceived the inconsistency of trying to integrate round objects into a flat plane, so—along with linear perspective—they rejected the illusion of volume in objects and figures. This flattening of the figure not only ended any need for the shading of dark and light sides on the figures, but it

also paved the way toward the reversal of more established priorities and placed a new emphasis on color, instead of dark-light structure.

The impressionists were the first who consistently took their paint and canvas outdoors to paint a scene, and linear perspective serves little purpose in the rendering of landscape. Linear perspective was demonstrated by an architect, Brunelleschi, to be used in the rendering of architecture, and that is where it serves most usefully. There are seldom any straight or parallel lines in nature to converge towards organized vanishing points. The impressionists gravitated toward the field of landscape painting, where sight counts for so much more than calculation" (Gombrich 1965, 315).

The landscapist found three elements of the Renaissance illusion were still useful: the separation of planes, atmospheric perspective, and color perspective. But changing the content of paintings changed the relative status of the major elements of perspective.

Monet's first step in initiating the use of more saturate color in painting was to de-emphasize value contrast in favor of color contrast. He then discarded, or changed the status of, the remaining elements of Renaissance perspective in favor of a flatter pictorial space. In *Poppy Field in a Hollow near Giverny* (fig. 11.2), the space is turned up at the back edge as if the viewer were standing in the center of a large bowl. The immediate foreground suggests recession, but the background turns up toward the sky and starts to flatten out: choosing a subject that is itself flat becomes another approach to flattening pictorial space.

Unlike painters who create "congruent compositions" with a consolidation of light, warm, thick, and opaque areas of paint, Monet purposefully separated at least two of these compositional elements in this painting. The composition in dark and light was maintained as distinct and separate from the composition in warm and cool. If a diagram were drawn of the light areas, it would include the strip of sky and the light triangle of grass on the left. The dark areas would include the long line of bushes near the top of the painting with the smaller dark patches of bush immediately below. The warm area at the bottom of the painting, however, is the red rectangle of flowers that recedes in linear perspective toward the background. Monet often separated dark-light composition from composition in warm and cool. The elements of perspective were first structured to yield congruent compositions in the sixteenth century; Monet then restructured these elements in order to separate the formerly congruent dark-light and warm-cool elements of this compositional technique.

136 Changing Images of Pictorial Space

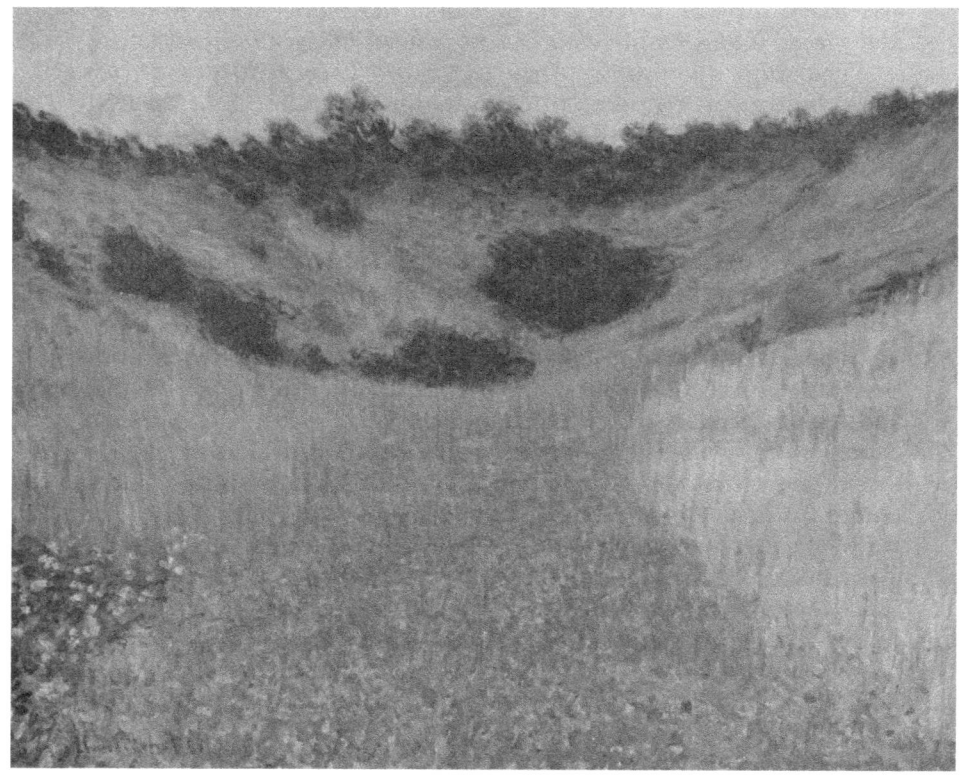

11.2. Claude Monet. *Poppy Field in a Hollow near Giverny.* 1885. Oil on canvas (25⅝" × 32"). Juliana Cheney Edwards Collection, Courtesy, Museum of Fine Arts, Boston.

The seventeenth-century "débat sur le coloris," between Le Brun and de Piles, continued—but with new leaders—through the first half of the nineteenth century (Dunlop 1967, 23). This argument had split artists into two opposing factions: those who considered color to be superficial and drawing to be the most important structure in painting, against those who believed color to be paramount.[2]

2. Dunlop writes that "French painting in the first half of the nineteenth century was dominated by Ingres and Delacroix. It is natural to think of them as opposites: the one an upholder of line and of Classicism, the other a defender of colour and Romanticism" (Dunlop 1967, 23).

The constant inversion of the status of these two basic opposites will continue producing new images for the next hundred years.

Finally, at the end of the nineteenth century, several artists discovered—with the help of such precedents as those of Tiepolo and Delacroix—a method that promised to unite rather than juxtapose these two dichotomies. The use of color temperature as a device for achieving a sensation of volume, and later its use as a compositional element, began to fit color into the same formal structures that had previously been reserved for dark-light relationships. The consolidation of three major concepts furnished a fertile ground for the equality, even perhaps the supremacy, of color: (1) the classic color theory; (2) the newfound formal structures of volume and composition through the use of color;[3] and (3) Kant's successful advocacy of the respectability that consciousness was necessarily developed through the senses. Monet's direction seems almost inevitable.

In Monet's *Rouen Cathedral, West Façade* (fig. 11.3), there is a further shift away from an emphasis on value contrast. The values do not range from black to white; they extend only from blue to a light half-tone. Monet did not use many different colors in this painting, but complements are strong contrast: they are the colorist's counterpart to black and white. Monet's value control allows more color contrast than would be acceptable in paintings such as *La Grenouillière* (fig. 11.1). Even though the painting appears to be mostly a monochromatic blue, there are accents of orange, which at this time Monet probably believed to be the complement of blue.

There was no longer any need for the Renaissance devices of linear and atmospheric perspective in the painting of a nearly flat surface with negligible recession. The illusion in this painting is of a softly undulating surface with shallow depressions—architecture without linear perspective. Monet flattened pictorial space by selecting a nearly flat subject to paint. Once again, a change in priorities was initiated, or facilitated, by a change in content

Monet executed several of these cathedral paintings simultaneously. He set them up each morning, and painted on one from

3. Delacroix had written in his journal, "Remember the simple effect of the head. It was laid in with a very dull grey tone. I could not make up my mind whether to put it more into shadow or to make the light passages more brilliant. Finally, I made them slightly more pronounced compared with the mass and it sufficed to cover the whole of the part in light with warm and reflected tones. Although the light and shadow were almost the same value, the cold tones of the shadow were enough to give accent to the whole" (Delacroix 1980, 79).

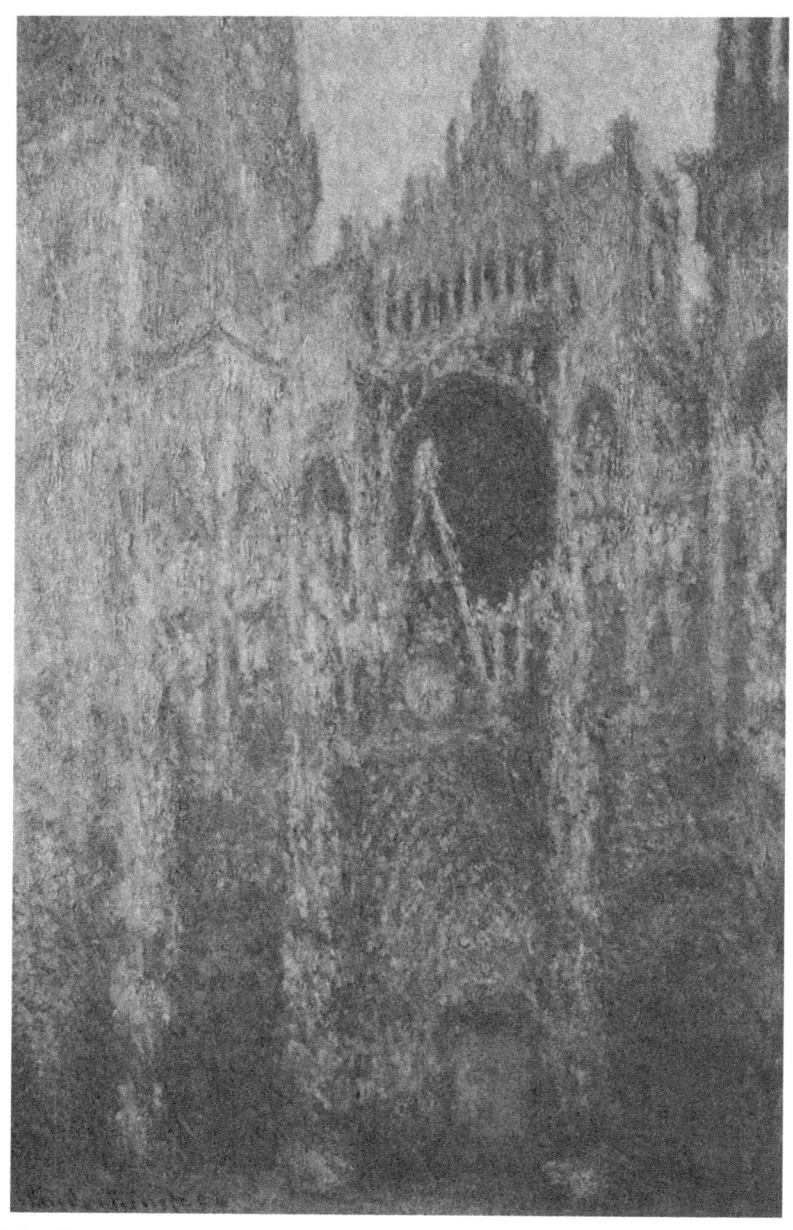

11.3. Claude Monet. *Rouen Cathedral, West Façade*. Dated [18]94. Oil on canvas (39½″ × 26″). National Gallery of Art, Washington; Chester Dale Collection.

eight to nine o'clock, on the next from nine to ten, and so on. Each painting was worked on only during one hour of each day. There were two reasons for this routine: to maintain a constant light throughout the execution of each painting and to create the sensation of a passage of time.

In both the cathedral series and the haystack series, Monet not only implied a passage of time but indeed "fragmented his object into a succession of moments of observation" (Hunter and Jacobus 1976, 11). When the paintings are seen together in a body, the changing light—as seen at different times of day—is evocative of different slices of time.

In *Rouen Cathedral, West Façade, Sunlight* (fig. 11.4), Monet succeeded in creating a luminosity over the entire painting that allowed subject matter to dissolve and all but disappear in an orgy of blazing sunlight. Monet dropped all pretense of contrast in value or dark-light composition. Color was adjusted to the same value throughout the painting. The color in the hemispherical recessions of the facade is changed in temperature, not in value. The light blue shadows on the facade echo the blue of the sky that slices down into the building. This connection maintains a unified cool composition and simultaneously flattens the picture plane. The sky, being of the same value and color, is not allowed to recede visually more than the similar blue areas on the façade. The pictorial space in this painting is shallow. It is about as flat as a painter can keep a painting (I believe no painter achieves a flatter space until Willem de Kooning and Jasper Johns in the twentieth century). But perhaps this flatness is bought at the cost of a decorative surface that is crusted with sweet cake icing.

The impressionists' search for light led them to broken color and the dissolution of form, which, rather than fusing together in the eye as so often touted, functioned to summon the viewer's eye and attention constantly back to the textured physical surface of the painting. Thomas Hess, an early editor of *Art News*, argued that the impressionists dissolved form into "arbitrary units of color," which were expected to fuse in the retina, as the viewer moved away from the painting, to depict the play of sun and shadow across objects. But, because viewers seldom stay twenty feet away from a painting, many of these works do not fuse and instead remain visually flat-textured surfaces in which the "bumpy hatches can never be overlooked" (Hess 1951, 31).

Because of the impressionists' application of thick paint, the flat

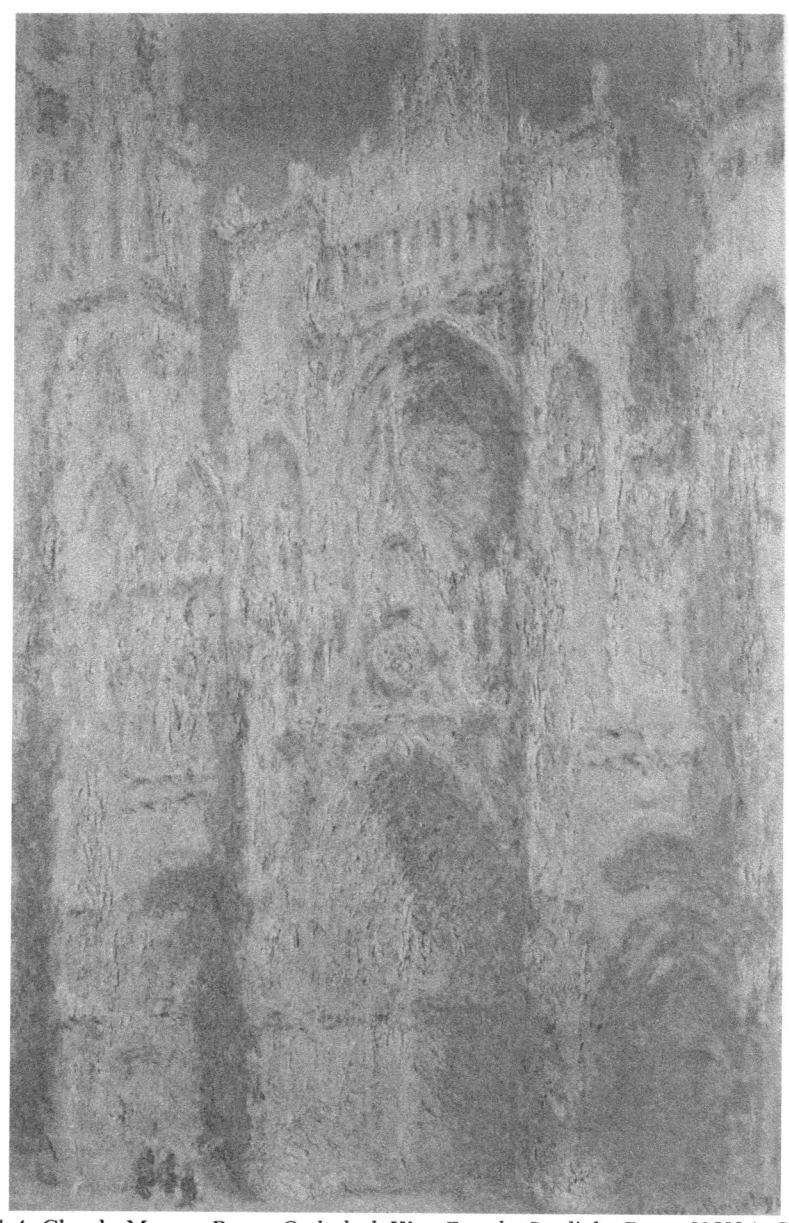

11.4. Claude Monet. *Rouen Cathedral, West Façade, Sunlight*. Dates [18]94. Oil on canvas (39½" × 26"). National Gallery of Art, Washington; Chester Dale Collection.

surface of the painting could no longer be pushed from the viewer's consciousness, and the physical presence of the paint surface assumed more status. These paintings were no longer illusions in which the viewer could "look through" the surface to "see" objects. Instead, the viewer was forced to an awareness of the canvas as a single physical entity. Michael Podro points out that viewers make real distinctions between those paintings in which the surface and technique are *not* noticed and those in which they *are* noticed: in the first case the viewer "looks through" the surface to perceive depicted objects; in the second case the paint surface is inescapable. The second attitude is recognized as "characteristic of art." The more Rembrandt's handling of paint forces us to attend to the brush strokes that describe drapery, "the more we are led to notice more aspects of the folds of the drapery which in turn redirect us to the paint; it is an analogy which 'grows and grows in the mind'" (Podro 1972, 87). The reversal of priorities concerning the transparent-opaque opposition in the treatment of the picture plane is a major component in the modernist attack on Albertian Renaissance perspective.

12
Cézanne's Elaborate Separation of Planes

MONET HAD EXPLORED the relationship among the three major painterly realities: the physical entity of the flat picture plane, the depiction of depth upon that flat surface, and the real depth and space of the world outside the painting. Cézanne relentlessly pursued Monet's lead, but he searched for "a new solution that would reconcile his 'sensations' of depth in the three-dimensional space of external reality with an acute awareness of the two-dimensional limits of the painting surface" (Hunter and Jacobus 1976, 18).

Modernism has evidenced a concern for flatness, Timothy Clark notes, and painters since Courbet have time and again considered their rediscovery of the flatness of the picture plane a striking fact. This flatness could not have become such a compelling and practical issue unless it signified some substantial set of qualities related to the late nineteenth-century picture of the world. The rich stream of painterly ideas that flowed from the concept and the quality of the flat surface of the painting after 1860 might be "redescribed" in terms of the complex significance that was related to both flatness and areas of society other than art. Flatness was often understood to be compatible with the attributes of the common man: it was plain, workmanlike, and emphatic, and the loaded brushes were considered appropriate tools; thus, painting was considered to be honest manual labor (Clark 1985, 13).

Clark points out that flatness was also an emblem of modernity, and flat surfaces were reminiscent of posters and labels and fashion prints and photographs. More straightforward painters brandished this flatness as a symbol of their direction as Fine Artists rather than illustrators. But this assertive two-dimensionality of the picture plane also functioned as a complex code that signified certain aspects of the world and art's relation to it. Because certain truths, on the one hand, felt to have been revealed by higher mathematics and, on the

other, considered part of the contemporary understanding of the nature of subjectivity, painting could be understood to "replace or displace the Real" (Clark 1985, 13). That is, the painting began to be thought of as something real itself, not just a depiction of an external reality.

Furthermore, Clark contends, the unbroken unity of the surface was interpreted, especially by Cézanne, as a sign for the unrelenting consistency and evenness of sight itself. In its day the flat picture plane did mean all these things, and flatness was an irreducible fact of painting, with endless attempts to use it as a metaphor (Clark 1985, 13).

Paul Cézanne (1839–1906) admired the bright color of the impressionists, but he thought their paintings were too flat, too decorative and superficial. He insisted that they had sacrificed the structure of pictorial form—volume, spatial placement, and depth—to an irresponsible quest for color. He determined to synthesize the solidity of Poussin and the more saturate color of the impressionists. Cézanne was searching for a compromise between the dark and light volume of the baroque and the colorful flatness of impressionism. He probed that middle ground between the incongruity of the baroque figurative bulk woven into flat pictorial space and the more monolithic appearance of complete flatness in the treatment of space and figure in impressionist paintings.

In his early paintings, Cézanne composed and modeled in a method similar to the baroque manner. He used dramatic dark-light contrast to achieve volumetric illusion. But, after the influence of the impressionists began to shape his paintings, he used more color. Although he followed the classic color theory as it pertained to spatial placement, he still used a dark and light side to achieve the appearance of volume.

In his early paintings, Cézanne used a strong dark and light side to develop the illusion of volume in figures and fruit, and he composed primarily in dark and light. These paintings show that Cézanne still accepted the traditional viewpoint that granted higher priority to dark-light structure than to color. For *Still Life with Apples and Oranges* (fig. 12.1)—still composed in dark and light, with cool blue used to make the background recede—Cézanne invented a new method to create the appearance of volume in the fruit. He divided the apples into separate planes, of red (warm), yellow (transition), and green or blue (cool). The red areas establish what Cézanne calls the "culminating point"—that point of the apple that appears to be

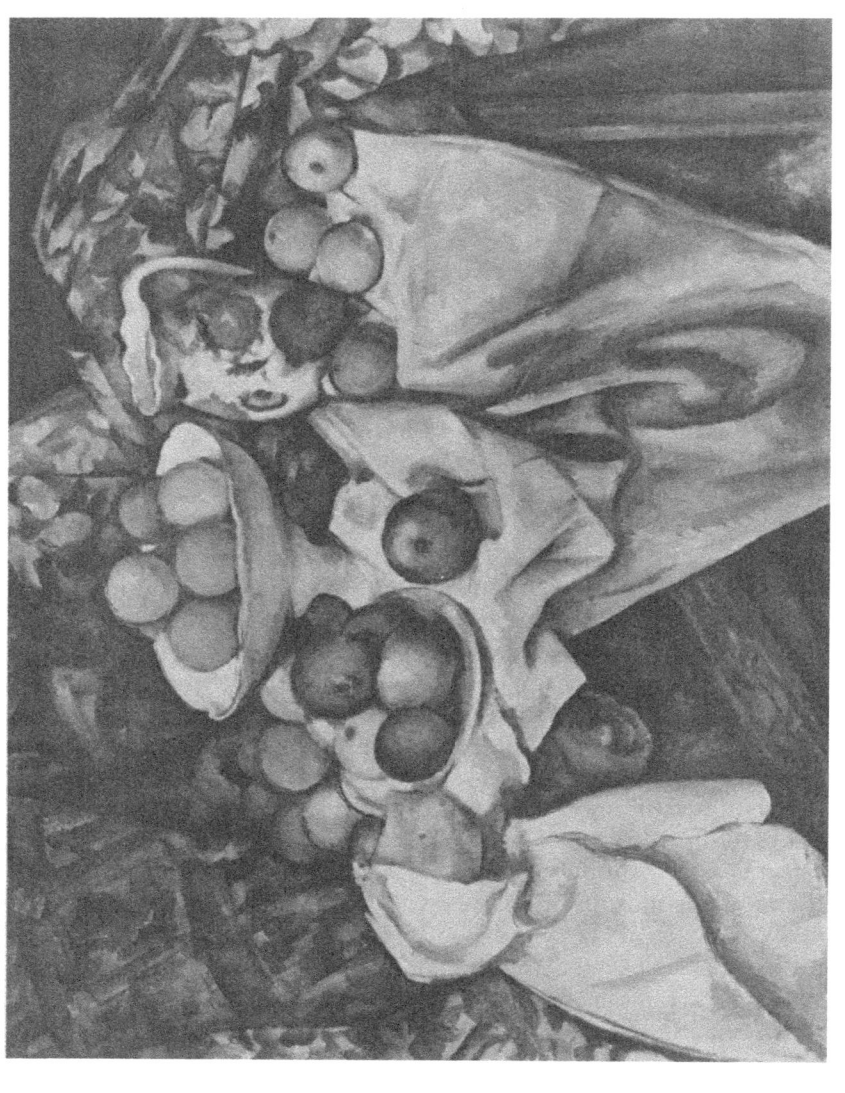

12.1. Paul Cézanne. *Still Life with Apples and Oranges*. 1895–1890. Oil on canvas (28¾″ × 36¼″). Louvre, Paris. Photo: Giraudon/Art Resource, New York.

nearest the viewer—while the blurred blue and green areas induce the edges to recede behind the salient red middle of the apple.

The classic color theory had traditionally been used to create spatial placement in painting, but Cézanne was the first to modify the priorities of this theory in order to make it more compatible with the creation of volume within a single object. Blatt explains that "subtle gradations of hue around an object beginning at a climactic center, the point closest to the observer, create volume and a fullness of form" (1984, 316). Depicting an object in the round is rather simple once the concept is understood: if the center of the object appears salient and the edges appear to recede, the object must appear to be round. In a letter to Emile Bernard, Cézanne wrote that "in an orange, an apple, a bowl, a head, there is a culminating point; and this point is always—in spite of the tremendous effect of light and shade and colorful sensations—the closest to our eye; the edges of the objects recede" (from Chipp 1968, 20). Roger Fry, one of the leading formalist critics of the Bloomsbury group in England, observed that "through the bewildering labyrinth of this analysis [Cézanne] held always, like Ariadne's thread, the notion that changes of colour correspond to movements of planes" (Fry 1927, 39). The idea that the aspects of reality revealed by color were as important as those revealed by dark and light was not new. Leonardo, noticing the change in color of the different planes of objects, had even offered a scientific explanation: thus impressionist painting already existed in Leonardo's writings if not on canvas (Fry 1927, 29).

Cézanne, by defining the volume of the object in terms of salient and recessive frontal planes,[1] avoided the compromise of sacrificing the illusion of volume to color, or vice versa. He created a sensation of bulk or volume in his figures yet still retained full saturate color. Cézanne's development of color, rather than dark and light, to define volume is a reversal of priorities in the dark-light versus color opposition.

Cézanne then incorporated this structural use of color into his spatial image. In his later landscape paintings, such as *Mont Sainte*

1. In his classic book, *Cézanne's Composition*, Erle Loran maintains that "Cézanne invented the system of modulating a volume from its cool, dark side to its light, warm parts in chromatic nuances—that is, a series of steps or planes. The volumes attain by means of these tiny, overlapping color planes a solidity different from that attained through mere dark-to-light modeling; it is a solidity based on the protruding character of warm color and the receding tendency of cool" (Loran 1950, 25).

Victoire (fig. 12.2), Cézanne fragmented each scene into a myriad of frontal planes, some advancing and some receding. He followed the first tenet of the classic color theory—warm colors in the foreground and cool colors in the background—without deviation. Unlike painters of the past, however, he used all saturate color: that is, he did not grey color as it receded into pictorial depth. Cézanne used color to create an integrated spatial and volumetric image that makes it possible for the painting to be read as flat, or as spatial and volumetric. This technique allows the possibility of maintaining an awareness of either a sensation of depth or the reality of the flatness of the painting.[2] One reading denies the other. When the viewer is conscious of depth, the flat surface is denied; when the viewer's awareness is dominated by the flat image, depth is denied. But neither reading can be resolved as final; both continue to assert themselves intermittently.

Cézanne discarded the obvious device of linear perspective—specifically converging parallel lines—in order to concentrate on the spatial use of color and the separation of planes. He discarded the single, unified viewer-site of Renaissance linear perspective in favor of a system similar to the Greco-Roman. He ignored the Albertian viewpoint, which unified the painting by depicting all the objects from a single viewpoint, once again to depict each object from its own particular frontal view, unrelated to the viewpoint of other objects or to the overall space of the painting. Cézanne consistently changed perspective and viewpoint within the picture in direct avoidance of Renaissance central perspective with its single, unified viewpoint.

Cézanne reversed the traditional use of atmospheric perspective, employing it to flatten pictorial space rather than to create an illusion of depth. An even focus was maintained consistently throughout the painting: edges, details, and brush-strokes were equally crisp, whether they signified distant mountains or salient foreground. Cézanne's brush strokes did not follow the shape of the object; they remained parallel to each other so as to assert the flatness of the painting. These parallel brush-strokes depicting frontality led Cézanne to depict separate planes as patches of color, representing

2. Seitz, suggests that in Cézanne's paintings, "assertion of the picture plane does not result in patternistic flatness but is inseparable from depth; 'translucent' or 'transparent,' the plane is implied rather than stated. Its existence and its position in space (for details often extend from it) are established by all the contributing elements of the composition" (Seitz 1983, 42).

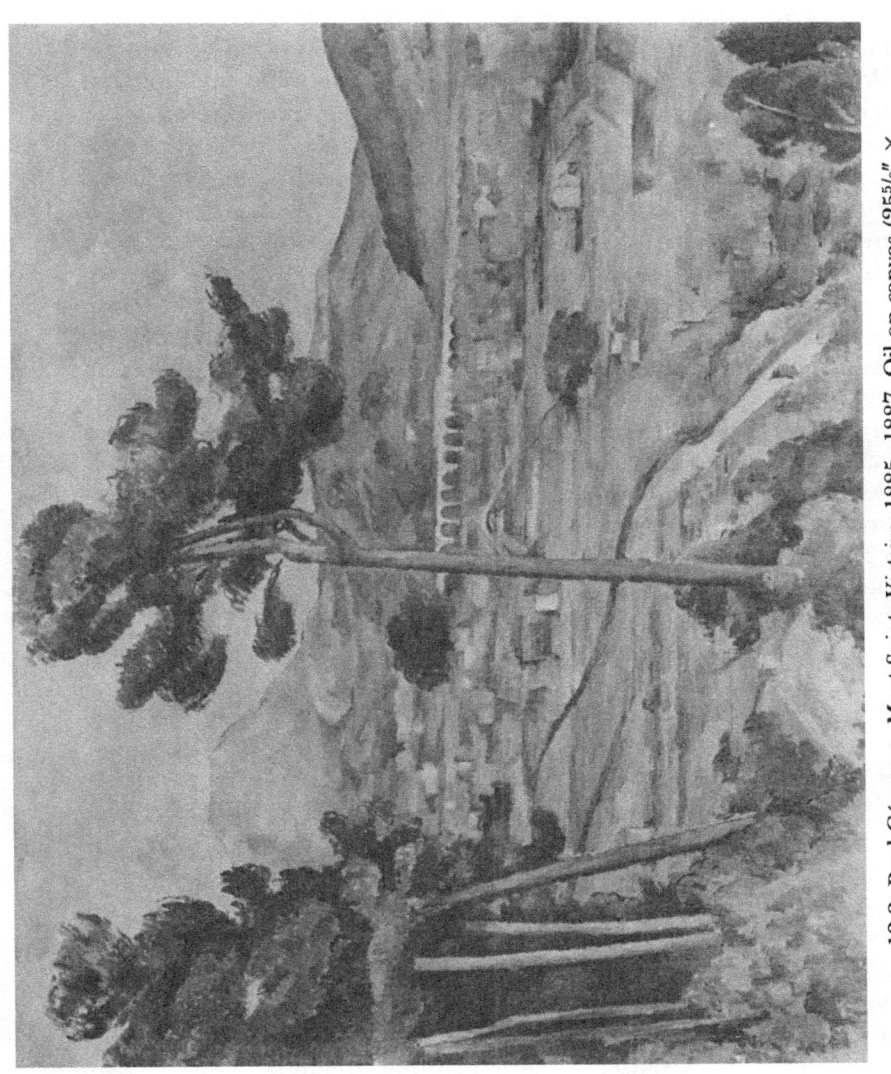

12.2. Paul Cézanne. *Mont Sainte Victoire.* 1885–1887. Oil on canvas (25⅝" × 31⅞"). Metropolitan Museum of Art, New York. Bequest of Mrs. H. O. Havemeyer, 1929. The H. O. Havemeyer Collection.

paper-thin layers in space, which appeared to recede into the distance (Twitchell 1987, 25).

Structuring the painting in color inverted priorities in the opposition of dark-light and color: Cézanne now attached little importance to dark-light structure and instead granted primary status to color. This major innovation is a complex elaboration of the first major fifteenth-century spatial device: the separation of planes. All one need do is compare a Renaissance painting (in which value is most important) to a painting by Cézanne (which concedes hegemony to color) to discover that each is capable of depicting certain aspects of reality that the other cannot. Each painting exemplifies a different structure and thus exposes the otherwise invisible boundaries and limitations of the other.

Cézanne's discovery that the world could be delineated as a series of planes rather than as line and shade was *the* turning point in modern art. Cézanne, often called the father of modern art, is accorded this place in history primarily because modern artists were to become so heavily dependent upon his plane concept as an alternative to the previous line and shade dependent methods of the Renaissance and the baroque. His invention of a schema of planes used to depict the exterior world on a flat surface almost made the traditional line and shade schema obsolete.

During the fifteenth century, the separation of planes was reinforced by linear, atmospheric, and color perspective. Cézanne used this same separation of planes, aided only by color perspective; he referred to this effect as his "little sensation." He wanted to create the *sensation* of depth rather than the *illusion* of depth—psychological, not visual, space. "Each dab of color became for him a living paint cell, a significant plane defining the position of an object and all the intermediate layers of space between objects" (Hunter and Jacobus 1976, 19).

Cézanne created a consistent and continuous plastic space. The use of color to depict one synthesized image of volume and spatial placement induced mass and space to coincide, coalesce, and become one undulating entity. Cézanne was perhaps an artistic precursor of Einstein, who hypothesized that the presence of mass affects the essential curvature of space. Cézanne paintings might be thought of as a sensation of solid relief rather than as an illusion of different objects separated by empty space.

In traditional painting, volume had been depicted by one method and depth by another. Volume had been depicted primarily

by the use of a unified light source and a dark and light side (though linear and atmospheric perspective also played a part at times), while depth had been depicted by the separation of planes, emphasized by linear, atmospheric, and color perspective. In Cézanne's new method, however, both volume and depth were depicted by one unified system: an elaboration of frontal planes that were separated only by the adjustment of color perspective. The use of one unified system to depict what had previously been accomplished by several devices was responsible for the coalescence of mass and space into one powerful entity.

Of the five major elements of pictorial illusion in Cézanne's later paintings, one was discarded, one was avoided, two functioned to create a synthesis of mass and depth, and one was inverted in order to create the illusion of flatness rather than depth. The first element, the unified light source, was discarded. Any opportunity to use the second element, linear perspective—at least any obvious use of converging or parallel lines—was avoided or eliminated by Cézanne's choice of subject matter.

The third and fourth elements that functioned to create mass and depth were the separation of planes and the classic color theory. The fifth element, inverted so as to negate any illusion of continuous depth—to create an illusion of flatness—was Cézanne's distribution of focus in atmospheric perspective. Cézanne had brought each separate part of the painting to a "finish of equal importance" in order to avoid "vague receding backgrounds which will let a face or a mountain drop in one's lap" (Hess 1951, 31).

The flattening effect of Cézanne's atmospheric perspective was reinforced by the overall tactile texture of the paint. Thomas Hess comments that the process of using complicated texture to focus the viewer's attention on the surface of the painting pulled the drama "back into its own two-dimensional existence" and avoided "framed holes in the wall." These two aspects, working in tandem to flatten the painting visually, thrust the "importance of the painting as a painting" into the awareness of the spectator and began to break painting "free from the ideas of decoration and imitation" (Hess 1951, 31).

Cézanne unraveled the traditional fibers that had constituted the Renaissance illusion. Then he negated, reversed, and recombined these fibers to create a new spatial fabric. As Gablik tells us, "The history of art begins with tradition. Traditions give us something upon which we can operate: something that . . . we can criticize and

change" (Gablik 1977, 167). John Dixon explains that a radically new vision—even as it destroys old traditions—must be realized within the bounds of those established, disintegrating traditions: Cézanne, like Giotto, fulfilled the old traditions while he initiated the new. His world was depicted as palpably three-dimensional and solid, but it no longer extended beyond the picture plane; it was translated into it. Illusion was not allowed to disrupt the flat surface of the painting. Giotto's flat wall reappeared as the dominant plane in painting, and the painting was no longer a transparent plane through which viewers gazed but an object in their presence (Dixon 1984, 293).

The work of great painters has an endless potential for growth. "Even after they are gone," says Frank Stella, "we sense that their work is expanding and that new things are to come." Even though we "appreciate the newness we are, in fact, more impressed that the echoes and resonances of these creations still embody both the past and the present" (Stella 1986, 60).

Certainly Cézanne had successfully examined those aspects of the Renaissance illusion that seemed natural, universal, and self-evidently true. He gave new and different emphasis to the same fibers or elements of perspective and thus offered a viable alternative in order to expand the potential of the system laterally.

At this point, the new priorities and choices that Cézanne faced in his search for direction and image begin to seem clear. He chose planarity over shading, the sensation of relief over enclosed empty space, color structure over value, simple color over a subtle adjustment of complex personal tone, rationality over subjectivity, and formal structure over the intuitive. He also adopted a fractured perspective (more complex than, but similar to, that of the Romans) rather than the familiar unified, single viewpoint of Renaissance perspective. Cézanne's fractured perspective, which fragments the location of the viewer into a myriad of disconnected locations—one for each separate object, plane, or view—may be seen to suggest a pluralistic, rather than a single, viewer.

Each painter, in searching for direction, is confronted with oppositional choices such as those Cézanne faced. The danger lies not so much in making the wrong choices, but in a failure to make any choice at all. It is the competency of the painter that makes for awareness of such choices: the painter must first recognize that there *is* such a category as painterly versus linear in order to treat the dichotomy in a consistent manner. This consistency of approach is what the painter refers to as commitment. Through a full commit-

ment to one direction, the painter avoids muddling about with no clear bearing. There is perhaps no wrong choice so much as a lack of consistency, a failure of will.

Those aspects of truth revealed by Cézanne's priorities (elements such as planarity, relief, and color structure) are present in Cézanne's paintings. But those aspects that can be revealed only by the opposing elements (such as line, shading, enclosed space, and dark-light structure) cannot be addressed. Thus, a full understanding of Cézanne's work, like that of others before him, depends on seeing it in the context of paintings by others. It is a supplement to other paintings rather than complete within itself.

13
The Modernists

ANY INVENTION OF THE MAGNITUDE of Renaissance perspective must have its tradeoffs: each advance has liabilities as well as assets. The major liability inherent in Renaissance perspective is its tendency to value craftsmanship and objectivity over individual expression. The invention of Renaissance perspective indicated a "scientifically oriented preference for mechanical reproduction and geometrical constructs in place of creative imagery" (Arnheim 1974, 284).

The logical, Euclidean view of the world that had dominated European thought since the Renaissance persisted into the nineteenth century. Then came sudden change. Alfred North Whitehead's statement that all European philosophy consists of footnotes to Plato may well be true before the advent of the nineteenth century (Whitehead 1978, 39), but two important changes took place during this century that involved entirely new and unsettling concepts: the discovery of non-Euclidean geometry and the hypothesizing of a fourth dimension. These concepts involved a recognition that rational conclusions could be deduced from abstract assumptions rather than from what was commonly assumed to be "true." For the first time we could safely ask, "What if this were true?" and then proceed from that point to construct new, but logical, universes with the mathematical rigor that had been associated with the old Euclidean and Newtonian ones. This new ability to make imaginative assumptions about other realities ended the hegemony of Euclidean geometry and Renaissance perspective in painting—an obvious change applauded in the 1960s by the painter Barnett Newman when he named one of his paintings *The Death of Euclid*.

The artist of the Renaissance and the baroque had been able to focus on one visual detail as more important than the rest, but the modernist could focus on one concept or structure at the expense of others. The modernist focused on ideas. Seitz contends that the painting of this century has "emphasized the human need for autonomous discipline, for a focus, and for an idea as a center" (Seitz

1983, 97). There were many viable illusions, alternatives, and possible patterns of warp and weft in the continuity of the fabric of an intricate universe.

Renaissance criticism and art were designed for a specific audience and were meant to achieve particular effects: the arts, existing to service the audience, were subject to the judgment of that audience (Tompkins 1980, 210). In contrast, the arts in the modern period were not produced for a specific or a known audience, nor were the desired results so well defined. Modern art was not expected to motivate the audience or create political pressure; rather, the work presented another separate and more perfect world, "which the flawed reader must labor to appropriate" (Tompkins 1980, 210).

The twentieth-century artist's work was no longer a sign in a social situation nor a model for ideal human behavior, but "an interplay of formal and thematic properties to be penetrated by the critic's mind" (Tompkins 1980, 210). The suspicion that an art work might perform a service would tend to disqualify it for consideration as a work of art: "Now, as Andy Warhol says, artists make things for people that they don't really need" (Gablik 1984, 25). Jane Tompkins contends that to the formalist critic, art did not function to glorify the state, or to civilize humans by honing the sensitivity of their perceptions, or to transport them into a meditative trance but instead "serves men by providing them with an image of perfection, a goal toward which they can aspire." Modern art—thought to hold hegemony over nature, and life itself—was no longer an instrument but an end. Accordingly, "with the arrival of formalist criticism, the issues that had occupied literary critics from Plato onwards simply drop from sight" (Tompkins 1980, 221).

Where the medieval thinker attacked metaphysics with terms like "substance, accident and causality, essence and idea, matter and form, potentiality and actuality, we now treat them in terms of forces, motions, and laws, changes of mass in space and time" (Burtt 1954, 26). Art, as well as other twentieth-century disciplines, came to center on space, then time, as content. Joseph Schillinger, author of *The Mathematical Basis of the Arts*, noted in 1976 that the current direction of science itself is now space centered: modern science tends to explain physical phenomena as derivations of the properties of space (Schillinger 1976, 365).

Even economic constructs have evolved toward spatial metaphor. The philosopher Louis Althusser contends that Karl Marx's theories of economics, so undeniably influential on twentieth-century con-

cepts, were far more spatial than the planar, two-dimensional theories of previous economists. The reasoning of these earlier economists proceeded in a direction of linear causality. They theorized that economic phenomena derived from a planar space in such a manner that an effect could be understood in sequential terms from given causes (Althusser 1972a, 239). But Marx defined economics in terms of location. He presented economic phenomena within a region, determined by a regional structure and "itself inscribed in a site defined by a global structure: therefore as a complex and deep space, itself inscribed in another complex and deep space" (Althusser 1972a, 240). The concept of space in its many applications has offered an important paradigm and focus for modern criticism, not only in literature but in the fine arts, language, and culture (Mitchell 1980, 271).

The nineteenth-century concept of the fourth dimension—as a higher unseen world hidden in the intricacies of non-Euclidean space—has been one of the dominant intellectual influences of the century. The continuing twentieth-century interest in the curved space of non-Euclidean geometry and the fourth dimension changed the face of art forever. Since the beginning of the twentieth century, Galileo's notion "that the temporality of motion is reducible to terms of exact mathematics, has also been of fundamental importance—it means that time for modern physics becomes nothing more than an irreversible fourth dimension" (Burtt 1954, 96).

At the beginning of the twentieth century, Einstein had posited that the fourth dimension—about which there would be so much ado later in the century—must be the relationship between time and space. Simultaneously, and apparently independently, artists began to wonder how they could hope to capture our world from a single viewpoint and in three dimensions—height, width, and depth—when our reality could obviously be viewed from many different and equally valid points of view and seemed to exist in four dimensions. Time and space were no longer absolute; they were suddenly relative to the position of the observer (Dampier 1966, 403).[1]

1. Even though Einstein's theory of the relativity of time and space (1905), Minkowski's space-time continuum (1908), and Niels Bohr's model for the hydrogen atom occurred almost simultaneously with the birth of Cubism, there was no apparent connection between them and Cubism (Gablik 1983, 82). In spite of the fact that Cubism seemed to manifest similar concepts and attitudes, "it has been more or less established that popularizations of the new theories did not come into existence for quite some time, and the Cubists had little or no knowledge of them" (Gablik 1984, 82). Einstein's influence was not felt before 1919 (Henderson 1983, xix).

Non-Euclidean understandings that space beyond our perception could be curved and thus change the appearance of objects moving about within it appealed to modern artists (Henderson 1983, 6). Obviously this curved space invalidated Renaissance linear perspective, which was based on straight lines; likewise, the Renaissance method of rendering objects no longer made sense if objects could be said to hold no permanent form (Henderson 1983, 6). Modern painters attempted to introduce the element of time into painting, which had traditionally existed only in space. At the same time, Einstein was pointing out "that space and time are indissociable, that together they constitute a space-time field that cannot be described readily by the perpendicular axes of Euclidean geometry" (Blatt 1984, 359–60).

Spatial form has become the foundation of our notion of time, Mitchell maintains: we cannot, in fact, tell time without the mediation of space. Time is so much a part of our life and experience in many ways that we habitually use spatial imagery to quantify time (Mitchell 1980, 274). We speak of time as long, short, circular, or cyclical, and we often describe distance in temporal terms: for instance, the location of Spokane, Washington, is often described as a five-and-one-half hour drive from Seattle.

Modernists, as early as cubism and constructivism, came to focus on space as relative to time. They came to see this fourth dimension as the very material out of which the universe was woven. The artist's cardinal concern with space-time was stated early in the twentieth century by Gabo and Pevsner in their published *Constructivist Manifesto*:

> The "fundamental bases of art" must rest on solid ground: real life.
> In fact (actuality) space and time are the two elements which exclusively fill real life (reality).
> Therefore, if art wishes to grasp real life, it must, likewise, be based on these two fundamental elements.
> To realize our creative life in terms of space and time: such is the unique aim of our creative art. (from Goldwater and Treves 1966, 454)

Modern artists rebelled against the hold of Renaissance perspective and the imitation of nature. In 1914, Malevich introduced the square to painting because squares were never to be found in nature (Gablik 1977, 84). Malevich wrote, "An artist who creates rather than

imitates *expresses himself*; his works are not reflections of nature but, instead, new realities, which are no less significant than the realities of nature itself" (Malevich 1959, 30).

Picasso's Time and Space

Before Cézanne there had been only two choices for pictorial delineation: the linear, a use of line to delineate silhouette; and shade, in the painterly sense, the use of dark and light areas to develop form independent of line or silhouette. Cézanne had added a third choice: representation as a series of planes. This third choice made it possible to translate a three- or four-dimensional reality into a plane concept that was felt to be more relevant to the two-dimensional, frontal plane of the canvas itself than was the Renaissance system of line and shade. One of the most important elements of cubism was a depiction of reality in terms of planes, as Cézanne had done, rather than with line and shade.[2] This plane concept established a momentum and continuity of direction for modern art, and it unified the structure of cubism. Picasso is known to have said that Cézanne was his one and only teacher (Blatt 1984, 321).

One of Picasso's major contributions was to continue Cézanne's break with Renaissance spatial concepts. He crushed the faceted bas-relief, space, and objects up against the "screen" of the picture plane, leaving no room for anything but those objects, and he created an extremely shallow illusion of relief.[3] Picasso held as tight a control of the illusion as any Renaissance painter. He was as rigorous and consistent at maintaining shallow space as earlier painters had been in their creation of deep space.

Gertrude Stein was a good friend of Picasso's, and they often discussed their ideas. In her monograph on him, she explained his concern with minute segments of time, which created the sensation of a fragmented and immediate vision as opposed to the holistic memory-aided Renaissance representation. Stein mentions frag-

2. Hofmann insists that "Cubism was a revolution in that the artist broke with tradition by changing from a line to a plane concept. The earlier school modeled with color between the outlines of a linear composition. The new school become [sic] plane conscious" (Hofmann 1967, 46).

3. Berger has observed that "there is space in a Cubist painting in that one form can be inferred to be behind another. But the relation between any two forms does not, as it does in illusionist space, establish the rule for all the spatial relationships between all the forms portrayed in the picture" (Berger 1969, 21).

ments of lapsed time between the artist's view of one part of the anatomy and his view of the next. There is also, of course, a small, lost splinter of time between his view of any single part, such as an eye, and the actual rendering of it on the canvas—from memory:

> Really most of the time one sees only a feature of a person with whom one is, the other features are covered by a hat, by the light, by clothes for sport and everybody is accustomed to complete the whole entirely from their knowledge, but Picasso when he saw an eye, the other did not exist for him and only the one he saw did exist for him as a painter, he was right, one sees what one sees, the rest is a reconstruction from memory and painters have nothing to do with memory, they concern themselves only with visible things and so the cubism of Picasso was an effort to make a picture of these visible things. (Stein 1970, 22)

Picasso began to imply the element of time in his painting. The performance of a concert or a poem may exist over the period of an hour or two, and the performance is not there when the listener returns the following day. The performance of music exists only as an experience in time, but painting has traditionally existed in space. Viewers can look at a painting for an instant or a week, and if they return in a month it is still there. It exists in and occupies space, not time.

Picasso, perhaps after discussions with Apollinaire, painted a faceted, planar representation of objects in several simultaneous views, suggesting either the movement of the painted object or the movement of the viewer. Picasso had been freed, by impressionism's rejection of linear perspective and Cézanne's use of multiple viewpoints, to depict objects in multiple perspectives and from several sides, from above and below, and from inside and outside (Blatt 1984, 322).

This attitude was influenced by the modern awareness that personal experiences and concepts of reality are biased relative to the position of the observer. The limited, shallow space of the represented image was also influenced by the new, non-Euclidean reality in that our universe was no longer considered to be infinite in the Newtonial sense: it was finite. In Euclidean space and Newtonian time, Dampier comments, space stretched in straight lines "indefinitely beyond the farthest stars, and time, both before and after us,

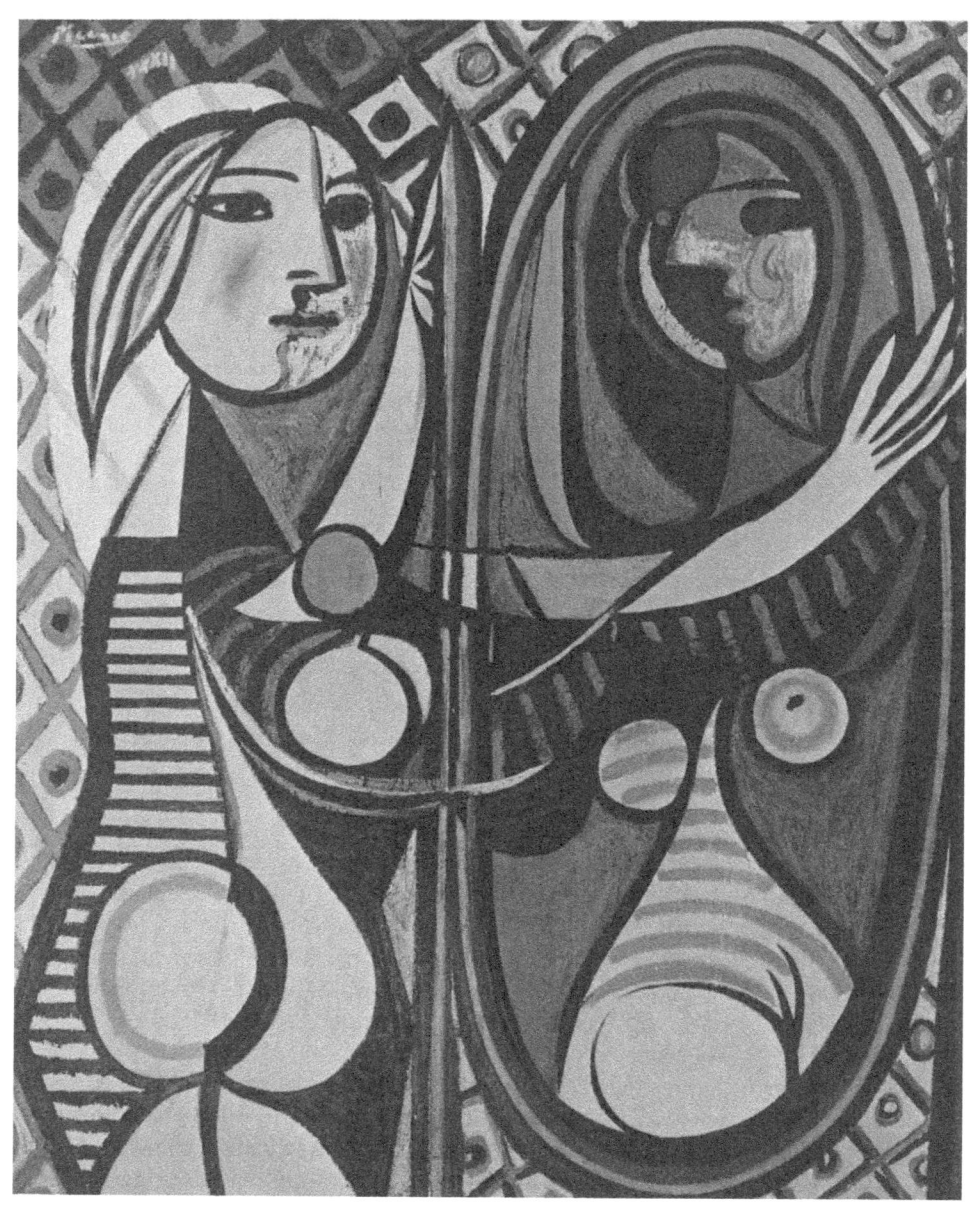

13.1. Pablo Picasso. *Girl Before a Mirror*. March 14, 1932. Oil on canvas (64″ × 51¼″). Collection, Museum of Modern Art, New York. Gift of Mrs. Simon Guggenheim.

flowed on uniform and eternal." Non-Euclidean space and time, however, were curved. Time could still "run from everlasting to everlasting in a never ending series of moments, but the curvature of space means a Universe finite in its space dimensions" (Dampier 1966, 447).

In his 1932 painting *Girl Before a Mirror* (fig. 13.1), Picasso used devices such as a simultaneous front view and profile of the girl's face to suggest movement. In some respects this technique "represents a return to what we have called the Egyptian principles, in which an object was drawn from the angle from which its characteristic form came out most clearly (Gombrich 1956, 432). But the simultaneous views also suggest a movement of either the sitter or the viewer. In 1912, Duchamp executed a series of paintings *Nude Descending a Staircase*, in which he attempted to capture the illusion of movement in a painted figure by depicting a succession of positions as a figure descends a staircase.

Because there is no movement without time, it might be said that suggested movement implies the element of time. This use of the figure as a device to illustrate temporal concepts is no less a step in removing man as the center of attention than was the use of the figure as a spatial device. Blatt, however, insists that what is unique about cubism is not the depiction of time, but an emphasis on spatial concepts based on a number of different geometries, rather than on Euclidean geometry alone (Blatt 1984, 334).[4] Linear perspective was the most suitable pictorial representation of Renaissance "truth," and today "it is widely agreed that cubism and its derivative forms in modern art are in the same way the proper pictorial means for representing the 'truth' of the post-Einsteinian paradigm" (Edgerton 1975, 162).

Renaissance art depicted the external appearance of specific objects and figures; cubism depicted the inner form and structure of specific objects; and modern art went on to depict the basic abstract essences common to all objects, processes, and art itself. Cubism offered a transition from a focus on perception and mimesis to a focus on conception and abstraction: "Paintings were no longer just to be looked at, but now they had to be understood" (Blatt 1984, 336). Until at least the 1960s, the concept of time and its relationship to painting transcended any other concept.

4. Margaret Hagen's book *Varieties of Realism* compares Western Post-Renaissance, Japanese, Northwest Coast Indian, and Egyptian styles of "realism" and the variety of geometries that create them.

14

Hans Hofmann's Spatial Chimera

THERE HAD BEEN no international school of painting until the advent of French impressionism, which was then immediately imitated around the world. Before that there was an English school, a German school, and so on (Cachin 1971, 117). But after the international success of impressionism, other movements became international in scope. Americans began to experiment in meaningful and structural ways after the first decade of the new century, and they had commandeered the helm before the second half of the century began. Certainly the art of the world looks unmistakably American in the second half of the twentieth century (Rose 1969, 66).

Irving Sandler, whose *Triumph of American Painting* has been called the best-known work on American painting in the postwar period, states that most of the abstract expressionists were beginning their painting careers during the 1930s, when aesthetic principles were shaped by economic, political, and social calamities such as the Great Depression, the Dust Bowl, and Hitler's rise to power, which eventually culminated in World War II (Sandler 1970, 5).

The leading artists during this period tended to work in socially oriented styles: Thomas Hart Benton and the Regionalists leaned toward right-wing isolationism, and they idealized America's agrarian past; William Gropper and the more Marxist Social Realists depicted class struggle and the plight of workers (Sandler 1970, 5). But the geometric painters, who conceived of a painting as a self-contained entity, chose to limit their explorations to formal concerns (Sandler 1970, 17). Then, in the late 1930s, the vanguard came to believe that geometricism was too limited, too easy, and too boring. Furthermore, they came to identify geometric shapes with the impersonal objectivity of modern society that inhibited their belief in the importance of the individual (Sandler 1970, 19, 220).

Paris had been the center of world art until the Nazis occupied

the city in 1940. An act of war suddenly made New York the new center of world art, and this new awareness of being the world leaders in art gave the young modernists the confidence to stop following European artists (Sandler 1970, 31). During the 1940s and 1950s, these artists reacted against the bloated hyperbole and stereotypes of the Social Realists and turned from political art toward sensuous experience, which they felt to be more real (Sandler 1970, 12). But political events still exerted a strong influence on the development of American art in the early 1940s.

Serge Guilbaut, in *How New York Stole the Idea of Modern Art*, analyzes the history of American political ideologies during and just after World War II and their influence on the art of the time. He tells us that American artists left for the war when social realism had been battling with nationalistic art for supremacy in the market; when they returned three years later they found the gallery walls covered with abstract art (Guilbaut 1983, 116).

After the 1930s, painters as well as intellectuals had lost interest in attracting the attentions of the *hoi polloi*. They had begun to target the more affluent burgeoning elitist private art market (Guilbaut 1983, 47). The rejection of Marxist ideas and the nonpolitical stance of certain left-wing, though anti-Stalinist, New York painters and intellectuals, which started in 1939, now merged with the rapid rise of nationalist sentiment during World War II to establish an artistic middle road, poised precariously between the opposite poles of political left and right, that was both abstract and expressionistic (Guilbaut 1983, 2).

This middle road led to a new art form capable of preserving the social commitment that the Depression generation felt to be so important while rejecting the heavy-handed propaganda and illustration that had seduced so many revolutionary and liberal painters during the 1930s (Guilbaut 1983, 2). This new avant-garde art flourished after 1948 because the moderate but dissident sentiments expressed both in the painting and the writing of these artists were compatible with the attitudes of the "new liberalism" (outlined in Schlesinger's book, *The Vital Center*), which had emerged victorious from the 1948 presidential election (Guilbaut 1983, 3). Consequently, abstract painting superseded other forms of art and came to represent liberal American culture (Guilbaut 1983, 195). When the United States entered the stifling McCarthy period, this new liberal dissidence seemed even more refreshing and necessary (Guilbaut 1983, 3). It had been argued in 1944 that to engage in modern

painting was to take political action against Hitler; in 1948 it was argued just as fervently that modern artistic expression served to defy communism (Guilbaut 1983, 187). The new liberals poised themselves halfway between fascism and communism (Guilbaut 1983, 190). These artists wanted to communicate with an audience. They wanted to express the anxiety of the postwar period (Guilbaut 1983, 196). But political criticism was impossible, given the climate of the times; any such criticism was judged as offering succor to the Soviets (Guilbaut 1983, 196).

The abstract expressionists found a way to maintain the impact, power, and visibility of the political mural without risking the dangers of social content. They attempted to remain in the uncommitted middle so each individual painter could declare independence from both left and right wings (Guilbaut 1983, 198). Their new art form, offering a committed, militant, active dialogue that neither preached nor condescended to its audience, "emphasized the individual aspect of creation but at the same time laid bare the process, the mechanics of painting, and the difficulty, not to say impossibility, of describing the world" (Guilbaut 1983, 197). The atom bomb had made it impossible to express the anxieties and fears that formed the foundation of modern ideology in the same terms that had worked so well for the two previous generations "without falling into the grotesque or the facile" (Guilbaut 1983, 196).

The ideas of the politically neutral avant-garde were subsequently assimilated and co-opted by politicians until art became liberal ideology (Guilbaut 1983, 200). Freedom was the most important symbol of the new liberalism during the Cold War period, and abstract expressionism became a metaphor for freedom; Schlesinger, however, had maintained that freedom was impossible without alienation and anxiety (Guilbaut, 1983, 201).

In *The New York School*, Sandler notes that during World War II, young American artists began to wonder if there could be any art in the face of such grave social crises, and if there could, what should they paint? Several young painters who were later to become abstract expressionists turned to primitive art and mythology, then searched for a transcendental art, while others who were influenced by the newly discovered existentialism "asserted that in a catastrophic world only the struggle for self-creation was of value. The artist was transformed into a victim hero" (Sandler 1978, 18).

Feeling the anxiety and the alienation from society at large that Schlesinger had insisted was an inescapable result of freedom, these

artists supported each other in a communal sense of aesthetic mission aimed at maintaining the standards of high art (Sandler 1978, 42). More than a dozen young painters had created exciting new abstract expressionist images by 1951, and during the following decade this "first generation" of the New York School received growing worldwide recognition to the point that America became the primary source for ideas in world art (Sandler 1978, ix). This American stamp was easily recognizable, and although it had developed from European art, "American art was soon bigger, bolder, more literal and direct, more powerful in impact, and more devoted to speed and rawness of execution than European art had ever been" (Rose 1969, 66).

By the fall of 1949, Hans Hofmann (1900–1966), de Kooning, Kline, Reinhardt, Tworkov, and other gestural painters had organized what they called the "Club" on Eighth Street in New York (Sandler 1978, 31). Hofmann's major idea—the breeder idea that he spoke of to his students and for which he was best known—is the concept of spatial tension that he described as "push and pull." There are two basic interpretations of this concept, and they make more sense if they are considered as alternating oppositions.

One interpretation of "push and pull" is that of ambiguous spatial placement, which is demonstrated in *Rising Moon* (fig. 14.1). Most of the painted shapes or planes in Hofmann's paintings can be inferred by the viewer to be in more than one spatial position. When the viewer looks at a particular plane, it appears to be salient, while the planes around it appear to recede. However when the viewer focuses attention on another adjacent plane, that plane now becomes salient, while the previously salient plane recedes. This constant visual push and pull of planes, from a salient to a recessive position, creates a spatial movement and tension between them. The sensation of shifting back and forth in space as the viewer shifts attention around the contained territory of the painting destroys the spatial stability of the painting in favor of movement and dynamic, changing relationships.

This structure seems to have been a fitting choice in the twentieth century when nothing was stable, when the only constant was the accelerating constancy of change. Space was Hofmann's subject matter; the qualities of space that he was most interested in capturing were that "space expands and contracts in the tensions and functions through which it exists. Space is not a static, inert thing. Space is alive; space is dynamic; space is imbued with movement expressed

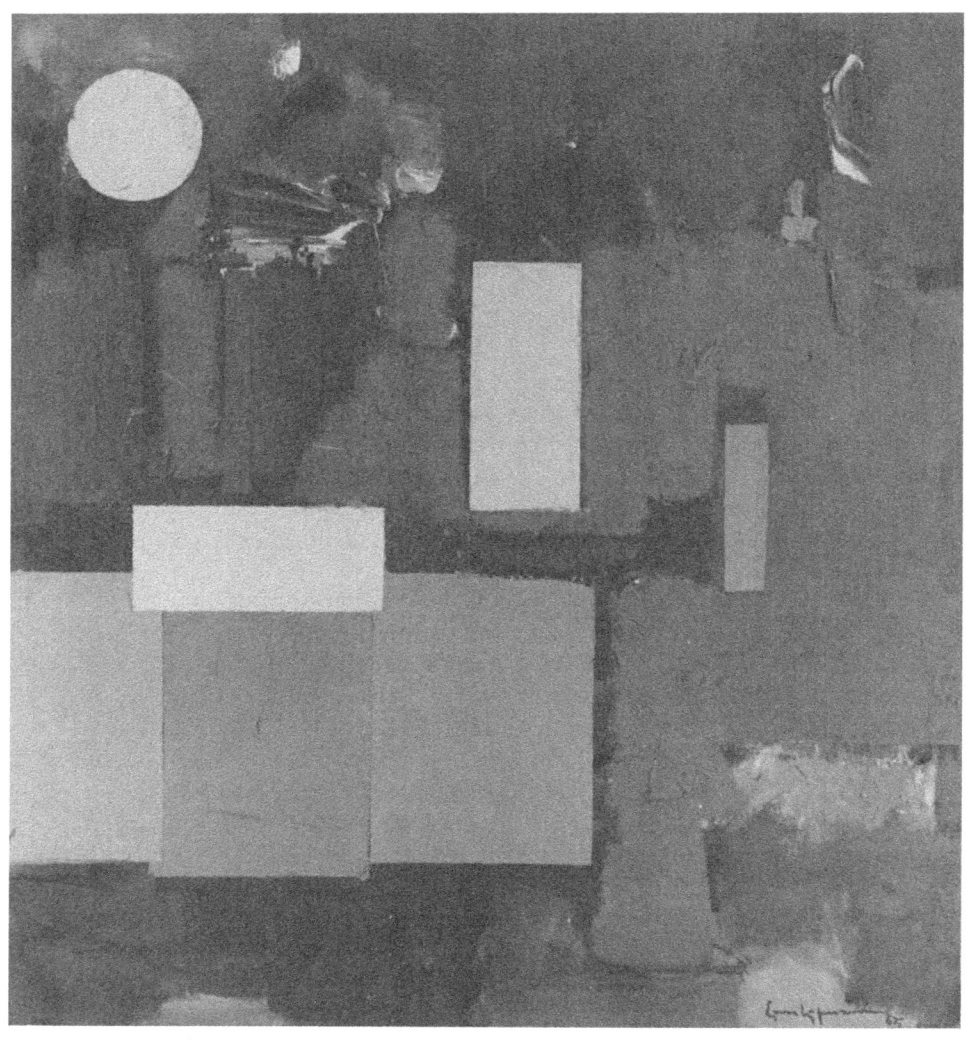

14.1. Hans Hofmann. *Rising Moon.* 1964. Oil on canvas (84" × 78"). Courtesy of the Andre Emmerich Gallery, New York. Photograph by Malcolm Varone, NYC.

by forces and counterforces; space vibrates and resounds with color, light and form in the rhythm of life" (Hofmann 1967, 66).

Had Hofmann's concept extended only this far, the spatial appearance of his paintings might be somewhat similar to that of medieval paintings. Bunim had observed as early as 1940 that painting in the early twentieth century exhibited spatial development analogous in some ways to that of the medieval period. She contends that optical representation and systematic space were no longer stressed in modern painting; they had given way to new concepts involving a nonrepresentative picture plane with "objects and symbols combined according to personal conceptual systems" (Bunim 1940, 192).

But Hofmann's search explores other avenues. The second half of his "push and pull" concept is based on his use of thick paint as nothing but thick paint, with no reference to any outside object. The thick paint, in tandem with the ambiguous spatial illusion, creates a two-fold consciousness in the viewer's mind that cannot be rejected. The viewer cannot escape perceiving the painting as two alternating images: the illusion of pictorial space and the concrete solid reality of the paint surface. The ambiguous perception is similar to that which is evident in Cézanne's paintings. The viewer is compelled to focus at one time on the illusion of ambiguous space and at another time on the thickly encrusted, solid substance of the real paint surface on a flat picture plane. Hofmann allowed an illusion of depth in his painting, but only in conjunction with an opposing force that pulled the viewer's awareness back to the surface of the paint (Rose 1969, 59). Sustaining a balance between the flatness of the paint surface and an illusion of depth created a new kind of complex space that resembled neither the shaded volume of traditional painting nor the bas-relief space of cubism (Rose 1969, 59).

This recursive exchange of spatial images in aporetic opposition creates spatial tension. This tension is a result of the simultaneous sensation of shapes being pushed away from and pulled toward the viewer in real space as well as in pictorial space. Hoffman accomplished this elaborate exchange between the real and the illusion with value control and a knowledge of atmospheric and color perspective, aspects of illusion that also relied on the classic color theory and its reversal. Hofmann himself has commented that he creates the sensation of depth by rejecting shading in favor of color relationships because he is opposed to creating illusionistic penetrations of the picture plane:

Since one cannot create "real depth" by carving a hole in the picture, and since one should not attempt to create the illusion of depth by tonal gradation, depth as a plastic reality must be two dimensional in a formal sense as well as in the sense of color.[1] "Depth" is not created on a flat surface as an illusion, but as a plastic reality. The nature of the picture plane makes it possible to achieve depth without destroying the two-dimensional essence of the picture plane. . . .

The forces of *push and pull* function three dimensionally without destroying other forces functioning two dimensionally. (Hofmann 1967, 44)

Hofmann's tendency to compose his paintings "through the interaction of color, by pitting planes of color against each other to create a sense of volume" sprang from Cézanne's paintings and Matisse's Fauvist works (Sandler 1978, 6).

Einstein's concept of the fourth dimension as the inseparable relationship between time and space, which began to be well known outside scientific circles two decades after its publication, was an important influence on Hofmann (Henderson 1983, 345). His interests in movement, change, and opposition—unlike those of the Cubists—originate in the time-space relationships of Einstein's theory of relativity. Hofmann's ideas concerning the simultaneous coexistence of shapes in multiple spatial placement as well as the existence of the painting itself in two simultaneous but separate spatial forms—the flat, textured, two-dimensional surface in tension with the illusion of depth—are directly related to Einstein's concept of the fourth dimension using movement to simplify a relationship between time and space. Of this relationship Hofmann wrote: "Life does not exist without movement and movement does not exist without life. Movement is the expression of life. All movements are of a spatial nature. The continuation of movement throughout space is rhythm. Thereby rhythm is the expression of life in space" (Hofmann 1967, 66). Hofmann's three-dimensional approach "simulates 'life' generated by the pulsating movements of flat forms—a kind of breathing effect" (Sandler 1970, 21).

One of the aspects of the fourth dimension that artists found most interesting was the concept of simultaneous coexistence in

1. "Tonal gradation" is what is usually termed *shading*. Hofmann uses the word *plastic* to mean "the transference of three-dimensional experience to two dimensions" (Hofmann 1967, 72).

more than one dimension. Perhaps complete parallel worlds were hidden somewhere in the curves of non-Euclidean space. This concept of parallel worlds later became a part of Planck's quantum mechanics, born at the beginning of the twentieth century at approximately the same time as Einstein's space-time concept.

Reared and trained in Europe, Hofmann learned well the lessons of early European modernists. He was particularly aware of the Constructivists' rejection of both shading effects and any illusion of bulk or volume, as outlined in the *Constructivist Manifesto*. In this manifesto, Gabo and Pevsner adamantly denied that volume expressed space: "Space can be as little measured by a volume as a liquid by a linear measure. What can space be if not impenetrable depth? Depth is the unique form by which space can be expressed. We reject physical mass as an element of plasticity" (from Goldwater and Treves 1966, 454).

Hofmann's approach to pictorial space agreed with the Constructivists in this aspect. He used no shading, and he avoided any illusion of bulk or volume. He also rejected the linear perspective and the diminishing size of receding objects, both of which had performed such excellent service during and after the Renaissance. These were all changes that Hofmann had noted when he wrote, "Depth, in a pictorial, plastic sense, is not created by the arrangement of objects one after another toward a vanishing point, in the sense of Renaissance perspective, but on the contrary (and in absolute denial of this doctrine) by the creation of forces in the sense of *push and pull*. Nor is depth created by tonal gradation—(another doctrine of the academician which, at its culmination, degraded the use of color to a mere function of expressing dark and light)" (Hofmann 1967, 43).

This rejection of linear perspective and shading in favor of color perspective and Cézanne's plane concept was a stand taken at the beginning of modern art and adhered to, for the most part, through the entire duration of the period. Objects, figures, and space, were to be depicted flat in order to establish a unity with the evolving flat picture plane, and so to guide painting toward a subjective rather than an analytical approach. This inversion of priorities—a privileging of subjectivity over the objectivity of the Renaissance—is implicit in Edgerton's statement that "linear perspective has come to be regarded as unaesthetic, since it implies the primacy of objective realism over true artistic subjectivity" (Edgerton 1975, 56).

The artist is always interested in creating a strong image that

leaves the viewer moved by the effect but incapable of recognizing the cause. When the viewer feels a sensation but cannot decipher how such an effect was achieved, the effect seems magical. But then, magic itself isn't really magic, is it? What we call magic is diversion, deception, illusion.

The magician's illusion is always more interesting when the audience has no clue as to the method. The more impossible the illusion seems, the more magical it appears to be. Once an illusion has been explained, it no longer holds mystery nor commands interest. For this reason, magicians will not explain their illusions, ever. Perhaps fear of removing the mystery from their craft is the reason that many painters often refuse to talk about their own work as lucidly and specifically as they are capable of talking about the work of others.

Linear perspective was thought to be too obvious during the modern period. It seemed to explain, and to be responsible for, any illusion of depth when it was present. It not only stood as an obvious explanation for any depth that it created, but it also readily claimed credit for depth that may actually have been created by other means. No matter how much illusion of depth an artist created on the canvas, or by what innovative or arcane methods, if there was any linear perspective present, the viewer tended to dismiss the other accomplishment as owing to this obvious and now simple device.

When Masaccio first used linear perspective to create an illusion of depth, the device was understood by few even among the ranks of master artists: the effect was startling. Now, when linear perspective is known to every schoolchild, it is no longer mysterious or exciting. The use of such a device in the twentieth century might be analogous to trying to fool a meeting of the magicians union with "pick a card: any card."

The position of the painter today is similar to that of the magician when television first became popular. With the advent of television, magic shows all but died out. No matter what miraculous thing the magician revealed, the audience had a tendency to think it resulted from a camera trick rather than magic. It took decades for the contemporary magicians, such as Doug Henning and David Copperfield, to invent new illusions that were compatible with the medium of television.

Hofmann believed that painting based only on a line concept was scarcely more than illustration. Such painting, he felt, could not achieve a strong pictorial structure because "pictorial structure is

based on a plane concept. The line originates in the meeting of two planes. The course of spatially conceived line develops from different positions in a multitude of planes. Only in a mathematical sense is a line, in itself, thinkable" (Hofmann 1967, 65).

In an article about the meaning of art, Alan Leepa emphasizes the importance of the work of art as a real object itself, rather than as a picture of an external reality. He wonders if there is any way to avoid the limitations that language imposes on us. He also wonders if we can avoid meanings that "are foggy, lacking in clarity, faulty in preciseness, confused and undisciplined in purpose." In answer to his own question, he insists: "In art, a step is taken in this direction when lines and colors are not used to represent a realistic object but are themselves looked on as objects with which direct experiences can occur" (Leepa 1968, 204).

Before the advent of modern art and its concern with space as the content of art, painters referred to their work as "pictures." They painted "pictures of a landscape" or "pictures of a person." But the modernists began to call their work "paintings," and what a thing is called begins to influence the thinking about it. Those who called their work paintings had a tendency to be less mimetic than others; they began to think of the painting as a real object, complete unto itself. This interest in the painting as an object in that real world outside the painting became the major thrust of art during the 1950s.

15
Abstract Expressionism

ALMOST ALL COMPETENT PAINTERS think of themselves as realists, or as those who explore aspects, or expand concepts, of reality: if one painter's works appear different from another's, it is because each defines reality differently, or because each chooses to examine a different aspect of this reality. Nathan Oliveira maintains that "every artist deals with his sense of reality. This reality is for him to determine, and involves a broad and varied range of expressive symbols" (from Protter 1971, 272). And we often "speak of an artist's having achieved a new degree of realism, or having found new means for the realistic rendering of (say) light or motion. What happens here is something like the 'discovery' that not the earth but the sun is 'really fixed' " (Goodman 1976, 37–38).

Artists have explored, on a two-dimensional plane, many methods for depicting some combination of the multitude of possible realities. The Egyptians drew things as they knew them to be. They drew an object in the most recognizable view, which also happens to be the easiest view to draw. They drew the face in profile because a profile of a face is a unique shape, easily recognized and easy to draw. They drew eyes in front view because that is the most characteristic and recognizable view of an eye, also the easiest to draw. They drew shoulders in front view; arms, hands, feet, and legs in profile. It might be said that Egyptians drew things as they were or as they knew them to be, not as they appear to be.[1]

The plans and elevations that a contemporary engineer or architect presents to craftsmen and builders bear more similarity to the Egyptian method of drawing than they do to Renaissance illusion or its progeny, photography. This "engineering" view, potentially more descriptive and accurate than Renaissance illusion, may be said to be more "realistic," in one sense of the word, than a photograph. The

1. For a detailed explanation of the perspective used by the Egyptians, see Margaret Hagen's *Varieties of Realism* (Hagen 1986, 168–75).

extreme stylization of Egyptian and Assyrian art, for example, does not mean they are not realistic: in many respects they are very realistic (Pirenne 1970, 179).

To pursue this direction, we might entertain the idea that abstract expressionists think of themselves not only as the final realists, but as those who manipulate reality itself. Terms like "realist" or "realism" suggest creation of something like reality, but as Barbara Rose reminds us, Mondrian "claimed that the art object was not an imitation of anything but an autonomous reality" (Rose 1969, 108).

The abstract expressionist might perceive the cubist's painting of multitude views of a bowl on a table, or the realist's illusionistic rendition of a similar bowl, or the Egyptian's accurate depiction, to be abstraction, in the pure sense of abstraction. "Abstract," as it applies to art may be said to be "that which comprises or concentrates in itself the essential qualities of a larger thing or of several things" (*Webster's Third New International Dictionary*). In each of the three styles of painting mentioned above, oil paint on canvas looks like or describes something else: a bowl, a face, or a landscape. The paint is not what it appears to be. The abstract expressionist, however, executes a large slash of red paint on canvas that is exactly what it appears to be. The paint appears to be—and is—a slash of red paint on canvas. It is not *like* real; it *is* real. The paint is no longer supposed to be a landscape or a tree; it is only and ultimately a painting. An abstract expressionist painting might be said to be only what it appears to be.

Twentieth-century art offers a sample from the fabric of specific realities rather than analogous explanations of some other reality. It can create a paradigm of perception so inclusive that human beings tend to interpret their experiences and arrange their lives according to its influence. It offers a small piece of reality that Thomas R. Maitland likens to the cloth swatch which the tailor uses as a sample: this sample shows the actual cloth itself rather than pointing to or explaining some other fabric that exists somewhere else. Art, like the tailor's sample, is a piece of reality that allows human beings to perceive what things are, and from this piece of reality they create their world. More than offering an illustration that describes their world, art contributes "the fabric of new worlds which men now come to see and understand as their world (Martland 1981, 1).

Abstract painting rejected the visual depth and what John Paoletti calls the "trickery" of the Renaissance "for an honestly stated exploration of the painted surface and its limits." In American paint-

ing of this period, everything worked to stretch the paint "tautly over the surface, seemingly denying recessional or volumetric space and giving new presence to the edge of the painting" (Paoletti 1985, 57).

Thus the abstract expressionist changed the relationship between the rest of the world outside the painting and the painting itself. The de-emphasis, and finally the rejection, of objects depicted in paintings might at first glance appear to disconnect "pure art" from the phenomenological world. But such paintings became solid phenomenon themselves, another commodity in our world of goods to be bought, sold, and stored for investment. The rejection of objects depicted in the painting reified the painting itself. In other words, as the content of painting came to be thought of as less objectified or less phenomenologically real, the painting itself was forced to be considered more so.

Zen

Zen Buddhism began to change the face of modern art well before World War II. Stanton Macdonald Wright's paintings were showing the influence of his study of Taoism and his practice of Zen as early as the 1930s (Gordon 1985, 1). But Zen did not capture the imagination of young American artists until after World War II.

Though doubtless an important influence in abstract expressionism, Zen has been falsely mystified. Expectations about its effect on and its application to painting have often been misunderstood. Zen has two major functions in the arts—whether karate, flower arranging, the tea ceremony, or painting. Zen itself encourages demystification, and it disciplines the practitioner of a skill until performance becomes automatic: without thought, preconception, or self-consciousness.

A painter has little need to probe deeper into Zen philosophy or discipline than this. The abstract expressionist's interest in Zen was limited primarily to the process of applying paint by reflex—without thinking about it, automatistically allowing the hand to execute maneuvers with no prior mental planning or preconception. Of the hand's separate consciousness Henri Focillon wrote: "Hands are almost living beings. Only servants? Possibly. Servants, then, endowed with a vigorous free spirit, with a physiognomy. Eyeless and voiceless faces which nonetheless see and speak" (Focillon 1948, 65). Abstract expressionists welcomed the unpremeditated and unpredictable ac-

tions of the unconscious hand because they were far too aware of man's irrationality ever to believe their actions could be held to machine-like predictability (Sandler, 1970, 30).

The Dancer from the Dance[2]

Abstract expressionism is often called Action Painting, not necessarily because of the considerable physical action involved in this style of painting, but because the "action" of applying the paint seems to be recreated in the mind of the viewer during the act of looking at these paintings. Two black, parallel skid-marks in the street signify both object and action; that is, the skid-marks act as a trigger or a "sign" that causes the mind to recreate the presence of the car and reenact the action that caused the marks. The mind recreates a mental image by analyzing the evidence of a particular action. Therefore, when the viewer encounters an assertive slash of paint across a canvas he or she tends to reenact mentally, either consciously or unconsciously, the physical action of the painter in the making of such a mark.

Critics during the 1950s focused on the paintings of the "so-called action painters—Jackson Pollock, Willem de Kooning, Franz Kline and others—Abstract Expressionists whose dramatic gestures and splashy brushmarks had encapsulated the act of creation, hence their canvases were regarded as records of events or processes" (Walker 1975, 4). This sense of capturing and preserving an action often created a subtle kinesthetic sense of the viewer's own movement or involvement in the process of recreating the painting. Many viewers felt a kinesthetic sense of their own body movement as they mentally recreated the action recorded in the painting. Pollock's drip paintings, for example, "are infused with surging energy, producing an immediate impact on the viewer, causing him to respond as an active participant rather than as a passive observer" (Sandler 1970, 102). Modern art created a subjective self-awareness in viewers, who were "forced to become increasingly aware of their roles in constructing an experience of nature" (Blatt 1984, 362).

If this "action" theory is pursued, it leads to the judgment that if the painted marks are finger and wrist moves—small, restrained, mincing, predictable, and self-conscious—the audience will feel little

2. "How can we know the dancer from the dance?" From Yeats, "Among School Children."

kinesthetic energy and fail to recreate any assertive action. They will therefore be quickly disenchanted. But if the strokes are bold, unpredictable, varied in size and shape, and woven into a cohesive tapestry, the viewer-participator recreates the movements of the artist to discover a theater.[3] Pollock's paintings *White Cockatoo* and *Summertime*, whose "lyricism and purity of movements remind one of the abstract yet deeply expressive gestures of the modern dance" (Hunter 1959, 144), present just such a moment for the viewer-participator.

Just as it is easy to perceive self-consciousness in the body language of others, so can the practiced eye spot a self-consciousness in the painted gesture on canvas. For the Action painter the required discipline was the ability to put paint on canvas without thinking, or appearing to think, about it.

This concept overlaps certain existentialist concerns that were influential during the late 1940s and well into the 1950s. Sandler points out that the critics and the artists themselves often borrowed from the terminology of existentialism: they spoke of painting as "an unpremeditated 'situation' in which a creatively 'committed' artist 'encountered' images of 'authentic being.'" For them, the process of creation was solitary and abundant with struggle, anxiety, and anguish (Sandler 1978, 48).

The cubist's implied movement of the painted object, or the movement of the viewer, had been elaborated into the abstract expressionist's implication of the action, or the dance, of the absent painter (Blatt 1984, 352). To paraphrase the question asked by Yeats: Do the paint strokes signify the action, or the presence, of the painter—or both?

The methods of beginning a painting can be divided into two basic oppositions. The first method requires planning a painting. Painters who practice this method tend to execute preliminary studies and drawings until they have solved many of the major problems of proportion, dark-light composition, and so on. They may do as many as ten or fifteen drawings of the idea before they start a painting, but the problem is never resolved in the drawing to the point that the painting is just a copy of the drawing. "In repeated

3. Panofsky reasons: "Anyone confronted with a work of art, whether aesthetically re-creating or rationally investigating it, is affected by its three constituents: materialized form, idea (that is, in the plastic arts, subject matter) and content" (Panofsky 1955, 16).

variations an idea is developed which may dominate the later image," Seitz comments. "Yet the conception is never finished; it is never frozen to the point where it is reproduced by mere craftsmanship" (Seitz 1983, 96–97).

The second method is automatism, the discipline of not planning: starting a painting with no idea in mind and allowing the hand to work automatically, with no preconception as to where it is going. This simple act of thinking of not thinking makes such an event impossible. If I hand you a glass of water and tell you to drink it without thinking of the word *aardvark*, the simple act of instruction has rendered the act impossible. It is easy to "act natural" when no one watches, but actors must learn to "act" natural when the camera is turned on them. Thus abstract expressionists delight in disciplining themselves to accomplish what their own self-consciousness has rendered seemingly impossible.

Though the direct influence of Zen is fairly recent, no good Renaissance painter would have found the attitudes unfamiliar. The first maxim of Zen is to develop an infallible technique and then let Zen free you. It is said that the student of Zen painting is expected to draw a better circle freehand than can be done with a compass. This is not an attitude that European artists of any century would find foreign.

Vasari tells this story. Pope Benedict once sent an emissary through Siena and Florence to determine who might be the best artist to execute some paintings for St. Peter's. The emissary asked Giotto to furnish him with a little drawing to send to His Holiness. Giotto, "who was a man of courteous manners, immediately took a sheet of paper, and with a pen dipped in red fixing his arm firmly against his side to make a compass of it, with a turn of his hand he made a circle so perfect that it was a marvel to see it." The pope's emissary thought he was being laughed at, but the pope understood and "saw that Giotto must surpass greatly all the other painters of his time" (Vasari 1958, 8).

Freud and the Automatic Hand

Interest in automatism and the unconscious cannot be attributed simply to the Zen influence. Zen concepts were pertinent to abstract expressionism as a result of a developing interest in the unconscious and other concepts that were already attracting interest by the end of the nineteenth century. Dream-like images became an important

source of inspiration for abstract painters because of the popularization of Freud's study of dreams and the surrealists' use of such imagery (Selz 1981, 244).

Surrealism was certainly not the first movement in the arts that had been influenced by interest in the unconscious, but it was the first to exhibit such an overriding and obvious interest. Abstract expressionists were heavily influenced by this aspect of surrealism, and the process metamorphosed into something entirely different under their investigations. The unconscious furnished a new and exciting source of creative imagery for many of the abstract expressionists, such as Gorky, Pollock, Motherwell, and the early Rothko and Gottlieb. The abstract expressionists' interest in the unconscious was part of their determination to invent a new image that was so comprehensive it could convey universal meaning (Rose 1969, 73).

Surrealists were first interested in expressing the unconscious by presenting images without order, logic, or sequence, as in a dream. The surrealist was more representational with these ideas than was the Action painter. But conversely, the surrealist use of automatism—automatic drawing based on the graphic psychological disclosure and the vitality of the moving hand (Rose 1969, 16)—was not at all representational, and it was this direction that was pursued by abstract expressionists. Automatistic abstraction was the direction the surrealists had left generally unexplored (Sandler 1970, 37). The surrealist's objective "was to draw without conscious control, to introduce pure chance and 'the unreasonable order' of dream images into the making of art" (Rose 1969, 16). But, even among the surrealists, automatic drawing results in scrawling random configurations of line.

The abstract expressionist used this surrealist invention to create the unpredictable through the act of not planning—through automatism, the act of transferring control from the mind to the hand. There was great reliance on chance and the propitious accident. Abstract expressionists, however, used this device in a more Jungian sense, stressing aspects related to the unconscious and automatism, as opposed to the more Freudian approach of the surrealists, "who generally illustrated dreams, hallucinations, and other such psychological experiences." Pollock himself was undergoing Jungian analysis (Sandler 1970, 65).

Thus interest in the illogical unconscious synthesized three related concepts: Zen, existentialism, and psychology (both Jungian and Freudian). These artists knew how to utilize a good accident,

and a master was expected to develop a process that consistently created good accidents. Chance has historically been a source of certain qualities that the artist can never achieve by planning and calculation: "Montaigne in the sixteenth century already observed that a painter will discover in his canvas strokes which he had not intended and which are better than anything he might have designed. That is a common fact in artistic creation" (Shapiro 1978, 220).[4] Pollock's drip paintings, for example, are fecund with a multitude of inventions, rhythms, textures, and unpredictable movements and shapes (Sandler 1970, 115).

Pollock Negates Compositional Climax

Jackson Pollock (1912–1956) began his drip paintings during the 1950s, when his reputation was greater than that of any other abstract expressionist (Sandler 1978, 15). There is seldom great painting without great risk, and risk became an integral part of abstract expressionism. Pollock was an excellent painter who suddenly dropped a successful direction to begin these new paintings composed of drips and splashings. Pollock laid his canvas down upon the floor, poured thinned paint into cans with a hole in the bottom, then walked around dripping this paint on his canvas. There were several appropriate reasons for such a method. Because the artist's control over his material was impaired, more room was left for accident. To the Freudian, who believes that there is no accident—what appears to be accident is controlled by the unconscious—it would appear that Pollock was in search of the unconscious image when he enticed accident. This device might be interpreted as a substitute for the Zen discipline of Mushin, or action without conscious thought. It could also be interpreted as an avenue of inspiration for vital new images. Sam Hunter insists that all the abstract expressionists relied on accident, "felicitous or disruptive, to give vitality to their creations" (Hunter 1959, 135).

Automatism, gleaned from the surrealists and given direction and discipline through the influence of Zen, was a strong element in abstract expressionism. This divorce of the conscious mind from the

4. This automatistic discipline may also seem, to the participator, more transcendental than the more preconceived approach. William James explains that "motor automatisms [are] more convincing than sensations. The subjects here actually feel themselves played upon by powers beyond their will" (James 1925, 478).

hand allowed the hand, through the unconscious, to make its own decisions; the hand was capable of creating better and more complex shapes than could be consciously drawn by the artist. Perhaps automatism functioned as a substitute for the inspiration that artists had traditionally drawn from their choice of subject matter. Historically, artists had been able to insure good shapes in their paintings by selecting objects that had interesting shapes, and the rendering of these objects created good shapes on the canvas. But because the abstract expressionists did not accept the ideas and styles of their time, they were faced with "what they referred to repeatedly as 'a crisis in subject matter' " (Sandler 1970, 31).

The modernists, too, had been able to rely on a principle of selection so long as they chose to start with the drawing of still-lifes, figures, and landscapes. Yet when they completely vacated the land of mimicry to enter the empire of the unconscious, when they began to paint spontaneously without subject matter as a point of departure, they were suddenly left to their own devices as to how to invent interesting shapes. They found it difficult to create interesting shapes from their own minds. When they tried to invent new shapes, they had a tendency to draw a line around them and fill in the flat shape; this approach, however, resulted in simplistic and uninteresting shapes. In order to avoid this pitfall, the abstract expressionists learned to abdicate control by dripping paint or using a large tool, such as a house painting brush. They learned to avoid verticals and horizontals, and to turn the hand loose in order to create more complex and interesting shapes than they might have planned or preconceived.[5] But, as Sandler notes, these painters were not captivated by every mere "free-associational" accident; they insisted on screening "accidents" through a process of willed action and choice in which the artist chose to reject, accept, or change the results. In other words, there was a "right way." They felt compelled to make choices that left evidence of the struggle and the difficulty of making decisions, and a "suspension of will was helpful in order to gain access to primary sources of energy that might otherwise be blocked" (Sandler 1970, 96).

Clement Greenberg has been called "the most important single

5. As Barbara Rose points out, "The Surrealist legacy in the form of automatism both as a process of formal invention and a technique for generating images continued to have importance" (Rose 1969, 66).

spokesman on behalf of Abstract Expressionism" (Sandler 1970, 212). Greenberg and his foil Harold Rosenberg formed a classical dichotomy: each offered a valid alternative to the other; each exposed the limitations inherent in the opinions of the other. Greenberg, who might be called a megaformalist, was the culmination of the style of formalism that had been conceived by Roger Fry and tended by Wolfflin. From his capitalist's perch Greenberg attempted an objective analysis of visual form biased toward the recognition of illusionistic elements. He seldom mentioned content.

Rosenberg, in contrast, might be called a protostructuralist. His Marxist view offered a more consciously subjective analysis of the linguistic aspects of art. Although Greenberg's opinions were dominant during the fifties, it was Rosenberg's more literary and linguistic direction that evolved into structuralism and eventually poststructuralism in art criticism.

Greenberg insisted that a nonillusionistic flat surface was meaningful in an age in which illusions of every kind were being destroyed. Accordingly, it was important to avoid illusionistic devices, such as the modeling of volume with shading; the integrity of the flat picture plane should be maintained, and all temptations to poke visual holes through the surface with perspective should be resisted. This position can be seen to be quite similar to Cézanne's. Though Greenberg claimed to be opposed to illusion, such reasoning demonstrates a concern with maintaining an illusion of flatness. Elaine de Kooning's familiar comment that "flatness is just as much an illusion as three-dimensional space" supports such a view (from Sandler 1970, 96). By 1950 there were tacit agreements among leading painters about the rendition of pictorial space:

1. The major thrust of the current search was to concentrate on a flatter picture plane. Any attempt to create illusionistic depth was not acceptable (Seitz 1983, 41). If depth was sought, it would be limited to the psychological sensation of depth rather than any controlled, geometric illusion. Shallow space, as suggested by figure-ground reversals, was sometimes acceptable because figure-ground reversals were considered "integrated," as opposed to simple separations of figure and ground. Sandler holds that "the 'box' associated with Renaissance painting was to be flattened and thus rendered modern, but the picture plane was also to be made *cubic*" (Sandler 1978, 11).

2. Volume or bulk was not applicable to the persistent advance toward a flatter picture plane, at least not the illusionistic volume achieved through the shading of darks and lights (Seitz 1983, 9).

3. The painting should be an object, not the illusion of an object. Painting would "be the image," not contain the image.

4. The unity of the painting should not be penetrated by intermittent negative shapes or holes. The entire painting should ideally be composed of positive shapes, though the ambiguous space created by figure-ground reversals, as in the work of Franz Kline, was acceptable. In this latter mode each area in the painting functioned as a positive shape for some major portion of the viewing time (Hess 1951, 137; Gordon 1985, 12).

5. Linear perspective was too easy, too obvious, too illusionistic, and in no way relevant to any of the stated goals (Seitz 1983, 9).

6. Shading was not relevant to current pursuits. It was as obvious as linear perspective, and it blunted both contrast in value and color. Shading was too consciously preconceived and controlled for current interests, and it was too illustionistic, for it created the appearance of sculptural bulk (Seitz 1983, 9).

7. Process was more important than product. This important Zen influence did not allow for preconceived solutions. The solution was to be found in the process of painting. An often repeated comment, "If you know the process you can't screw up," was indicative of the sentiment held by painters of this time. Sandler insists that "the gesture painters refused to preconceive particular meanings, regarding the process of painting as an intense, unpremeditated search for the images of their creative experiences" (Sandler 1970, 93).

In paintings like *White Light* (fig. 15.1), Pollock dripped wet paint into wet paint so that one color sank into and merged with the other. This technique kept each color physically on the same plane with the other colors. The visual effect is that the separate colors appear as part of each other: "Automatically, like the thread of a spider or the crystallization of a mineral, line can form cellular structures, labyrinths, webbings, nets, and membranes, thus losing their autonomous separateness" (Seitz 1983, 12). This complex use of line strengthened the shallowness of the sensation and created a unified single image.

The dripping of myriad thin paint lines created so tightly interlocked an image that the lines no longer functioned as outline: line

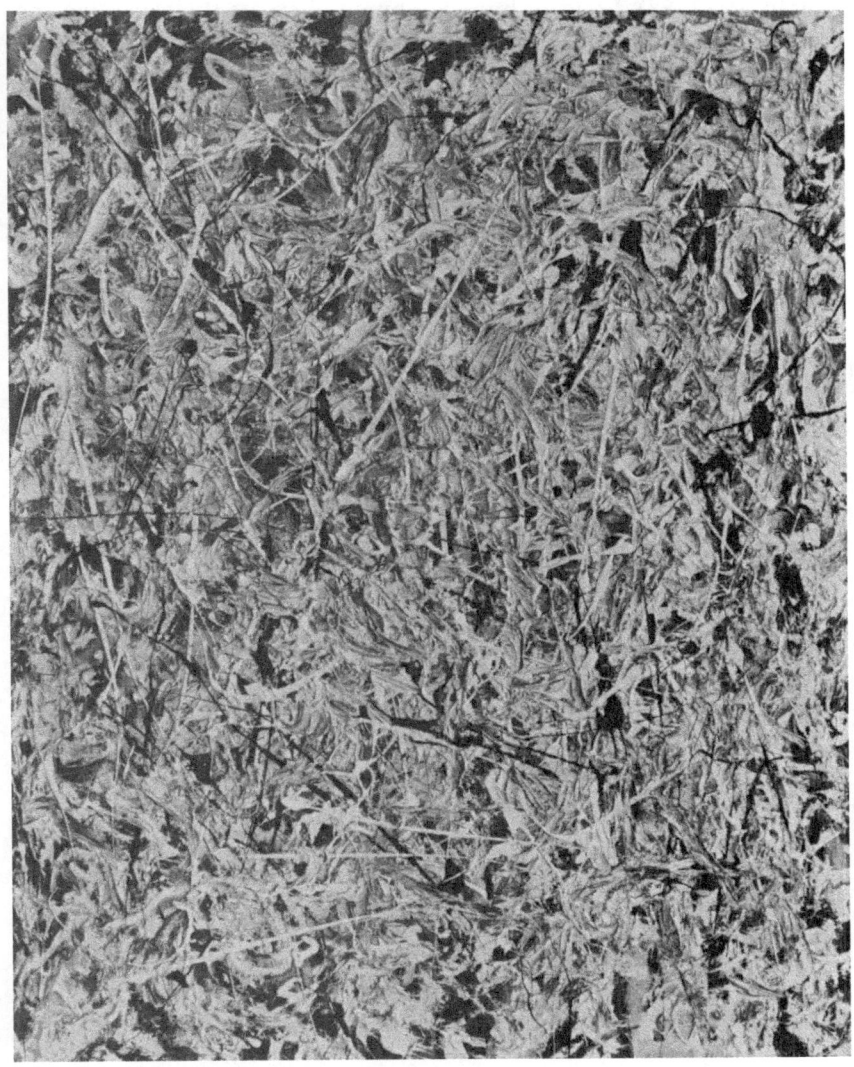

15.1. Jackson Pollock. *White Light.* 1954. Oil, enamel, and aluminum paint on canvas (48¼" × 38¼"). Collection, Museum of Modern Art, New York. The Sidney and Harriet Janis Collection.

neither marked the edge of planes nor outlined linear shapes, even abstract shapes, in the manner that it had so functioned in the past (Gablik 1977, 83). Webs of lines combined to create their own masses almost in a painterly sense. There were no distinguishable silhouettes, and the difference between the painterly and the linear was no longer applicable. Pollock had blurred the distinction and the boundaries between Wolfflin's two polar categories.[6] He had synthesized the two traditionally dichotomous categories (Gablik 1977, 148).

Sandler suggests that the flowing skeins of line do not function traditionally to define or outline images or planes but produce instead "autonomous painterly drawing." These lines create an interwoven web of forces; overlapping, they appear to project out in front of the canvas. The surface is not fragmented into planes. It is perceived as a field that at times seems invisible (Sandler 1978, 233). Because the eye is forced to move constantly, this field resists being perceived as anything other than a single, cohesive, holistic image (Sandler 1970, 115). The tendency toward an all-over image first appeared in the paintings of Monet and Bonnard and reached its logical conclusion in the paintings of Jackson Pollock and the all-black paintings of Robert Rauschenberg (Gablik 1977, 82).

Earlier we observed that traditional compositional climax is created by elements of the Renaissance illusion and that Renaissance perspective is itself a reweaving of the elements of Greco-Roman perspective. Now it should be evident that mimesis continues to function as a guiding force for the painter even though its components have been unraveled and rewoven so many times that its presence is difficult to recognize.

6. Rose explains: "Because painting and drawing are compressed into a single technique by means of the overtly painterly quality of the dripped line, there is no discontinuity between the two [linear and painterly] as there is in all painting, to a greater or lesser extent, before Pollock's" (Rose 1969, 18).

16
Kline's Structure by Absence

THOSE MANIFOLD STYLES that were clustered under the umbrella of modern art shared one important common denominator: a striving to maintain the entity of the flat picture plane. So fundamental and so orthodox was this notion that it usually remained at the edge of the discussion; critics, artists, and writers alike had a tendency to hold it as a given (Seitz 1983, 41).

The kind of pictorial space that is depicted on the flat surface of a canvas is conditioned by the tradition of past painting, and since Cézanne, Seitz notes, tradition has insisted that pictorial space should be consistent with the reality of the painted surface. For a painter during the 1950s to ignore the picture plane was "to dissociate himself from tradition in formation; it is as if an artist living in the second decade of the quattrocento had chosen to abandon linear perspective or the analytical depiction of muscles" (Seitz 1983, 41).

Abstract expressionists resolved the immutable dichotomy between the spatial illusion necessarily present whenever there are marks on a canvas and the viewer's awareness of the picture plane, by treating it as a "confrontation of space with flatness, movement with stasis, and mass with emptiness" (Seitz 1983, 53).

Where now, is the aporetic line between physical reality and visual truth? In abstract expressionism the flat picture plane, which was maintained by illusion, was spatially congruent with the actual two-dimensional surface of the painted canvas. Even the illusion of shallow space was denied by the retention of a flat, opaque, visual curtain screening the front of that stage described by Alberti's cube. Illusion was now congruent with reality. This curtain—the marks on the opaque picture plane—was the cause of the illusion, and the illusion is the cause of the curtain; thus cause and effect are recursively inverted.

Modern art, particularly abstract expressionism, can be under-

stood as an invention in style and method designed to explore and discuss Renaissance form and structure (composition, proportion, and perceived limitations in the depiction of space and reality). Abstract expressionism thus offers permutations of, and alternatives to, Renaissance form and structure. It may deny or invert some structures, such as the illusion of depth, while reaffirming other structures, such as dark-light composition, proportional relationships, or the control or integration of figure-ground relationships. To the question of whether there is "an art that is an imitation of transcendental values, that is to say, of ideas themselves," Herbert Read answers, "I think there is, and that is the basis of modern 'abstract' art" (Read 1953, 86).

In spite of the tendency for our verbal and visual languages to grant a higher priority to the concept of presence than to absence, those ideas and structures that seem to be absent are often strongly implied by the presence of the opposing concept. Thus, black-and-white implies an absence of color; a flat picture plane implies the absence of space and volume; and linearity implies the absence of painterliness. A viewer, when confronting a nonrepresentational painting, like *Mahoning* (fig. 16.1), might ask: Why does this painter not render things? In other words, those ingredients that are noticeably absent may be said to be of as much importance as those that are present. Often a painter is, in effect, trapped by what offends him or her: one's direction may come to be defined by those ideas most rigorously avoided.

Abstract expressionism became a useful method for extending the macrocosmic interests of the Renaissance into microcosmic realms.[1] The abstract expressionist could focus in depth and detail on any area or structure of interest and ignore those structures of little relevance. If the painter were interested in surface and constant visual activity, climax could be ignored, as Pollock had done. If the painter were interested in color, shading could be rejected, as Cézanne and Hofmann had done. If, however, the painter were interested in value contrast, dark-light composition, and compositional climax, he or she might leave out the unneeded color and work in black-and-white in order to strengthen structure, as Franz Kline did.[2]

1. "However unprecedented they first appear, the forms and ideas of art seldom are without origins in the past. Abstract expressionism is both radical and traditional" (Seitz 1983, 153).

2. Hunter tells us that "the repudiation of color is one way of returning to the

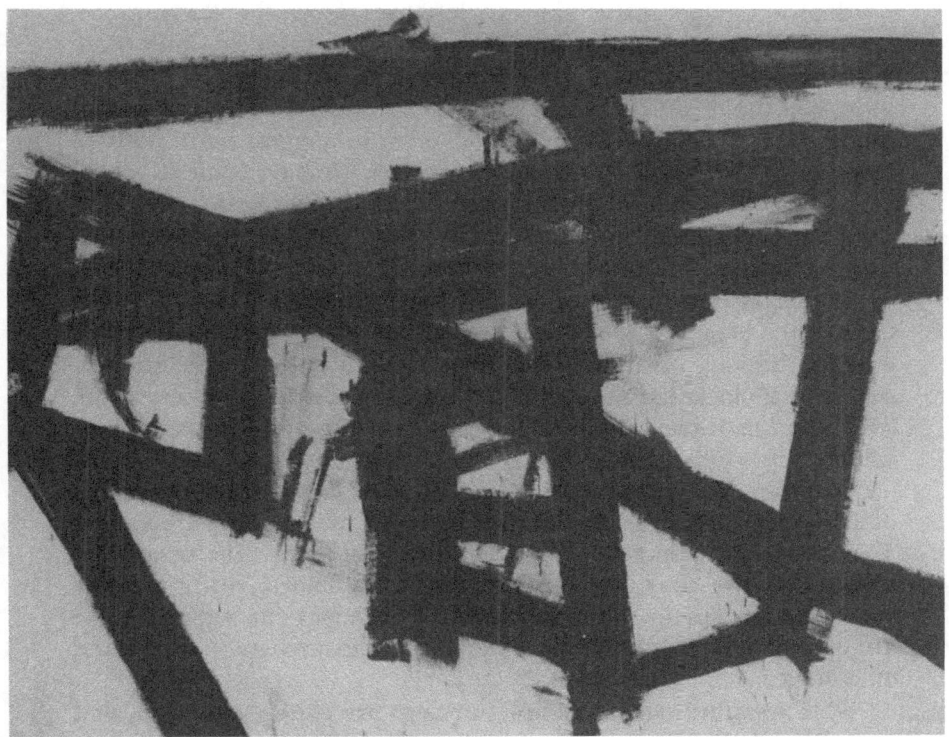

16.1. Franz Kline. *Mahoning*. 1956. Oil on canvas (80" × 100"). Collection of Whitney Museum of American Art. Purchase, with funds from Friends of the Whitney Museum of American Art.

In each case the absence of climax, shading, or color seems as important as the presence of its opposite.

In 1950, Franz Kline (1910–1962) began to build larger canvases. He dropped color and his interest in the subject matter of the Achcan School in favor of large black-and-white abstractions that "continued to recall the great bridges and elevated railroads of his early works" (Rose 1969, 72). In renouncing human form in favor of the steel structure of the city, Kline, on the one hand, denied any

fundamentals of structure, as Willem de Kooning, Robert Motherwell, and Franz Kline have . . . demonstrated" (Hunter 1959, 146).

residual anthropocentric interests left over from the Renaissance, but, on the other hand, returned to this interest by choosing those structures made by man. To put a triple twist on the tail of ambiguity that the modernist loved so much,[3] it might be pointed out that though the machines of man would seem to suggest man, nothing seems to be further from man in our minds. We have come to associate the machine with dehumanization, and "ironically it is mechanical form, man's purest creation, which most directly contradicts the forms of his own organism" (Seitz 1983, 55).

Kline was not interested in color, so he often left it out. It was difficult to look at any black-and-white painting during the 1950s without thinking of Franz Kline, even though de Kooning, Motherwell, and Pollock had also done achromatic paintings (Sandler 1970, 245). "Franz Kline" had become a metonomy for the absence of color.

Another inversion of traditional Renaissance priorities was the modern rejection of classic clarity in favor of romantic ambiguity. The Renaissance emphasis on Euclidean geometry is the search for the known, the clear, the rational, the mathematical, and the provable. Non-Euclidean thought, however, traverses the region of the unknown, the assumed, the conjectural, the ambiguous, and the imaginary.

It is apparent, when Kline's paintings are closely observed, that those ideas he had relinquished in order to focus on more important interests were the four Renaissance perspectives—linear, atmospheric, color, and the separation of planes; Renaissance sculptural bulk, or volume; and any clarity of spatial placement as well as any sculpturally enclosed or empty depth. Or, as Seitz puts it: "With mass went the emptiness by which it was surrounded, the enclosed volume of the stage box. It is significant that bulk and perspective were rejected together, for it was by this rationalization of sight that exact size and precise location in space could be decided by rule" (Seitz 1983, 9).

When Kline's contemporaries encountered his paintings, the absent elements loomed larger and more obvious than the elements

3. "So important is the recognition of the ambiguous in the works and ideas of modern artists that it is impossible to circumscribe it as one of several topics. We are continually concerned, in each section, with forms and ideas whose implications are multiple, and whose meanings are ambiguous in one sense or another—dualistic" (Seitz 1983, 105).

that were present. Where is the perspective? Where is the volume? Where are the objects? What is this supposed to be a picture of? What such paintings were not was more obvious than what they were: Kline's paintings seemed to make viewers more conscious of what was missing than what was present. Yet several traditional structures were maintained.

In *Mahoning* (fig. 16.1), it is easy to perceive Kline's concerns with structural elements that have been of service to painters since the High Renaissance. The most immediately obvious structural device is dark-light composition. The classic formula of large, medium, and small is also present in the relationship between the large black masses, the medium-sized black shapes, and the smaller individual splinters around the periphery. This arrangement culminates in compositional climax.

The balance established between Kline's sharply focused edges and areas and his blurred edges and areas serves multiple duties. The blurred areas function as a device of compositional climax—focus and blur—and they also work effectively as a half-tone transition between dark and light. Kline achieved this blurring by the use of different techniques. A brush moving rapidly across the surface of the painting created a blurred edge and caused the viewer to recreate the speed of the brush across the canvas, while a slow-moving brush loaded with paint made a much sharper edge. The relationship between these two different treatments of the edge can cause the viewer to infer, though unconsciously, the change in speed, rhythm, or tempo of which Hofmann spoke. This change in rhythm contributes to the implied image of dance (discussed in chapter 15). Sometimes this inferred presence of the painter is the most important experience of the painting.

At first glance, Kline's paintings appear to consist of a black figure on a white ground, but the white shapes that are cut out of the black soon assert themselves as salient white figures on a black ground. "His passive whites are often of equal, if not greater, importance than the blacks," Hess observes, "for they are only superficially quiescent" (Hess 1951, 137). The viewer can shift the figure and ground back and forth so that first black reads as figure, then white. They cannot both occupy our awareness as figure at the same time; it is an either/or situation (Arnheim 1974, 228). When the black in Kline's painting is in focus, it reads as figure and appears salient. But when the white is prominent, it then becomes figure and is seen as salient.

The two contrasting values appear to be moving back and forth in space, exchanging spatial positions with each other (Arnheim 1974, 228): this is spatial ambiguity. These shapes do not maintain a stable spatial placement. They tend to move back and forth in depth, creating a spatial tension that is part of the effect that Hans Hofmann has labeled as "push and pull." Kline insisted: "I paint the white as well as the black, and the white is just as important" (from Sandler 1970, 245). This characteristic example of figure-ground reversal illustrates one of its interesting effects: the choice of which shapes to focus upon and in what order is the one element of the painting that the viewer controls.

Though painters since the Renaissance have known and experimented with figure-ground relationships, and the mannerists were interested in spatial ambiguity, no style of painting has given so much attention to spatial ambiguity and figure-ground relationships as that of the modernists. Many abstract expressionists were not satisfied so long as there was even one shape left in their painting that could be read only as negative. They intended to create paintings in which each shape could at some time be read as positive so that no blank, inactive area was left to puncture the solid image of the painting. (This device might also be seen as a reversal of the traditional priority of figure over ground.)

This integrated, ambiguous approach to spatial tension was used almost as much as the older and more familiar lateral tension. In figurative painting, lateral tension is often created by slanting the axis of the major body parts so they rock back and forth across the surface of the painting. In the hipshot contraposto pose, the axis of the head is slanted in one direction, the axis of the ribcage in the other direction, while the axis of the hips returns to the first direction, parallel to the head. Kline uses this lateral tension between shapes just as a painter of the human figure does. In *Mahoning*, he has several shapes and strokes rocking laterally against each other, and he develops a silhouette that contrasts long, monolithic, passive areas with choppy, fragmented areas of activity as if the black shape were a human figure in contraposto.

There were three major ways in which Pollock and Kline differed. Kline made use of composition in dark and light; Pollock did not. Kline organized his compositions to climax; Pollock did not. Kline's work was dependent upon the reversal of figure and ground; Pollock's was not. Most of Kline's shapes were destined to read as negative at some time. Pollock, however, avoided negative shapes.

In short, Kline pursued Renaissance form, structure, and composition, though divorced from the Renaissance illusion and modified by an extension of Hofmann's ideas and concepts—particularly his "push and pull" concept. Pollock, in contrast, tried to avoid Renaissance form. It was for de Kooning to maintain the structures and concepts of .Pollock's drip painting, finally translating them into a language more adapted to the brush. In that translation he set out in a direction which led to a new and integrated approach to the human figure in painting.

17
de Kooning's Illusion Denying Illusion

I Still Get a Thrill When I See a Bill, the title of one of Mel Ramos's paintings, refers to the work of Willem (Bill) de Kooning (b. 1904) and indicates how important his paintings have been to those painters who followed him. De Kooning's paintings are a logical extension of Pollock's "all-over" concept adapted to a process more suited to the brush. This new brush-oriented process ultimately made it possible to return to figurative subject matter in a manner that is rooted in history yet remains within the confines of a flatter picture plane and the tacit objectives of abstract expressionism.

In a perceptive recent biography of de Kooning, Harry Gaugh maintains that it is difficult to establish who first began to paint in black-and-white: de Kooning, Pollock, Motherwell, and Kline all began at approximately the same time (Gaugh 1983, 25). Achromatic painting is not an uncommon experiment for young painters in their quest for the mastery of composition and structure. Many young painters have used this method to focus their attention and direction on structural rather than decorative aspects. If we accept the analogy that the process of developing new techniques in art is similar to unraveling a fabric into its individual threads and fibers so it may be rewoven to form a new fabric, then we can see how the process may be simplified if some of the threads—such as color and temperature—are eliminated.

An equally valid opinion is that de Kooning eliminated color in order to strengthen the aporia of ambiguous relationships. Taking a cue from Hess, Gaugh says that de Kooning chose black and white "to achieve a higher degree of ambiguity—of forms dissolving into their opposites—than ever before" (Gaugh 1983, 27). And still another reason for the elimination of color may have been an attempt to avoid those associations with the world outside the painting that color makes so emphatically.

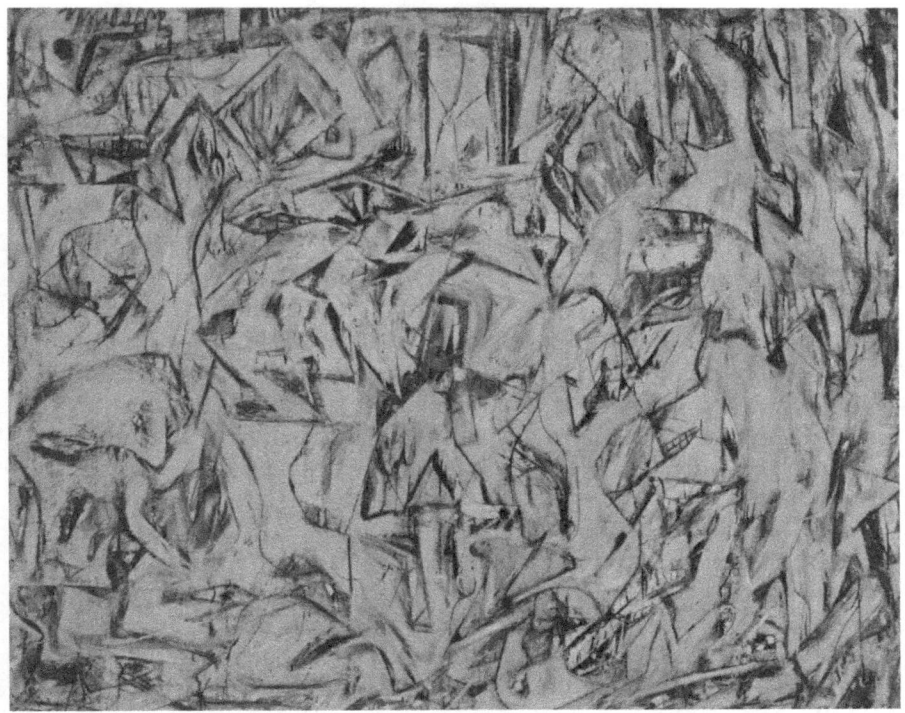

17.1. Willem de Kooning. *Excavation*. 1950. Oil and enamel on canvas. (6'8½" × 8'4⅛"). Collection Frank G. Logan Purchase Prize, Gift of Mr. and Mrs. Noah Goldowsky and Edgar Kaufmann, Jr. Courtesy of the Art Institute of Chicago, Chicago.

In 1950, de Kooning eased out of this achromatic restriction and painted the largest painting of his career, *Excavation* (80" × 100"). By this time, de Kooning had flattened his pictorial space until there were only hints of a hidden visual depth. He not only rejected but indeed negated all illusionistic suggestions of depth by using the action painter's device of sweeping strokes executed with large muscles and the entire body (Gaugh 1983, 64). The painterly quality of his brush-strokes asserted "the physicality of [the] canvas which supported them" (Sandler 1978, 5). He also exploited his knowledge of perspective and illusionistic elements in order to maintain this flatter surface visually.

Elaine de Kooning's significant comment that "flatness is just as

much an illusion as three-dimensional space" applies directly to Willem de Kooning's work during this period: he used illusionistic devices to make a flat surface appear flat. His illusionistic surface is congruent with reality: he uses illusion to deny illusion and to support reality. Thus, de Kooning has demonstrated that spatiality in meaningful painting is affirmed even as flatness is asserted.

The strokes of the brush—both large and small—overlapped and intertwined to create the same kind of inseparable webbing that Pollock had created (Seitz 1983, 11). De Kooning interlocked brushwork with the images of men and anatomy without destroying the integrity of the picture plane. The human form became the elemental building block of de Kooning's painted universe. Though his early work is nonfigurative, the brush-strokes weave over and under the picture plane to suggest the somatic bulk of the human figure; they are "like a flat wall of living musculature" (Seitz 1983, 48).

De Kooning's paintings were broken into small shapes of equal size, similar shape, and equal emphasis in order to avoid the traditional compositional climax. He had learned this technique from Pollock; in his often quoted statement, "Jackson broke the ice," he gracefully rendered credit for this breeder idea that was to influence him and so many others for the next decade (Sandler 1970, 102).

The spatial construct of *Excavation* (fig. 17.1) is not related to Hofmann's ambiguous spatial "push and pull." Instead, this painting maintains a shallow illusion of interlocking planes. Although one plane can be seen to slip behind another, and at times this relationship may shift aporetically, there is no space deep enough to support Hofmann's sensation of push and pull. This pictorial space, unlike Hofmann's, is not so much reminiscent of medieval painting as it is of Giotto's flat, solid wall in the fourteenth century.

In order to establish an ambiguous spatial push and pull, each particular shape in the painting must be capable of being perceived at one time as positive and at another as negative. But De Kooning's painting offers no negative shapes. He succeeded in making all the shapes read simultaneously as positive shapes. Each part of the painting was painted the same as each other part. He did not change stroke, "voice," or technique from part to part or shape to shape. He creates a fusion of what has traditionally been an opposition between figure and ground.

There is a "door" in the bottom middle of this painting, and it is quite literally a door. He worked it into the painting after seeing a

weathered blue doorway while walking through New York and commenting that he would like to put that shape into his painting (Gaugh 1983, 37). The door is slightly ajar, suggesting but not showing the existence of space behind the solid wall of the picture plane. The position of the door is indicative of the attitude in the rest of the painting. There are many slots and slices that seem to suggest the presence of openings or wrinkles that lead to a deeper, secret space, but no depth is ever shown. The suggestion of depth becomes a titillating spatial striptease.

Like a fan dancer's ritual, de Kooning's painting centers all the interest in and upon pictorial space. He allows us to sense, but he never quite allows us to see, the object of his concern. We know from Barthes that the spectator's perception of a striptease is forced "back into the all-pervading ease of a well-known rite" by the use of music hall props, which make the unveiled body seem emotionally more remote (Barthes 1982, 86). Similarly, de Kooning captures the dignity of a solemn ritual through this distancing of the viewer from his chosen subject matter, space, which he keeps well camouflaged. De Kooning, however, never claimed to maintain the stable illusion of a completely flat canvas and even remarked that "Nothing is that stable" (from Sandler 1978, 5).

The abstract expressionists would have liked to work with the figure. But when Mark Tobey was asked why the modern artist did not paint the figure, he answered, "They wish very much to do so, but cannot" (from Seitz 1983, 118). And in a lecture of October 30, 1951, Tobey said, "We have tried to fit man into abstraction, but he does not fit" (from Seitz 1983, 104). Frank Stella insists it was Cézanne's plane concept that pushed the figure out of painting: "the emphasis on and consequent proliferation of planar representation had begun to dissolve the space around the human figure as well as the figure itself" (Stella 1986, 71).

No agreement had been needed to exclude the figure from abstract expressionism. Before 1950 the figure had been excluded because it could not immediately be assimilated within the parameters of the tacit concerns shared by the abstract expressionists. These painters had found no way to reconcile an illusion of figurative volume or mass within the limitations of the flatter picture plane. Even if the figure were kept visually flat so as not to violate the flat plane, this flat figure still left permanently negative recessive shapes in those areas that the figure did not occupy. It took time for de Kooning to reconcile the figure with the tacit concerns of the period.

In 1949, de Kooning had started to smuggle the figure into abstract expressionism. His paintings from this era are composed of shapes that suggest the human figure. These shapes have the ambiguous quality that the abstract expressionist loves so much; the shapes appear at one time to be abstract and at another to be figurative. "Not only are we confused by the double image of a flesh-colored field of hills and valleys, referring equally to figure and landscape," Barbara Rose remarks, "but also the darting and skipping line does not create any entirely legible or closed contours either" (Rose 1969, 77). What better way to include the figure in a style that loved ambiguity and excluded climax, volume, and mass!

De Kooning began to work on *Woman I* (fig. 17.2) in 1950. He painted almost every day for two years on this canvas in what Harry Gaugh describes as a virtuoso performance of process triumphant over product. De Kooning scraped off image after image, painting after painting, layer after layer (Elaine de Kooning has guessed that more than two hundred paintings were wiped out during this process). Gaugh creates a strong image of the process:

> Feeling it impossible to finish, de Kooning abandoned it. At the same time, like an ancient siren, the image continued to attract him. After showing the unfinished canvas to Meyer Shapiro and discussing it with him, de Kooning went back to work, pulled off the cutout lips from a Camel cigarette advertisement he had pasted on the head, and repainted the face. In an outburst of energy, he not only completed *Woman I* in June of 1952 but pursued the image in multiple manifestations through a series of paintings and drawings stretching into 1953. This coven of sympathetic witches was first exhibited at the Sidney Janis Gallery in March 1953. (Gaugh 1983, 41)

De Kooning's process is an excellent example of the discipline of a master painter. De Kooning was more interested in painting as an experimental learning process than in completing a finished product. When he first came to this country in 1926, he already had the strong discipline of a thorough art training in the guilds of Holland. One of the strengths of this kind of training is its emphasis on painting as a constant and continual process of becoming a painter, as opposed to making paintings. The best art training institutions have always concentrated on turning out painters, not paintings.

de Kooning's Illusion Denying Illusion 195

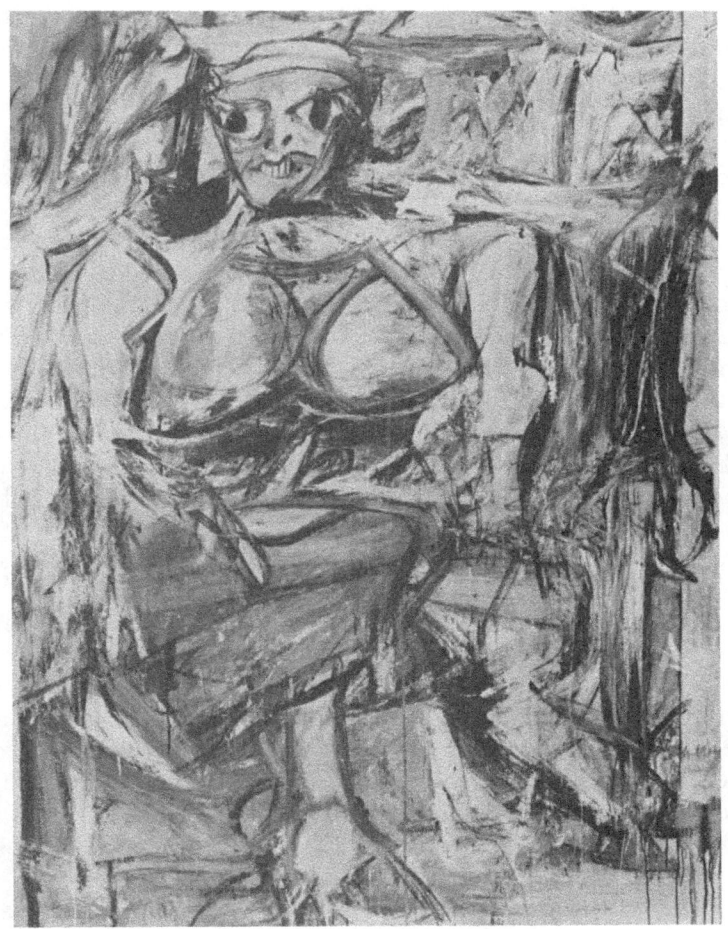

17.2. Willem de Kooning. *Woman I*. 1950–1952. Oil on canvas (6'3⅞" × 5'8"). Collection, Museum of Modern Art, New York. Purchase.

De Kooning had learned to pursue a meaningful and unified direction aimed at some body of work in the future, rather than thinking only of each individual finished painting. He had learned that the image cannot be forced onto the canvas: it grows naturally from the wedding of spatial structure to personal process, interest, and insight. None has any value without the others. De Kooning's process of leaving evidence of his mistakes and revisions serves to

"indicate the long struggle to complete or perfect a picture, which nonetheless always looks unfinished, as if subject to further modification" (Sandler 1970, 131).

In order to make the figure function within the limitations of the picture plane, in the spirit of the 1940s and 1950s, de Kooning had to coax the figure to fit within the spatial confines of that plane. The figure had to be painted no differently from anything else in the painting. It had to be executed in such a manner that it created no negative shapes. It had to be kept flat by dissolving or fragmenting solid bodies and by filling voids (Seitz 1983, 41). It also had to be broken into similar kinds and sizes of shapes in order to avoid any compositional climax. This process granted a higher priority to the structure of the painting itself than to the objects that were depicted in the painting.

There are several ways to reconcile the figure with a visually flat surface, and at one time or another de Kooning used all the following methods: his lack of shading kept the figure visually flat; he fragmented the body into anatomical planes spread across the surface (as the cubists had); and he opened up parts of the figure and merged them with the background so the two formed a single, intergrated image (Sandler, 1970, 122–23).

There was no longer talk of background, ground, or even the integration of figure and ground, because there was no figure and there was no ground. The entire painting was figure: it was one image. Every inch functioned as positive shape. There was no longer any evidence of the empty space that was enclosed between the painted figures in traditional painting. All the space was occupied, packed, stuffed full of positive shapes.

In *Woman I*, de Kooning painted the entire painting in the same manner. Every stroke was similar to every other stroke and interwoven through the surface, regardless of what particular external object it might be associated with. This painting would still have no climax were there not eyes and mouth to focus on.

Painters of a lesser muse are afraid to paint wet paint into wet paint. They prefer a faster drying paint so they can paint on a neat, dry, easily controlled surface. Painting over dry paint is easier for them. De Kooning, on the other hand, wishing to paint wet into wet, mixed oil of cloves with his paint to retard the drying time (Gaugh 1983, 61). Though this "wet into wet" method is more difficult, it allowed him to integrate the brush strokes better. Thus his paintings have the look of paint-painted-into-paint, rather than paint stuck

on top of paint. Each stroke is integrated with every other stroke and gesture in the painting. De Kooning's areas of raw, unfinished brushstrokes shift ceaselessly and "suggest a perpetual state of becoming" (Sandler 1978, 48).

Though de Kooning painted Woman, his subject matter was not Woman. His content was space, composition, and brushstroke. Gaugh comments that "the authority of de Kooning's brushwork in mangling the image internally as well as externally makes it clear that the painter's stroke, liberated from any descriptive function, supplants Woman as the subject of his art" (Gaugh 1983, 56). He adapted Pollock's all-over, climax-free style and the flat, interwoven structure of the picture plane to the figure. But it is integration that is important, not the human figure.

De Kooning visually established the picture plane as the farthest point from the viewer. He then set everything in front of that so all his paint appeared to be on, or in front of, the picture plane (Gaugh 1983, 56). The paint was the picture plane. illusion was reality. This is the final step in the inversion of the traditional Renaissance relationship that had established the illusion of depth as a higher priority than the flat picture plane.

18

The Ascendancy of Pluralism

THE ART OF THE 1960S CONTINUED, for the most part, its investigations into the formal structures of painting, in the process becoming more reductionist and even more microcosmic in its focus. Painters of the 1960s focused their individual interests on various precise, specific, and narrow areas of exploration. If abstract expressionism is perceived as a meta-art, with a reductive microcosmic focus achieved by the restructuring of Renaissance perspective and form in order to create new illusions and images, then the art forms of the 1960s must be seen as substructures, satellites inspired by and circling the main body of abstract expressionism.

In the late 1950s, young painters, in order to have any idea what was happening in the art world, had to be part of the New York art scene. Painters in the hinterlands knew only what they saw in magazines such as *Art News,* and they tended to execute variations of the works they saw in these magazines (Sandler 1978, 280–81). Most of the young painters in New York had been so stunned by the work of de Kooning and Kline that they believed any other direction was superficial. Under the influence of these leaders, gesture painting had dominated the New York School during the early 1950s (Sandler 1978, 292). By 1957, however, abstract expressionism was a "dying or dead orthodoxy" (Sandler 1978, 280).

Abstract expressionism split into two different directions: gesture painting and color field painting (Sandler 1970, 148). The art of the 1950s had a hot, gestural, painterly look; art of the 1960s was cool, antiseptic, and mechanistic. This move toward clearly defined, unmodulated color was so relentless that painterly painting was receiving little critical attention by the end of the 1950s (Sandler 1978, 292). There was a solid and sizeable market for modern art by the early 1960s, and artists "who just a decade earlier could not even imagine the possibility of success became culture heroes—and wealthy ones" (Sandler 1978, 257).

Artists during the 1960s had a wide choice of direction in which

their work could go and still be considered relevant to the spirit of the times.¹ While many painters continued to explore ever flatter pictorial space, others began to flatten their canvases physically by using thin washes of paint that soaked into the surface of the unprimed canvas and thus denied even the slight physical bulk of paint. These paintings were physically flatter; but they were not visually flatter. The thin paint was transparent, atmospheric, and once again suggestive of visual penetration and depth.

Newman's Binocular Paintings

The color field painters tried to rid their art of all references to nature, recognizable images, past art, or present art because they felt such connections would create a predictable response (Sandler 1970, 150). They also sought to escape the confinement of the frame by painting large open areas that seemed to swell beyond the edges of the painting (Sandler 1970, 151). These painters simplified detail and technique and suppressed nuance in a successful attempt to produce an impact similar to that of the primitive art they admired (Sandler 1970, 153). This is the direction modern art had been heading for decades: each painting had now become one large, cohesive, monolithic image. In the last chapter I shall argue that such a monolithic approach is one of the features that distinguishes modern painting from postmodern painting, which purposely offers a more fragmented image.

Barnett Newman used stains, transparent paint, and atmospheric effects to create an illusion of deep space. Many of Newman's paintings appear to be experiments in the two-dimensional representation of binocular vision. Though some *trompe l'oeil* painters, like William Harnettt, had avoided any binocular effect in order to "fool the eye," I can think of no painters before Barnett Newman and Larry Poons who successfully induced a binocular effect on a flat surface in a structural manner. As Stella maintains, "In the end, it was left to Barnett Newman to break definitively with easel painting and to account finally and determinedly for the emer-

1. "It is not necessary to believe in the historical succession of styles, one irrevocably displacing its predecessor, to see that a shift of sensibility had occurred. In the most extreme view, this shift destroyed gestural painting; in a less radical view, it at least expanded artists' possible choices in mid-century New York, restoring multiplicity" (Alloway 1968, 48).

gent binocular vision of twentieth-century abstraction" (Stella 1986, 84).

Newman started with opaque paint of several similar but subtly different hues and values. These similar colors were often applied by wash, sponge, scrubbing, dabbing, and scrumbling to create a deep atmospheric color that appeared to be continuous and visually penetrable. Several of the painters who worked with stains created paintings of unprecedented physical flatness, but their stains, which also appeared disembodied and more optical and illusionistic, opened and expanded the picture plane (Sandler 1978, 232).

By 1970, Newman was using the thin transparent stains of paint that are shown in *Vir Heroicus Sublimis* (fig. 18.1), and his paintings were big—eight feet and larger. While a small spot of color will seem to lie flat on the surface of the canvas and appear paper-thin, a large area of the same color will look "deep" even if it is opaque (Plagens 1971, 63). Newman's use of vast expanses of one color posed new formal problems and effects: these expanses eliminated figurative and symbolic associations; they seemed more saturate; and they avoided the contrast of light and dark values that tends to dull color (Sandler 1970, 148). These large expanses of color overwhelmed the retina and detached the viewer from the everyday world (Sandler 1970, 151).

Peter Plagens notes that unlike most large paintings, Newman's were intended to be seen close up, rather than from a distance. Seeing these large paintings from close up tended to make viewers feel surrounded by the atmosphere of the painting; accordingly, they were not conscious of the edges or the format of the painting. By extending all the shapes from edge to edge, Newman avoids having his paintings perceived in the natural image of "a window to the outside world" (Plagens 1971, 63). In this respect, Stella feels, abstract painting is superior to representational painting because "realism today can only look through a viewfinder out the window of perspective" (Stella 1986, 77).

In front of his seemingly endless colored atmosphere, Newman painted one thin, sharp, opaque line—he referred to such lines as "zips" (Plagens 1971, 63)—usually about the width of a strip of tape, sometimes narrow tape and sometimes wider tape. This "zip" of opaque paint contrasted with the ground in value, opacity, and often temperature. This contrast, which creates such a strong spatial reading, was accomplished by using elements of atmospheric and color perspective, and is often combined with a contrast between the

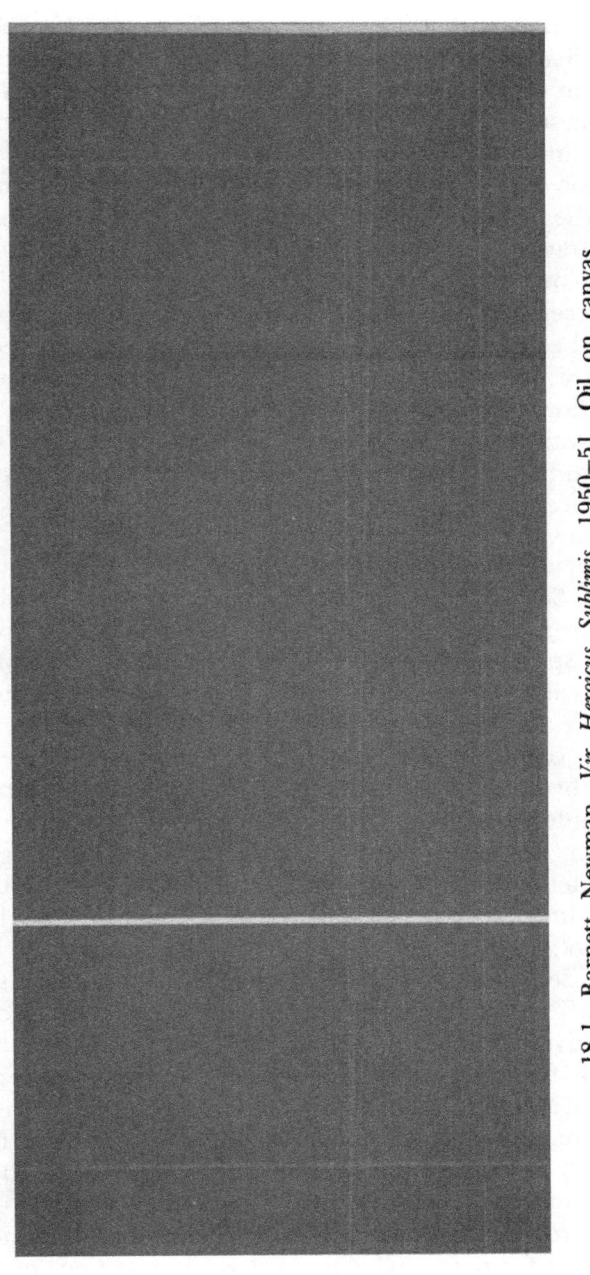

18.1. Barnett Newman. *Vir Heroicus Sublimis*. 1950–51. Oil on canvas (7′11⅜″ × 17′9¼″). Collection, Museum of Modern Art, New York. Gift of Mr. and Mrs. Ben Heller. Reproduced courtesy of Annalee Newman insofar as her rights are concerned.

opaque and the transparent. Once again a new image was achieved by a new combination of the traditional elements of spatial illusion.

The creation of an illusion of space, even deep space, was once more acceptable so long as it was not accomplished by the separation of planes, shading, or linear perspective, all of which came to be thought of as too easy, too heavy-handed, and immediately recognizable. Because these three devices were incompatible with this period in painting, "drawing as such had been ruthlessly eliminated from 'mainstream' colour-field painting in the 1960s" (Hughes 1981, 402). It was quite acceptable to use Renaissance devices of atmospheric perspective and color perspective in this sensation of depth because these devices are subtle, recognized by few viewers, and not dependent upon "drawing." The color-field painters thus created their spatial illusion with two of the five major elements of illusion—sometimes with an additional boost from the contrast between the opaque and the transparent.

Such a contrast—a narrow, light, warm, opaque strip of paint across a wide, dark, cool, atmospheric ground—was startlingly binocular in effect. Sandler contends that the space between the strip of paint and the ground was palpable; this "zip" of paint appeared to be "ravaged by space; their tremorous eroded edges suggest vulnerable human touches" (Sandler 1970, 190). Some viewers had the distinct impression that they could see around the strip in the same fashion as they could see around a vertical finger on an extended arm: none of the continuous atmospheric background appeared to be covered or interrupted.

Despite their aesthetic success, Barnett Newman's paintings exerted little influence on the young painters who followed, probably, Sandler conjectures, because such paintings seemed to offer fewer oppositional options and alternatives than the gestural style of Hofmann and de Kooning. The gestural style seemed to be structured so as to offer many opportunities for the exploration of oppositional alternatives: "painting representationally and/or abstractly; in depth and/or flatly; Cubist-inspired relational design and/or Impressionist-inspired non-relational fields; with reference to past art and/or in reaction against it" (Sandler 1978, 11). I suggest that much of the popularity of this gestural style hinged upon the presence of just such inherent oppositions occurring as a natural part of the structure and process of the style, which seemed to offer painters rich opportunities for new combinations and permutations of these oppositional elements. Moreover, I believe that the potential it pro-

vides for contrast may also be the principal reason for the influence and sustained interest, over many centuries, in variations of the Renaissance system of perspective as a foundational structure. Perhaps those styles that are easily unraveled and rewoven to render new images and directions will always be the most influential and lasting.

Poons's Spatial Confetti

Using painted ellipses on a dyed canvas ground, Larry Poons created a binocular image that was different than Newman's; but the device Poons used was similar in its exploitation of atmostpheric and color persective. His image suggests an atmosphere of confetti that seems to surround the viewer physically. Poons used no drawing, so there was no need for linear perspective (the ellipses are all the same size whether they appear salient or recessive). It can be observed in *Untitled* (fig. 18.2) that Poons used atmospheric and color perspective to make some of the ellipses float only slightly in front of the picture plane, while others appear to leap off the canvas and extend past the viewer.[2] This technique is an extension and an exaggeration of the priorities of the fifties: that it was acceptable to create an illusion of depth between the picture plane—which is congruent with the canvas—and the viewer, but any illusion of recession or depth behind this plane was still to be avoided.

Dyed fabric, though it does not appear so atmospheric as transparent paint, appears slightly less solid than opaque paint. The receding ellipses, in paintings like *Untitled* (fig. 18.2), are the same value (atmospheric perspective) and the same temperature (color perspective) as the dyed red that establishes the picture plane. Only a difference in opacity between the canvas and these ellipses creates any spatial distance between them and the dyed red background. For the most part they lie flat on, or in, the surface of the canvas.

Those ellipses that advance the most, however, are in strong contrast to the ground in three major ways: They are opaque against an atmospheric ground; they are much lighter and thus contrast in value; they are cool on a hot ground and thus contrast in color tem-

2. As Rose notes, this "illusion that the image was being projected in front of the picture surface—that in other words, the entire canvas field is positive foreground as opposed to negative background on which positive forms are depicted—is also at work in Larry Poons's early paintings of brilliantly colored dots on dyed canvas fields" (Rose 1969, 97).

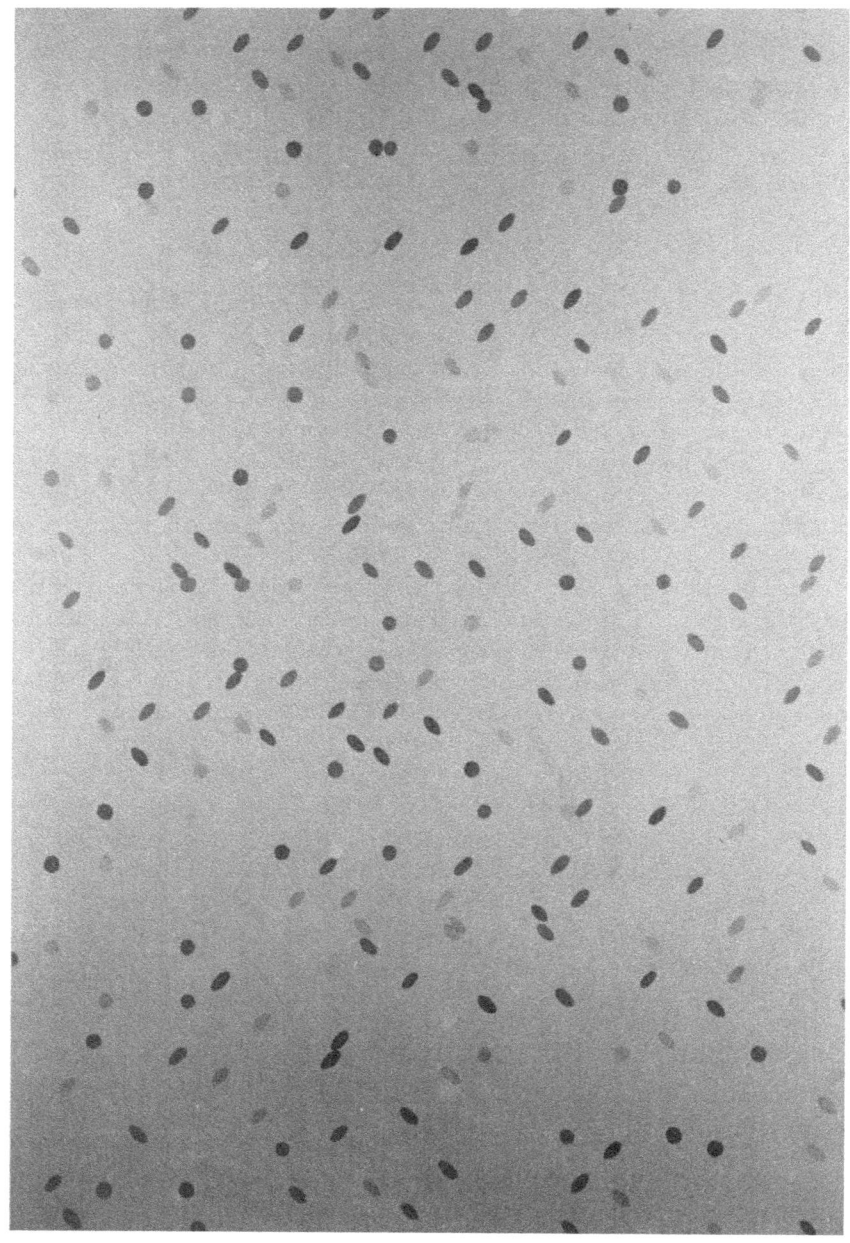

18.2. Larry Poons. *Untitled.* 1966. Synthetic polymer on canvas (130″ × 90″). Collection of Whitney Museum of American Art, New York. Purchase 66.84.

The Ascendancy of Pluralism 205

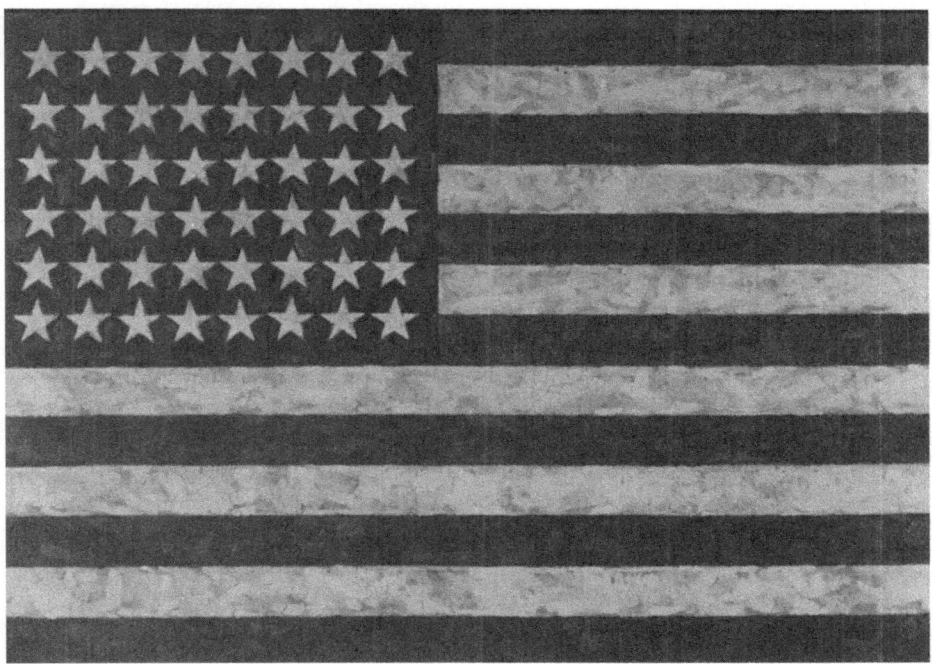

18.3. Jasper Johns. *Flag.* 1958. Encaustic on canvas (42½″ × 60¾″). Collection, Jean Christophe Castelli, New York. © Jasper Johns / VAGA New York 1989.

perature. The third is an example of the now familiar reversal of the classic color theory. The other ellipses are arranged sequentially in graduated increments of contrast between the extremes of opacity, value, and temperature.

Photo-Realism's Aporetic Content

At first glance, photo-realism could appear to be a return to an illusion similar to that of the Renaissance. The photo-realist, however, depicted a flat object—the photograph: "Photo-Realists are not interested in photographic realism (in the sense that realist painters such as Andrew Wyeth and Alex Colville seek to emulate the detailed accuracy of camera vision). To them the photographs are simply flat images for use on flat planes" (Walker 1975, 44).

Photo-realism offered a new twist on the idea of painting flat objects in order to maintain a flat picture plane in the tradition of Monet's paintings of the semi-flat facade of Rouen Cathedral, Harnett's paintings of paper money and letter racks, and Jasper Johns's flag paintings. Johns's *Flag* (fig. 18.3). Sandler believes that Johns "created a realist art that does not resemble any other." His paintings were a strange combination of abstraction, realism, flatness, and facsimile that raised many new questions about the relationships among at least four topics: painting, depicted objects, illusion, and reality. By eliminating traditional figure-ground situations, he avoided the sense of depth suggested by these relationships. By choosing flat objects to depict, he kept the image and the picture plane congruent: the flatness of one augmented the other. He also covered the entire surface with a paint-stroke of uniform density. This fusion of the picture plane, subject matter, and illusion enabled Johns to combine "pictorial elements from past styles commonly considered antithetical: gesture painting superimposed on a ruled design associated with geometric abstraction but put in the service of representational description" (Sandler 1978, 187). In short, Johns's approach is a synthesis of traditionally oppositional elements.

Sandler points out that Jasper Johns's new technique raised at least four new questions about the relationships among structural priorities in painting, representation, and language. (1) "[Can] a painted copy of a flag which could pass for a flag point to a flag as a sign or be its symbol?" (2) "What is the difference between *presenting* a flag *as* a work of art and *representing* it *in* the work?" (3) Does recreation "result in 'transformation'"? (4) "If a picture of a flag is not a representation, it is non-representational?" (Sandler 1978, 185–86). Johns was furiously demolishing the old boundaries between abstraction and illusion.

The photo-realist paintings of flat photographs contained at least one additional illusion of their own, and sometimes three or four—as in Don Eddy's *Silverware for M.* (fig. 18.4). Often the photographic illusion on the flat photographic surface was echoed within the photograph itself simply because most photo-realists chose to photograph reflective objects that contained their own illusions. A painting (an illusion on a flat surface) of a photograph (another illusion on a flat surface) often depicted a third illusion on a flat surface (such as Don Eddy's reflections in a plate glass window), thus creating a triple entendre analogous to the theatrical tradition of a play within a play within a play. Accordingly, such a painting must be read as an illusion within an illusion within an illusion. The source of

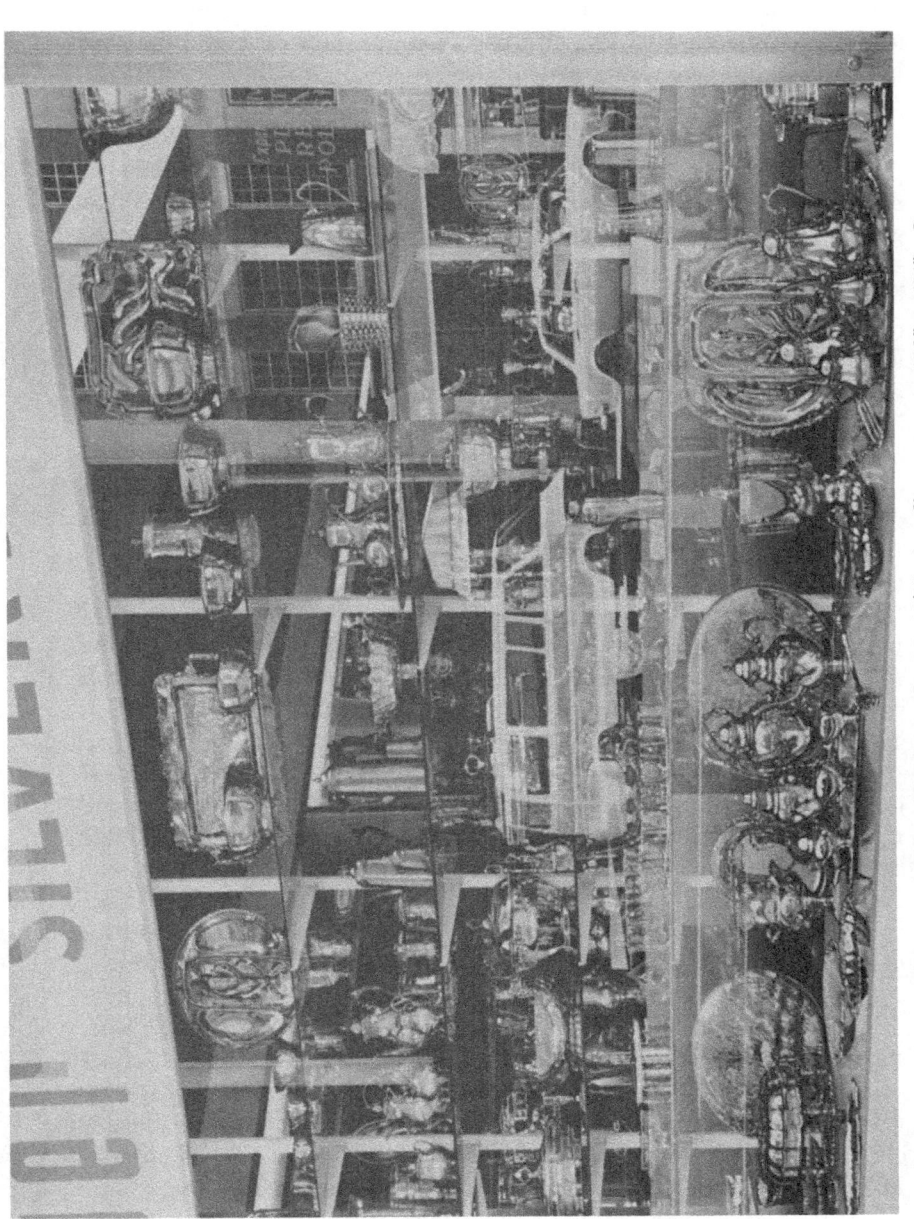

18.4. Don Eddy. *Silverware for M.* 1975. Acrylic on canvas (40" × 55"). Courtesy Nancy Hoffman Gallery, New York.

the perceived illusion in photo-realism is often as elusive as the source of light from a lamp in a house of mirrors. Is the light we see a mere reflection, or does it radiate from the lamp itself? When we look at a photo-realist painting, do we see a painted illusion, a photographic illusion, or a reflected illusion?

Photo-realist painters, such as Ralph Goings or Don Eddy, often photographed glass store windows, which reflected landscapes and cityscapes in their flat surfaces. Other photo-realists painted photographs depicting glass, chrome, and other shiny, reflective objects, such as cars. They painted giant facsimiles of these photographs; like Don Eddy's *Silverware for M.*, a photo-realist painting might mimic an illusionistic photograph of a plate glass store window. The window, being transparent as well as reflective, revealed a view of the scene behind the glass while it simultaneously reflected the scene in front of the glass. Both photograph and painting can capture both scenes at once; the eye cannot. The eye must focus on one image at the expense of the other. John Szarkowski describes the difference between camera and retinal focus. "A glance at the reader's own reflection in a mirror will help clarify the issue: One sees one's face not in the plane of the mirror, but behind it, at an optical distance twice as great as that from eyes to mirror. It is impossible to focus on both the mirror and the reflection at the same time. Photography however can record in sharp focus both near and distant objects (the mirror and the reflection)" (Szarkowski 1973, 11).

When faced with a view of a store window in the "real" world outside the painting, the viewer must choose to focus either on the reflection (in which case the reflective surface and the actual scene behind it cannot be seen clearly, if at all), or on the actual scene behind it (in which case the reflection cannot be seen clearly). Focus is often forced to shift back and forth between the two scenes in a constant reversal of priorities. One illusion thus negates the other.

In the world outside the painting, the importance of the relationship between the reflection and the actual scene behind the window are constantly overturned, just as in the painting there is a constant negating of the awareness of one of the four illusions—the reflection in the glass, the actual scene behind the glass, the illusion created by the photograph, or the illusion created by the painting—in favor of another. Each awareness negates the other.

During the 1960s, some of the minimalist painters, the ultimate microcosmic reductionists, tried to keep all the space in their paint-

ings active (thus positive in the sense that de Kooning's surfaces remain positive) by using a minimum of marks or interruptions on the surface. Other minimalists painted their canvases and panels all one color, then exaggerated the actual thickness of the paintings. They painted the thick edges of the painting the same color as the picture plane so that the physical nature of the painting as an object was emphasized. Such a painting was meant to read as a large solid rectangular block of paint or color.[3] In short, it was meant to read as an object, a positive shape.[4] Other artists were concurrently denying this very objectness. Being an artist today requires the questioning of the very nature of art itself (Gablik 1977, 158).

Though this plurality and multiplicity may have been good for art, it is more than a challenge for the writer. Through most of this book I have been able to cover reasonably well the major thrust and attitudes of each century with the example of one major artist. Not so with the 1960s. I am resisting the temptation to discuss each artist of the period in order to illustrate every individual interest and accomplishment. For instance, I am fascinated by Lichtenstein's cartoon essays, which reverse at least two major traditional priorities. He points out the possible superiorities of a cartoon symbol over an illusion, thus granting a higher priority to popular art than to the traditional fine art. He offers an alternative method of depicting specific realities that an illusionist finds difficult to capture, such as a woman saying "hello" in an icy voice, or fire coming out of the wing guns of an airplane, with the bold letters spelling a staccato RAT A TAT TAT. These painted words strengthen the image both figuratively and discursively. The words signify sound and action, and the letters in the painting are as real as the letters in the comic strip—or as I shall explain later, as real as letters in the world outside the painting. They do not just *signify* letters in the comic strip;

3. This method of painting "is a reminder that shaped blocks of one color have the power of touching emotion and memory at the same time they are being seen" (Alloway 1968, 53).

4. Some of this focus on the importance of the work of art as an object may be due to the influence that John Cage exerted on two major painters of the 1960s and 1970s. Hofstadter notes that Cage's friends Jasper Johns and Robert Rauschenberg both explored the distinction between objects and symbols by using objects as symbols for themselves—or, to flip the coin, by using symbols as objects in themselves. All of this was perhaps intended to break down the notion that art is one step removed from reality—that art speaks in code, for which the viewer must act as interpreter. The idea was to eliminate the step of interpretation and let the naked object simply *be*, period" (Hofstadter 1979, 703).

they are letters. They blur the boundaries between signifier and signified. But I shall resist the impulse to cover the entire period and stick to the general spirit of the relationship between the reality of the canvas and the reweaving of elements of the illusion.

The Parting

Many paintings during the 1970s were excellent. They moved the viewer, and I celebrate the attitude of freedom that existed at this time. Many other paintings of this period, however, were nothing more than "nice effects." They were attractive and they often offered a propitious point of verbal departure for critics. But ultimately many of these works failed in the crucible: "Because such objects had virtually no incident, and apparently no complexity, viewers found them inert, sterile and boring" (Walker 1975, 24).

Two major criticisms—primarily Marxist—have been leveled at modern art, Gablick notes: the first is the claim that modern art has no tradition; the second is the accusation that it lacks spirituality. The Marxist contends that modern art was traditionless, that every new style was another beginning. Moreover, traditional beliefs were associated with backwardness and a lack of momentum: "The period through which we have just lived has been, on the whole, one in which whatever was inherited from the past was thought of as a tiresome impediment to be escaped from as soon as possible" (Gablik 1984, 115).

But, in my view, this art did have traditions. Modern art had zealously pursued the tradition begun by Giotto at least seven centuries earlier, the tradition of a close examination of reality and an exploration of alternative illusionistic depictions of that reality by various combinations of the elements of the Renaissance system of perspective. Modern art's rejection of the two most obvious techniques of Renaissance perspective (linear perspective and the shading of volume), was not a rejection of interest in the illusion. What is the thrust of late twentieth-century directions—such as photo-realism, Lichtenstein, Newman, Poons, Johns, and de Kooning—if not a visual discussion concerning the relationships among the illusion, the real, and the sign? Such illusions were often pursued by using traditional Renaissance devices of perspective: specifically, atmospheric and color perspective and the separation of planes.

The modernists had also pursued the tradition of "form as content" that began in the sixteenth century. From their experiments

evolved new forms of dark-light composition, warm-cool composition, and compositional climax—the last of which was negated in Pollock's all-over style and finally developed into the minimalists' low incident painting. These modernists pursued an interest in proportion, value control, and the subordination of detail to mass. Modern art was not just traditional; it was richly steeped in tradition, as all legitimate art forms must ultimately be.

Each new art, each new vision, even as it destroys the old traditions, must be realized within the bounds of those established but distintegrating traditions. John Dixon insists that both Cézanne and Giotto are prime examples of how artists exploit the old tradition as they simultaneously destroy it in order to initiate the new (Dixon 1984, 293). It is perhaps even more desirable, and certainly just as accurate, to regard the new as an evolution or a lateral displacement rather than as a replacement. Each new idea is a variation, a further development, a related form that exposes the limitations of previous traditions, rather than a destroyer of the old. Thus, Pollock's all-over style can be perceived as a complex new awareness, an evolution, an alternative rather than a devastation, of the concept of compositional climax.

The second criticism—that modern art lacks spirituality—refers to the fact that modern art was not political; it was not intended to change societal structures (Gablik 1984, 115). This, the stronger of the two attacks on modern art, comes from Marxist critics primarily because modernists had rejected the many possible functional aspects of art: "Marxist aesthetics demands that art illuminate social relationships and help us to recognize and change social reality. For art to be a social force, it must have a wide audience, and it must pass judgment on the phenomena of life" (Gablik 1984, 25).

It is true that modern art never boasted a wide popularity among the general populace and certainly never professed to anything so functional as passing judgment on life. And it was obviously a formalist who said, that "political art results in poor politics and bad art."

The Marxist believes modern art is spiritually sterile and morally corrupt because it is purely individual and aesthetic (Gablik 1984, 24). But the Marxist criticism needs to be seen in the context of the recurring series of reversals of the relative priorities of the spiritual and the material that have transpired over two millennia. The medievals reversed the Greco-Roman priority when they began to place more value on depicting the spiritual than the material. The Renais-

sance, reversing the medieval order, returned to the depiction of the material over the spiritual. Now, however, critics tell us that the very notion of the spiritual has been inverted. Religious, transcendental, or aesthetic qualities in painting are called spiritually sterile and morally corrupt, while the spiritual is now considered to be that which may affect a change in society.

But formalists felt that the aesthetic *was* the spiritual. They believed the aesthetic experience was related to, or the same as, a religious experience. This seems to be a principal difference between modern and postmodern painting. Modern art pursued the transcendental; postmodern art aspires to more intellectual and discursive interests.

By the late 1970s, only the most obtuse of those in the art field had failed to perceive the decline of modern art. Robert Hughes summarizes the change:

> There was no specific year in which the Renaissance ended; but it did end, although culture is still permeated with the active remnants of Renaissance thought. So it is with modernism, only more so, because we are much closer to it. Its reflexes still jerk, the severed limbs twitch, the parts are still there; but they no longer connect or function as a live whole. The modernist achievement will continue to affect culture for another century at least, because it was large, so imposing, and so irrefutably convincing. But its dynamic is gone, and our relationship to it is becoming archaeological. (Hughes 1981, 375)

The Renaissance paradigm in painting had finally been laid to rest, and young artists in their continuing efforts to escape the Renaissance image switched their interests and loyalties from experiments with form and spatial concerns to a concern with language.

19

Postmodernism and the Post-Cartesian Viewer

INFORMED PEOPLE in the second half of the twentieth century are inundated by an ever-increasing flow of information: fragmented bits and pieces of an eternally changing puzzle that we venture to solve in order to gain fleeting glimpses of new realities. We are aware of a profusion of alternative modes of thinking, as no other people or civilization has ever been.

Clifford Geertz, well known for his essays in interpretive anthropology, points out that our society knows that Hopi Indians see the natural world in terms of events rather than objects. We know that Eskimos experience time as cyclic rather than serial (Geertz 1983, 161). And the Indochinese, in a manner directly opposite to ours, picture their future as lying behind them. As fatalists, they experience time like a movie film, as if their life had already been filmed and the past is that part that has already advanced through the projector. They perceive the past as residing in front of them, their future situated behind them, ready to be shown. But we, on the other hand, consider that our life is being "filmed" as it happens. We view time as moving from the past, which lies behind us, into the future ahead of us, "the present being merely that moving limit between the two" (Burtt 1954, 95).

This abiding awareness of other patterns of consciousness extends our horizons and stimulates our imagination. The ability to "recognize the existence of a plurality of perspectives, as one does in relativity, is to be already in some sense beyond all of them" (Gablik 1977, 81). This awareness of other points of view shows us other realities and expands our consciousness in ways that have not been available to any other people in history. Our thinking, our art, our science, and our world view are all eclectic. Our concepts and ideas are littered with parts and pieces—some well petrified, some warm, and some still quivering—from other civilizations, past and present.

Modern historical consciousness goes deeper than a simple awareness of a plurality of cultures and attitudes; we are burdened with the awareness that we will never discover "the right and true culture, the right and true philosophy or religion" (Miller 1975, 10). As we draw near the end of the twentieth century, especially after experiencing the destruction wrought by the use of new technologies during the First World War and again, on an even more terrible scale, at the end of the Second World War, we are overwhelmed by the perception that our culture is contrived and unnatural and doomed to disappear, as have all great cultures in the past (Miller 1975, 11).

Miller suggests that believing our civilization will end in ruins "is also in some sense to think of it as already in pieces, for if it is so fragile, what real solidity does it have even now?" The opposition between illusion and the "desolation of reality" is the very essence of art. Reality is perceived as ugly and meaningless, and that which man has created by "transforming the world into his own image" is fleeting illusion. We believe man's cultures are temporary, nothing but mist; that "Love, honor, God himself exist, but only because someone believes in them," for man has made God his own creation (Miller 1975, 11–12).

Our unique strength, our awareness of other points of view and our willingness to concede their validity paradoxically becomes our primary dilemma. Not only are we aware of other realities as they exist in other societies, but we are also painfully aware of a multiplicity of points of view within our own society, within our own country. In such a pluralist society, because we understand the legitimacy of other points of view, we cannot agree on the simplest questions of cause and effect, of what is significant or trivial, good or bad, right or wrong.

In such a society, where we cannot agree on the most fundamental questions—a society where we strike no agreement as to what is obscene, what is ethical, what is moral, or what is just—we are incapable of deciding what to allow, what to prohibit, and what to encourage. We understand too well that each side of every issue results in both desirable and undesirable consequences. In our righteous protection of individual liberties, we are incapable of deciding whether we should allow such things as the teaching of evolution in the school, pornography (including that featuring children), gay rights, the proliferation of Nazi organizations, drugs in school lockers, date rape, and the segregation of AIDS patients. We needed

no Tower of Babel to provoke a jealous God into scrambling our languages so as to dissipate our programs. In fact, it is our very ability to speak, translate, and have access to ideas from many other languages that has afforded us the knowledge of such a multiplicity of opposing, but equally valid, answers and solutions, none of which can ever be complete within itself.

Given such a variety of indecision, how could we suddenly come to a firm resolution about something as elusive as what art should be? Art departments throughout our society cannot agree about what skills and concepts art students should be taught in the last half of the twentieth century. Many professors still drill their students on linear perspective and shading techniques; and many students practice their craft by painting still-lifes and nude models throughout their undergraduate studies. Other professors would consider such training tantamount to that of a science department that concentrated its efforts on teaching undergraduates the techniques of Ptolemaic astronomy.

Twenty-five hundred years ago Pythagoras introduced to Europe a mathematics-based reality that lasted for three hundred years. This mathematical construct of truth was temporarily reawakened at the beginning of the Middle Ages but waned; then it was rediscovered by Copernicus, Kepler, Galileo, and Newton and fully implemented by the seventeenth century. We have now experienced another three hundred years or more of mathematically revealed truth.

Non-Euclidean geometry and the fourth dimension began to offer a pluralism of alternatives to the reign of "objective" Renaissance vision. Einstein, Planck, and Freud further changed our comprehension of reality. The quantity of our knowledge has been doubling regularly in the second half of the twentieth century, but scientific and artistic progress are not achieved by adding more detail or accumulating more knowledge within existing categories or paradigms; progress "is made by leaps into new categories or systems" (Gablik 1977, 159).

When, and in what way, might a new scientific "category or system" affect scientists, philosophers, or painters? We might already suspect that this role could be played by the new theory of "superstrings." This new construct insists that the subatomic building blocks of the universe are not the pinpoint particles we thought they were in the recent past. Instead, they are infinitesimally small strings, some of which are open, and some joined in a loop (Angler

1986, 57). These strings, like the Merlin of old, can become anything. They can represent any particle of matter, from quarks to electrons, according to how they turn and vibrate. How these particles interact determines which of the four forces of the universe is created (Angler 1986, 57).

This simple change in the heuristic construct of subatomic particles suddenly allows the conceptual unification of the four forces that we understand to be the cement of the universe. This theory unifies electromagnetism; gravity; the strong force, which holds the atomic nucleus together; and the weak force, which gradually pulls apart the unstable radioactive elements.

Combining these four bonding forces of the universe into one elegant "theory of everything" (or TOE, as physicists call it) demands no less than ten dimensions. If the discovery of one extra dimension in the nineteenth century freed the artist from the past restrictions of the Renaissance illusion, will the addition of six more dimensions go unnoticed? How will we be affected by the knowledge that not just objects but everything in the universe is constructed of exactly the same clay? People, thoughts, pain, gravity, water, and electricity—all start as the same tiny strings, small and numerous beyond our comprehension. These things can no longer be envisioned as minor distortions in the fabric of the universe. We are no longer distortions: we are, as the ecologists remind us, one nature, continuous and infinite.

Personal and subjective images are no longer secondary to modern art's objective monolithic universality of space and form. There is a new interest in the power of the personal image as a primary concern. The heroes of the young postmodern artists are no longer Leonardo, Michelangelo, Cézanne, and de Kooning. The new heroes are more likely to be painters of the Middle Ages and painters in the northern manner, such as Bosch, Breughal, Grünewald, and Vermeer.[1] Postmodern painters may stem from the more discursive tra-

1. David Salle contends that one of the two important themes in his work is "the linguistic idea of the 'the obligatory,' that we're only able to say what, in a sense, can be said" (from Schjeldahl 1987, 40). Later he goes on to say that "one of the greatest painters of the obligatory . . . who doesn't shrink from any physical or moral realities is Breughal. I think that there is an idea about the body being the location of human inquiry that one finds in my work, that makes it somehow resonant with much earlier kinds of paintings. I'm not comparing my work to allegorical painting, but you do what you have to do" (from Schjeldahl 1987, 72–73).

dition of Northern Europe and the Middle Ages than that of the Italian Renaissance and impressionism. Many of the illusionist structures that derive from the Renaissance no longer apply.

For several years I have sensed a strong resemblance between the art and society of the late twentieth century and that of the Middle Ages. Some of the regional art exhibitions I have attended seem absolutely medieval in perception and discursive qualities. I also noticed that some smaller countries were beginning to restructure their societies along nothing less than feudal lines: in South America, for instance, we see Columbian drug lords establishing and defending their own serfs and fiefdoms. I began to find hints of similarities between these two periods in the work of several authors.

Several recent books, comics, and movies point to our sudden interest in medieval and pseudo-medieval tales, including such items as the illustrations of Frank Frazetta; the movie *Excaliber*; the two characters in *Star Wars*, Darth Vader and Luke Skywalker; the Conan series in novels, movies, and comic books (Eco 1986a, 61); and Herbert's popular novel *Dune* and its sequels, as well as the recent movie *Willow*. During the last decade in Italy, several round tables and symposia have addressed the topic of the "return of the Middle Ages," and novels set in medieval times have enjoyed an unexpected success (Eco 1986a, 63).

The foundations, and thus the problems, of the Western world can be traced to structures that evolved during the late Middle Ages: Eco lists modern languages, merchant cities, a capitalistic economy, modern armies, the modern notion of a national state, the conflict between rich and poor, the perception of ideological deviation (heresy), love as an "unhappy happiness," gunpowder, the compass, moveable type, and acceptance of Arabian mathematics (Eco 1986a, 64). He further suggests that "the Middle Ages are the root of all our contemporary 'hot' problems, and it is not surprising that we go back to that period every time we ask ourselves about our origin" (Eco 1986a, 65).

When we turn to Aristotle and Plato, we interpret them as suggested by medieval scholars; if we read Aristotle directly, free of medieval interventions, his writing "will not connect with our everyday life" (Eco 1986a, 68). The fervor during the Middle Ages was not necessarily caused by prevailing religious views, and during our century, "a lot of hidden medievalism" can be found in various speculative systems, such as structuralism (Eco 1986a, 70).

The Roman empire was not undermined by Christianity; it had

already undermined itself by welcoming a multitude of new ideas: Alexandrian culture, the cult of Mithra, magic, a variety of new sexual ethics and hopes of salvation, new racial components, homogenization of classes and social roles, and "as a rule a great repressive tolerance" that justified the acceptance of everything (Eco 1986a, 75). The medieval fear of the end of the world at the millennium can be likened to current apocalyptic fears inspired by real and imagined atomic and ecological catastrophes today (Eco 1986a, 79). Furthermore, there is a near perfect correspondence between the medieval and the current educational systems, each attempting, with equal camouflage of their paternalistic goals, to control minds and "bridge the gap between learned culture and popular culture through visual communication" (Eco 1986a, 81).

There are no answers, but there seem to be many new questions. After experiencing another three hundred years of mathematics-based objectivity, are we beginning to question this construct once again? Are we entering an "Electric Middle Ages?" A reality based on mathematics depends upon certain assumptions. We once assumed, for instance, that there was such a thing as a single objective truth, and that this truth could be revealed through mathematics. But during the 1960s, did we begin to reject the monolithic objectivity of mathematical truth? Art in the Middle Ages was pluralistic; so is the art at the end of this century. Society no longer harbors monolithic values, opinions, or artistic styles. If modernism was a cohesive ideology leading to rigorous mandates concerning the right and the wrong directions art might be allowed to pursue, then postmodernism, in contrast, is more eclectic, "able to assimilate, and even plunder, all forms of style and genre and circumstance, and [is] tolerant of multiplicity and conflicting values" (Gablik 1984, 72).

Stephen Toulmin, professor of the philosophy of science at the University of Chicago, has explained that the crucial difference between modern science and postmodern science concerns the difference between the two views of the meaning and the application of "objectivity." Philosophers like Heidegger and Habermas have warned against the tendency of modern science and technology to attempt to analyze objectively and conclude "facts" about people and things in the same mode, as if the behavior of both were equally predictable. This practice gives rise to the perhaps deserved reputation of science and technology as dehumanizers, because they ignore

the importance of subjective feelings and values (Toulmin 1983, 111).

We might then reason that postmodernists, whether scientists or artists, reconstruct their search for what they once believed to be the only objective truth to resemble more nearly a question: "What can we make of this?" (Toulmin 1983, 113). A "truth" in postmodern scientific or aesthetic theories more nearly resembles the truth "of portraits, which aim at being faithful, just, or 'unmisleading' likenesses" (Toulmin 1983, 113). These scientific and aesthetic "portraits" of reality tend to subordinate inflexible mathematics to the techniques of rational objectivity in which personal judgment, feeling, and perhaps justice create an intimate synthesis of logic tempered with discriminating conscience.

As William Cecil Dampier reminds us, mathematics is not in our scheme of the world, even in physics, until we put it there. There is continuing evidence that the people of many societies have similar thought structures, and the successful imposition of mathematics upon our world views depends upon the relationship between one society's experience and another's (Dampier 1966, 491–92). Discoveries in physics are in a peculiar, split state; Newton's classical physics still yields valuable results, but the most exciting discoveries and concepts today come from relativity and quantum mechanics. Dampier quips that we use Newtonian theory "on Mondays, Wednesdays and Fridays, and the quantum theory on Tuesdays, Thursdays and Saturdays." This schismatic tendency appears to some extent whenever an important intellectual revolution is in process, as when the concepts of Aristotle and Galileo vied with each other for ascendancy. But our society seems to illustrate this tendency in an extreme form: "It may possibly even allow us to hold a third set of ideas on Sundays" (Dampier 1966, 474–95).

Medieval painters, and northern painters during the sixteenth century, were fascinated by scenes of Hell. They painted their fantasies of what such a place might literally be. Many painters at the end of this century are also interested in scenes of Hell—witness Sue Coe and others. But our concept of Hell today is not the same as it was in the distant past. It may not be so literal an image to us as it was to sixteenth-century painters. In our language, New York City may signify Hell. The song says, "Just send me to Hell or New York City / It's all the same to me."

Dan Rice's powerful 1985 image of a polluted New York,

220 Changing Images of Pictorial Space

19.1. Dan Rice. *Satan Sanitation*. 1985. Oil on panel (120" × 285"). Collection of M. G. Lewin & Co. Winterpark, Florida.

painted on a large panel cut in the shape of a garbage truck, is titled *Satan Sanitation* (fig. 19.1). Rice states that he feels an affinity "with Bosch's use of apocalyptic allegories, satire and panoramas of worlds crammed with tiny, vulnerable figures. Bosch reflected his culture's pessimistic view of human nature and of humanity, a civilization haunted by fears of 'The Wrath,' that man was largely doomed, as many feel is imminent today with the ongoing threat of nuclear annihilation" (Rice 1987, 1). Fascinated with Bosch's focus on the evils of technology, Rice declares that "Bosch was one of the first to paint machines, inventions and technological developments as symbols ultimately leading to the down fall and destruction of mankind. . . . Bosch's Hell becomes Hell on earth; in these paintings man is destroying himself" (Rice 1987, 2).

What differentiates northern painters like Bosch from southern ones is their "attention to many small things versus a few large ones; light reflected off objects versus objects modeled by light and shadow; the surface of objects, their colors and textures, dealt with

rather than their placement in a legible space; an unframed image versus one that is clearly framed; one with no clearly situated viewer compared to one with such a viewer" (Alpers 1983, 44). Moreover, the northern tradition sacrifices a single possibility for "an aggregate of aspects" (Alpers 1983, 59). Such differences are similar to a list of the differences between modern and postmodern art.

I noted in chapter 8 that Descartes, during the seventeenth century, had demonstrated to the satisfaction of European societies that what we call "self" describes an inalienable nature that manifests either consciousness or spatial extension. Taking a cue and a slight left turn from David Carrier's position in "The Deconstruction of Perspective," I would like to suggest that traditional Renaissance perspective satisfies a Cartesian viewer who comprehends "self" as extension within the space of an external world that he or she presumes can be represented in a unified, "picture-like" construct.

Such a traditional notion of self leads to the creation of a two-dimensional image that egocentrically extends a scene, unified by perspective, that is oriented to a single viewing location. Such traditional paintings imply a viewer's specific location outside the painting by firmly anchoring the perspective of all the depicted objects to a single viewpoint. It might be said that such paintings "construct" their own viewers in a sense similar to that mentioned by Umberto Eco, who contends that he used the first hundred pages of *The Name of the Rose* "for the purpose of constructing a reader suitable for what comes afterward" (Eco 1984, 48).

But in our society, the abiding awareness of pluralistic realities (other points of view) makes us question the veracity of any world that can be fully depicted from a single viewpoint. The isolated, self-sufficient, Cartesian self seems to be an anachronism as we come to the close of the twentieth century. Current critics and artists strive to substitute—for paintings that construct such a Cartesian model of self—images that may better reflect our world view (Carrier 1985, 27).

The Albertian model in painting was "considered as an object in the world, a framed window to which we bring our eyes"; the northern model, however, conceives of the painting as taking the place of the eye itself, not as a plane section through the cone of sight (Alpers 1983, 45). Consequently the frame, the picture plane, and the viewer's location are left undefined: "If the picture takes the place of the eye, then the viewer is nowhere" (Alpers 1983, 47).[2]

The postmodernist's pluralistic viewpoints are created by what Leo Steinberg calls the "flatbed picture plane," with its manifold perspectives that refuse to locate the viewer in any specific position or identity. Steinberg uses the term "flatbed picture plane" to refer to the flatbed printing press, a horizontal bed that supports a printing surface (Steinberg 1972, 82). This term, describing the state of the picture plane after the 1950s, has been adopted by several writers—such as David Carrier, Suzanne Bloom, Ed Hill, and Douglas Crimp—to refer to (1) a horizontal picture plane, and (2) a pluralistic spatial orientation that they feel may be a characteristic of many postmodern painters.

The viewer's place outside the depicted space is implied by a pluralism of visual activities and choices; the viewer plays with multiple instructions received from many perspectives that may take place upon the flatbed surface (Carrier 1985, 28). The postmodernist picture plane establishes a more complex relationship between the viewer and the image: "No single point is defined as the right viewing point" (Carrier 1985, 28).

Even the cubists and the abstract expressionists assumed that painting represented a Cartesian "worldspace" suggesting an erect human posture (Steinberg 1972, 82). Paintings inspired by the natural world evoke responses normally experienced in an erect posture, with the viewer parallel to the picture plane. Therefore the traditional picture plane implies a vertical position, whether its suggested space extends behind the picture plane, remains flat and congruent with it (Steinberg 1972, 84), or, I would add, appears to protrude in front of it.

The work of modernists such as de Kooning, Kline, Pollock, and Newman—even though they were attempting to break away from

2. The French priest Jean Pélerin, known as Viator, succeeded in locating "the eye point not at a distance in front of the picture, but rather on the very picture surface itself, where it determines the horizontal line that marks the eye level of persons in the picture. The eye of the viewer (who in Alberti's construction is prior and external to the picture plane), and the single, central vanishing point to which it is related in distance and position, have their counterparts here *within* the picture. The first eye point located by Viator is joined on each side, at equal distances, by two so-called distance points from which the objects in the work are jointly viewed. The points are functions of the world seen rather than prior places where a viewer was situated. It is solely to people and objects in the work, not to the external viewer, that these three points refer" (Alpers 1983, 53).

Renaissance perspective—was still oriented to a vertical plane and was still "addressed to us head to foot," Steinberg says, because this is the form that is dictated by the concept of the vertical viewer. It is in this sense that the abstract expressionists were often referred to as nature painters. The change of reference from the vertical to the horizontal "flatbed picture plane" is what marks the evolution from nature as muse to culture as the painter's source of inspiration; such paintings are more analogous to cultural operational processes than to anything in nature. It was the work of painters like Dubuffet, Johns, and Rauschenberg that changed the orientation of painting (Steinberg 1972, 84).

Though we still exhibit postmodernist paintings vertically—just as we tack maps, plans, or horseshoes to the wall—these paintings no more depend upon a vertical posture than does a tabletop, a chart, a studio floor, or any "receptor surface on which objects are scattered, on which data is entered, on which information may be received, printed, impressed—whether coherently or in confusion" (Steinberg 1972, 84). Steinberg insists that when Rauschenberg "seized his own bed, smeared paint on its pillow and quilt coverlet, and uprighted it against the wall," it constituted his "profoundest symbolic gesture" (Steinberg 1972, 89). And such a depicted or implied horizontal surface in a painting is more suggestive of writing than of painting (Fried 1987, 52–107 passim).

But I am not entirely comfortable with this first portion of Steinberg's argument—the horizontal orientation of the picture plane. I do not see the evidence or the result in current paintings, and I do not feel the theory is convincingly developed or argued. Certainly the pattern of paint and drips on Rauschenberg's bed clearly indicates that it was first placed upright, then painted in that vertical position; it was not painted and then placed upright, as Steinberg suggests. This, it seems to me, should disqualify Rauschenberg's bed, just as Steinberg does not hesitate to disqualify Pollock's paintings as examples of the flatbed picture plane, even though Pollock's work seems to assert no head or foot orientation, as the bed certainly does. Steinberg maintains that even though Pollock started his paintings as they lay on the horizontal floor, he tacked them to the wall to develop them further; thus he "lived with the painting in its uprighted state, as with a world confronting his human posture" (Steinberg 1972, 84).

There are many possible reasons for Rauschenberg's choice of a bed as a work of art. One might well be a comment on Plato's well-

known painter's bed (three times removed).³ Another reason Rauschenberg—as well as other artists, such as Tapies—might have appropriated a bed to exhibit is that the bed, after years of service, assumes the shape of its occupant and perhaps therefore suggests the presence (even the Cartesian extension) of its absent owner. Steinberg's theories also fail to account for the numerous dome and ceiling paintings from the past that were oriented to a viewer who stands below and looks up—who is perpendicular, rather than parallel, to the surface of the painting. Nor does he account for the horizontal implications of Degas's worm's-eye and bird's-eye views, or the many photo montages of the 1920s and 1930s.

In spite of these limitations to Steinberg's idea, he has nevertheless suggested a fourth kind of pictorial space and a new concept of the picture plane. This influential idea, well discussed in the recent literature of art criticism, should not escape mention in any complex discussion of pictorial space and illusion. Moreover, I believe the theory merits a more rigorous development.⁴

The second portion of Steinberg's theory of the flatbed picture plane, of considerable interest to me, seems to point out an important departure from Renaissance perspective. Rauschenberg laid his paintings flat in order to impress several separate photographic transfers onto their surface.

The fragmentation of the image that is characteristic of north-

3. Plato wrote that there were three creators of beds, (or couches, as Plato called them). The first was the perfect couch or the idea of couch created by God; the second was the actual couch fashioned by a craftsman; the third was the painter's imitation of a couch three times removed. Plato asks if, "the producer of the product three removes from nature you call the imitator" (Plato 1938, 597, e)? Then he asks "if a man were able to produce both the exemplar and the semblance," would he "be eager to abandon himself to the fashioning of phantoms and set this in the forefront of his life as the best thing he had" (Plato 1938, 599, a)? He goes on to counsel that, if a man "had genuine knowledge of the things he imitates he would far rather devote himself to real things than to the imitation of them, and would endeavor to leave after him many noble deeds and works as memorials of himself, and would be more eager to be the theme of praise than the praiser" (Plato 1938, 599, b). Perhaps Rauschenberg wished to exhibit a bed only once removed: to be the theme of praise rather than the praiser.

4. Alpers, for instance, demonstrates that "while Alberti's text on painting was all words with no illustrations, his northern counterparts offered, by contrast, annotated pictures. They offered a geometric way to transform the world onto a working surface without the intervention of viewer and picture plane, without, in other words, the invention of an Albertian picture plane" (Alpers 1983, 53).

ern painting is also a characteristic of photographs (Alpers 1983, 53). A photograph is itself an illusion; but each of these illusions is oriented by its own perspective to a separate viewer location. A series of photographs is a series of fragmented apostrophes—rather than a cohesive central text—each, in turn, turning away from the main body or text.[5] Each apostrophe refers, like the fragmented images of Greco-Roman painting, to a separate viewer. This orientation to what I might call a "pluralist viewer" resulted in what Steinberg describes as "a kind of optical noise," the effect of which is to emphasize "the waste and detritus of communication—like radio transmission with interference; noise and meaning on the same wavelength, visually on the same flatbed plane" (Steinberg 1972, 88).

In order to maintain relationships between these fragmented images, Rauschenberg was obliged to conceive of his picture plane as a surface to which anything "reachable-thinkable" could be attached; his painting had to become whatever a billboard or a bulletin board is. If one of the photographs or collage elements created an unwanted illusion of depth, he casually smeared that surface with paint in order to support the viewer's awareness of the flat surface (Steinberg 1972, 88). Any kind of photograph or object can now be attached to the surface of a painting because such objects no longer represent a view of the world, but rather "a scrap of printed material" (Steinberg 1972, 88).

The integrity of the picture plane that had once relied upon the painter's competence to control the illusion is now an accepted "given." Flatness is no longer a problem requiring repeated proof. Painters are no longer obliged, as de Kooning was, to adjust each area until it is carefully resolved into homogeneous conformity with the overall spatial "voice" of the painting. The "all-purpose picture plane" has liberated postmodernist painting to pursue a more unpredictable course (Steinberg 1972, 88).

In the work of postmodernist painters, I perceive less preoccupation with a careful adjustment of the illusion that was once needed to verify the actuality of the flat surface. We now know and accept the fact that the painting is flat, so it is no longer necessary to corroborate this real fact incessantly through illusion. I do not mean to say that there is no concern with pictorial space and illusion; I

5. I mean *apostrophe* in the sense of a turning aside from the main text: a digression or a footnote. Thus, some of these paintings may be seen as a series of footnotes in place of the central text.

merely wish to point out that this aspect now occupies a lower priority in the hierarchy of painterly concerns. The point of visual flatness has been adequately made. In the opposition of illusion and language, priorities have once again been reversed, for the time being, in favor of the linguistic rather than the illusionistic aspects of painting.

20

Postmodernism: A New Language

AS WE LOOK BACK across the history of Western painting, we can see that most painters think of themselves as "realists," though their images may appear drastically different because they hold differing opinions about "what is real," or which aspects of reality are most important. Painters have spent the last six centuries developing, permuting, and reweaving the five major elements of illusion while they probed the aporetic connection between the real world outside the painting and the painting itself. Our concept of space changed as we began to concentrate on the connection between space and time; we measured distance in increments of time, and great distances in increments of how fast light could travel from one point to the other. These changes affected our painted images. Our ideas and images are changing once more as we now perceive space as a psychological entity ("I need my own space," or "give your children space to grow"). But the most significant change in art during these centuries may be another recent tendency to search for how the real world is to be "signified" in painting rather than how it is to be depicted illusionistically.

Painting, as it existed from Giotto through Barnett Newman, was considerably different from the practice of painting now. The discrepancy between the two may be profitably understood as a difference in attitude, an attitude that grows from a simple change in an equation. Renaissance art and modern art rested on a foundation of illusion. Modern art—particularly art since Manet—might be understood as concern with the *aporetic relationship* among three elements: (1) the world outside the painting, (2) the painted illusion of the objects and the space in this world, and (3) the manner in which this illusion came to be reconciled with the flat canvas. Modern painters came to consider the painting itself to be a part of that phe-

nomenological world that exists outside the painting. Here, once again, is the crux of Cézanne's pictorial problem: "finding a new solution that would reconcile his 'sensations' of depth in the three-dimensional space of external reality with an acute awareness of the two-dimensional limits of the painting surface" (Hunter and Jacobus 1976, 18).

Painting in the postmodernist period, however, may come to be perceived as linguistic rather than illusionistic; accordingly, the most interesting areas of investigation may now be the relationships among the reality of the canvas, the sign, and the reality of the sign. Because we live in a world full of pictures, says Carrier, we may have come to doubt the capacity of any pictorial image to define even the appearance of reality. The Cartesian self, "that observer who views the world as if it could be understood as a picture, as if its reality could be captured in a flat image, also seems a fiction" (Carrier 1985, 29). The new "linguistic" painting might be understood, in a similar equation, as the aporetic relationship among three new elements: (1) the world outside the painting, (2) the manner of signification of this world in the painting, and (3) the manner in which this signification might be reconciled with the flat surface of the painting (which, it must be remembered, still remains part of the outside world). Although only one of the three elements of the original equation has changed, the creation of new permutations necessarily changes the relationship of all three elements. Painters are beginning to explore the boundaries and limits of language, not just illusion, in order to create new images.

These new painters, conditioned by the printing process, the "flatbed" surface, are acutely interested in situations wherein the two parts of the sign—the signifier and the signified—are integrated. For them, the painting, like the spoken word, can function as both signifier and signified. Jasper Johns's flag paintings (see fig. 18.3) might serve as one of many transitions between the two styles of painting. Johns's painting is as "realistic" as he could make it. It "looks like" a real flag. Yet he relies upon none of the elements of the illusion: there is no unified light source; there is no shading of volume; there is no separation of planes; there is no linear, atmospheric, or color perspective. Still, his painting "looks like a flag."

It is a perfect reproduction of a flag. But we must remember that the flag is itself always a reproduction (if there can be a reproduction when there is no original); there exists no "original" flag,

though each reproduction maybe treated as if it were an original. Such a conspicuous image makes it difficult to read the painting as nothing but a painting in the sense that a modernist would expect. Is Johns's flag a painting, or another reproduction, or a reproduction of a reproduction? What, then, is a reproduction of Johns's painting? The flag is also a visual metonomy for the United States; it is America.[1] If the flag is such a metonomy, then is Johns's painting also a metonomy? The questions that Johns asks are related to painting as both illusion and language.

This new interest in art as language came about, Kristin Olive observes, when the structuralists, reasoning that a systematic approach to language was possible, took "linguistics as a model to lend logic and underlying structure" to their works. Later, the poststructuralists argued that systematic knowledge was impossible and used linguistic models to prove that structuralist texts undermined themselves. The poststructuralists turned fragmented concepts and quotations from these texts back on themselves in order to negate them, for "art no longer claims modernist logic, autonomy, purity, or unity". Postmodernist art relies instead on "outside references, quoted images, and disharmony of its parts": in short, multiplicity and fragmentation (Olive 1985, 82).

One might take David Salle's *Dual Aspect Picture* (fig. 20.1) as a typical postmodern image. His works feature numerous unrelated bits of information that suggest many meanings rather than a single correct meaning and focus on the reverberation of meaning among numerous bits, rather than the meanings between individual fragments (Olive 1985, 83). Salle mixes images from many sources. He avoids the modernist reverence for the unique and the original by painting copies and imitations, and he rejects modernist monolithic logic and unity in favor of the unexpected irrational qualities of contingency and disunity (Olive 1985, 85).

The viewer's response is, therefore, not determined by the artist because "no single interpretation can be devised" (Olive 1985, 83). Salle's strategy is analogous to hurling a bucket of rubber balls into a small room to ricochet off the walls and each other in a complex and unpredictable order and pattern: Salle purposely uses culturally

1. Metonomy is a figure of speech using the name of one thing for that of another that is associated with it or suggested by it, such as "the White House has decided," to mean "the president has decided."

20.1. David Salle. *Dual Aspect Picture*. 1986. Acrylic, oil/canvas; (156″ × 117″ [2]). Collection, Ludwig Museum, Cologne. Photo: Zindman/Fremont.

charged images and techniques to prolong the resonance of these colliding bits of information (Olive 1985, 84).[2]

The appearance of the human body in Salle's work "leads back to long-established dualities between soul and body, man and woman, first and third worlds" (Heartney 1988, 129). Such a renewed thrust toward dualism marks another important difference between modern and postmodernist art. One of the major attributes of modern art was its transcendental tendency, and the transcendental experience is a monistic experience of unity, of the "One." On the other hand, postmodernism's more intellectual interest in art as language tends to lead to binary oppositions, mirror categories—in short, dualism. Postmodernism's multiple views might be thought of in literary terms as more fragmented than the monolithic cause-and-effect cohesiveness of modern art.

Salle's "colliding bits of information" and the renewed interest in more dualistic concepts are compatible with the displacement of Newtonian and Einsteinian physics by quantum mechanics (particularly Heisenberg's uncertainty principle).[3] Such interests may well have been influenced by the same factors in society that influenced the growth of influence for quantum mechanics.

As quantum mechanics begins to assume a higher priority in the late twentieth century, postmodernism also gains favor over modernist concerns. The relationship between the transcendental, cohesive, monolithic, rational image of modern art and the physicist's pursuit of an objective, relativistic, unified field theory, or "theory of everything," has been well established. This relationship seems to ring as clearly as the relationship between the dualistic, fragmented,

2. Salle himself says, "But for so long there was this art-myth that [flags and targets] were neutral. I've often thought it would be interesting if people could look at my images as neutral as well, instead of assuming that they're charged. I do believe that there will come a time in which this so-called disturbing interest in my work will be seen as a condition of the work, much as the stripes in Stella's early work, for which he was attacked, are now seen as a *condition* of the work, how the work looks, not the thing which determines its quality" (from Schjeldahl 1987, 71).

3. The uncertainty principle addresses the dualistic problem of deterring both position and velocity of quanta. As these quanta diminish in size, the problem becomes more complex. Either the quality of position or of velocity may be specified by itself as accurately as wished, but the two qualities are related inversely. The more accuracy with which one is calculated, the less accuracy with which the other may be fixed. That is, either position or velocity must be prioritized in each new calculation if either is to be fixed accurately. Heisenberg thus corroborates that even a mathematical text is able to offer less than half a truth at any one time.

complex, unpredictable resonance of colliding bits of information in postmodern painting and the complex uncertainty of randomness and "statistical probabilities" inherent in quantum mechanics.

There are similarities between quantum mechanics and Salle's use of images: both reject any univocal meaning or answer, both recognize paradox, and both cast doubt on positive conclusions. Salle's work asserts that language—whether verbal or visual—cannot maintain univocal meaning.[4]

In this sense, the new postmodernist image, with its isolated apostrophes and pluralistic points of view, may be seen as a logical answer, or adaptation, to a new century that promises to be "high tech" rather than industrial. The monolithic industrial society found it more economical to produce its commodities and ideas in a homogeneous, cohesive sameness. It was cheaper to make a million Fords just alike than to make each different car suit the individual's taste. However, in the high tech market, linked by computer networks, the buyer can order a Ford Escort in hundreds of different variations—different motors, different upholstery, different suspension, et cetera. It has become economically feasible to produce items to individual likes and dislikes.

Alvin Toffler in *The Third Wave* notes that many industries no longer aspire to become giant, city-based corporations. They may again be gradually breaking down into what he calls "cottage industries." This new society does not have the monolithic cohesiveness of the old "melting pot," but is instead hermetically partitioned into a multitude of professional, ethnic, religious, and class points of view. American society no longer sees the world from a single point of view; the Western European world view has begun to break down. Each professional or ethnic pocket is oriented toward a separate illusion on the flatbed picture plane from the point of view of its own separate interests.

Art has never offered solutions or answers, but it has expanded our consciousness by asking the right questions. I suggest that the questions it now asks begin more and more to concern the relation-

4. Salle says that one of the two important themes in his work is "the linguistic idea of 'the obligatory,' that we're only able to say what, in a sense, can be said. We all speak and think and act within what linguists call the obligatory. I would say a real theme of my work has been to get outside of that, or to address the possibility of transcending that, or at least making it so painfully visible that you can think about what the world would be like if that weren't the case, even though ultimately whether it is or is not the case is not even discussable" (from Schjeldahl 1987, 40).

ship between reality and language than the relationship between reality and illusion. When Picasso and Braque transferred "real" things, like theater tickets and portions of newspapers, directly from the world outside the painting to the surface of their collages, it was the first time painters had, in any organized sense, placed anything "real" in their paintings. This direction was advanced further when abstract expressionists chose to let the paint represent nothing other than paint itself; the paint *was* what it appeared to be. Painters now search for other "realities" to be included in the painting. Like a forgetful person, holding a bridle, who wonders whether it signifies a lost horse or a found bridle, painters now seem to ask what parts of their painting function as signifiers and what parts function as signified.

Much current painting concerns itself with semiotic exploration. The human figure now is often signified—sometimes no more elaborately than in a pictograph—rather than depicted photographically. Painting once again approaches writing. The first painted images developed in two directions; one direction became writing and the other, eventually, illusion. Now the two are brought together once again.

In fact, there seems in painting now to be an abundance of actual writing—including the painting of letters. The letters are perhaps chosen because they form a major part of the world outside the painting, the world the artist intends to signify on the canvas. The letters with which we are relentlessly assailed on street and business signs, magazines, posters, billboards, freeways, and license plates are real: and such a letter—for instance, an M—is as "real" on the surface of a painting as it is on a billboard, or a freeway sign, in the world around us. Western thought evolved from a representational language that imitated the "reflection of an objective world, to a modernist parallelism of language/world, [then] to a structure of signifiers in which we are hermetically entrapped" (Bloom and Hill 1982, 13). But our society believes this language serves to bring us in contact with this world as often as it seals us away from it (Bloom and Hill 1982, 13).

A current painting of a figure is often no closer to illusion than a painting of a letter. The world in the painting is signified in a consistent manner, so the sign *man* approaches the same "reality" as the M. That is, if the M in the painting is as "real" as the M on the freeway sign, or as the M on the billboard, then the written word *man* is also real in the painting. Indeed, so is the same sign when it exists in the

rest of the world, outside the painting. If this word *man* is as real as the *M*, then a pictograph of *man* must also be a "real" sign. A pictograph has an advantage over a written sign. It exhibits a more obvious reference to that which it signifies, thus avoiding the arbitrary quality of the written sign that has bothered so many thinkers in the past. Svetlana Alpers notes that there was an attempt as early as the seventeenth century, by such thinkers as Bacon, Liebniz, John Wilkins, and Comenius, to invent a new universal language that might avoid the arbitrary quality of written and spoken signs. Sir Francis Bacon had even experimented with the "Characters Real" of China, and his followers tried to invent a pictographic system of writing, called "real characters," that would use a system of simple signs with an obvious pictorial reference to the signified objects and concepts (Alpers 1983, 96).[5]

Just as literature is beginning to be analyzed in terms of spatial form, says W. J. T. Mitchell, so also are the visual arts being explored as language systems. Such a concern amounts to more than just talking about the arts. It seems to be a new attempt at integrating both art theory and practice with our constructs for understanding the real world. The ancient fragmentation into separate fields of study—i.e., painting and writing—is now yielding to an integration of these fields. (Mitchell 1980, 295–96).

Critical theory has turned from describing the function of art to defining its structure as being similar to that of language, Jane Tompkins comments. Late twentieth-century assessments of art concern themselves with the kind of knowledge that art furnishes. The basis for this concern can be found in the new attitude toward lan-

5. It was such attempts to find signifiers that were visually related to the signified that Jonathan Swift satirized at the end of the fifth chapter in the third book of *Gulliver's Travels*, when he wrote of a method of conversing invented by the people in Balnibarbi: "An expedient was therefore offered, that since words are only names for *things*, it would be more convenient for all men to carry about them such *things* as were necessary to express the particular business they are to discourse on. . . . However, many of the most learned and wise adhere to the new scheme of expressing themselves by *things;* which hath only this inconvenience attending it; that if a man's business be very great, and of various kinds, he must be obliged in proportion to carry a greater bundle of *things* upon his back unless he can afford one or two strong servants to attend him" (Swift 1984, 163). Swift goes onto explain that "another great advantage proposed by this invention was that it would serve as an universal language to be understood in all civilized nations, whose goods and utensils are generally of the same kind, or nearly resembling, so that their uses might easily be comprehended" (Swift 1984, 164).

guage, one that considers language a thing with "no power of its own," a tool that "cannot do anything but mirror the image of a preexistent reality." Language can only transmit knowledge that has been accessed through other disciplines. The particular knowledge that art "transmits, moreover, lies in areas that are not well-suited to scientific measurement—human attitudes, feelings, and values" (Tompkins 1980, 221–22). Many new artists are interested in exploring the possibilities of the sign as an aesthetic manifestation.

Perhaps this new interest in language sheds some light on the reason why many postmodernist painters are prone to use quotations, allusions, and other references to outside sources—that is often referred to as "appropriating" images from artists of the past. Once painting is thought of in conjunction with verbal language, then it makes sense that some painters would choose to create scholarly texts and arguments. They may then wish to document their assertions with quoted precedents and the opinions of their peers.

I do not mean to suggest that all painting will henceforth ask only those questions that concern language. There are still questions about illusion that stimulate the curiosity of painters, and many are interested in exploring the thin line between illusion and language. Though the hegemony of illusion and the Cartesian viewer is ebbing, painting as visual semiotics is at about the same state that painting as illusion was before Giotto. We are looking for a new Giotto, or "Giotta." And the possibilities in painting are unlimited at this time. There is so much to come. Young painters work at the beginning of an exciting new period of discovery and advancement. There are as yet few academic shibboleths—no artificial means to determine the authenticity of a new image.

Any historical examination of painting indicates that the life of form and structure are eternally renewed and invigorated. The search for new images creates new geometries, new languages, and new structures. The adventurous thinker and painter will never stand still. He or she will never, ever, be caught defending the status quo. As "the moving finger writes," the painter paints, and having painted, moves on.

Works Cited
Index

Works Cited

Abrams, M. H. 1953. *The Mirror and the Lamp.* New York: Oxford Univ. Press.
Alberti, Leon Battista. 1966. *On Painting.* Rev. ed., ed. John Spencer. New Haven: Yale Univ. Press.
———. 1972. *On Painting and On Sculpture.* Ed. Cecil Grayson. New York: Phaidon.
Alloway, Lawrence. 1968. "Systemic Painting." In *Minimal Art: A Critical Anthology.* ed. Gregory Battcock. New York: Dutton.
Alpers, Svetlana. 1983. *The Art of Describing: Dutch Art and the Seventeenth Century.* Chicago: Univ. of Chicago Press.
Althusser, Louis. 1972a. "Marx's Immense Theoretical Revolution." In *The Structuralists from Marx to Lévi-Strauss*, ed. Richard DeGeorge and Fernande DeGeorge, 239–54. New York: Anchor.
———. 1972b. *Politics and History: Montesquieu, Rousseau, Hegel, and Marx.* Trans. Ben Brewster, Bristol, England: Western Printing Services.
Angler, Natalie. 1986. "Hanging the Universe on Strings." *Time*, 13 Jan., 61–63.
Antal, Frederick. 1969. "Florentine Painting and Its Social Background." In *Social and Economic Foundations of the Italian Renaissance*, ed. Anthony Molho, 116–22. New York: Wiley.
Arnheim, Rudolf. 1974. *Art and Visual Perception: A Psychology of the Creative Eye.* 2d ed., rev. and enl. Berkeley: Univ. of California Press.
Ashton, Dore, ed. 1985. *Twentieth-Century Artists on Art.* New York: Pantheon.
Barasch, Moshe. 1985. *Theories of Art: From Plato to Winckelmann.* New York: New York Univ. Press.
Barthes, Roland. 1982a. "The Face of Garbo." In *A Barthes Reader*, ed. Susan Sontag, 82–84. New York: Hill and Wang.
———. 1982b. "Striptease." In *A Barthes Reader*, ed. Susan Sontag, 85–88. New York: Hill and Wang.
Benveniste, Emile. 1971. "Categories of Thought and Language." In *Problems in General Linguistics*, Trans. Elizabeth Meek, 55–64. Coral Gables: Univ. of Miami Press.
Berger, John. 1969. *The Moment of Cubism, and Other Essays.* New York: Pantheon.

Birren, Faber. 1965. *History of Color in Painting.* New York: Van Nostrand.
Blatt, Sidney J. 1984. *Continuity and Change in Art: The Development of Modes of Representation.* Hillsdale, N.Y.: Lawrence Erlbaum.
Bloom, Suzanne, and Ed Hill. 1982. "Wringing the Goose's Neck One Last Time or, Painting vs. Photography and the Deconstruction of Modernism." *Afterimage #9,* no. 10 (May): 9–14.
Blunt, Sir Anthony. [1940] 1962. *Artistic Theory in Italy 1450–1600.* London: Oxford Univ. Press.
Bryson, Norman. 1981. *Word and Image: French Painting of the Ancien Régime.* London: Cambridge Univ. Press.
Bunim, Miriam S. 1940. *Space in Medieval Painting and the Forerunners of Perspective.* New York: Columbia Univ. Press.
Burtt, Edwin Arthur. 1954. *The Metaphysical Foundations of Modern Physical Science.* rev. ed. Garden City, N.Y.: Anchor.
Cachin, Françoise. 1971. *Paul Signac.* Trans. Michael Bullock. Greenwich, N.Y.: New York Graphic Society.
Calder, Ritchie. 1970. *Leonardo.* New York: Simon and Schuster.
Carrier, David. 1985. "The Deconstruction of Perspective: Howard Buchwald's Recent Paintings." *Arts Magazine,* no. 60 (Oct.): 26–29.
Chipp, Herschel B. 1968. *Theories of Modern Art: A Sourcebook by Artists and Critics* Berkeley: Univ. of California Press.
Clark, Kenneth. 1958. *Leonardo da Vinci: An Account of His Development as an Artist.* Rev. ed. Baltimore, Md.: Penguin.
———. 1978. *An Introduction to Rembrandt.* New York: Harper and Row.
Clark, Timothy J. 1985. *The Painting of Modern Life: Paris in the Art of Manet and His Followers.* New York: Knopf.
Cole, Bruce. 1976. *Giotto and Florentine Painting 1280–1375.* New York: Harper and Row.
———. 1980. *Masaccio and the Art of Early Renaissance Florence.* Bloomington: Indiana Univ. Press.
Culler, Jonathan. 1981. *The Pursuit of Signs, Semiotics, Literature, Deconstruction.* Ithaca, N.Y.: Cornell Univ. Press.
Damisch, Hubert. 1984. "Claude: A Problem in Perspective." *Studies in the History of Art* 14: 29–44.
Dampier, William Cecil. 1966. *A History of Science: and Its Relations with Philosophy and Religion.* 4th ed. London: Cambridge Univ. Press.
De Bruyne, Edgar. 1969. *The Esthetics of the Middle Ages.* Trans. Eileen Hennessy. New York: Ungar.
Delacroix, Eugene. [1951] 1980. *The Journal of Eugene Delacroix: A Selection.* Trans. Lucy Norton. Ithaca: Cornell Univ. Press.
De la Croix, Horst, and Richard G. Tansey. 1986. *Gardner's Art Through the Ages.* 8th ed. New York: Harcourt Brace Jovanovich.
De Man, Paul. 1986. *The Resistance to Theory.* Minneapolis: Univ. of Minnesota Press.

Derrida, Jacques. 1973. *Speech and Phenomena, and Other Essays on Husserl's Theory of Signs.* Evanston, Ill.: Northwestern Univ. Press.
———. 1976. *Of Grammatology.* Trans. Gayatri Chakravorty Spivak. Baltimore: Johns Hopkins Univ. Press.
———. 1982. *Margins of Philosophy.* Trans. Alan Bass. Chicago: Univ. of Chicago Press.
———. 1986. *Memoires for Paul de Man.* Trans. Cecile Lindsay, Jonathan Culler, and Eduardo Cadava. New York: Columbia Univ. Press.
Dixon, John W. 1984. "Painting as Theological Thought: The Issues in Tuscan Theology." In *Art, Creativity, and the Sacred: An Anthology in Religion and Art*, ed. Diane Apostolos-Cappadona, 277–96. New York: Crossroad.
Dunlop, Ian. 1979. *Degas.* New York: Harper and Row.
Eco, Umberto. 1983. *The Name of the Rose.* Trans. William Weaver. New York: Warner Books.
———. 1984. *Postscript to "The Name of the Rose."* Trans. William Weaver. New York: Harcourt Brace Jovanovich.
———. 1986a. "The Return of the Middle Ages." In *Travels in Hyperreality: Essays.* Trans. William Weaver. San Diego, Calif.: Harcourt Brace Jovanovich.
———. 1986b. *Art and Beauty in the Middle Ages.* Trans. Hugh Bredin. New Haven: Yale Univ. Press.
Edgerton, Samuel Y., Jr. 1975. *The Rediscovery of Renaissance Perspective.* New York: Basic Books.
Eliade, Mircea. 1985. *Symbolism, the Sacred, and the Arts.* Ed. Diane Apostolos-Cappadona. New York: Crossroad.
Ferguson, Wallace K. 1969. "Renaissance Economic Historiography." In *Social and Economic Foundations of the Italian Renaissance*, ed. Anthony Molho, 116–122. New York: Wiley.
Focillon, Henri. [1942] 1958. *The Life of Forms in Art.* Rev. and enl. 2d Eng. ed. New York: Wittenborn.
Foucault, Michel. 1970. *The Order of Things: An Archaeology of the Human Sciences.* New York: Pantheon.
———. 1984. "What Is an Author?" In *The Foucault Reader.* ed. Paul Rabinow, 101–21. New York: Pantheon.
Francastel, Pierre. 1967. *Medieval Painting.* Trans. Robert Wolf; ed. Hans Jaffe. New York: Dell.
———. 1977. *Peinture et société: naissance et destruction d'un espace plastique de la renaissance au cubisme.* Paris: Denoel/Gonthier.
Fried, Michael. 1980. *Absorption and Theatricality: Painting and Beholder in the Age of Diderot.* Berkeley: Univ. of California Press.
———. 1987. *Realism, Writing, Disfiguration: On Thomas Eakins and Stephen Crane.* Chicago: Univ. of Chicago Press.
Friedlaender, Walter. 1969. *Caravaggio Studies.* 1955. New York: Schocken.

Fry, Roger. 1927. *Cézanne: A Study of His Development.* New York: Macmillan.
Gablik, Suzi. 1977. *Progress in Art.* New York: Rizzoli.
——. 1984. *Has Modernism Failed?* New York: Thames and Hudson.
Gaugh, Harry F. 1983. *Willem de Kooning.* New York: Abbeville.
Geertz, Clifford, 1983. *Local Knowledge: Further Essays in Interpretive Anthropology.* New York: Basic Books.
Gibson, James J. 1950. *The Perception of the Visual World.* Cambridge, Mass.: Riverside Press.
Goldwater, Robert, and Marco Treves, eds. 1966. *Artists on Art: From the Fourteenth to the Twentieth Century.* New York: Pantheon.
Gombrich, E. H. 1956. *The Story of Art.* 8th ed. New York: Phaidon
——. 1961. *Art and Illusion, a Study in the Psychology of Pictorial Representation.* 2d ed., rev. Princeton: Princeton Univ. Press.
Goodman, Nelson. 1976. *Languages of Art, an Approach to a Theory of Symbols.* Indianapolis, Inc.: Hackett.
Gordon, John S. 1985. "Stanton Macdonald Wright Returns." *Artelier* (University of Southern California, Los Angeles), Winter: 1, 10.
Guilbaut, Serge. 1983. *How New York Stole the Idea of Modern Art: Abstract Expressionism, Freedom, and the Cold War.* Trans. Arthur Goldhammer. Chicago: Univ. of Chicago Press.
Haber, Ralph Norman, and Maurice Hershenson. 1973. *The Psychology of Visual Perception.* New York: Holt.
Hagen, Margaret A. 1986. *Varieties of Realism: Geometrics of Representational Art.* London: Cambridge Univ. Press.
Heartney, Eleanor. 1988. "David Salle: Impersonal Effects." *Art in America* 76, no. 6 (June): 120–29, 175.
Henderson, Linda Dalrymple. 1983. *The Fourth Dimension and Non-Euclidean Geometry in Modern Art.* Princeton: Princeton Univ. Press.
Hess, Thomas B. 1951. *Abstract Painting.* New York: Viking.
Hofmann, Hans. 1967. *Search for the Real and Other Essays.* Cambridge: MIT Press.
Hofstadter, Douglas R. 1979. *Godel, Escher, Bach: An Eternal Golden Braid.* New York: Basic Books.
Hughes, Robert. 1981. *The Shock of the New.* New York: Knopf.
Huizinga, Johan. 1946a. *Homo Ludens: A Study of the Play-Element in Culture.* Boston: Beacon.
Hunter, Sam. 1956. *Modern French Painting: Fifty Artists from Manet to Picasso.* New York: Dell.
——. 1959. *Modern American Painting and Sculpture.* New York: Dell.
Hunter, Sam, and John Jacobus. 1976. *Modern Art from Post-Impressionism to the Present: Painting, Sculpture, and Architecture.* New York: Abrams.
Ivins, William M., Jr. 1946. *Art and Geometry: A Study in Space Intuitions.* New York: Dover.
James, William. 1925. *The Varieties of Religious Experience.* New York: Longmans.

Kaminsky, Jack. 1962. *Hegel on Art*. Albany: State Univ. of New York Press.
Kant, Immanuel. [1781] 1943. *Critique of Pure Reason*. Trans. J. M. D. Meikeljohn. Rev. ed. New York: Wiley.
Kubovy, Michael. 1986. *The Psychology of Perspective and Renaissance Art*. London: Cambridge Univ. Press.
Lapicque, Charles. 1959. "Color into Space." *Portfolio Including Art News Annual*, no. 1: 72–95.
Leepa, Alan. 1968. "Minimal Art and Primary Meanings." In *Minimal Art, a Critical Anthology*, ed. Gregory Battcock. New York: Dutton.
Libby, William Charles. 1974. *Color and the Structural Sense*. Englewood Cliffs, N.J.: Prentice-Hall.
Loran, Erle. 1950. *Cézanne's Composition*. Berkeley: Univ. of California Press.
Luckiesh, M. [1922] 1965. *Visual Illusions, Their Causes, Characteristics and Applications*. New York: Dover.
MacCurdy, Edward. 1939. *The Notebooks of Leonardo da Vinci*. New York: Reynal.
Malevich, Kasimir. 1959. *The Non-Objective World*. Trans. Howard Dearstyne. Chicago: Theobald.
Martland, Thomas R. 1981. *Religion as Art: An Interpretation*. Albany: State Univ. of New York Press.
McMullan, Roy. 1975. *Mona Lisa, the Picture and the Myth*. Boston: Houghton Mifflin.
Miller, J. Hillis. 1975. *The Disappearance of God, Five Nineteenth-Century Writers*. Cambridge: Harvard University Press.
Mitchell, W. J. T. 1980. "Spatial Form in Literature: Toward a General Theory." In *The Language of Images*, ed. W. J. T. Mitchell, 271–99. Chicago: Univ. of Chicago Press.
———. 1986. *Iconology: Image, Text, Ideology*. Chicago: Univ. of Chicago Press.
Morassi, Antonio. 1955. *G. B. Tiepolo*. Garden City, N.Y.: Phaidon.
Newton, Isaac. 1984. *Optica*. Vol. 1, 1670–1672, of *The Optical Papers of Isaac Newton*. Ed. Alan E. Shapiro. London: Cambridge Univ. Press.
Olive, Kristin. 1985. "David Salle's Deconstructive Strategy." *Arts Magazine* 60 (Nov.): 82–85.
Ortega y Gasset, Jose. 1972. *Velazquez, Goya, and the Dehumanization of Art*. Trans. Alexis Brown. New York: Norton.
Paoletti, John T. 1985. "Art." In *The Postmodern Moment: A Handbook of Contemporary Innovation in the Arts*, ed. Stanley Trachtenberg, 53–79. Westport, Conn.: Greenwood.
Panofsky, Erwin. 1924–25. "Perspective as Symbolic Form." This English translation, undated and anonymously typed, is available from the shelves of the Warburg Institute. Originally published as "Die Perspektive als 'Symbolische Form.'" *Vorträge der Bibliothek Warburg*. (London: Warburg Institute): 258–330.

---. 1955. *Meaning in the Visual Arts: Papers in and on Art History.* Garden City, N.Y.: Anchor.
---. [1960] 1965. *Renaissance and Renascences in Western Art.* 2d ed. Stockholm: Almqvist and Wiksell.
---. 1968. *Idea, a Concept in Art History.* Trans. Joseph Peake. New York: Harper and Row.
Pirenne, M. H. 1970. *Optics, Painting, and Photography.* London: Cambridge Univ. Press.
Plagens, Peter. 1971. "Zip: Another Magazine Article on Barnett Newman." *Art in America,* 59 (Nov./Dec.): 62–67.
Plato. 1938. *Republic.* Trans. Paul Shorey. In *The Collected Dialogues of Plato,* ed. Edith Hamilton and Huntington Cairns, 575–844. Princeton: Princeton Univ. Press.
Podro, Michael. 1972. *The Manifold in Perception: Theories of Art from Kant to Hildebrand.* London: Oxford Univ. Press.
---. 1982. *The Critical Historians of Art.* New Haven: Yale Univ. Press.
Protter, Eric, ed. 1971. *Painters on Painting.* Rev. ed. New York: Grosset and Dunlap.
Read, Herbert. 1953. *The Philosophy of Modern Art.* New York: Horizon.
---. 1955. *Icon and Idea.* Cambridge: Harvard Univ. Press.
Rice, Dan. 1987. Letter to the author, 25 January.
Rose, Barbara. 1969. *American Painting, the Twentieth Century.* vol. 2. Cleveland, Ohio: Skira.
Rose, Bernice. 1976. *Drawing Now.* New York: Museum of Modern Art.
Ruskin, John. 1851. *Modern Painters.* 5th ed. London: Smith.
Salerno, Luigi. 1985. "The Roman World of Caravaggio: His Admirers and Patrons." In *The Age of Caravaggio,* 17–21. New York: Metropolitan Museum of Art.
Sandler, Irving. 1970. *The Triumph of American Painting: A History of Abstract Expressionism.* New York: Praeger.
---. 1978. *The New York School, the Painters and Sculptors of the Fifties.* New York: Harper and Row.
Schillinger, Joseph. 1976. *The Mathematical Basis of the Arts.* 1948. New York: Da Capo.
Schjeldahl, Peter. 1987. *Salle.* New York: Vintage.
Seitz, William. 1963. *Hans Hofmann.* New York: Doubleday.
---. 1983. *Abstract Expressionist Painting in America.* Cambridge: Harvard Univ. Press.
Selz, Peter. 1981. *Art in Our Times, a Pictorial History.* New York: Abrams.
Shapiro, Meyer. 1978. *Modern Art: Nineteenth and Twentieth Centuries.* New York: Braziller.
Shearman, John. 1962. "Leonardo's Colour and Chiaroscuro." *Zeitschrift für Kunstgeschichte* 25, no. 1:13–47.
Snyder, Joel. 1980. "Picturing Vision." In *The Language of Images,* ed. W. J. T. Mitchell, 219–46. Chicago: Univ. of Chicago Press.

Stein, Gertrude. 1970. *Gertrude Stein on Picasso.* Ed. Edward Burns. New York: Liveright.
Steinberg, Leo. 1972. *Other Criteria: Confrontations with Twentieth-Century Art.* New York: Oxford Univ. Press.
Stella, Frank. 1986. *Working Space.* Cambridge: Harvard Univ. Press.
Swift, Jonathan. [1735] 1984. *Gulliver's Travels.* New York: Schocken.
Szarkowski, John. 1973. *Looking at Photographs; One Hundred Pictures from the Collection of the Museum of Modern Art.* New York: Museum of Modern Art.
Tarkovsky, Audrey. 1987. *Sculpting in Time: Reflections on the Cinema.* New York: Knopf.
Tompkins, Jane P. 1980. "The Reader in History: The Changing Shape of Literary Response." In *Reader-Response Criticism: From Formalism to Post-Structuralism,* ed. Jane Tompkins, 201–32. Baltimore: Johns Hopkins Univ. Press.
Toulmin, Stephen. 1983. "The Construal of Reality: Criticism in Modern and Postmodern Science." In *The Politics of Interpretation,* ed. W. J. T. Mitchell. Chicago: Univ. of Chicago Press.
Twitchell, Beverly H. 1987. *Cézanne and Formalism in Bloomsbury.* Ann Arbor: UMI Research Press.
Vasari, Giorgio. 1958. *Lives of the Artists.* Trans. Alfred Werner. New York: Noonday Press.
Vitruvius. 1934. *On Architecture.* Loeb Classical Library.
Walker, John A. 1975. *Art Since Pop.* New York: Barron.
Waterhouse, Ellis. 1976. *Roman Baroque Painting, a List of the Principle Painters and Their Works in and around Rome.* Oxford: Phaidon.
White, John. 1967. *The Birth and Rebirth of Pictorial Space.* London: Faber and Faber.
Whitehead, Alfred North. 1978. *Process and Reality, an Essay in Cosmology.* New York: Macmillan.
Williams, Raymond. 1976. *Keywords: A Vocabulary of Culture and Society.* New York: Oxford Univ. Press.
———. 1950. *Principles of Art History: The Problem of the Development of Styles in Later Art.* Trans. M. D. Hottinger. New York: Doubleday.
Wolfflin, Heinrich. 1952. *Classic Art: An Introduction to the Italian Renaissance.* Trans. Peter Murray and Linda Murray. New York: Phaidon.
———. 1966. *Renaissance and Baroque.* Trans. Kathrin Simon. Ithaca: Cornell Univ. Press.

Index

References to illustrations are indicated in **boldface** type

Absolute color. *See* Color, absolute
Abstract expressionism, 160–63, 171–84, 188, 193–94, 198, 222–23
Aerial perspective. *See* Perspective, aerial
Aesthetics, 93, 101
Alberti, 38–41
Albertian perspective. *See* Perspective, Albertian
Albertian view. *See* View, Albertian
Alberti's
 cube, 38, 94, 179, 183
 dissertation *(Della Pittura)*, 38, 40
 four axioms, 40
Alternatives
 to compositional climax, 83, 211
 to line and shade, 148
 offered by gestural painting, 202
 to Renaissance form, 122, 148, 184, 212, 215
 to Renaissance perspective, 53, 94, 118, 120, 141, 146, 150, 210, 224
Ambiguity. *See* Spatial, ambiguity; Content, ambiguous
Andes of Ecuador, The (Church), 47, **48**
Angler, Natalie, 215, 216
Apotheosis of the Pisani Family (Tiepolo), **105**, 106
Arena Chapel, 26, 28–30, 62, 64
Aristotle, 1, 10, 12, 70–71, 89–90, 217
Atmospheric perspective
 as compositional climax, 87
 creates most efficient illusion, 43
 exaggeration of, 45–46, 110

 explanatory chart, 46
 in sculpture, 43
 in shading of volume, 75, 77
 Newman's method, 199–200, 202
 Poons's method, 203
 reversal of, 146, 149
Automatic hand. *See* Hand, autonomy of
Automatism, 119, 172, 175–78

Bed
 Plato's, 223–24, 224n
 Rauschenberg's, 223–24
Beautiful Gardener, The (Raphael), 49, **50**
Bird's-eye view. *See* View, bird's-eye or worm's-eye
Blue Boy (Gainsborough), 53, 110, 111
Bosch, Hieronymus, 220
Botticelli, Sandro, 41, 42
 The Miracle of St. Zenobuis, 41, **42**
Brancacci Chapel, 57–58, 64
Breeder ideas, 67n, 67–68
Brunelleschi, Filippo, 38, 40
Bruno, Giordano, 92–93, 120

Capitalism, 22–25, 39, 70
Caravaggio, Michelangelo da, 82, 96–100
 David and Goliath, 97, **98**

Cartesian. *See also* Viewer, Cartesian
 concept of painterly sign, 103
 definition of existence and self,
 90–91, 97, 221–24, 228
 structure in painting, 102, 103
Cast shadows. *See* Shadows, cast
Cézanne, Paul, 142–51, 156–57, 165–
 67, 211, 228
 Still Life with Apples and Oranges, 143,
 144
 Mont Sainte Victoire, 145–46, **147**
Chromatic aberration, 52, 110, 112
Church, Frederick, 47
 The Andes of Ecuador, 47, **48**
Cimabue, Giovanni, 15–20, 30
 Madonna and Child, 16, **17**, 18, 19
Classical Landscape (Lorrain), 95n
Color. *See also* Color perspective;
 Composition, in warm and cool
 absolute, 16–18, 30, 61, 81n, 102,
 136
 debate of *(le débat sur le coloris)*, 102–3,
 136–37
 planes of, 143, 145–46, 149, 166
 saturation modeling, 18–19, 30, 61,
 74
 shot, 61, 61n
 tonal unity, 18, 61, 74, 79, 81n
Color perspective
 chart for classic color theory, 49
 classic color theory, 35n, 47, 49, 51–
 53, 110, 143, 145–46, 149
 exaggeration of, 47
 Newman's method, 200
 Poons's method, 203–5
 and reversal of classic color theory,
 52–53, 110–12, 112n, 205
 universal chart for, 114
Composition. *See also* Ground plane,
 control of
 compositional climax, 83, 86–88,
 182, 184, 187–88, 192, 196–97
 congruency of, 80–82, 135
 in dark and light, 18, 75–80, 79–
 80n, 83, 102, 135, 139, 143, 184,
 187–88
 fragmented, 18, 199, 224–25
 spatial, 65, 77, 108–10

unified, 30–31, 53, 56, 58, 60, 64,
 79–81, 139
as visual organization, 30, 64–67, 78
in warm and cool, 80–81, 135, 137
Cone of sight, 36, 39, 221
Congruent composition. *See*
 Composition, congruency of
Constructivist Manifesto, 155, 167
Content
 ambiguous, 186, 186n, 190, 194
 controls pictorial space, 135, 137,
 149, 205–6, 208
 form as, 69, 82, 210
 rejected, 178–79, 200
Copernicus, Nicolaus, 70–71, 89
Core shadow. *See* Shadows, core
Council of Trent, 95
Criticism
 formalist, 69, 116, 145, 153, 179,
 211–12
 Marxist, 179, 210–11
 modern, 153–54, 157, 173–74, 179
 poststructuralist, 179, 229
 structuralist, 179, 217, 229
Cubism, 156–59

Dark-light. *See* Composition, in dark
 and light; Volume, shading of
David and Goliath (Caravaggio), 97, **98**
de Kooning, Elaine, 179, 191
de Kooning, Willem, 189–97
 Excavation, **191**, 191–93
 Woman I, **195**, 194–97
Depth. *See* Illusion, of depth, of depth
 rejected; Sensation, of depth
de Piles, Roger, 102–3, 122, 136
Death of Euclid, The (Newman), 152
Degas, Edgar, 124–29
 Miss La La at the Cirque Fernando,
 125, **126**
 The Tub, 125, 127, **128**
Descartes, René, 90–92, 97, 103, 221
Diminishing size, 15, 21, 40, 54
Discursive qualities. *See* Painting,
 discursive aspects of
Dual Aspect Picture (Salle), 229, **230**

Duchamp, Marcel: *Nude Descending a Staircase,* 159

Eddy, Don, 206, 208
 Silverware for M., 206, **207**
Einstein, Albert, 154–55, 166–67
Elements. *See* Illusion, elements of, elements destructured or restructured; Perspective, aerial, elements destructured or restructured; Renaissance illusion, elements of
Enrico Scrovegni Presenting a Model of the Arena Chapel (Giotto), 28, **29,** 30, 62
Euclid, 1, 3
Euclidean geometry, 2, 116, 152, 157, 186
Excavation (de Kooning), **191,** 191–93
Expulsion of Adam and Eve from Paradise (Masaccio), 65, **66**

Ficino, Marsilio, 55, 71
Figure
 implied, 192, 194
 painted flat, 12, 16, 132–34, 167
 rejected in painting, 178, 186, 193
 return to, 189, 192–94, 196–97
 as sign, 233–34
 as spatial device, 14, 106–9, 123
 spatially not related, 2, 3, 5
 as temporal device, 159
Figure-ground
 eliminated, 205
 integration of, 12, 21, 130, 179, 192, 196–97
 reversal of, 179–80, 187–88
 separation of, 52–53, 110, 112, 130
Flag (Johns), **205,** 206, 228–29
Flatbed picture plane. *See* Picture plane, flatbed
Form. *See* Content, form as; Nature, vs. form; Perspective, as symbolic form; Separation, of form from content

Formalism. *See* Criticism, formalist
Fourth dimension, 115–17, 152, 154–56, 166, 215
Fra Angelico, 112; *Madonna,* 112, **113**
Fragmentation. *See also* Composition, fragmented; Greco-Roman perspective; Perspective, fragmented; Picture plane, fragmented; Time, fragmented
 in postmodern painting, 229, 231
 of view, 146, 150, 156
Freudian approach. *See* Surrealism

Gabo, Naum, 167
Gainsborough, Thomas, 53, 107–8, 110
 Blue Boy, 53, 110, **111**
 The Mall on St. James Park, **108,** 108–9
Galileo, 90, 154
Gauguin, Paul: *Where Do We Come From? What Are We? Where Are We Going?* 124
Geocentric. *See* Universe, geocentric
Geometry
 Euclidean, 1, 116, 152, 159, 186
 non-Euclidean, 115–17, 120, 152, 154, 155, 159, 186
 varieties of, 159n
Gestural painting. *See* Painting, gestural
Ghiberti, Lorenzo, 43
 The Story of Jacob and Esau, 43–44, **45**
Giotto, 22, 26–34, 150, 175, 211
 Enrico Scrovegni Presenting a Model of the Arena Chapel, 28, **29,** 30, 62, 64
 The Vision of Joachim, 31, **32**
Girl Before a Mirror (Picasso), **158,** 159
God
 disappearance of, 91–92, 123–24
 as prime mover, 91–92
Gorky, Arshile, 133
Greco-Roman perspective, 2–3, 54
Greenberg, Clement, 178–79
Ground plane, control of, 15, 43, 47, 109

Hand, autonomy of, 172–73, 175–76, 178
Heinsenberg's uncertainty principle, 231, 231n
Heliocentric. *See* Universe, heliocentric
Herringbone perspective. *See* Perspective, herringbone
Hofmann, Hans, 134, 163–69
 plane concept of, 163, 166, 169
 Rising Moon, 163, **164**
Holy Trinity, The (Masaccio), 64

I Still Get a Thrill When I See a Bill (Ramos), 190
Illusion
 absense of, in medieval painting, 12, 15
 as convention, 15, 19, 25
 congruent with reality, 183, 192, 197
 to deny illusion, 192, 208
 of depth, 25, 40, 42–43, 47, 62, 95–96, 199, 202–3
 of depth rejected, 133, 148, 179, 191, 193, 225
 devices of, 26–27, 33–35, 44, 64
 elements of, ix, 58, 80, 179, 202, 228
 elements of, destructured or restructured, 4, 6, 20–22, 69, 80, 83, 121, 135, 137, 149, 182, 198, 202, 210, 227
 of illusion, 206, 208
 magician's, 168
 multiple illusions, 206–8, 225
 negation and affirmation of, 131, 134, 146, 149, 179, 191–92, 208
 and reality, 205, 210, 214, 227–28, 233
 rejected, 179, 180
 unified, 4, 35, 64
Integration of figure and ground. *See* Figure-ground, integration of

Johns, Jasper, 205–6, 229
 Flag, **205**, 206, 228–29

Kant, Immanuel, 117, 121
Kepler, Johannes, 89, 90
Kline, Franz, 184, 186–89
 Mahoning, 184, 185, 187–88

Lady with an Ermine (Leonardo da Vinci), 75, **76**
La Grenouillière (Monet), 131, **132,** 137
Landscape
 compositional method, 107–8
 Odyssey (Roman), 6, 22, 63
 straight lines not in, 41, 135
 used to avoid linear perspective, 127, 133, 135
Language. *See also* Reality, and language
 algebra as, 118–19
 extends or limits thinking, 118–20, 229, 233–35
Lasansky, Mauricio, 69, 83–86, 123, 124, 198
 Nazi Drawing #21, **85,** 86–88
 Nazi Drawings, 83
Last Judgment (Michelangelo), 94
Last Supper (Leonardo da Vinci), 78, **79**
Le Brun, Charles, 102–4, 121, 136
Le débat sur le coloris. See Color, debate of
Leonardo Da Vinci, 44, 46n, 47, 47n, 49, 51n, 71–82, 99, 100, 145
 Lady with an Ermine, 75, **76**
 Last Supper, 78, **79**
 Virgin of the Rocks, 72, **73,** 78
Lichtenstein, Roy, 209
Light
 blue waves bend, 48–49, 51
 inseparable from color, 14, 103
 medieval concepts of, 13–14, 16
 unified source of, 26, 35, 60, 62, 64, 75, 77, 149
 unified source of, rejected, 130, 149
Linear perspective
 as extension of optics, 39, 89
 invalidated, 155
 invention of, 38
 not useful in landscape painting, 41, 135

obviousness of, 40, 133, 168, 180, 202
rejection of, 34, 88, 106, 127, 134, 137, 146, 149, 157, 167, 203, 210
Linearity. *See* Painterly vs. linear
Linguistic aspects of painting. *See* Painting, discursive aspects of, linguistic aspects of
Lorrain, Claude, 95n; *Classical Landscape,* 95n

Madonna (Fra Angelico), 112, **113**
Madonna and Child (Cimabue), 16, **17,** 18, 19
Mahoning (Kline), 184, **185,** 187–88
Malevich, Kasimir, 155
Mall on St. James Park, The (Gainsborough), **108,** 108–9
Mannerism, 41, 94–95
Marxism. *See* Criticism, Marxist
Masaccio, Tommaso, 43, 57–65, 67–68, 74, 75
 Expulsion of Adam and Eve from Paradise, 65, **66**
 The Holy Trinity, 64
 Tribute Money, 58–60, **59,** 63, 75
Math-based reality. *See* Reality, math-based
Meta-art, 69, 123–24, 198
Metalanguage, 123
Metonomy, 186, 229
Michelangelo, 79, 80n, 94
Miracle of St. Zenobuis, The (Botticelli), 41, **42**
Miss La La at the Cirque Fernando (Degas), 125, **126**
Modern art
 death of, 198, 212
 as monolithic image, 143, 199, 229, 231
 as transcendental image, 231
Monet, Claude, 130–31, 135, 137, 139
 La Grenouillière, 131, **132,** 137
 Poppy Field in a Hollow near Giverny, 135, **136**
 Rouen Cathedral, West Façade, 137, **138**
 Rouen Cathedral, West Façade, Sunlight, 139, **140**
Mont Sainte Victoire (Cézanne), 145–46, **147**
Movement implied in painting. *See* Painting, movement implied in

Nature
 in abstract expressionism, 173
 imitation of, 20–21, 25–26, 34, 54–55, 69, 96
 man's relationship to, 10, 26
 observation of, 14, 26, 55, 70, 96
 rejected as content, 155, 199
 vs. culture, 223
 vs. form, 69, 82
Nazi Drawing #21 (Lasansky), **85,** 86–88
Nazi Drawings (Lasansky), 83
Negative shapes. *See* Shapes, positive or negative
Neoplatonists, 55, 71, 89
Newman, Barnett, 152, 199–202
 The Death of Euclid, 152
 Vir Heroicus Sublimis, 200, **201**
Newton, Isaac, 103, 103n, 106–7, 219
Non-Euclidean. *See* Geometry, non-Euclidean; Reality, non-Euclidean; Space, non-Euclidean; Time, and space, non-Euclidean
Nude Descending a Staircase (Duchamp), 159

Observation of nature. *See* Nature, observation of
Odysseus in the Land of the Lestrygonians (Roman), 6, **7,** 63
Odyssey paintings. *See* Landscape, Odyssey (Roman)
Opaque paint advances, 112, 114, 200, 202–3
Opaque picture plane. *See* Picture plane, opaque vs. transparent
Overlapping planes, 14, 28, 41–42

Painterly vs. linear, 71–72, 74, 77, 79, 82, 99, 100, 181–82
Painting
 binocular effects in, 202–3
 called painting, 169, 229
 called pictures, 169, 221–22, 228
 as dance, 174, 187
 discursive aspects of, 58–60, 209, 212, 216
 gestural, 173–74, 180, 198, 202–3, 206
 image in vs. image of, 83, 107, 131, 180, 196
 as language, 58, 119–20, 123, 212, 228–29, 231–35
 linguistic aspects of, 179, 228–29, 234–35
 movement implied in, 157, 173–74
 process in, 172–74, 176, 178, 180, 194–96
 as real object, 143, 150, 165, 169, 171–72, 183, 221, 233–34
 traditionally exists in space, 155–57
 wet-into-wet, 196
 as window, 13, 27, 28, 41, 123, 141, 150, 200, 221
 as writing, 233–34
Parallel lines, 10, 21, 40, 41, 146
Perspective. *See also* Atmospheric perspective; Color perspective; Greco-Roman perspective; Linear perspective
 aerial, 35, 44, 47, 62n, 110
 Albertian, 39n, 40, 40n, 57n, 124–25, 127
 distortions of, 45, 94, 134
 elements destructured or restructured, 4, 7, 15, 20, 22, 54, 94, 124, 135, 150, 182, 203
 four kinds of, 4, 56
 fragmented, 16, 150, 157
 herringbone, 3
 limitations of, 36–38, 40, 41
 objectivity and, 36–37, 93
 as propaganda, 60
 as rational mathematical system, 36
 and separation of planes, 41–42, 47, 143, 146, 148–49, 202

 as symbolic form, 38, 118
 texture as element of, 46
 unifies pictorial space, 69
Pevsner, Antoine, 167
Photo-realism, 205–8
Photography, influence on painting, 131–33
Picasso, Pablo, 156–59
 Girl Before a Mirror, **158,** 159
Pictograph. *See* Sign, pictograph as
Picture plane
 absense of, in northern painting, 221
 affirmed, 106, 134, 149–50, 165–167, 183, 192
 analogous of pane of glass, 27, 41, 106
 flat, 26–28, 104–6, 131–34, 139, 142–43, 150, 165–67, 179–80, 183–84, 190–93, 196–97, 199, 206, 222, 225, 226–28;
 flatbed, 222–25, 228, 232
 fragmented, 222, 225
 images pressed flat against, 94, 99, 156, 192
 limitations of flatness, 193, 196
 medieval, 4n, 6, 27
 opaque vs. transparent, 27, 36, 141, 150
 penetration of, 41, 97, 99, 165
 postmodern, 222
 projection in front of, 97, 99, 182, 200, 203, 203n
Plato, 1, 217, 224n
Plato's bed. *See* Bed, Plato's
Pluralism. *See* Reality, pluralist; Spatial structure, pluralism in; Time, pluralist concepts of; Viewer, pluralist; Viewpoint, pluralist
Pollock, Jackson, 83, 88, 173, 176, 177, 180–82, 188–90, 192, 224
 Summertime, 174
 White Cockatoo, 174
 White Light, 180, **181**
Poons, Larry, 199, 203–4, 210
 Untitled, 203, **204**
Poppy Field in a Hollow near Giverny (Monet), 135, **136**

Portrait of Angelo Doni (Raphael), **84**, 86, 87
Positive shapes. *See* Shapes, positive or negative
Post-Cartesian viewer. *See* Viewer, post-Cartesian
Poststructuralism. *See* Criticism, poststructuralist
Poussinists, 102, 219–20
Priorities
 color vs. drawing, 102–3, 114, 119, 121–22, 125, 131, 135, 143, 148, 150
 color vs. volume, 143, 145
 illusion vs. abstraction, 22, 88, 134, 200, 202, 206
 illusion vs. linguistics, 205, 212, 226–29, 235
 illusion vs. sign, 205, 209–10, 233
 illusion vs. surface, 5, 22
 illusion vs. symbol, 209
 mass vs. detail, 16, 30, 65, 67, 211
 material vs. spiritual, 5, 22–23, 25, 63, 211–12
 mimesis vs. form, 4, 96, 133, 189, 196–97
 plane concept vs. line and shade, 150, 156, 169
 presence vs. absence, 25, 184–85
 process vs. product, 194
 quality vs. quantity, 11–12, 22
 reversal of, 5, 22, 26, 72, 93, 120, 131, 134–35, 141, 145, 148, 167, 186, 188, 208–9, 211
 theory vs. practice, 5, 26, 40, 92
Process in painting. *See* Painting, process in; Priorities, process vs. product
Prospect scenes (Roman), 6, 22
Proto-writing, 119
Push and pull. *See* Spatial structure, push and pull
Pythagorean world view, 1, 22

Quantum mechanics, 231–32

Ramos, Mel
 I Still Get a Thrill When I See a Bill, 190
Raphael, 83, 86–87
 The Beautiful Gardener, 49, **50**
 Portrait of Angelo Doni, **84**, 86, 87
Rauschenberg, Robert, 223–25
 Bed, 223–24
Realism, 36, 96, 99, 170–72, 205–6, 227–28
Reality
 four-dimensional, 154–56
 and language, 233
 of letters, 209–10
 math-based, 1, 22, 55–56, 71, 89–90, 90n, 215, 218–19
 non-Euclidean, 152
 of paint or canvas surface, 171, 183, 210, 228
 pluralist, 115, 116, 120, 122, 154, 170, 213–15, 221–22
 of sign, 209, 210, 228, 233–34
 subatomic, 215–16
 ten-dimensional, 216. *See also* Illusion, congruent with reality; Illusion, and reality
Renaissance illusion
 elements of, ix, 83, 88, 135, 182
 relationship to capitalism, 22–25
 as self-evident truth, 95, 118–19
 system of, 47, 58
Renaissance perspective
 devices of, 35, 81, 210
 not synonymous with linear perspective, 35
 as rational mathematical system, 37–38, 56, 63, 68
 restructured from Greco-Roman perspective, 2–4, 7, 22
 as self-evident truth, 58
 system of, 2, 4, 15, 35–38, 53–54, 69, 81, 210
Reversal of figure and ground. *See* Figure-ground, reversal of
Rice, Dan, 219–20
 Satan Sanitation, 220, **220**
Rising Moon (Hofmann), 163, **164**
Rococo, 101, 104, 106

Rosenberg, Harold, 179
Rouen Cathedral, West Façade (Monet), 137, **138**
Rouen Cathedral, West Façade, Sunlight (Monet), 139, **140**
Rubenists, 102–3

Salle, David, 229, 231–32
 Dual Aspect Picture, 229, **230**
Satan Sanitation (Rice), 220, **220**
Saturation modeling. *See* Color, saturation modeling; Volume, shading of
Sensation. *See also* Figure-ground, separation of; Perspective, separation of planes
 of depth, 142, 146, 148, 165, 179, 202
 of solid relief, 148, 150
 of volume, 103, 145
Separation. *See also* Figure-ground, separation of; Perspective, and separation of planes
 of atmospheric and color perspective, 35, 44, 110
 of form from content, 54–55, 69, 99, 189
Sfumato, 79, 82
Shading of volume. *See* Atmospheric perspective, in shading of volume; Volume, shading of
Shadows, 5, 31, 60, 62, 75
Shapes, positive or negative, 180, 187–88, 192–93, 196
Shot color. *See* Color, shot
Sign. *See also* Cartesian, concept of painterly sign; Figure, as sign; Priorities, illusion vs. sign; Reality, of sign
 arbitrary quality of, 234
 pictograph as, 233–34
 as substitute for things, 25
Silverware for M. (Eddy), 206, 207, 208
Space. *See also* Time, and space
 baroque obsession with, 90–91, 97
 Cartesian extension into, 91, 97, 99
 as content, 25–26, 107, 109, 116, 127, 153, 163, 167, 169, 193, 197
 evolution of concept, 55–56, 227
 Greco-Roman, 2–3, 5, 63
 interest of, to artists, ix, 25, 117, 153–54
 invasion of viewer's, 97
 medieval, 6, 10, 11, 15, 19
 non-Euclidean, 116, 154–55, 167
 not expressed by volume, 165, 167, 172
 psychological, 148, 179, 227
 psychophysiological, 36, 36n, 37
 representation of, 35–36, 39, 54, 56, 69, 167
 rococo, 104, 106
 shallow, 28, 65, 94, 96, 134, 139, 156, 157, 179
 stage, 6, 21, 41, 65
 stratified, 6, 22
 unified, 3, 39, 54, 56, 65, 69
 visually activated, 208
 and volume united, 146, 148–49
Spatial structure. *See also* Composition, spatial
 ambiguity of, 5, 12, 19, 27, 163, 165, 180, 188, 192
 break with Renaissance, 104, 141, 152, 155–56
 placement on ground plane, 27–28, 35, 47, 56, 59, 62, 95, 106, 109, 112, 143, 145, 148, 188
 pluralism in, 222
 push and pull, 163, 165–67, 192
 tension in, 163, 165, 166, 188
 unity of, 19, 56, 64, 75, 107
Stage space. *See* Space, stage
Steinberg, Leo, 222–25
Still Life with Apples and Oranges (Cézanne), 143, **144**
Story of Jacob and Esau, The (Ghiberti), 44, **45**
Story of Joshua (early Christian), 6, **8**
Stratified style (medieval). *See* Space, stratified
Structuralism. *See* Criticism, structuralist
Subordination of detail to mass. *See* Volume, in details, in mass
Summertime (Pollock), 174
Superstring theory, 215, 216

Surrealism, Freudian approach of, 175–77
Swift, Jonathan, 234n

Ten dimensions. *See* Reality, ten-dimensional
Theory of everything (TOE), 216, 231
Tiepolo, Giovanni, 102–4, 106–7
 Apotheosis of the Pisani Family, **105,** 106
Time
 displacement of, 117–18
 and the fourth dimension, 154
 fragmented, 156–57
 implied, 117, 139, 157, 159
 interest of, to artists, 26, 117–18, 156–57
 and motion, 107, 159
 pluralist concepts of, 213
 and space, baroque, 90–91
 and space, as content, 26, 107, 153, 155
 and space, medieval, 11, 12, 22
 and space, relativity, 154–55, 166–67
 and space, non-Euclidean, 159
Tonal unity. *See* Color, tonal unity
Transcendental. *See* Modern art, as transcendental image
Transparent paint, receding, 112, 114, 199, 202
Transparent picture plane. *See* Picture plane, opaque vs. transparent
Tribute Money (Masaccio), 58–60, **59,** 63, 75
Tub, The (Degas), 125, 127, **128**

Uncertainty principle. *See* Heisenberg's uncertainty principle
Unconscious, 173, 175–78
Unified field theory, 231
Unity. *See* Composition, unified; Illusion, unified; Light, unified source of, unified source of, rejected; Perspective, unifies pictorial space; Space, unified; Viewpoint, unified
Universe
 anthropocentric, 10, 65, 89, 130
 finite, 10, 56, 157, 159
 four forces of, 216
 geocentric, 10, 71
 heliocentric, 1, 71, 89
 infinite, 56
 as mathematical machine, 71, 90–92
Untitled (Poons), 203, **204**

Value
 contrast, 46, 87, 104, 200, 203
 control of, 16, 18, 27–31, 74, 75, 82, 104, 137, 139
 vs. color, 80, 120–21, 125, 135, 137, 139, 145, 148, 150
Vanishing axis, 21
View
 Albertian, 38, 40, 94, 125, 131, 146
 bird's-eye or worm's-eye, 6, 125, 127
 one-eyed, 36, 38
Viewer
 awareness, 45, 134, 141, 146, 149, 173
 Cartesian, 97, 131, 221–24, 235
 controls pictorial space, 12, 27, 163, 187–88, 208
 displacement, 150, 222
 impact on, 33–37, 38, 97, 163, 165, 168, 173, 200
 implied or constructed, 127, 146, 150, 221–24
 integrated into world of the painting, 57–58, 64–65
 modern, 12, 19, 27
 movement implied, 157, 159, 173–74
 as participant, 94, 174
 pluralist, 150, 222, 225
 position of, 2, 27, 40, 64, 127, 134–35, 139, 150, 221, 223–25
 post-Cartesian, 222
 re-creates action or presence of artist, 173, 187

Viewpoint
 pluralist, 2, 3, 146, 150, 154, 157, 159, 171, 222, 232
 unified, 3, 4, 13, 21, 26, 64, 146, 221
Vir Heroicus Sublimis (Newman), 200, **201**
Virgin of the Rocks (Leonardo da Vinci), 72, **73,** 78
Vision of Joachim, The (Giotto), 31, **32**
Vitruvius, 42–43n
Volume
 absence of, in medieval painting, 12
 created by dark and light, 16, 31, 46, 60–61, 67, 75, 77, 87, 131, 143
 created by warm and cool color, 103–4, 137, 137n, 143, 145–49
 culminating point, 143, 145
 in details, 16, 30
 in mass, 18, 19, 30–31, 67
 rejected, 88, 132, 134, 167, 172, 179, 180, 210
 shading of, 5, 18, 35
 simultaneously developed and destroyed, 131
 strengthened by atmospheric perspective, 62, 63, 75, 82

Warm-cool. *See* Composition, in warm and cool; Volume, created by warm and cool color
Wet-into-wet technique. *See* Painting, wet into wet
Where Do We Come From? What Are We? Where Are We Going? (Gauguin), 124
White Cockatoo (Pollock), 174
White Light (Pollock), 180, **181**
Woman I (de Kooning), 194, **195,** 196, 197
Worm's-eye view. *See* View, bird's-eye or worm's-eye
Wright, Stanton Macdonald, 172

Zen Buddhism, 172, 175–77, 180, 209

CHANGING IMAGES OF PICTORIAL SPACE
was composed in 10 on 12 Baskerville on a Merganthaler Linotron 202
with display type in Friz Quadrata
by Eastern Graphics;
and published by

SYRACUSE UNIVERSITY PRESS
SYRACUSE, NEW YORK 13244-5290

Printed in the USA
CPSIA information can be obtained
at www.ICGtesting.com
CBHW021944160324
5358CB00001B/4